Beauty and Tranquility:
The Eli Lilly Collection of Chinese Art

This catalogue is dedicated to the memory of Mr. and Mrs. Eli Lilly

Beauty and Tranquility:
The Eli Lilly Collection of Chinese Art

Yutaka Mino and James Robinson

Indianapolis Museum of Art

1983

Credits

Editorial Coordinator: Jean Kane

Editor: Nancy Van Itallie

Designer: Marcia K. Hadley

Photography: Robert Wallace and McGuire Studios, Inc.

Calligraphy: Dr. Fu Shen (title), Dr. Yutaka Mino (index)

Typesetting and Composition: Weimer Typesetting Co., Inc., Indianapolis

Printing: Design Printing Co., Inc., Indianapolis

This catalogue and the exhibition on which it is based would not have been possible without the generous support of several agencies, which we gratefully acknowledge here:

Research and editorial costs have been funded, in part, by a generous grant from the Andrew W. Mellon Foundation. Additional support for the production of this catalogue has been provided by a grant from the National Endowment for the Arts, a federal agency, Washington, D.C.

Support for the exhibition and this catalogue has also been provided by the Indiana Arts Commission and the Institute of Museum Services, a federal agency that offers general operating and program funding to the nation's museums.

ISBN: 0-936260-13-0 cloth

ISBN: 0-936260-14-9 paper

Library of Congress Catalog Card Number: 82-084077

On the Cover:
Bowl
Jin dynasty, 13th century
Jun (Chün) ware
See Plate 83

Title Calligraphy—Beauty and Tranquility

Contents

Director's Foreword 6

Preface 7

Origins of the Lilly Collection of Chinese Art 9
 by Gene E. McCormick

Chronological Table of Chinese Dynasties 13

Map of China 14

Catalogue of the Collection 15

Jade, Plates 1–19 49

Bronze & Metalwork, Plates 20–52 89

Ceramics, Plates 53–118 157

Painting, Plates 119–130 291

Remainder of the Collection, Figures 1–37 334

Bibliography 346

Index of Chinese and Japanese Characters 348

Pronunciation Guide 352

Technical Appendix 353

NOTE:
The *pinyin* system of romanization is used throughout except for titles of books printed before 1970 and the personal names in the painting section.
 Measurements are given in both inches and centimeters.

Director's Foreword

The Indianapolis Museum of Art is fortunate in its outstanding collections. Some are awe-inspiring in their beauty and others are unique in their rarity. Still others are overwhelming in their antiquity.

The Eli Lilly Collection of Chinese Art is such a collection. It spans the history of civilization from pottery crafted in Neolithic times to artifacts made in this century. It includes fine bronzes, intricate jade objects, elegant ceramics, and exquisite paintings. In its immense scope, the Eli Lilly Collection of Chinese Art stimulates the mind and imagination on many levels.

A notable collector in many areas, Eli Lilly began to acquire Chinese art just after the end of World War II. He showed foresight in his belief that Westerners could better understand Eastern civilization through the study and enjoyment of its artistic achievements. The exhibition and this catalogue surely help illuminate the history of the East and its fascinating people. Eli Lilly was truly a man of vision and generosity.

The best of collections requires the best of scholarly interpretation. The Eli Lilly Collection of Chinese Art has been the responsibility of Dr. Yutaka Mino, an internationally recognized scholar of Oriental art who came to the Indianapolis Museum of Art in 1977 as curator of Oriental Art. His decision to join the IMA was largely based on his desire to research and to develop further the beautiful and extensive Eli Lilly Collection of Chinese Art.

Through the dedicated work and scholarship of Dr. Mino and assistant curator of Oriental Art James Robinson, who joined the Museum in 1979, this unique collection has been made available to the public through the elegant permanent installation at the Museum as well as this stunning and comprehensive catalogue. The diligent research, sound methodology, and flawless scholarship of Dr. Mino and Mr. Robinson have resulted in a valuable guide for both scholar and the lover of Oriental art. We are indeed grateful to them for their singular effort.

I would like to thank the catalogue editor, Nancy Van Itallie, the photographer, Bob Wallace, and the designer, Marcia Hadley for their work on this well-executed publication. Thanks, too, are due to Jean Kane, editorial coordinator, and Jeanne Hill, editorial assistant, for their perseverance in stylistic consistency. Special thanks go to

Dr. Fu Shen, curator of Chinese Art at the Freer Gallery, for the beautiful calligraphy on the cover; and to corporate historian Gene E. McCormick of Eli Lilly and Company for his interesting discussion of the collection's origins.

The analyses of the bronze pieces in the collection provide important scientific insight to these ancient artifacts. The analyses were conducted at Indiana University-Purdue University at Indianapolis under the supervision of Leon P. Stodulski, assistant professor of Analytical Chemistry. Dr. Stodulski, along with assistants Portia Bass and Mary Frances Striegel, deserve special thanks. Their studies have further refined the understanding of the collection.

The talents of Martin J. Radecki, chief conservator, and Richard Sherin, assistant conservator of objects, have also been important for this exhibition. Their technical abilities have ensured that these priceless treasures will be available to future generations.

Exhibiting a collection as grand in scope as the Eli Lilly Collection of Chinese Art requires a great deal of planning, creativity, and hard work. For their arduous labors in presenting the collection to its best advantage, I am grateful to Sherman O'Hara, Chief Preparator, and his staff: Sam Smith, Ted Allen, Tom Keesee, Cynthia Dunham-Heimbuch, and Laura Marshall.

A Centennial year is a challenge and an opportunity. Our Centennial has allowed us to display the finest pieces from the permanent collections in a series of major exhibitions and to present these collections in scholastically important catalogues such as this one.

This catalogue and the exhibition also serve as a tribute to the collector, Eli Lilly, one of the Museum's greatest friends. Building this collection is only one of the many ways in which he enriched our city, our state, and our Museum—and thus the lives of thousands of people and of generations to come. We hope that this catalogue and the exhibition will not only express the depth of our gratitude to this extraordinary man, but will also serve to fulfill his dream: to increase our understanding of other cultures through art.

Robert A. Yassin
Director

Preface

The Eli Lilly Collection was begun in the late 1940s and continued to be formed during the 1950s with the assistance of both C. T. Loo, an eminent dealer in Chinese antiquities, and Wilbur Peat, then director of the John Herron Art Institute. Eli Lilly, chief executive of Eli Lilly and Company of Indianapolis, went on collecting with the fortunate help of many noted scholars of his time. The Lilly Collection soon became one of the finest comprehensive collections of Chinese art built by an individual in this country, including as it does such excellent examples from all media.

The first work of Chinese art given by Eli Lilly, the cover piece of this catalogue, was received in 1947 by the John Herron Art Institute (which in 1968 became the Indianapolis Museum of Art). During the ensuing years Mr. Lilly, a generous benefactor of the Herron Museum, made many more gifts, and the greater part of his collection came to the Museum in 1960. The Lilly gifts, by virtue of their quantity and quality, immediately became the core of the Oriental collection.

With the founding of the Oriental Department in 1970 under the supervision of Paul Spheeris, the Lilly Collection began to receive the attention that it deserved. Several specialists were invited to examine and comment on the collection, but the fruits of their efforts have never been published. Scholars and connoisseurs began to learn of this outstanding collection, and over the years, many have come from all over the world to study and enjoy it.

In the fall of 1977, when Dr. Yutaka Mino became curator, a need was recognized for a major reorganization of the Oriental Department. At that time it became apparent that the collection should be publicized and properly installed in the galleries. A complete renovation of the gallery was begun in the spring of 1978 and the new galleries opened to the public that September. The resurgence of Museum visitors' interest in the Lilly Collection made evident the need for a complete catalogue.

Compiling a comprehensive catalogue of a collection so vast in scope as that assembled by Eli Lilly, as well as the increased activity of the Oriental Department, required more assistance. In October of 1979, James Robinson joined the department to research and help with the Oriental collections. With a sense of responsibility and a desire to share these unique and beautiful works of art, the department planned a series of publications to introduce the Oriental collection to the general public. Two articles devoted to the collection have appeared, in *Apollo* in 1978 and in *Arts of Asia* in 1981. We are now happy that the Eli Lilly Collection of Chinese Art can finally be presented in full for all to enjoy.

Before this long project could become a reality, many people were asked and offered to help, and they all deserve our sincerest thanks. First we would like to thank the trustees, staff, and volunteers of the Museum, whose support we have enjoyed. Secondly, we have been encouraged in this project by the many scholars and connoisseurs who have seen the collection and freely offered their opinions. Finally, we thank our wives and children, who have also helped in many ways for many hours.

We are fortunate that the Eli Lilly Collection of Chinese Art can be presented during the Centennial anniversary of the Museum, which has benefited in so many ways from Mr. Lilly's generosity. This catalogue was undertaken with the hope that it might be of help and interest to all those interested in Chinese art and culture, and we trust that this goal can in some measure fulfill Mr. Lilly's intentions when he began collecting. This long-awaited project, then, is gratefully dedicated to the memory of Mr. and Mrs. Eli Lilly.

Y. M. and J. R.
March 1983

Origins of the Lilly Collection of Chinese Art

Gene E. McCormick, Corporate Historian
Eli Lilly and Company, Indianapolis, Indiana

Mr. and Mrs. Eli Lilly

In the fall of 1947, Eli Lilly wrote:

> In contemplating the shining beauty of Chinese art objects, we must be able to look beyond the mere perfection of the article and fully realize the universal response to beauty inherent in the Chinese people.
>
> We should do well to emulate this trait as well as others of their closely related characteristics, such as the abiding serenity of spirit and gentle sympathy which so largely control the human relationships of that great people.
>
> We Westerners fall far short of the Orientals in these distinguishing features, and since solidarity can only be developed where there is agreement on the important values in life, we can serve world peace, while making our own lives pleasanter and more abundant, by striving to attain, personally and nationally, a high appreciation of the beautiful tranquility of spirit and compassion.

This was written shortly after Mr. and Mrs. Eli Lilly began formation of their Chinese collection by donating some objects to the permanent collection of the John Herron Art Museum and presenting others to the institution on indefinite loan.[1]

Their admiration for the culture of China had evolved over the years as a result of stimulating friendships with

Dr. Ko Kuei Chen, who had directed pharmacology at Eli Lilly and Company since 1929, and Dr. John G. Bowman, chancellor of the University of Pittsburgh, who also reproduced Chinese furniture and ceramics.[2] Another influential person in this regard was Wilbur D. Peat, director of the John Herron Art Institute, whom Mr. Lilly also had known for some time and whose early life in China gave him intimate understanding of its culture.[3] Concerned about the unending strife afflicting the Republic of China, Mr. and Mrs. Lilly had contributed frequently to war-relief work on behalf of that nation as early as 1939.[4] By 1945 they were seriously considering the formation of a Chinese art collection; Mr. Lilly sought advice about reputable dealers from Dr. G. H. A. Clowes, recently retired director of Lilly research, who recommended C. T. Loo, of New York City.[5]

But it was a book that Mr. Lilly read—before he made contact with the dealer—that fired his enthusiasm to develop a collection. It was written by F. S. C. Northrop, professor of philosophy at Yale University, in 1946, and bore the title *The Meeting of East and West.*[6] World peace was not possible, the author maintained, until the prejudices and fears generating the antagonism between those civilizations were eradicated, and the first step in building harmonious relationships between the East and the West was for each to cultivate understanding of the aesthetic perception indigenous to the culture of the other.[7] The Lilly Collection was, in effect, created to serve the cause of peace by revealing the unity of the human experience embodied in the art of China.

While the Lillys continued to donate objects to the permanent collection of the Herron Museum during the rest of the 1940s and from time to time in the 1950s, the major portion of their acquisitions was presented on indefinite loan, and then in 1960 the lent items also were given unconditionally to the museum.[8] With the 1960 gift the total collection consisted of 181 objects that covered a time span from the Neolithic period, 3000–2500 B.C., to the nineteenth century. The greater number of items are devoted to the dynastic periods of Song (960–1279), Ming (1368–1644), and Qing (1644–1912); but there also are a significant number from late Shang (1700s–1045 B.C.) and Zhou (1045–222 B.C.). The exquisite contents represent a wide variety of media: the pottery included sixty-four porcelains; thirty-one bronzes; twenty paintings; eighteen jades; and three individual objects in silver, lead, and glass.[9] Though small in quantity of artworks, the collection spans a vast reach of time to provide select evidence of a culture in a variety of its media. The Lilly

9

Collection is rare. The only other one in the United States developed on a similar basis is the renowned Freer Collection in Washington, D.C.

The Lilly Collection, which, incidentally, was the only venture that Mr. and Mrs. Lilly undertook in the field of art on a comprehensive scale, is notable also for the conditions upon which it was established. First, it was intended from the outset for public benefaction; the collection was created for reasons quite apart from acquisitiveness or investment return. Created expressly for donation to the Herron Art Museum, it was dedicated to local revelation and enrichment. Furthermore, institutional affiliation was considered requisite to the continuity of enlightenment; philanthropic support of that affiliation was, therefore, unrestricted. Finally, the donors acted with quiet altruism; recognition was inimical to their purpose.

In sum, the Chinese collection was created in the spirit of stewardship, a precept that Mr. and Mrs. Lilly followed in their endeavors to enhance the life of the mind. His collection of prehistoric artifacts of Indiana, for example, became a part of the holdings of the Glenn A. Black Laboratory of Archaeology, a teaching and research facility Mr. Lilly helped to establish at Indiana University, Bloomington; and through his efforts the Gennadius Library at Athens, Greece, acquired a vast array of papers of Heinrich Schliemann, the discoverer of Troy. Consequently, that institution became the leading scholarly resource on the life and works of the nineteenth-century archaeologist. Since boyhood Mr. Lilly had been thrilled by the exploits recounted in the Homeric legend. Perhaps his donation of Greek antiquities to the Herron Museum immediately prior to his donation of the Chinese collection was intended to illustrate something of the meeting of East and West.[10]

Mrs. Lilly followed the same path in the fields of cultural betterment that appealed to her, as with the fine collection of quilts she gave to Conner Prairie Pioneer Settlement; the timepiece collection, spanning four hundred years of the watchmaker's art, she bequeathed to the Indianapolis Museum of Art; and the collection of Revere silver, which has been regarded as the finest in the Midwest. Mrs. Lilly's durable support of the Children's Museum in Indianapolis further attested to the importance she placed upon institutional contribution to the city's vitality. She and her husband enjoyed working together in helping organizations devoted to the preservation of historic structures; they actively supported the Historic Landmarks Foundation of Indiana from the time of its inception in 1960.[11]

Customary to his way of life, Eli Lilly was involved in many activities at the time he began to develop the Chinese collection. Still president of Eli Lilly and Company, he was immersed in the pressures of guiding the firm through postwar readjustment, and he also was nearing the end of his presidency of the Indiana Historical Society, an office he had held since 1933—almost coincident with the period he was president of the company. One of the projects he initiated during that time was the Society's special publication program. He also began a respectable career as author: though he engaged others to help with research, he wrote his own books.[12] In addition, the team of archaeologists, anthropologists, and linguists he had brought together sometime earlier were completing their findings on the migration of the Delaware Indians on the American continent, a study to which he contributed by deciphering the pictographs of the Delaware legend.[13] Careful apportionment of time allowed Mr. Lilly to give personal attention to selecting the art objects for the Chinese collection.

Mr. Lilly followed certain guidelines—which he probably learned from his brother's experiences in collecting over the previous twenty years.[14] Eli Lilly's plunge into Chinese art began with a purchase of Song ceramics in March 1947, after a visit to the gallery of C. T. Loo in New York City. Mr. Lilly continued to call on the dealer from time to time, and likewise, Mr. Loo came to Indianapolis to bring objects that either Mr. Lilly had requested to see or the dealer wanted him to consider. After selections were made, whether in New York or Indianapolis, they were invariably submitted to Wilbur Peat for his critique. "Nothing was ever bought without the advice of Wilbur Peat," Mr. Lilly wrote some years later.[15] Mr. Loo complimented Mr. Lilly on his selectivity, noting that he chose things that were difficult to obtain.[16]

Mr. Lilly had no interest in auctions or the buying of collections; wanting the enjoyment of doing something original, he insisted upon acquiring only a few items at a time and, therefore, making purchases more frequently. This practice also allowed him to budget expenditures for the collection. He did not haggle over price, but he did negotiate—on the clear understanding that arrangements should be advantageous to both parties.

Altogether, he was scrupulous about receiving value for the purchase he had in mind. Once, in making a counteroffer to Mr. Loo's quotations on certain items, Mr. Lilly informed the dealer that, if it was not acceptable, he was not interested in further bargaining. After all, he pointed out, eighty-five percent of the objects under consideration were intended for donation to the Herron Museum.[17] He also was concerned about regaining as much as possible from investment in some paintings offered to him in the event he or his wife had to sell them before donating them to the Museum. They had come to the conclusion that "anyone wishing to sell us a painting must ship it to the John Herron who [sic] in turn will send it to several experts for their written opinions . . . to vastly strengthen ourselves if we should ever wish to sell the objects."[18] Mr. Loo was willing to accept the condition, but he said that Chinese paintings were too fragile to withstand much handling and shipping, and moreover, his insurance could not cover third-party arrangements. Mr. Lilly gave up the idea because he found it too complicated, and he put off buying the paintings. "I am looking for amusement rather than work and responsibility," he wrote.[19] The paramount condition he insisted upon in any sale was anonymity.

Mr. Loo closed his gallery in 1950, except for liquidation of stock, and informed Mr. Lilly that it was necessary for him to go out of business, for he could no longer jeopardize the lives of those who worked for him in China.[20] From that time on, Mr. Lilly relied on a number of dealers in building his collection. Precisely how he educated himself in the arcane task of collecting Chinese art is not known, but undoubtedly his critical faculty and bibliographical knowledge were cultivated by Wilbur Peat. Mr. Lilly was a voracious reader. Dr. Chen and, of course, C. T. Loo also provided advice in matters of selection.

With regard to problems of authenticity, the x-radiography technique currently being used to analyze the bronzes in the collection would have delighted Mr. Lilly, because he believed that technological application is essential to useful exploration, that it is a rational extension of the productive mind. It was his idea to adopt the proton magnetometer for prehistoric archaeological research at the Angel Site in Newburgh, Indiana, which he supported through the Indiana Historical Society.[21]

To foster the meeting of East and West through public benefaction was not enough, however, for Mr. and Mrs. Lilly. This concern influenced their private life as well. In 1948 Mr. Lilly bought acreage adjacent to the south of Conner Prairie Farm, where during the 1930s his wife and he had worked indefatigably to restore and furnish the two-story brick house built in 1823 by William Conner, the sturdy pioneer who rose from fur trader and Indian agent to farmer, legislator, and businessman. On the newly purchased land next to that major Hoosier historic site was the former summer cottage of the E. C. Atkins family, which was situated on a wooded bluff overlooking White River to the west. This abode, the Lillys decided, was to be their Chinese house, and they named it "House of the Sylvan Harmonies." Dr. Chen translated the name into *Shen Ho Shih* for them and wrote it out in Chinese characters for a tablet over the main door.[22] The tablet is still there.

Dr. Chen and his wife also presented the Lillys with some scrolls and six portraits of Song emperors and made suggestions for the decor of the house. John Broerse was engaged to paint the interior. The living room ceiling and beams were decorated with brilliant Chinese symbols, the walls were painted a pleasant, gray green shade, and the drapes were made of yellow shantung. The furniture consisted of Baker reproductions and antiques; Dr. Bowman contributed a Ming table he had fashioned. On the dining room ceiling "bloomed the twelve flowers of the months of the year."[23] Large parties were frequently held at the Chinese house, especially in the summer, when the wide veranda along the west front could be used. For many years the Blatchley Nature Study Club, of Noblesville, to which the Lillys belonged, held its annual meetings in the home. The property and Conner Prairie Farm were donated to Earlham College in 1964.

Like the patron-administrator in colonial America who realized his own project designs, Mr. Lilly used his handiwork in creating the Oriental retreat. He made some Chinese-style tables for it; and, after much trial and error, he painted a Chinese landscape on a four-panel screen in black and white, using powdered graphite. This extension was typical of his grasp of subjects that fascinated him. Convinced that knowledge is only useful when applied, he tried his hand in many ways—from digging his own excavations to increase his understanding of archaeological research to overhauling his cars and boats, machining parts for production equipment at the company's plant, and repairing his household furniture. The woodworking he did in the immaculate, efficiently organized shops at his home and Wawasee cottage reflected an affinity with his carpenter great-grandfather, Gustavus Lilly, but he denied having any talent. "I'm just an assembler of wood," he once remarked. In his shop at Wawasee hung a sign that said, "Our Best Is None Too Good."

It is clear from Mr. Lilly's statement in the introduction to this account that he believed art serves a moral purpose. Art was not simply for the sake of art. And it is also clear that he was imbued with the Western predilection for determining the meaning of things (". . . We must be able to look beyond the mere perfection of the article . . ."). His perspective was programmatic. Consequently, it would appear that his view of the nature of Chinese art—with its empirical aesthetic and its mystical "oneness"—was antithetical to the importance he ascribed to the values of pictorial realism, an art form of the West that, in Northrop's terms, locates external objects in an inferred, postulated public space apart from the observer.

Versed as he was in archaeology and anthropology, Mr. Lilly did tend to "read" the meaning of artifacts in cultural context, to ascertain significance through the evidence of the hand's work. But he interpreted that work as both sign and symbol of man's genius, and it was in that perception he found a common bond between the art of the East and the West. The manual craft connoted to him the singularity of man's adventure in the perennial here-now of the world, the creative shaping of objects man needed for survival. Mr. Lilly responded instinctively to the immanent values of Chinese art and yet discerned them acutely in his mind, because he was an observer who could not set himself apart from the "postulated public space."

In light of the many and varied contributions Eli Lilly made to scholarship in the history and prehistory of the American Midwest and ancient Greece, the Chinese collection is a microcosm of his dedication to the "acquisition and diffusion of knowledge" about the human experience. Through genial association with many people, he sought to affirm the commonality of man. His endeavor to bring forth the universal as embodied in the Chinese collection, sprang from a locus of wonderment, a romance with life, that motivated all of his pursuits. The "assembler of wood" had had no formal education in the humanities, and neither had his father or brother, who also made notable contributions to cultural heritage. In large measure Mr. Lilly was inspired by his wife Ruth,

who gave him a clear understanding of himself and shared fully in his activities during their forty-five years of marriage.

The harmony Mr. Lilly envisioned between the aesthetic life and the rational mind is intimated in something he wrote when he was on the threshold of forming the Chinese collection:

> Wisdom lies in realizing that as long as we live we shall forever be working with the imperfect. One who is an artist in living can transmute the medium of imperfections into acceptable, if not ideal, conditions.[24]

NOTES

[1] Mr. Lilly's statement was prepared at the request of Wilbur D. Peat, director of the Herron, in paraphrase, for inclusion the introduction to the catalogue *Chinese Ceramics of the Sung Dynasty,* John Herron Art Museum, n.d. In his letter enclosing the statement, Mr. Lilly told Mr. Peat to feel free "to change it or throw it out altogether, just so the essence of the thing is kept." Letter, September 15, 1947, in the archives of Eli Lilly and Company. Unless otherwise indicated, documents cited in this article are from that source.

[2] Eli Lilly became acquainted with Dr. Bowman in the early 1930s when his father, J. K. Lilly, Sr., was making arrangements to donate the Stephen Foster collection of manuscripts and memorabilia to the university. (Pittsburgh was the composer's city of birth.) Eli Lilly credited the chancellor with arousing his interest in collecting Chinese porcelains. Eli Lilly to John G. Bowman, November 13, 1952.

[3] Mr. Peat was appointed director of the museum in 1929. Mr. Lilly had been a member of the Art Association of Indianapolis as early as 1922.

[4] In 1947 Chiang Kai-shek, as chairman of the Executive Council of the Government of China, bestowed the Medal of Honored Merit on Mr. Lilly "because he has contributed medicinal products and other substantial aid for our resistance against aggression." Excerpt from the certificate of award.

[5] G. H. A. Clowes to Eli Lilly, December 12, 1945.

[6] The MacMillan Company, New York.

[7] The West is more concerned with the theoretic component of life—the significance of things rather than the things themselves, the author declared. The Chinese attitude, in contrast, arises from an ineffability attached to anything perceived and, consequently, makes a distinction between the immutable and the transitory. In his *Interest in Chinese Art,* of 1968, Mr. Lilly said, "Throughout the book the underlying theme was that both the East and West must learn to appreciate the ways and thoughts of the other if disastrous clashes were to be avoided in the future." As was his custom, Mr. Lilly underscored passages he considered especially important in the book.

[8] Mr. Lilly offered the gift to the John Herron Art Museum in a letter to Mr. Peat, January 29, 1960. Enclosed with the letter was an inventory list of 116 items. Only one object, a twentieth-century stone rubbing, was donated afterward, in 1965. Why the Lillys made no further donations is not known.

[9] Inventory, "Lilly Gifts," Indianapolis Museum of Art.

[10] The small collection consists of thirteen objects, all dating from the sixth to the fourth century B.C., except for a second-century A.D. Phoenician item. The few pieces in the collection are indicative of the Lillys' lack of concern about fields that had been extensively developed. They did not, for example, collect American art per se; but acquired it primarily to furnish historic houses in which they were interested.

[11] When she died in 1973, Mrs. Lilly was eighty-one. Mr. Lilly died in 1977, a few months before his ninety-second birthday. Ruth Helen Allison and Eli Lilly were wed in 1927.

[12] Among his writings were the first bibliography of Indiana archaeology, 1932; *Prehistoric Antiquities of Indiana,* 1937 (still a standard reference); *Little Church on the Circle,* 1957; *Early Wawasee Days,* 1960; and *Schliemann in Indianapolis,* 1961. Mr. Lilly conceived and funded the research and publication of *The Carrey Drawings of the Parthenon Sculptures,* Indiana University Press, 1971, Theodore Bowie and Diether Thimme, editors.

[13] See *Walum Olum or Red Score, The Migration Legend of the Lenni Lenape or Delaware Indians,* Indiana Historical Society, 1954. In carrying out the Walum Olum study, Mr. Lilly provided a linguistic fellowship at Indiana University in 1941. He was instrumental in creating the school's department of anthropology. Organized in 1947, it was the first in the state's university system.

[14] J. K. Lilly, Jr., began his collecting career in 1926 with rare books. That pursuit inspired his father to launch the Stephen Foster collection in 1930, a pioneer endeavor in the bibliography of American music, and his brother Eli to collect prehistoric artifacts of Indiana. The Lilly brothers scrupulously avoided infringing upon each other's fields of interest; nevertheless, their avocations were complementary.

[15] *Interest in Chinese Art,* op. cit.

[16] C. T. Loo to Eli Lilly, May 9, 1947.

[17] Eli Lilly to C. T. Loo, May 5, 1947.

[18] Ibid., February 23, 1948.

[19] Ibid., March 8, 1948.

[20] C. T. Loo to Eli Lilly, March 9, 1950.

[21] The proton magnetometer was first used in this country at Angel Site for purposes of archaeological investigation, and it was at Angel Site that it was also successfully developed. See Richard B. Johnston, "Proton Magnetometer and Its Application to Archaeology," *Prehistory Research Series,* IV, 2, April 1964, Indiana Historical Society. Mr. Lilly suggested the application in 1958.

[22] K. K. Chen to Eli Lilly, October 10, 1949.

[23] *Interest in Chinese Art,* op. cit.

[24] "The President's Column," *Lilly SuperVision,* 1, 9, September 1946.

Chronological Table of Chinese Dynasties

Shang-Yin Dynasty 1700s–1045 B.C.

Zhou (Chou) Dynasty 1045–222 B.C.
 Western Zhou 1045–771 B.C.
 Eastern Zhou 771–222 B.C.

Qin (Ch'in) Dynasty 221–206 B.C.

Han Dynasty 206 B.C.–A.D. 220
 Western Han 206 B.C.–A.D. 9
 Eastern Han A.D. 25–220

Six Dynasties A.D. 220–589

Sui Dynasty . 581–618

Tang (T'ang) Dynasty 618–906

Five Dynasties . 907–960

Liao Dynasty . 907–1125

Song (Sung) Dynasty 960–1279
 Northern Song 960–1127
 Southern Song 1127–1279

Jin (Chin) Dynasty 1115–1234

Yuan (Yüan) Dynasty 1280–1368

Ming Dynasty 1368–1644
 Hongwu (Hung-wu) 1369–1398
 Yongle (Yung-lo) 1403–1424
 Xuande (Hsüan-te) 1426–1435
 Chenghua (Ch'eng-hua) 1465–1487
 Hongzhi (Hung-chih) 1488–1505
 Zhengde (Cheng-te) 1506–1521
 Jiajing (Chia-ching) 1522–1566
 Longqing (Lung-ch'ing) 1567–1572
 Wanli (Wan-li) 1573–1620

Qing (Ch'ing) Dynasty 1644–1912
 Kangxi (K'ang-hsi) 1662–1722
 Yongzheng (Yung-cheng) 1723–1735
 Qianlong (Ch'ien-lung) 1736–1795
 Daoguang (Tao-kuang) 1821–1850

Map of China

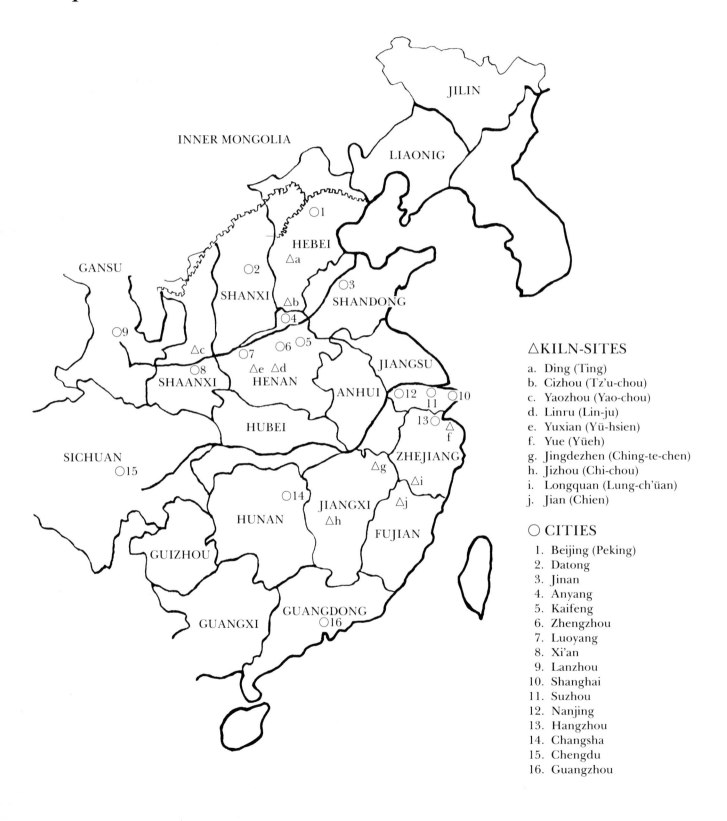

△ KILN-SITES

a. Ding (Ting)
b. Cizhou (Tz'u-chou)
c. Yaozhou (Yao-chou)
d. Linru (Lin-ju)
e. Yuxian (Yü-hsien)
f. Yue (Yüeh)
g. Jingdezhen (Ching-te-chen)
h. Jizhou (Chi-chou)
i. Longquan (Lung-ch'üan)
j. Jian (Chien)

○ CITIES

1. Beijing (Peking)
2. Datong
3. Jinan
4. Anyang
5. Kaifeng
6. Zhengzhou
7. Luoyang
8. Xi'an
9. Lanzhou
10. Shanghai
11. Suzhou
12. Nanjing
13. Hangzhou
14. Changsha
15. Chengdu
16. Guangzhou

Catalogue of the Collection

美与宁静

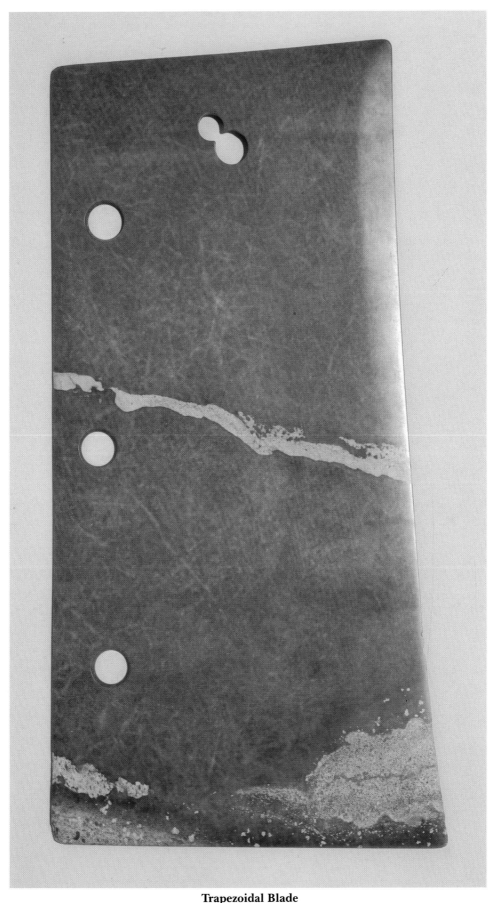

Trapezoidal Blade
Neolithic period, 3rd–2nd milleniums B.C.
Jade
See Plate 3

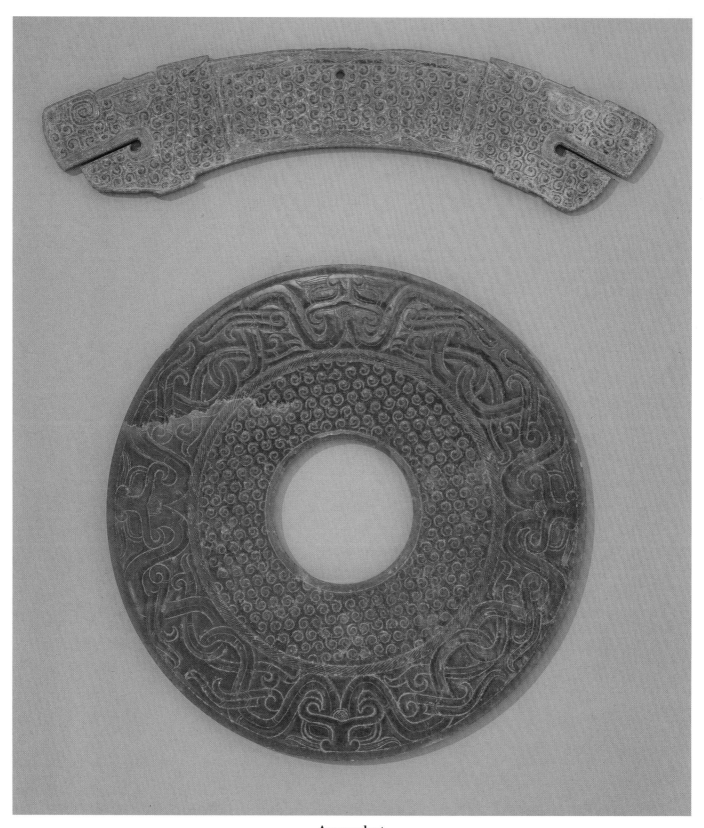

Arc pendant
Eastern Zhou dynasty, 5th–4th centuries, B.C.
Jade
See Plate 17

Bi
Western Han dynasty, 2nd century, B.C.
Jade
See Plate 19

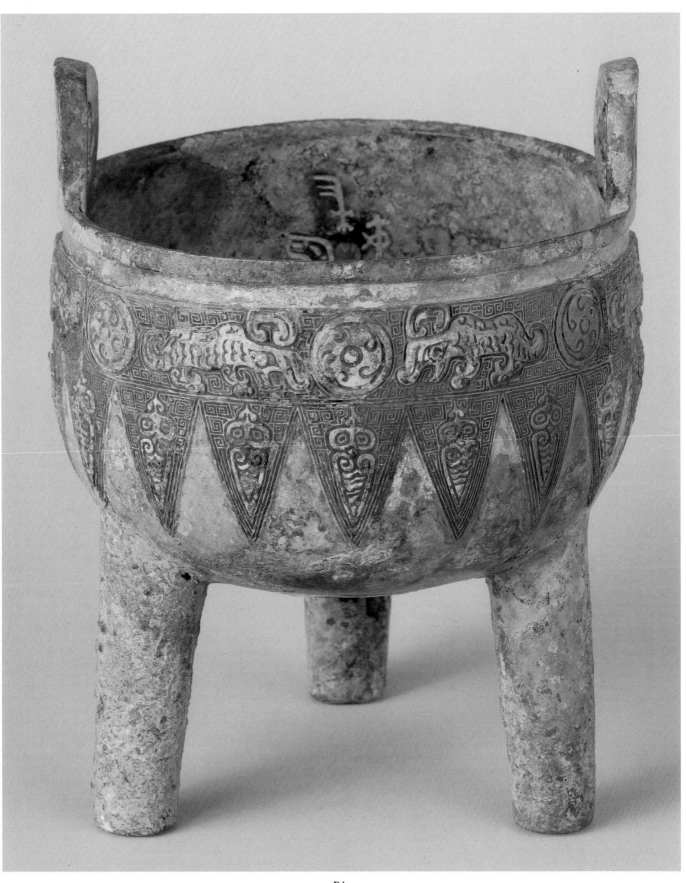

Ding
Shang dynasty, 13th–12th centuries B.C.
Bronze
See Plate 24

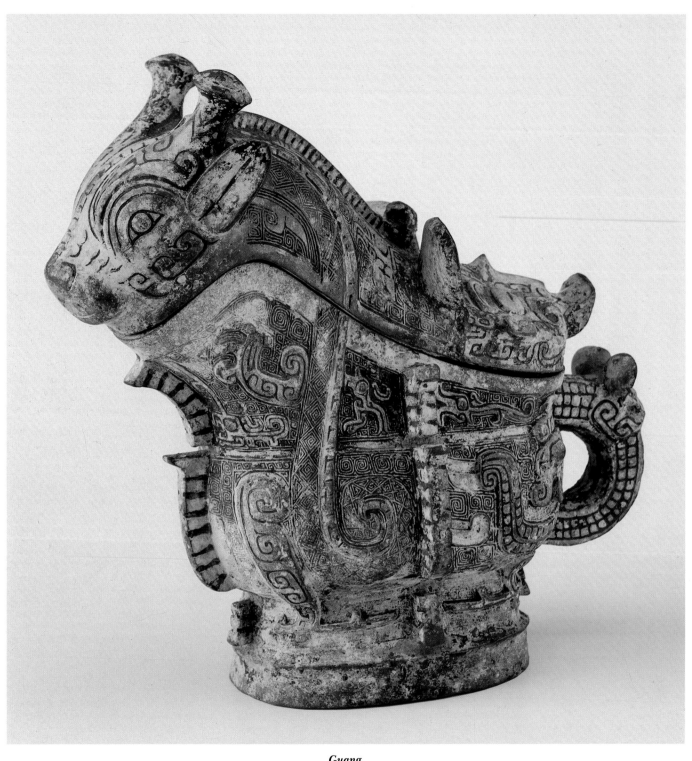

Guang
Shang dynasty, 13th–12th centuries B.C.
Bronze
See Plate 25

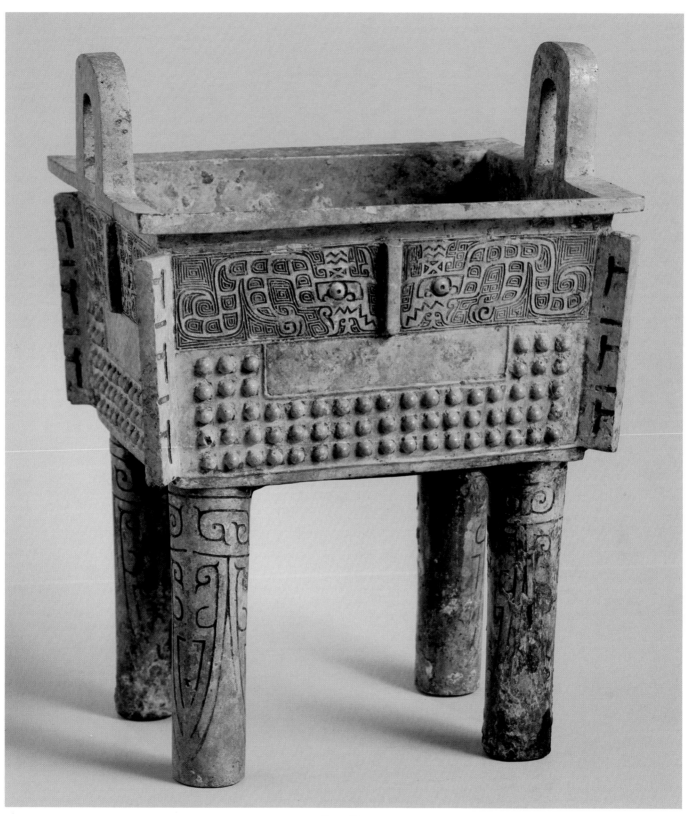

Fangding
Western Zhou dynasty, 11th century B.C.
Bronze
See Plate 28

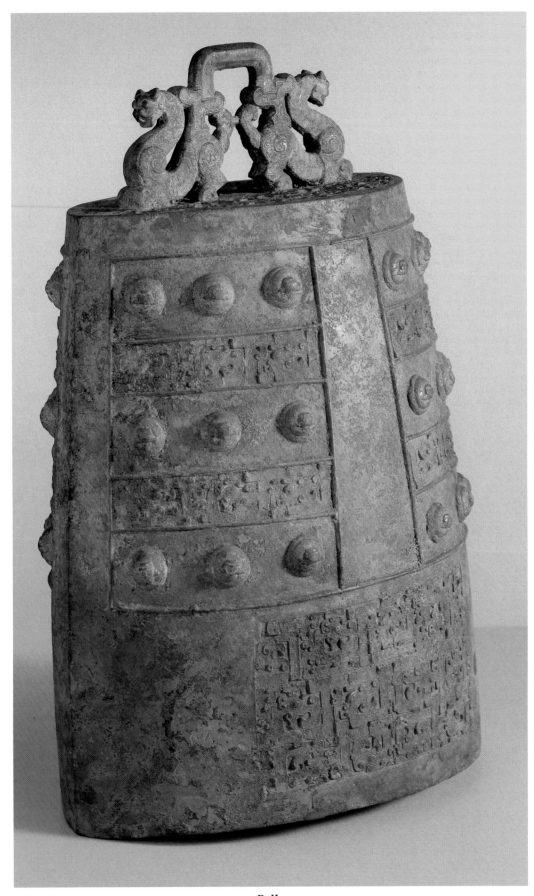

Bell
Eastern Zhou dynasty, 6th century B.C.
Bronze
See Plate 33

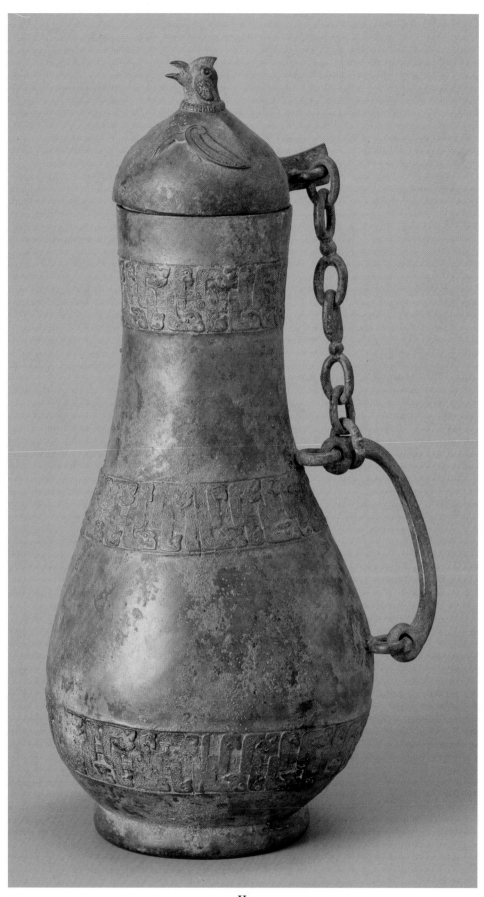

Hu
Eastern Zhou dynasty, 6th–5th centuries B.C.
Bronze
See Plate 34

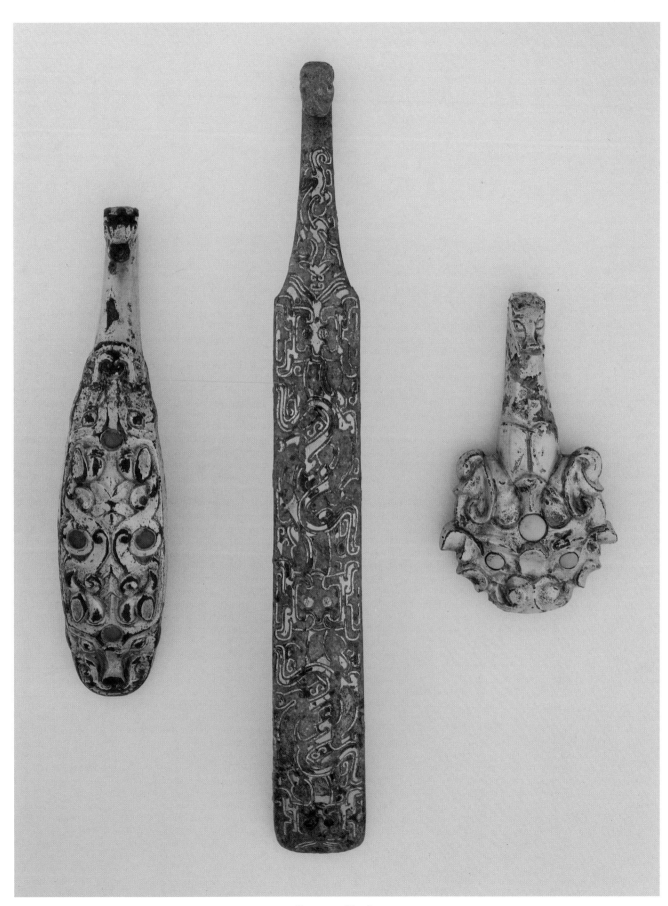

Garment Hooks
Eastern Zhou dynasty, 4th–3rd centuries B.C.
Bronze with inlay
See Plates 38, 39, 40, 41, 42, 43

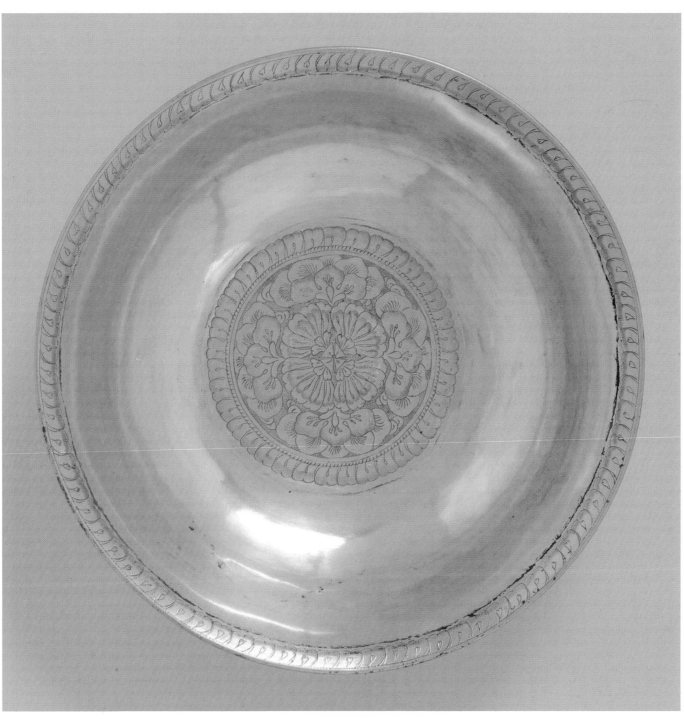

Silver bowl
Tang dynasty, 8th century
Silver with gold
See Plate 50

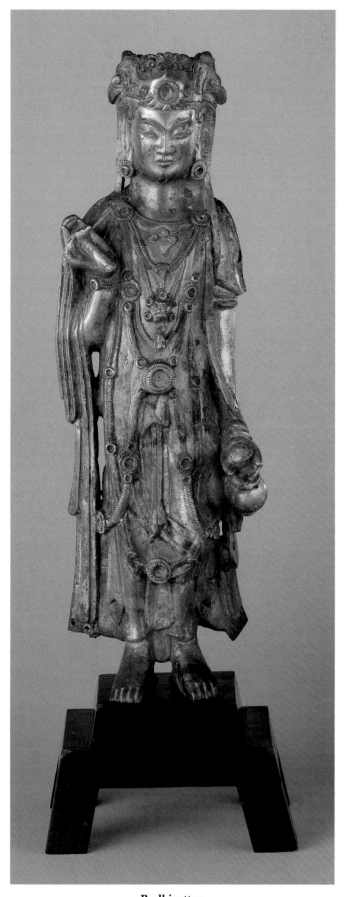

Bodhisattva
Sui dynasty or earlier
Gilt bronze
See Plate 52

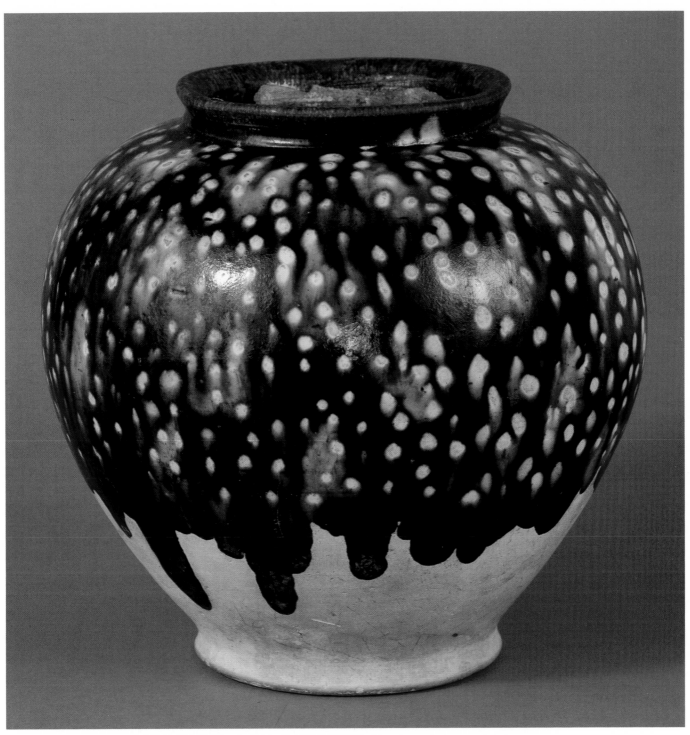

Jar
Tang dynasty, 8th century
Lead-glazed earthenware
See Plate 64

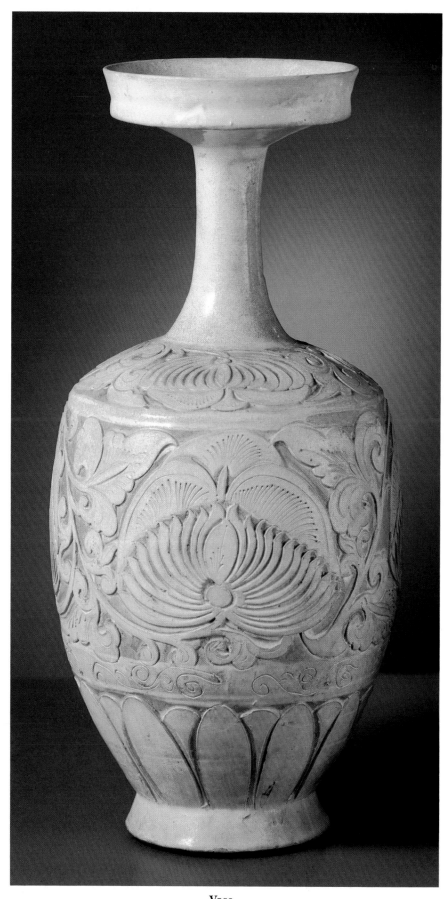

Vase
Northern Song dynasty, late 10th or early 11th century
Cizhou (Tz'u-chou)-type ware
See Plate 67

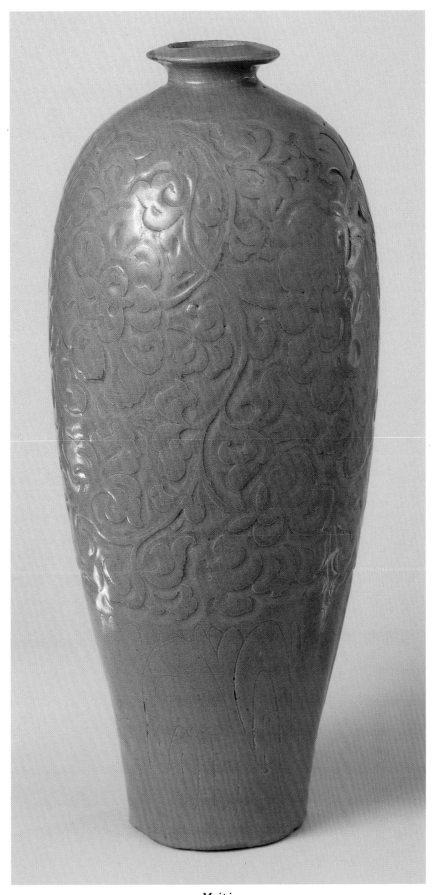

Meiping
Northern Song dynasty, ca. A.D. 1100
Yaozhou (Yao-chou) ware
See Plate 74

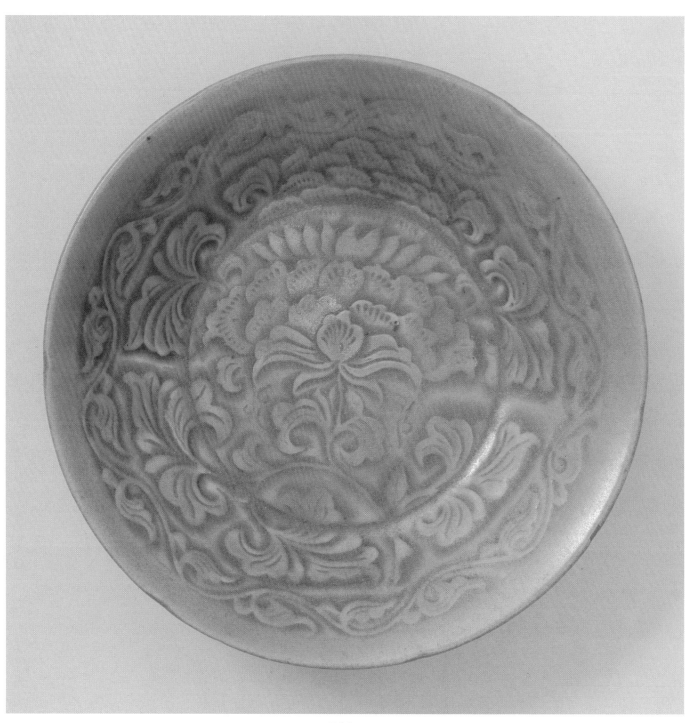

Dish
Northern Song dynasty, early 12th century
Linru (Lin-ju) ware
See Plate 75

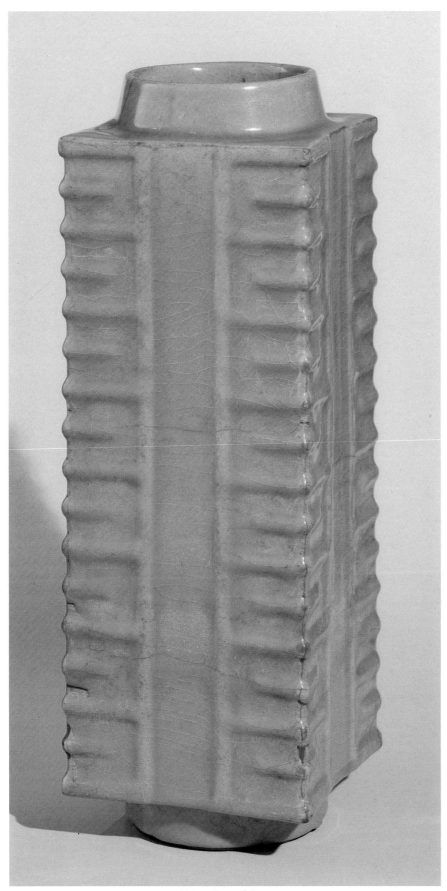

***Zong*-shaped Vase**
Southern Song dynasty, 13th century
Longquan (Lung-ch'üan) ware
See Plate 76

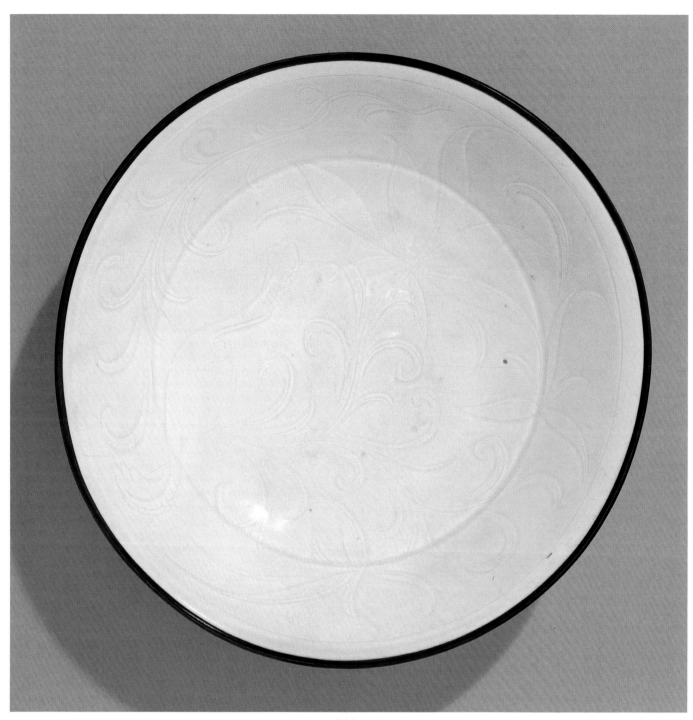

Dish
late Northern Song or Jin dynasty, 12th century
Ding (Ting) ware
See Plate 80

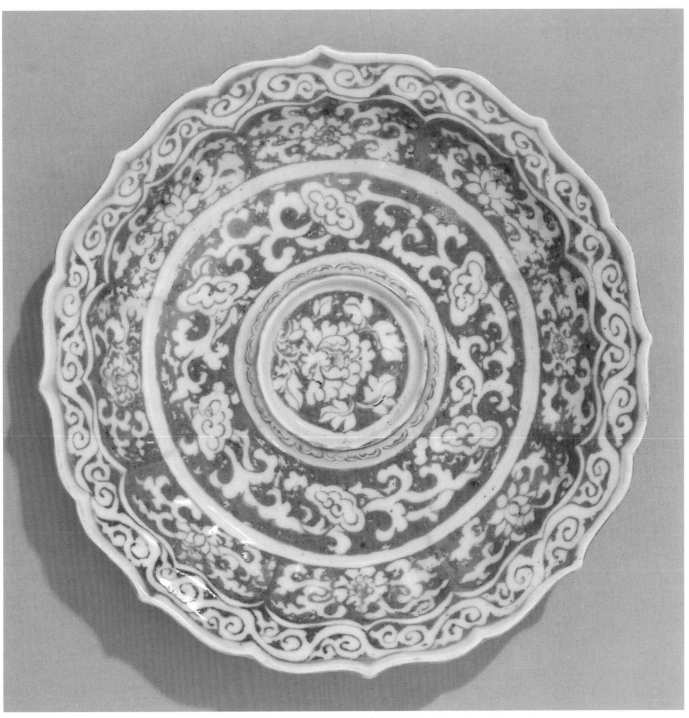

Cup Stand
Ming dynasty, early 15th century
Underglaze red ware
See Plate 88

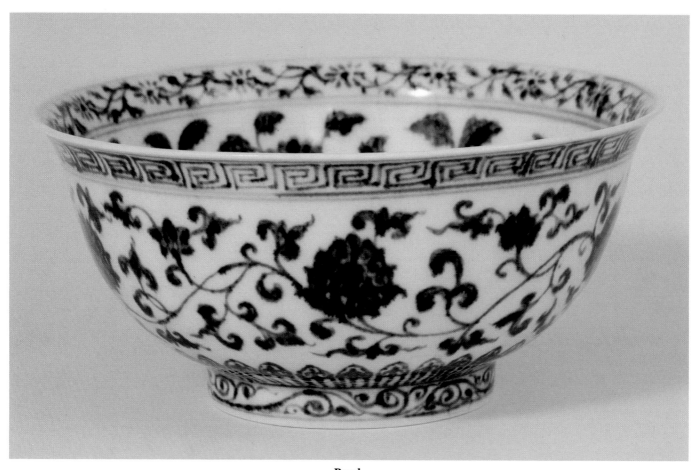

Bowl
Ming dynasty, Yongle period (1403–1424)
Blue-and-white porcelain
See Plate 89

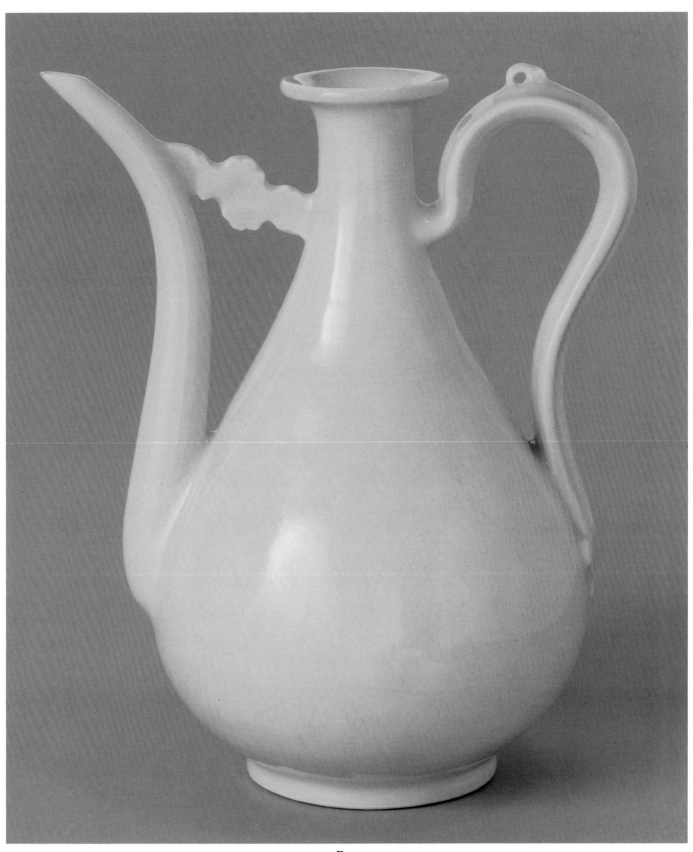

Ewer
Ming dynasty, Yongle period (1403–1424)
Porcelain with *anhua* decoration
See Plate 93

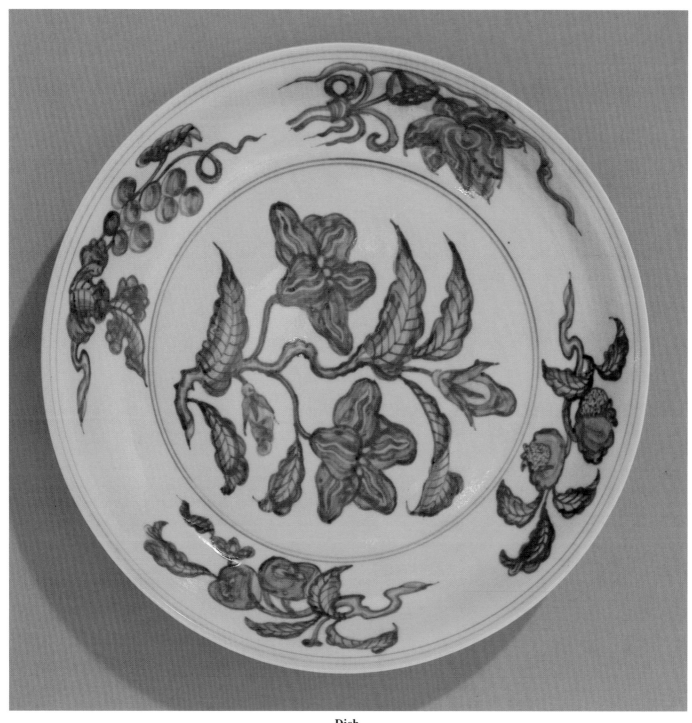

Dish
Ming dynasty, Hongzhi period (1488–1501)
Blue-and-white porcelain with overglaze yellow enamel
See Plate 97

Jar with Cover
Ming dynasty, Jiajing period (1522–1566)
Porcelain with underglaze blue and overglaze enamel decoration
See Plate 100

Vase
Qing dynasty, Kangxi period (1662–1722)
Blue-and-white porcelain
See Plate 107

Bottle
Qing dynasty, Kangxi period (1662–1722)
Porcelain with underglaze red decoration
See Plate 109

Vase
Qing dynasty, Kangxi period (1662–1722)
Porcelain with *famille verte* enamel decoration
See Plate 111

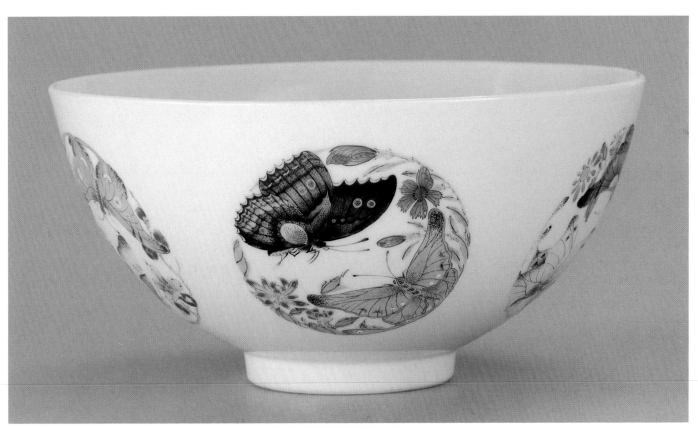

Bowl
Qing dynasty, Yongzheng period (1723–1735)
Porcelain with *famille rose* enamels
See Plate 113

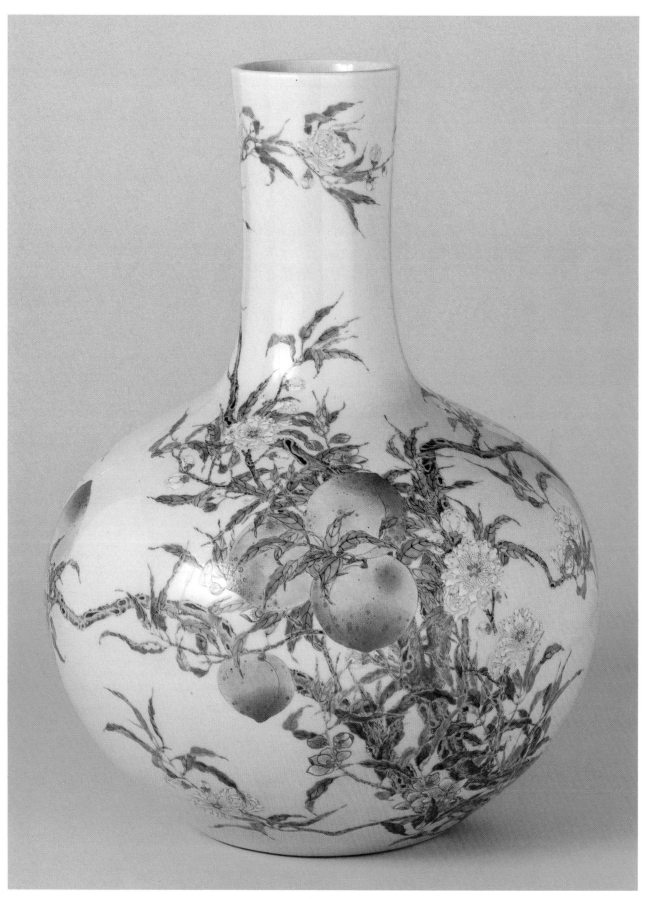

Vase
Qing dynasty, Qianlong period (1736–1795)
Porcelain with *famille rose* enamel decoration
See Plate 115

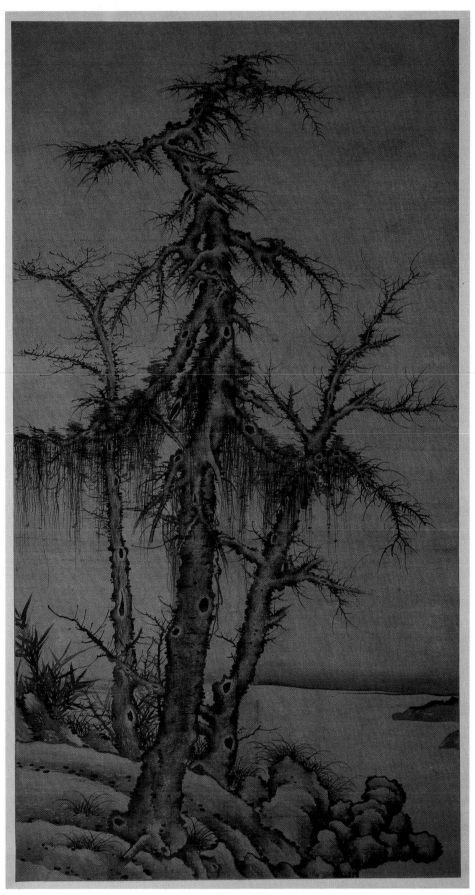

Old Trees, Bamboo, and Rocks
Li K'an (1245–1320), attributed to
Ink on silk
See Plate 121

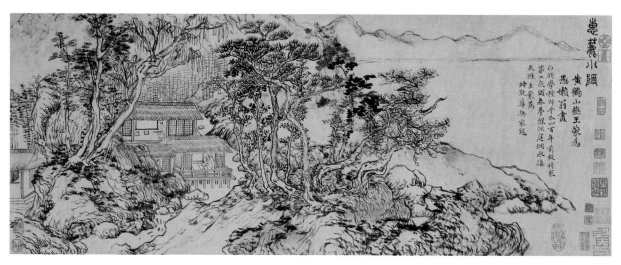

Retreat at the Foot of Mt. Hui
Wang Meng (ca. 1308–1385)
Ink and light color on paper
See Plate 124

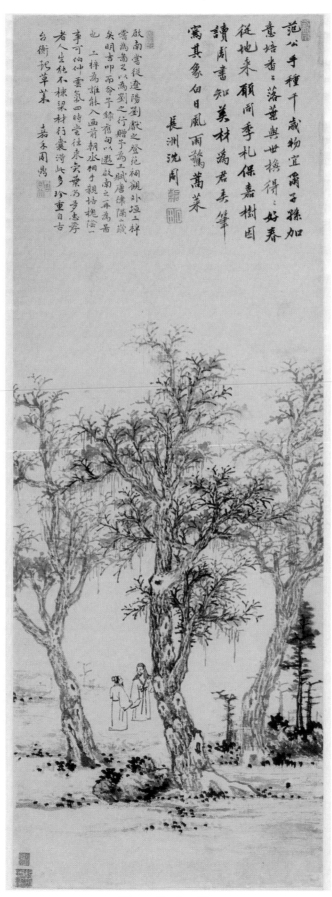

范公手種千歲物宜爾子孫加
意培番之落葉與世榱得之好春
從地來顧問季札保嘉樹囚
讀劇書知美材為君壽肇
寫其象白日風雨鶺萬葉

長洲沈周敬

啟南嘗從遂陽劉獻之燈范祠觀外垣三梓
常為萬之以為劉之行贈于為三賦唐律陽之歲
矣明吉卯而命子餘舊句以啟南之平為畫
也三梓為誰能入畫前永相于親培槐陰一
事可伯仙雲氣四時嘗往來宗葉為多忠存
者人生桃不棟梁材行囊潸此多珍重自古
台衡託草茉

嘉禾周鳳

Three Catalpa Trees
Shen Chou (1427–1509)
Ink on paper
See Plate 125

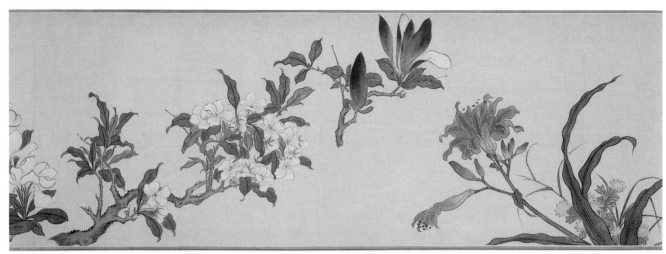

Colored Epidendrum and Bamboo, 1604
Ma Shou-chen (1548–1604)
Ink and colors on gold flecked paper
See Plate 128

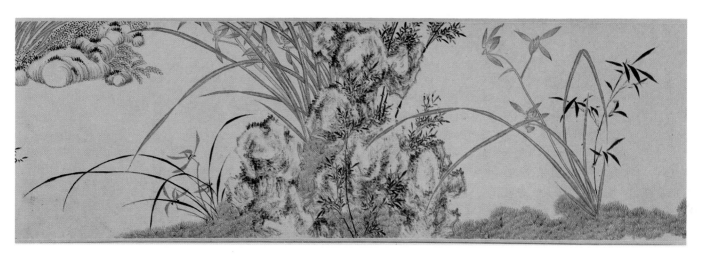

Twenty-four Seasonal Flowers, 1604
Wei Chih-k'o (active ca. 1600)
Ink and colors on paper
See Plate 129

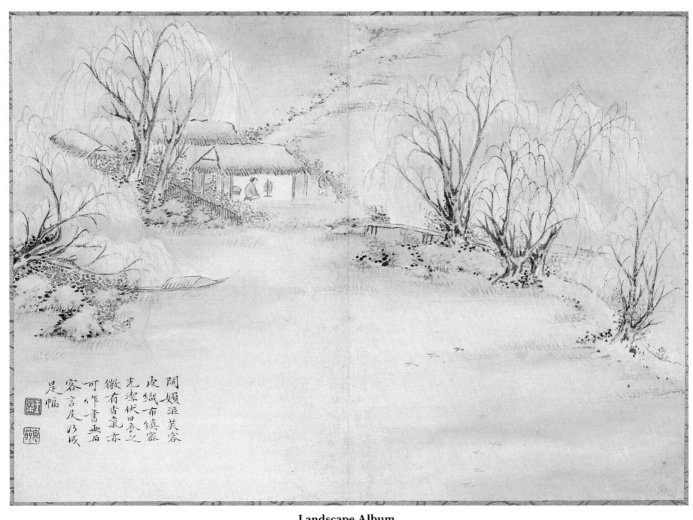

閒娛澗芙蓉
史織布鎮容
光潔伏晏之
微有香氣在
可作書畫而
容言及乃成
是幅

Landscape Album
Wang Kai (active ca. 1677–1705)
Ink and colors on paper
See Plate 130

Jade

Plates 1–19

Plate 1
ZONG
Neolithic period, 3rd millennium B.C.
Jade
Height, 1½ in. (4.0 cm.)
60.59

The broad, low, circular collars on either end extend beyond the rectangular shape of the squat body. There is a large ridge halfway through the hole, signifying that the piece was drilled from both ends. A deeply grooved ring is in the center of one collar. The decor motif, which is confined to the corners that make the circular shape square, consists of two striated bands in relief separated from a third, shorter band by a lightly engraved ring near the end of this short band. In the middle of each side is a flat band that separates the corner motifs and smoothly joins the circular collar. The *zong* is heavily chipped in several areas. The stone is a deep, dark green with lighter green clouds and an intrusive area of dark brown. The width and depth measure 3⅜ inches by 3½ inches (8.7 by 9.0 cm.).

Published: C. T. Loo, *Archaic Jades,* New York, 1950, pl. XXXIV–2; Katherine R. Tsiang, *Arts of Asia,* XI, 5, September–October 1981, p. 79, fig. 8.

The *zong* is one of the most important symbols in the Chinese culture. Yet the original meaning, use, and origins of this enigmatic object are perhaps forever lost in the superstitious, magical world that enveloped China before the emergence of writing in the Shang dynasty. We know from later texts that the *zong* became linked in opposition with the *bi* disk as the symbol of the Earth and feminine attributes (*yin*).

Until recently, the dating of *zong* with such slight decor was quite problematic, especially for the bulkier ones. Recent finds in China's southern and eastern regions show that this particular type of *zong,* with circles above the short band in each segment, has its origins in the Neolithic cultures. As shown by the find in the Liangzhu culture at Caoxieshan, Jiangsu, the circles should be read as eyes, and the band below them as a stylized representation of the snout. (Fig. A: *WWCLCK,* no. 3, 1980, pl. 3; and Hayashi, *Museum,* no. 360, March 1981, p. 24, fig. 6b.) A similarly decorated *zong* with a larger hole (and therefore a narrower neck) was recovered from a tomb in Guangdong that was placed in the third stage of the Shixia culture, dated by carbon-14 tests to the mid-third millennium. (Fig. B: *WW,* no. 7, 1978, p. 15, fig. 31. A similar and more clearly articulated *zong* is in the Winthrop Collection; Loehr, *Winthrop Collection,* Cambridge, Mass., 1975, cat. no. 235.)

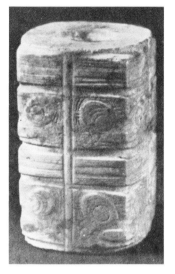

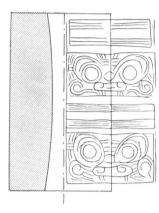

Figure A-1

Figure A-2, Schematic

Figure B

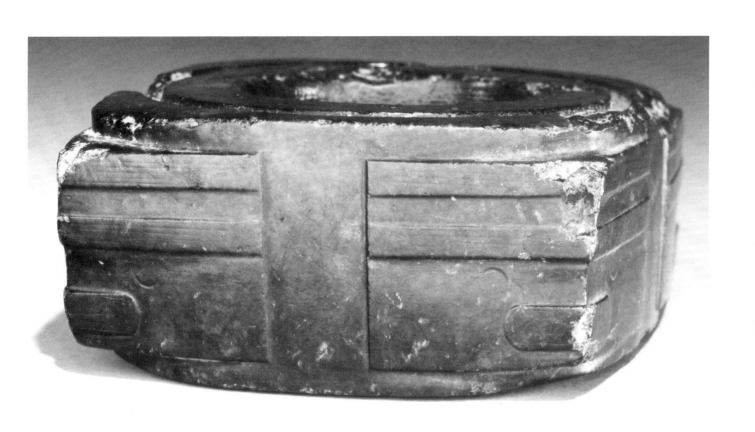

Plate 2
ZONG
Neolithic period, 3rd millennium B.C.
Jade
Height, 6½ in. (16.5 cm.)
60.61

The heavy, dark brown stone, with grainy clouds of white, has a rectangular exterior and circular interior. The hole tapers slightly from each end, indicating it was drilled from both ends. The exterior is symmetrical about the corners, and a flat band along each side meets evenly with the neck of the tube. Five similar segments are arranged vertically, and each contains the same pattern of a recessed groove at about a third of the segment height. In some cases, at the juncture of this recessed groove and the flat surface of the segment, there is a faint trace of an engraved circle. At the end with the longer neck there is an extra partial segment. On the interior wall of one end is a deeply cut U-shaped groove. The *zong* is square in cross-section and measures 2½ inches (6.5 cm.).

Published: C. T. Loo, *Archaic Jades*, New York, 1950, pl. XXXIV–1; Katherine R. Tsiang, *Arts of Asia*, XI, 5, September–October 1981, p. 79, fig. 8.

The design on this *zong* can be regarded as a multiple repeat of the smaller example (Pl. 1), except that the upper two "forehead" bands are merged into one broad band, and the lower band has been extended across the entire segment. This example can also be compared with a larger *zong* (L.:18.4 cm.) from a stereotypical tomb of the Liangzhu culture in Caoxieshan, Jiangsu, and with a smaller, five-segmented *zong* (L.: 13.8 cm.) excavated from a tomb in Guangdong, which was placed in the third stage of the Shixia culture and dated by carbon-14 tests to the mid-third millennium. (Fig. A: *WWCLCK*, no. 3, 1980, p. 12, fig. 23, and Hayashi, *Museum*, no. 360, March 1981, p. 24, fig. 5. Fig. B: *WW,* no. 7, 1978, p. 15, fig. 34.)

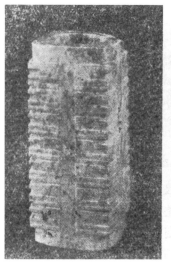
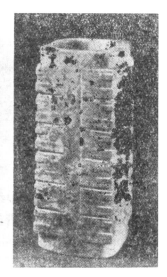

Figure A-1

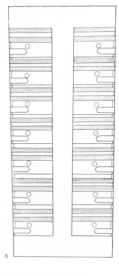

Figure A-2, Schematic

Figure B

52

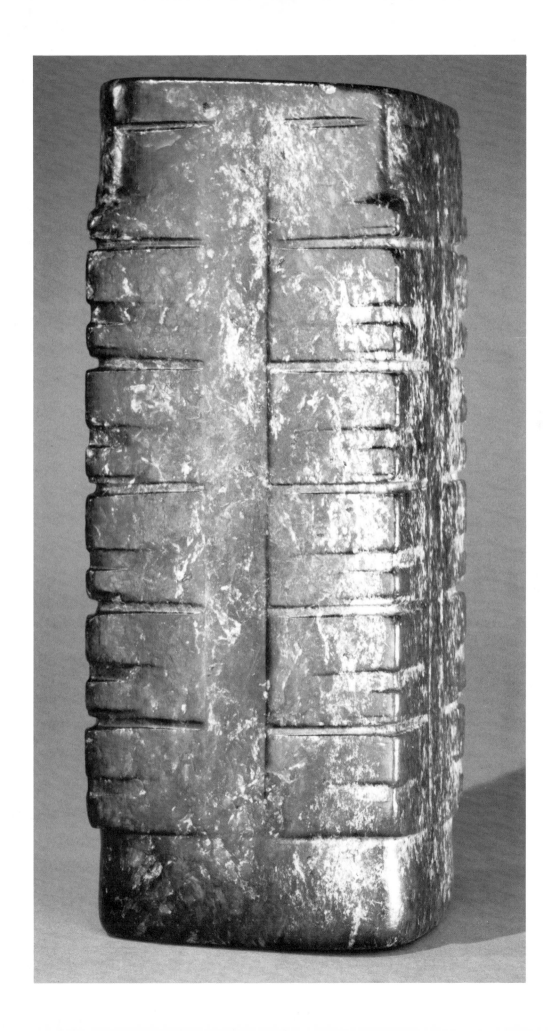

Plate 3
TRAPEZOIDAL BLADE *(TIXING DAO)*
Neolithic period, 3rd–2nd millennium B.C.
Jade
Length, 12⅝ in. (32.2 cm.)
60.51

The soft, translucent bluish-gray stone is filled with irregular lighter veins. Ivory-colored impurities converge in a streak across the center and in areas at both corners of the wide end. Three evenly sized holes along the back edge were drilled from one side, and the two small, intersecting holes in the middle of the short end were drilled from the other side. Opposite the three holes is the gently concave blade edge that is beveled smoothly from both sides. This blade is 6½ x 12¼ x 5½ inches (16.5 x 31 x 14 cm.), and ⅛ inch (0.3 cm.) thick.

Published: C. T. Loo, *Archaic Jades*, New York, 1950, pl. 5–4; Max Loehr, *Early Chinese Jades*, Ann Arbor, 1953, cat. no. 23 (not illustrated); Katherine R. Tsiang, *Arts of Asia*, XI, 5, September–October 1981, p. 77, fig. 1–a.

The bluish tone of the blade, the shape of which is based on a harvesting tool, imparts a rather delicate quality to this object. Large, and unusual in its approximation of a square, this rectangular blade has a delicacy not often associated with the ponderous blunt shapes of Neolithic cultures. The blade (or axe) is undoubtedly related to longer and narrower stone knives that also have holes along the back edge. According to archaeological reporters, similar long blades with even holes parallel to their backs appear for the first time in the Neolithic culture, and several utilitarian examples, some with as many as eleven holes, were recently reported from the third period of the Neolithic culture at Xuejiagang, Anhui. (Fig. A: *KKHP*, no. 3, 1982, p. 310, fig. 25.) The stratum containing the blades was dated by carbon-14 tests to ca. 3000 B.C. The writers of the report posited that these blades were found with enough other jade objects to suggest the emergence of a full-time craft industry from what had been a totally agrarian culture.

A slightly larger blade in the Field Museum, Chicago, was described by Laufer as a Zhou dynasty object from Shaanxi. (Fig. B: Laufer, *Jade*, 1912, pl. VIII–2.)

Figure A

Figure B

54

Plate 4
BRONZE HAFTED JADE DAGGER-AXE
 (TUNGNEI YUYUAN GE)
Shang dynasty, 13th century B.C.
Bronze and jade
Length, 12 in. (30.5 cm.)
60.58

The ridgeless blade, a cloudy gray jade, tapers smoothly to the top edge and point and is sharply beveled along the bottom edge. The curved, short handle, which is narrower than the blade, has deep channels, creating a design of a crested bird or phoenix that probably once held small squares of inlay, though no evidence of this now remains.

Published: C. T. Loo, *Archaic Jades,* New York, 1950, pl. II, no. 4; Katherine R. Tsiang, *Arts of Asia,* XI, 5, September–October 1981, p. 78, fig. 2.

In his catalogue C. T. Loo notes that this ceremonial blade is "reported to have been excavated at Anyang," and that the inlay (presumably turquoise in the handle) is now lost. Generally, bronze handles on jade blades such as this have had inlay, but this may not always have been the case. From a chance find in Shilou, Shanxi, an all-metal halberd almost identical in other respects to the Lilly example was found in relatively good condition. The report stated that besides a little rust, the halberd shone like new, and that no evidence indicated it was ever inlaid. (Fig. A: *WWCLCK,* no. 3, 1980, p. 202, fig. 1.) There is no reason to doubt the report of provenance recorded by C. T. Loo, as a very similar bronze blade was excavated from a tomb to the north of Wuguancun, Anyang, dated to the first cultural period there. (Fig. B: *KK,* no. 3, 1979, p. 225.) Like the Lilly example, it is an earlier type than those found with the Lady Hao (see Pl. 10).

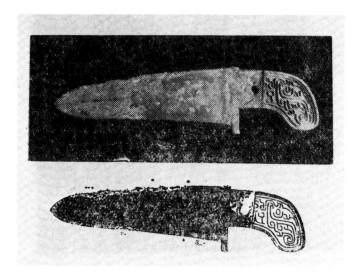

Figure A

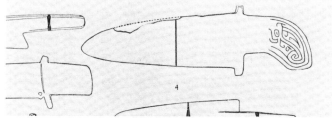

Figure B

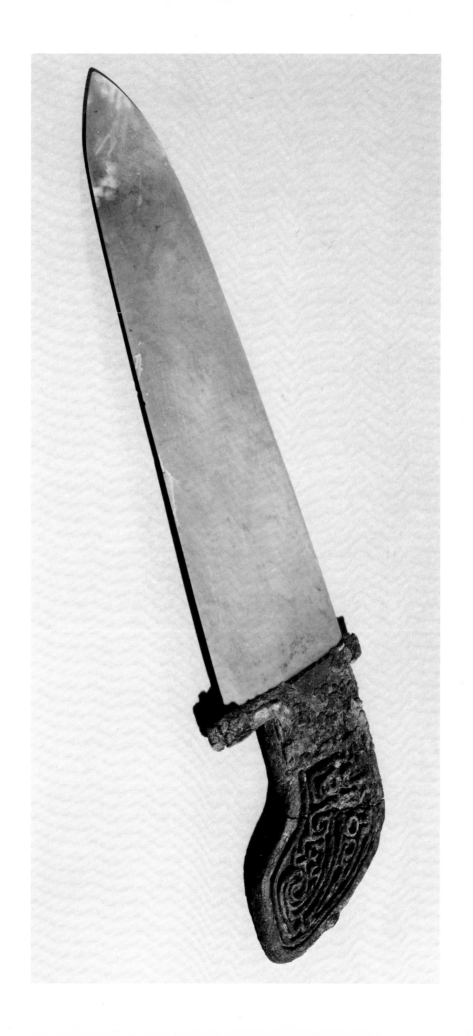

Plate 5
HALBERD BLADE *(GE)*
Shang dynasty, 11th century B.C.
Jade
Length, 11½ in. (29.2 cm)
60.54

This stout dagger-axe blade is made from a rich green stone with a handsome pattern of amber veins. Both edges are softly beveled from the central ridge that blends into the stone above the chip on one edge. The broad, square-shaped tang has five equally spaced double ridges at the end. The tang meets one edge of the blade at right angles, and cuts into the other edge. This latter cut and the pronounced thickness of the polished blade give it the character of an enormously enlarged arrow or spear. Its other measurements are width, 4 inches (10.2 cm.), and thickness, ¼ inch (0.75 cm.).

Published: C. T. Loo, *Archaic Jades*, New York, 1950, pl. VI, no. 2; Katherine R. Tsiang, *Arts of Asia*, XI, 5, September–October 1981, p. 77, fig. 1–b.

Enough blades with five double ridges are known that one may be tempted to prove this number is significant. Like the ubiquitous holes in so many of the jade blades, the presence of these ridges cannot always be explained by considerations of function or prototype.

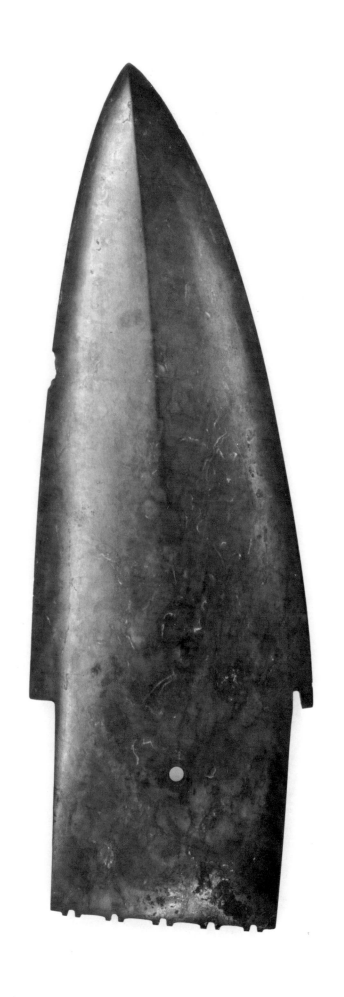

Plate 6
CHISEL *(GUI)*
Shang dynasty, 12th–11th century B.C.
Jade
Length, 8¾ in. (22.2 cm.)
60.62

As the chisel widens from the butt to the edge of the straight blade, the color changes from a mottled brown, through a bluish green with black veins, into a smooth, light olive tone. The rate at which the sides widen decreases slightly just past the biconical hole. The edge is beveled from both sides, forming a smooth crescent line with the thick polished biconvex body. The chisel's other measurements are width, 2¼ inches (5.7 cm.), and thickness, ⅜ inches (0.9 cm.).

Published: C. T. Loo, *Archaic Jades*, New York, 1950, pl. IX–6; Katherine R. Tsiang, *Arts of Asia*, XI, 5, September–October 1981, p. 78, fig. 3.

The shape of this ritual implement is clearly related to the Neolithic chisel. Its precise function in Shang society is unknown, yet in later times it became a symbol of rank, and in paintings is held vertically against the chest by courtiers.

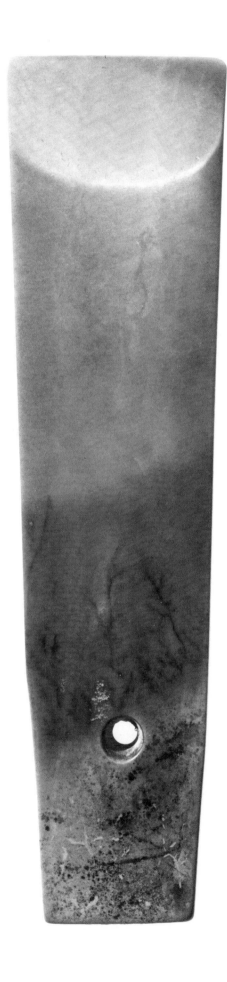

Plate 7
SCEPTER *(YA ZHANG)*
Shang or Western Zhou dynasty, 11th century B.C.
Jade
Length, 12¼ in. (31.2 cm.)
60.53

The soft brownish-gray jade, laced with light impurities, has been worked into a broad, gracefully flaring blade with a crescent edge that is beveled from one side. The short, broad tang has a hole drilled from one side. The tang is separated from the biconcave body of the blade by a segment defined by two notched projections and two pairs of double ridges on the silhouette. Seven shallow lines across the surface connect the ridges. Both corners of the tang have been broken. The thickness of the tang is ¼ inch (0.7 cm.).

Published: C. T. Loo, *Archaic Jades*, New York, 1950, pl. V, no. 1; John Ayers and Jessica Rawson, *Chinese Jade*, London, 1975, cat. no. 22; Katherine R. Tsiang, *Arts of Asia*, XI, 5, September–October 1981, p. 77, fig. 1–C.

A blade almost identical to the Lilly example has been published by Cheng Te-k'un as an example of the Taipingchang culture of Sichuan province. (Fig. A: Cheng Te-k'un, *Archaeology in China*, vol. 3, 1963, p. 315, pl. 3–f.) In a more recent article about jades unearthed in Guanghan, Sichuan, authors Feng Hanji and Tong Enzheng reproduce three comparable blades of varying lengths (56.1 to 41.4 cm.) and note they are the most special types of jades from this western region. (Fig. B: *WW*, no. 2, 1979, pp. 32–3, figs. 6–8.) In the discussion of the term used to name this handsome type, the writers suggest that the paired double ridges between the tang and blade, which seem to be common in these Sichuan blades, are most significant. They are the *ya*, "teeth", of the *zhang*, "scepter," and they could guide the cord that wraps the handle.

Cheng Te-k'un has proposed a date that ranges into the Spring and Autumn period (770–481 B.C.) for the blade he discussed. (See above and also "The T'ai-p'ing-ch'ang culture," *Hsieh-ta Journal of Chinese Studies*, 1, 1949, pp. 67–81.) Salmony, in a discussion of a bent and rather blunt example, suggested an early Western Zhou date. (Salmony, *Sonnenschein Collection*, 1952, pl. XXVIII–2.) Zhao Xinlai, in his discussion of a long Shang blade (66 cm.) possibly related to this type, suggested that the earlier the blade, the greater its length. (*WW*, no. 1, 1966, p. 53.) More recently, and thoroughly, Robert Bagley has addressed the dating of this broad-style blade with paired double ridges in conjunction with a stockier example in the Pillsbury Collection, and he concludes that "a date toward the end of Shang seems more appropriate." (Fong, *The Great Bronze Age*, 1980, p. 76.)

Figure A

图六 玉璋 (AK4.2,313)　　图七 玉璋 (AK4.2,35)　　图八 玉璋 (AK4.2,110482)

Figure B

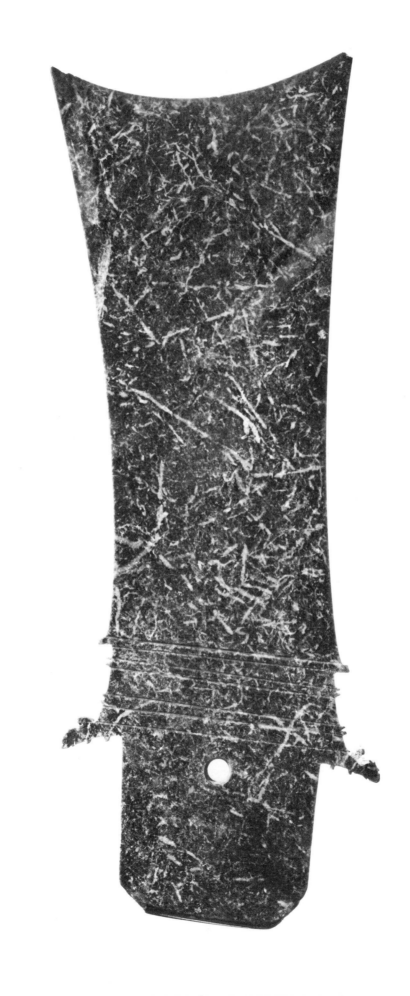

Plate 8
LONG BLADE *(CHANG YUE)*
Shang or Western Zhou dynasty, 11th century B.C.
Jade
Length, 25 in. (63.4 cm.)
60.60

The smooth deep-green blade is slightly concave with a longitudinal groove at the bottom of the curve. The tang is composed of two similar segments, each with two pairs of double ridges, separated by a wide, smooth band. The butt end has two ridges on either side of a low concave protrusion. Sixteen grooves across the tang join the inside edges of the projections and the centers between them. The remaining dimensions of the blade are width, 3½ inches (8.8 cm.), and thickness, ⅛ inch (0.4 cm.).

Published: C. T. Loo, *Archaic Jades,* New York, 1950, pl. VI–1; Katherine R. Tsiang, *Arts of Asia,* XI, 5, September–October 1981, p. 77, fig. 1–d.

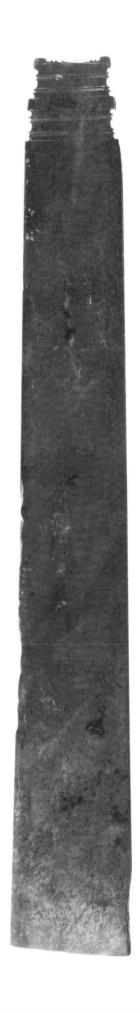

Plate 9
BI
Shang dynasty, 13th century B.C.
Jade
Diameter, 6¼ in. (15.8 cm.)
60.57

The soft, ivory-cream-colored surface is marred by only a few gray impurities. Three groups of three and one of two concentric rings unevenly divide the smooth surface into five bands. The design is the same on both sides, and the back is heavily encrusted with tan dirt, which covers a cinnabar red. The smooth collar extends equally above each side. Other dimensions for this *bi* are 2⅜ inches (6.0 cm.) for the diameter of the hole and ⅝ inch (1.6 cm.) thickness at the collar.

Published; C. T. Loo, *Archaic Jades,* New York, 1950, pl. 13–1; Katherine R. Tsiang, *Arts of Asia,* XI, 5, September–October 1981, p. 79, fig. 7.

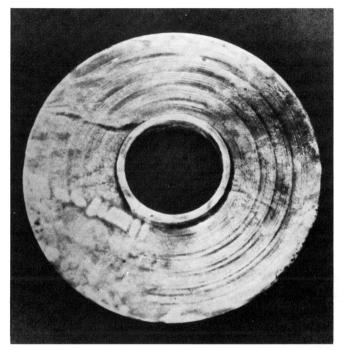

Figure A

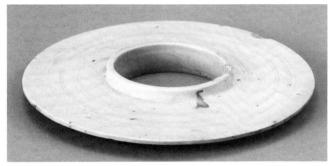

Plate 9, Detail

Among the sixteen *bi* disks excavated from the bountiful tomb of Lady Hao (see Pl. 10), four were the collared type represented here, and one with similar dimensions had four groups of grooves. (Fig. A: *Fu Hao,* 1980, p. 119, pl. 87–1.)

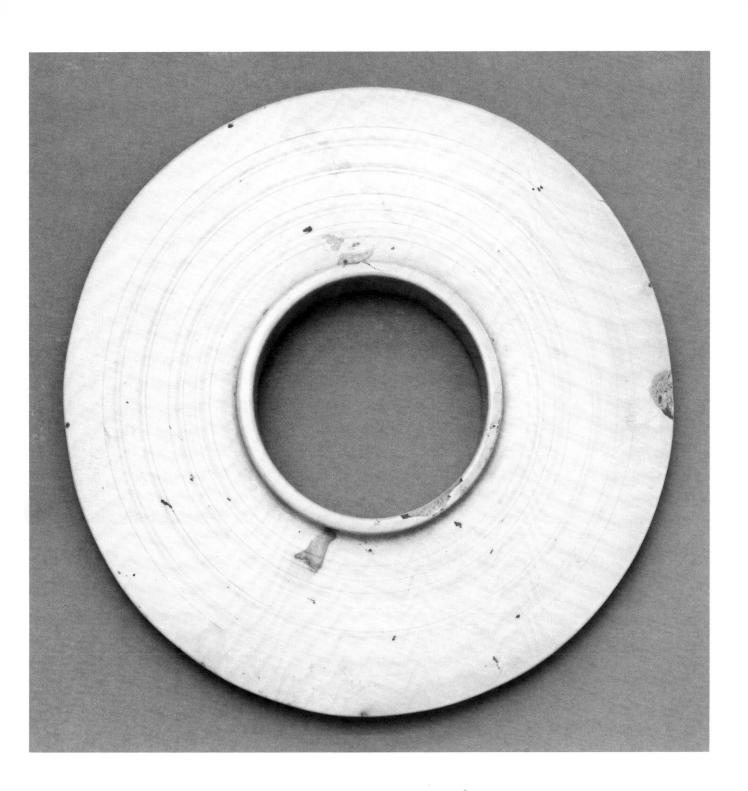

Plate 10
CRESTED PARROT PENDANT
 (GAOKUAN YINGWU PEIDAI)
Shang dynasty, 13th century B.C.
Jade
Length, 3¾ in. (9.4 cm.)
60.66

The curved beak just above the middle of the silhouette, below the crenellated outline of the high crest, suggests that this bird in profile may be a parrot. Behind the beak is the ring eye of the bird, which is executed in a double-line fashion, as are the other abstract patterns that softly decorate the surface of the stone. A single groove indicates the split of the beak below two chevrons. A conical hole near the top of the crested plumage would have allowed the bird to be suspended. On the reverse side, in the neck area between eye and beak, there is a hemispherical cavity about the size of the eye. The translucent greenish-gray stone has calcified to an ivory tone in many areas, and both sides have traces of red pigment. The foot has been broken and repaired, and cracks are visible in the body area. It is ⅛ inch (0.4 cm.) thick.

Published: C. T. Loo, *Chinese Arts*, New York, 1941, no. 230 (as an owl); C. T. Loo, *Archaic Jades*, New York, 1950, pl. XV, no. 2; Katherine R. Tsiang, *Arts of Asia*, XI, 5, September–October 1981, p. 78, fig. 4.

One of the most important Chinese archaeological finds was made in 1976 with the discovery of the undisturbed tomb of the Lady Hao, a consort to the powerful, long-ruling King Wu Ding. For the first time, an aristocratic tomb that had not been plundered could be scientifically excavated at Anyang, the last capital of the Shang dynasty. Among the almost two thousand objects recovered were more than seven hundred jade pieces. Two of the pendants found are extremely close to our fine example. (Figs. A and B: *The Jades of Yinxu*, 1981, pl. 44; *Fu Hao*, 1980, p. 166, figs. 86–4 & 5.) Minor differences in the Lilly jade—such as the absence of a bottom wing protrusion, the presence of a back shoulder, the chevrons on the beak, the disk eye, as well as the more rectangular treatment of the back of the crest—can all be found on other examples from this remarkable find. This pendant can confidently be assigned the same provenance as its counterparts from the tomb of the Lady Hao.

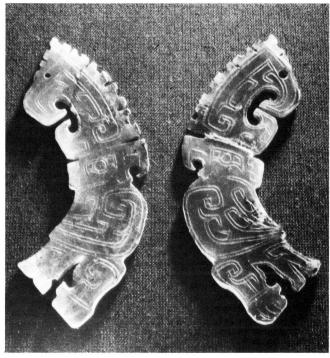

Figure A

Figure B, Rubbings

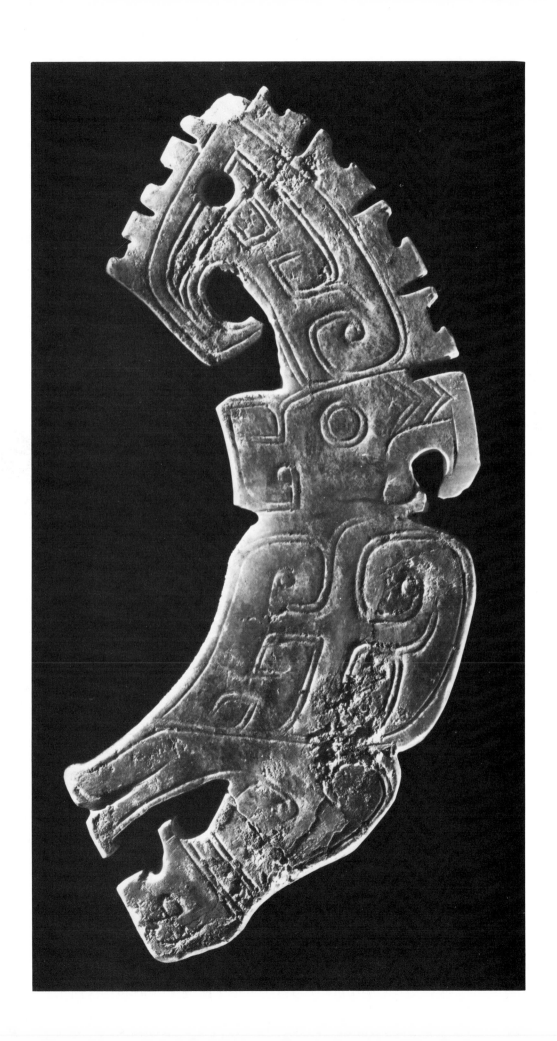

Plate 11
BIRD-SHAPED BODKIN *(NIAOXING KEDAO)*
Shang dynasty, 12th century B.C.
Jade
Length, 2⅜ in. (6.0 cm.)
60.70

Standing stiffly erect, this knot-opener appears to be a younger version of the high-crested parrot (Pl. 10). The low, simply serrated crest is recessed from either side of the head, and it has a biconical hole for suspension. The disk-shaped eye and abstract body patterns are all executed with double lines. Behind the leg of this utilitarian object, the handsomely proportioned extension tapers to an oblique edge. The body of the bird is a shadowy green with brown clouds, but toward the two ends the color changes to a light brownish green. Traces of red pigment are apparent. The piece is ¼ inch (0.6 cm.) thick.

Published: C. T. Loo, *Chinese Arts,* New York, 1941, no. 293; C. T. Loo, *Archaic Jades,* New York, 1950, pl. XV–4 (as an owl).

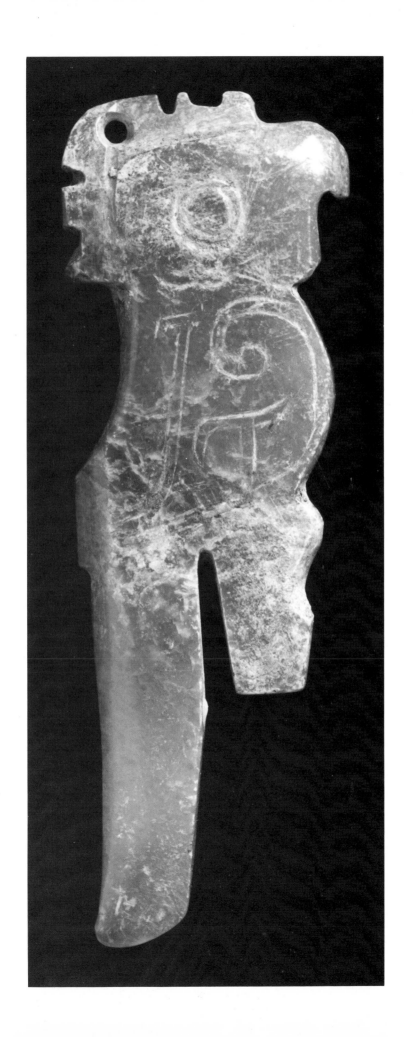

Plate 12
TWO BIRDS *(ERNIAO)*
Shang dynasty, 12th–11th century B.C.
Jade
Length, 2⅛ in. (5.3 cm.)
60.71

This unique motif is difficult to interpret completely. The bird-like central figure is in profile, with a curved beak. Below its beak a smaller bird appears to be supported on the knee of the larger bird. A truncated crescent shape, the significance of which is not clear, is attached to the back of the large bird. Double-, single-, and slanting-line engravings have been used to define the motifs. The stone is a light translucent green color with white calcification in the upper extremities. It is ⅛ inch (0.4 cm.) thick.

Published: C. T. Loo, *Chinese Arts,* New York, 1941, no. 231; C. T. Loo, *Archaic Jades,* New York, 1950, pl. XVIII–4.

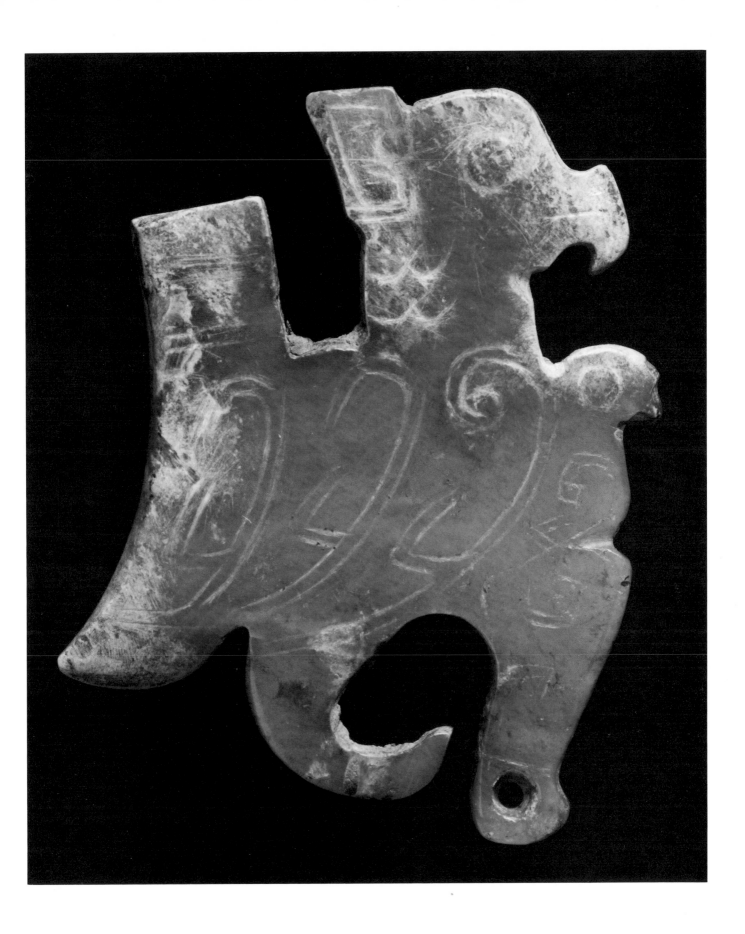

Plate 13
GOOSE *(E)*
Shang dynasty, 12th–11th century B.C.
Jade
Length, 2⅜ in. (6.6 cm.)
60.72

The varied curves of the front of this goose contrast interestingly with the rectangular treatment of the wing and tail feathers that are defined by single engraved lines, some of which are slanted. Sharply narrowing, the neck has three large scale motifs at its base, and the beak closely parallels the chest to which it is attached. The chest of the bird is flat, as is the rest of the contour. The head and foot are translucent light olive green in color, and the body has a cloudy, darker green band with brown veins. There are traces of red pigment on the piece, which is ¼ inch (0.6 cm.) thick.

Published: C. T. Loo, *Archaic Jades*, New York, 1950, pl. XXXIII–10.

Three analogous pieces found in the tomb of Lady Hao emphasize the elongated neck and double-engraved lines. (Fig. A: *Fu Hao*, 1980, p. 167, fig. 87; color pl. 33.) In describing the most interesting one, which is shown in profile with both legs depicted, the reporters suggested that this sort of object, which has a point below its foot, might have been inserted into a lacquered wood object as a piece of decoration.

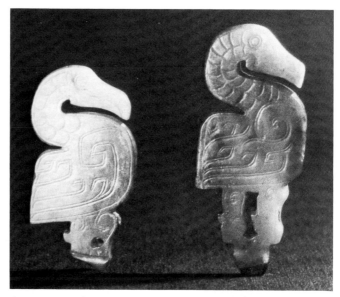
Figure A

Figure A, Rubbings

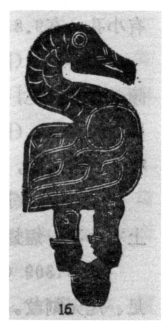
Figure A, Rubbings

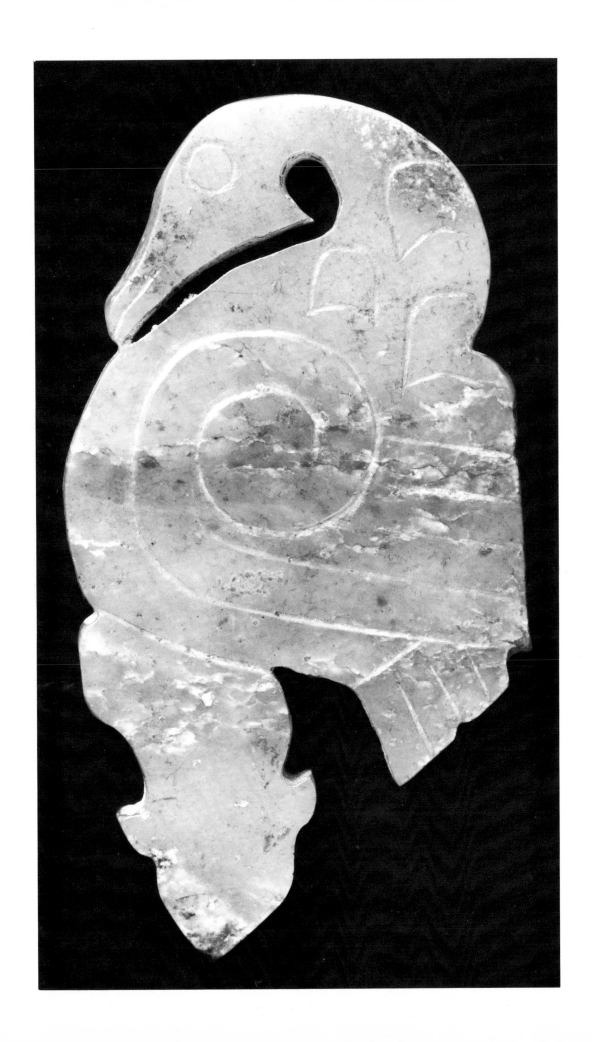

Plate 14
TIGER PENDANT *(YU HU)*
Shang or Western Zhou dynasty, 11th century B.C.
Jade
Length, 3 in. (7.7 cm.)
60.67

This crescent-shaped profile of a tiger is rendered in pale gray jade. Shallow, slanting lines define the legs against the body as well as the eye and mouth. Conical holes are centered in the eye and curled-back tail, and the mouth has a biconical hole. A groove cuts into the top of the forepaw, and there is a large hollow in the back side behind the rear leg. Many traces of red pigment can be seen over the surface, especially from the rear leg back. The pendant is ⅛ inch (0.3 cm.) thick.

Published: Katherine R. Tsiang, *Arts of Asia,* XI, 5, September–October 1981, p. 79, fig. 6.

A shorter tiger (5.8 cm.) made with a straight, rather than curved, piece of jade is in the British Museum. Jessica Rawson dates it to the Western Zhou dynasty. (Fig. A: *Ancient China,* 1980, color plate VII, opposite p. 141.) Two earlier and less abbreviated examples were found in the tomb of the Lady Hao. (Fig. B: *Fu Hao,* 1980, p. 161, fig. 84:12.)

Figure A

Figure B

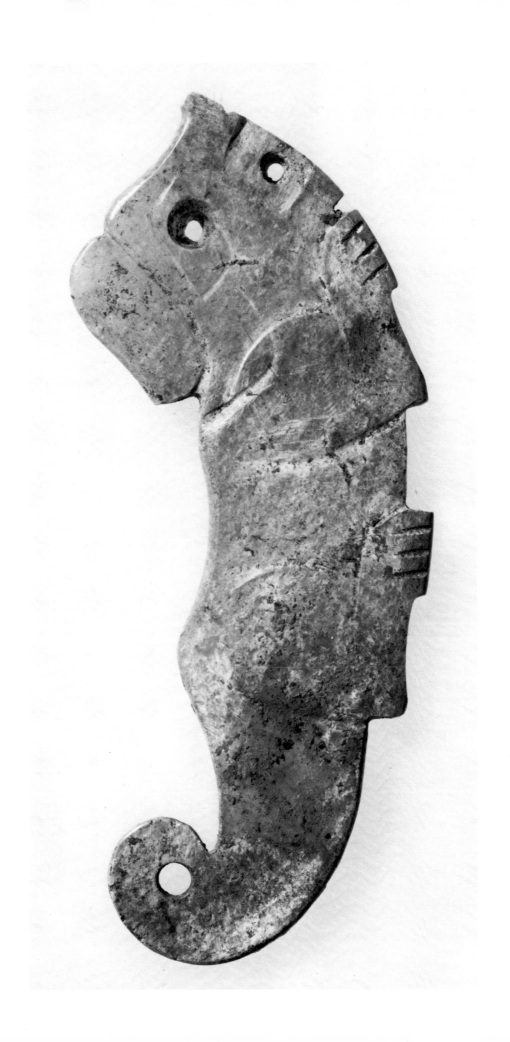

Plate 15
TIGER PENDANT *(YU HU)*
Western Zhou dynasty, 11th century B.C.
Jade
Length, 2⅝ in. (6.6 cm.)
60.68

The large-headed beast is fashioned from a pale green jade that has deteriorated to a grayish white color in the lower parts. The figure is depicted in profile, with minimum interior definition and only the upper edges rounded. The eye, nose, and mouth are outlined with a raised line, and the ear, legs, and claws are highlighted by a slanting groove. A conical hole is above the eye, and a biconical hole is in the mouth. There are traces of red pigment on the work, which is ⅛ inch (0.4 cm.) thick.

Published: C. T. Loo, *Archaic Jades*, New York, 1950, pl. 18–6 (as a bear).

Plate 16
DEER PLAQUE *(YU LU)*
Western Zhou, 11th century B.C.
Jade
Length, 1⅞ in. (4.7 cm.)
60.69

Basically a cloudy jade, it has brown and greenish-white markings. The stubby-legged deer standing regardant has two four-horned antlers. The eye, mouth, and tail are minimally defined by crudely cut lines. The piece is ⅛ inch (0.3 cm.) thick.

Published: C.T. Loo, *Chinese Arts,* New York, 1941, no. 290; C. T. Loo, *Archaic Jades,* New York, 1950, pl. XI–1.

Plate 17
ARC PENDANT *(HUANG)*
Eastern Zhou dynasty, 5th–4th century B.C.
Jade
Length, 12⅝ in. (32.2 cm.)
60.52

This large, translucent dark green pendant is similarly decorated on each side. Both ends are in the form of a dragon head with mouth slightly opened. The mustache, nose, ear, and eye socket are striated or hatched, and the delicate, raised spirals appear to be arranged along crossing diagonals, yet some of their randomly oriented tails connect to each other. The central body area between the heads is framed by a convex band decorated by fine lines in a zigzag pattern with cross-hatching and curls. The small hole in the center of the top, as well as the shape of the mouth, suggests that this polished pendant may once have been part of a magnificent necklace. It is 2 inches (5.0 cm.) wide, and ¼ inch (0.6 cm.) thick.

Published: C. T. Loo, *Archaic Jades*, New York, 1950, pl. XL–7 (not illustrated, but noted as one of a "pair of tiger pendants," the mate of which was illustrated); John Ayers and Jessica Rawson, *Chinese Jade*, London, 1975, cat. no. 106, p. 48 (not illustrated); Yutaka Mino and Katherine Tsiang, *Apollo*, CVIII, 199, September 1978, p. 159, pl. 4; Katherine R. Tsiang, *Arts of Asia*, XI, 5, September–October 1981, p. 79–80, fig. 11.

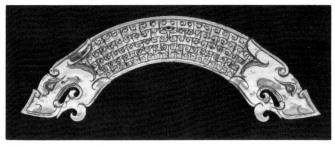
Figure A

Figure B

Plate 17, Detail

The similarity between this dragon motif and those on contemporary bronze vessels is quite striking and certainly indicative of the pervasive nature of design through all media that characterizes so much of the art of the Eastern Zhou. A telling comparison can be made with the large covered bronze jar (Pl. 35). The profile faces are quite similar, especially the curled-back snout, comma in front of the eye, and scales in the face. The smooth, flat bands surrounding both dragons are also similar, as are the abstract designs in the smooth framing bands.

This crescent-shaped pendant excellently represents the middle ground between two well-publicized traditions. On one hand, from a generally northern context, there are the highly polished jades with smoothly curving designs and sharp, pointed hooks and corners. (Fig. A: Lawton, *Warring States*, 1982, cat. 85. Dr. Lawton has presented a fine discussion of jade carving during this apex of the tradition. Ibid., pp. 127–177, nos. 76–133.) It is easy to see that the Lilly pendant is executed within more rectangular constraints. The ear, eye, nose, mouth, and chin have similar structures and positions in relation to the contour. On the other hand, these same parts are not as thoroughly abstracted as their later relatives from the southern Chu culture. (Fig. B: Collection of Mr. and Mrs. Myron S. Falk, Jr., New York, and also see ibid., cat. 99.)

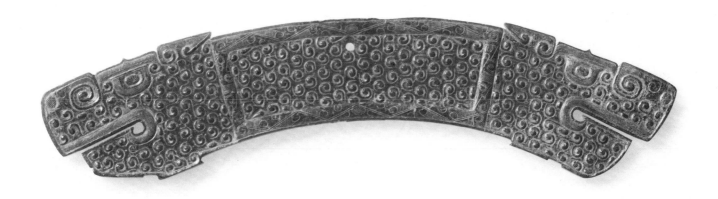

Plate 18
BI
Eastern Zhou dynasty, 4th–3rd century B.C.
Jade
Diameter, 3⅜ in. (8.5 cm.)
60.55

Fashioned from one piece that varies from a rich to a light amber, this double-ring *bi* carries two distinct designs. In the outer ring small, smooth hexagonal dots of relief are arranged in a geometric grid within incised lines at both edges. The inner ring is joined at three equidistant segments. This smaller ring contains C-shaped motifs in two bands that are alternately linked together. The dark area has begun to calcify, and some grayish tan soil remains in the narrow cut between the two rings. The *bi* is ⅛ inch (0.3 cm.) thick.

Published: C. T. Loo, *Archaic Jades*, New York, 1950, pl. XLVI–5; Katherine R. Tsiang, *Arts of Asia*, XI, 5, September–October 1981, p. 79, fig. 9.

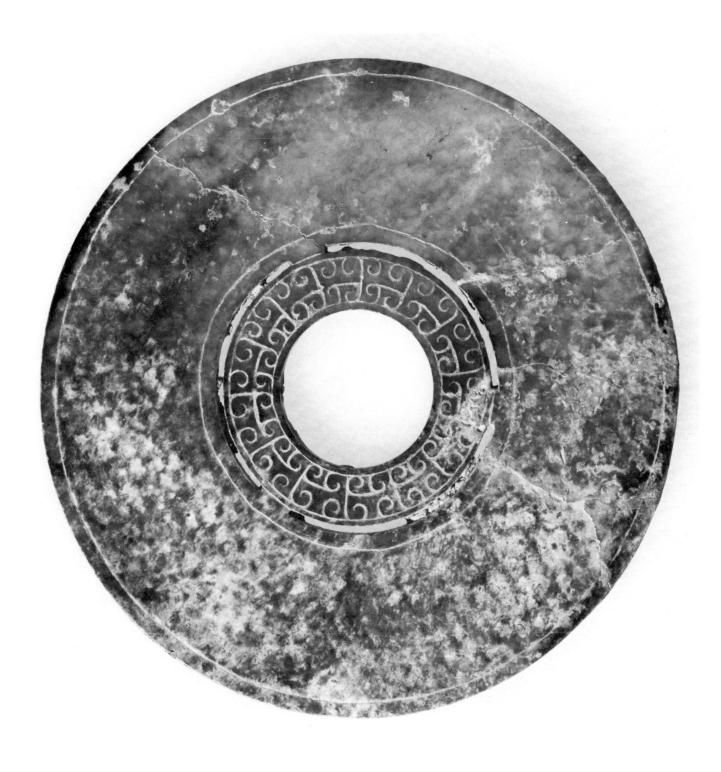

Plate 19
BI
Western Han dynasty, 2nd century B.C.
Jade
Diameter, 10⅞ in. (25.2 cm.)
60.56

This bold, well-engraved *bi* has but one major flaw that, like a wave crest, rises and lightens to a tan against the even, rich olive green of the rest of the *bi*. The ring is evenly divided by a band with a striated pattern. The inner ring contains spirals alternating in their orientation along a geometric grid. The design of the outer ring is symmetrically divided into quadrants that link together. From behind the *taotie* monster mask with horns and mustache come two double bands that suggest the body of the beast. After following an M-shaped path, the double band bends back, links to its counterpart in the next quadrant, and, where it continues under itself, splits evenly. Parallel to the final length of the body band is a similar but reversed segment that crosses on top of the main band. The *bi* is ¼ inch (0.65 cm.) thick.

Published: C. T. Loo, *Archaic Jades*, New York, 1950, pl. XXXVIII–6; Max Loehr, *Early Chinese Jades*, Ann Arbor, 1953, cat. no. 7 (not illustrated); Katherine R. Tsiang, *Arts of Asia*, XI, 5, September–October 1981, p. 79, fig. 10.

Figure A

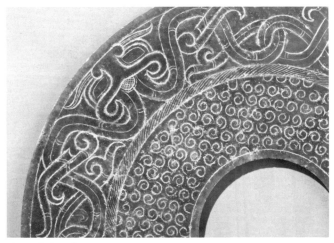

Plate 19, Detail

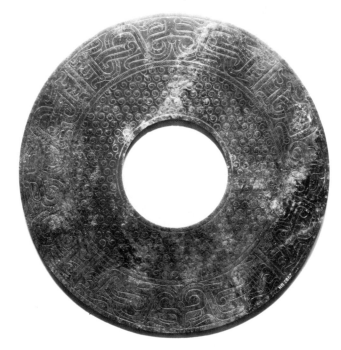

Figure B

Many examples of this popular design are known in collections and from excavations, but few exhibit the sustained high quality of this *bi*. (See for example, Loehr, *Winthrop Collection;* 1975, nos. 530–537; Salmony, *Sonnenschein Collection;* 1952, pls. LXX–LXXII; and *WW*, no. 4, 1966, p. 55; no. 5, 1972, p. 44; no. 4, 1973, p. 21; and no. 7, 1976, p. 57.) Often the monster mask and body are perfunctorily executed with short, deep grooves accenting the straight parts of the design. The end of the main beast sometimes transforms into either a bird or a dragon, and the segment parallel to the main band transforms into either a bird wing, a leg, or a body. Very popular during the late Eastern Zhou and early Han, the

design occurred on a wide variety of objects. (Fig. A: garment hook, Loehr, *Winthrop Collection*, 1975, no. 463.) The fine example in the Royal Ontario Museum is but one variation, and in it, the quadrants are divided with a striated band as are the two main fields of design. (Fig. B: Rawson, *Oriental Art*, XXI, 1, Spring 1975, p. 50, fig. 33, and Dohrenwend, *Chinese Jades*, 1971, p. 87.) Several examples of *bi* disks with this type of design were recovered from the second-century B.C. tomb of the Princess Douwan, in Mancheng, Hebei, and exhibited in the touring archaeological show of 1974–1976. (See Watson, *Genius of China*, 1973, nos. 143–148.)

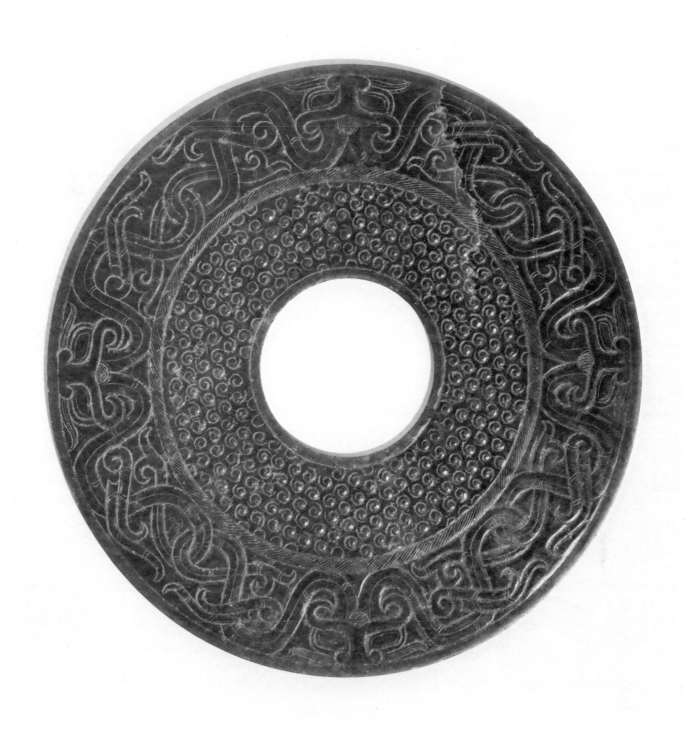

美与宁静

88

Bronze and Metalwork

Plates 20–52

Plate 20
HU
Shang dynasty, 13th century B.C.
Bronze
Height, 8⅜ in. (21.3 cm.)
60.45

The rounded body of this delicate cylindrical container joins the neck in a graceful curve. The design on the curved lid consists of two symmetrical *taotie* facing the rim. A knob, which handsomely echoes the contour of the lid, protrudes from a whorl design in the center. Below the reinforced lip are two lugs for a handle and two raised lines. Around the shoulder are four segments of decor consisting of horizontal S and C patterns centered about a protruding "eye." The main design around the body consists of two *taotie* masks with a dragon lying face up below each tail. These main design elements contrast with a background of irregular linear patterns that follow the main pattern. The high, plain foot is pierced by opposing pairs of cruciform and rectangular openings.

Published: Bernhard Karlgren, *BMFEA*, no. 34, 1962, pl. 56b (erroneously described as being in the Cranbrook Academy); Louisa G. Huber, *Arts of Asia*, XI, 2, March–April 1981, p. 75, fig. 1.

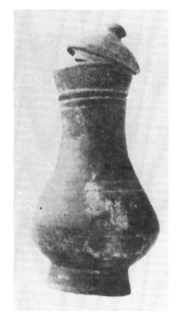

Figure A

Figure B

The magnificent bronze vessels from the Shang have become nearly synonymous with that first historical dynasty. From practically the very beginning of the Bronze Age, these precious ritual vessels were cast with unparalleled technical skill into shapes and designs befitting their ceremonial importance. Whether large or small in scale, these early bronzes are some of the finest aesthetic expressions of any culture in any period.

In her discussion of this vessel, Dr. Huber noted that this small wine container "is the oldest bronze vessel in the Indianapolis collection," and that the exceptional decoration and motifs "suggest provincial workmanship." The circular shape with design bands on only the shoulder and body also support an early attribution, for the jar shows none of the later examples' tendencies to become ovoid or elongated. The solid, symmetrical presence of this *hu* embodies the understated, refined aesthetic of the Shang culture. It is certainly comparable to the early *you*-type vessels, which share some similar typological developments. (See Kane, *Artibus Asiae*, XXXV, 4, 1973, pp. 363–370.) Slightly earlier examples of this *you*-type vessel in ceramic and bronze from as distantly separated sites as ZhengZhou, Henan, Pinggu near Beijing in Hebei, and Panlongcheng, Hubei, indicate how widespread this early Shang aesthetic was. (Fig. A: Tsou, *Xia Shang Zhou*, 1980, pl. 6–6; also *WW* no. 6, 1954, p. 35, fig. 5; Fig. B: *WW*, no. 11, 1977, p. 5, fig. 6–1. See also, Fong, *The Great Bronze Age*, 1980, no. 9.)

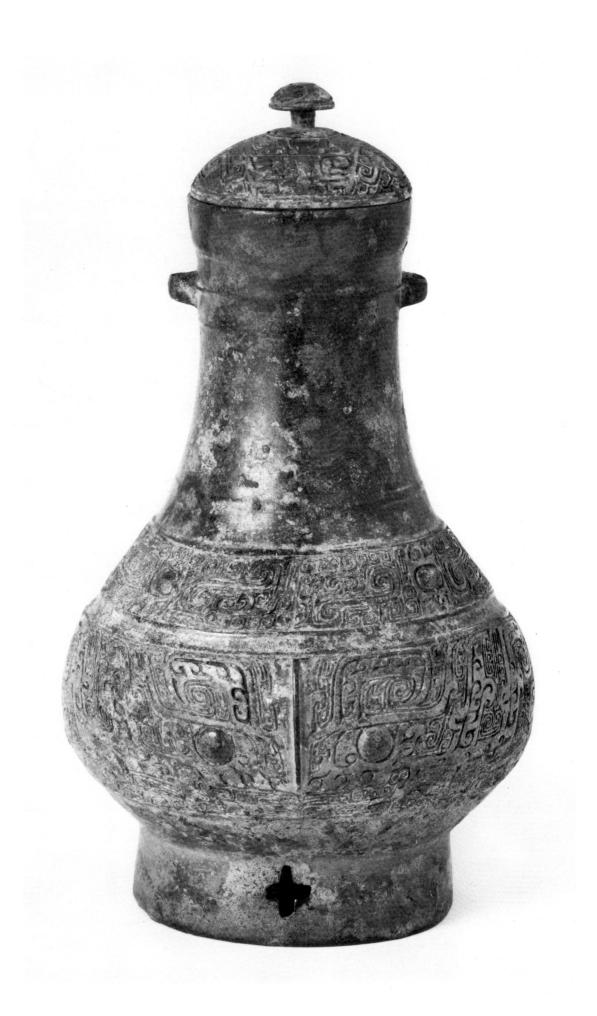

Plate 21
FANGYI
Shang dynasty, 13th century B.C.
Bronze
Height, 7¼ in. (18.3 cm.)
60.84

The rather squat, narrow body of this exquisite box is supported by a recessed foot with stepped openings in each side. The straight-sided body gently slopes outward to meet the lid, whose slope toward the top is equally sharp on all four sides. Small central ridges on each side of the lid and in the top two bands of the body, along with the absence of flanges at the edges, create a simple, even austere, shape. The small lugs that replace the flange in the upper registers of the narrow sides are an unusual feature. These lugs, like those of the small *hu* (Pl. 20), suggest some sort of handle or suspension device, which is not seen on other *fangyi* vessels.

The content of the decoration is as unusual as the shape of the vessel itself. As on our earliest vessel, the *hu* (Pl. 20), the design is rendered without relief, but it is slightly more advanced, because the background pattern is composed of more uniform spirals that follow the major motifs less directly. Of the major motifs, the most outstanding is found on the narrow sides of the lid. The flattened bird with outstretched wings is a design with analogies in jade, but it is not at all standard on other known bronzes, whatever the type. Normally, the *fangyi* lid has similar designs on all four sides, and such a bold contrast of designs is unprecedented.

Another noteworthy detail is the design layout on the body of the vessel. In this example, there is the unusual addition of a third, lower band set off from the main

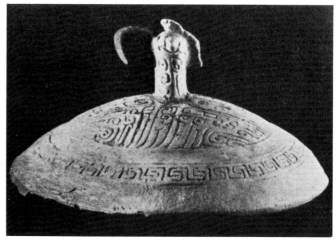

Figure A

taotie design by spirals. The main *taotie* design, with gracefully arching horns and claws that reach to the edges, has beneath its mouth what has been aptly termed an apron.

Published: Yutaka Mino and Katherine Tsiang, *Apollo*, CVIII, 199, September 1978, pp. 156–163, fig. 1; Louisa G. Huber, *Arts of Asia*, XI, 2, March–April 1981, p. 75, fig. 2.

The unique characteristics of this stately vessel can be accounted for in several ways. One, already mentioned in connection with the *hu* (Pl. 20), is that the piece may have been made in a non-Anyang workshop. (See Huber, *Arts of Asia*.) Interestingly, a design closely related to the bird motif on the lid can be found on a bronze lid excavated from Qingjiang, Jiangsu, that thus belongs to the obscure Wucheng culture. (Fig. A: *Shang Zhou*, Beijing, 1979, pl. 15.) Another explanation may be that this *fangyi* illustrates an early experiment in both form and decoration that was not pursued in later examples.

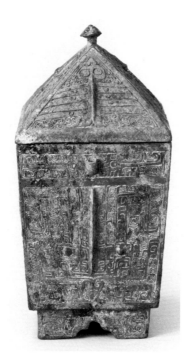

Plate 21, Detail

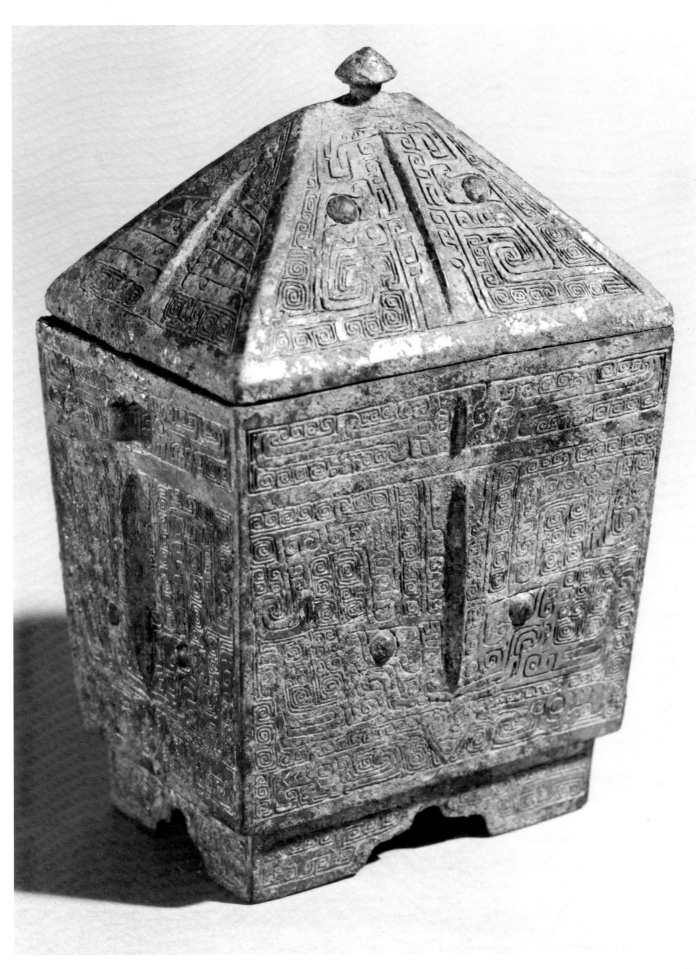

Plate 22
JUE
Shang dynasty, 13th century B.C.
Bronze
Height, 7 in. (17.7 cm.)
48.14

The disparate parts of this asymmetrical vessel are so well proportioned that they achieve a harmonious balance. The delicate triangular legs are solid, as are the caps to which the whole vessel was cast. Three low flanges and the handle divide the body into equal segments. The design, which consists of two *taotie* masks in the central band and blades rising to the lip, is easy to discern because of the flat, broad surfaces in the major motifs. This sublime vessel is the earliest object in the collection that carries an inscription (located under the handle).

Published: Louisa G. Huber, *Arts of Asia,* XI, 2, March–April 1981, p. 76, fig. 3.

Figure A

Figure A, Detail

Plate 22, Details

Figure B

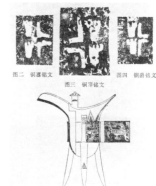
Figure B, Schematic

Despite its complicated shape, this type of small ewer, presumably for pouring wine, was one of the more popular vessels of the Shang dynasty. The Lilly *jue* is well cast and free from exaggeration.

The inscription, which may be a clan sign and consists of a cruciform shape above a human figure, is generally read *Ya-Yi*. This links the Lilly *jue* to a large group of bronzes. It has been noted that this important set of bronzes exhibit a strong similarity to objects recently excavated from the undisturbed tomb of Fu Hao, or the Lady Hao, and where dissimilar, the *Ya-Yi* group tends to be larger and more refined or advanced. (See Huber, *Arts of Asia.*) As this modest-sized tomb of a royal consort to Wu Ding, the fourth of the twelve Shang kings who ruled at Anyang, yielded over 1900 objects, including 460 bronzes, one can only be amazed at what must have been plundered from some of the large, magnificent royal tombs during the 1930s when the *Ya-Yi* group appeared on the market. In fact, one of the best theories is that this *jue* may have been pillaged from the ostensibly grander tomb of Wu Ding.

Another *jue* in the Honolulu Academy of Arts carries the same *Ya-Yi* inscription; its shape and decor are slightly different, but it is still probably contemporary with the Lilly piece. (Fig. A: Poor, *Honolulu Academy,* 1979, no. 22.) A *jue* that is extremely similar to our piece in both shape and decor was excavated in 1968 from Wenxian, Henan. Though a bit smaller, the designs and proportions, even to the post caps, are very close. It was found with both left- and right-handed *jue* and other bronzes that carried the single inscribed character *Xi* ("to migrate"). This character, also probably a clan sign, is found in the oracle bone divination texts from the time of Wu Ding. (Fig. B: *WW,* no. 2, 1975, p. 89, figs. 2–5.1 and *Shang Zhou,* 1979, pl. 13.)

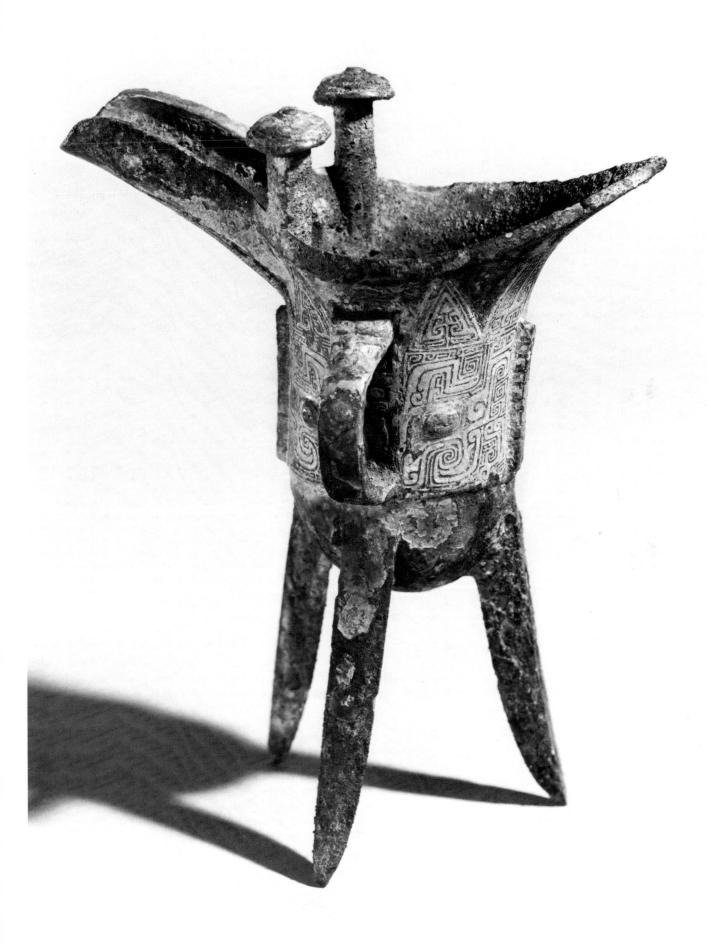

Plate 23
GU
Shang dynasty, 13th–12th century B.C.
Bronze
Height, 11⅝ in. (29.5 cm.)
48.115

In this tripartite *gu*, the upper and lower segments each have two registers of design. In the small register of the bottom segment above each half of the two relief *taotie* masks is a S-shaped dragon that confronts the central flange. Also in relief, it has one leg and C-shaped ears. Separating the bottom segment from the middle is a broad band with two raised lines and a cross-shaped opening above the flange bisecting each *taotie*. The center segment has two *taotie* masks in relief. In the lower register of the top segment, a snake motif is rendered in an S shape that echoes the motifs in the bottom segment. The triangular blades rising to the edge of the top segment also contain confronting *taotie* designs. There is no relief in this upper segment except for the eyes of the *taotie*, which repeat the shapes of those below. Of particular note is the low flange that runs through every segment and gently decreases to meet the rim evenly. The interior flat bottom is located at the base of the middle decorated segment. The inscription on the interior wall of the foot is placed behind an eye of the exterior mask.

Published: Chén Meng-chia, *Yin Zhou*, Tokyo, 1977, A469 and R42; Louisa G. Huber, *Arts of Asia*, XI, 2, March–April 1981, p. 77, fig. 6.

Plate 23, Detail

The decor on this beaker is our collection's most classical expression of the conservative trends that were popular during the Shang dynasty's final stages in Anyang, its last capital. Only the significant parts of the zoomorphic masks are depicted, and these are slightly raised in relief and covered with the same fine, tight spirals that fill the background.

During the Shang dynasty, the *gu* beaker was one of the more popular ceremonial wine vessels. Among the

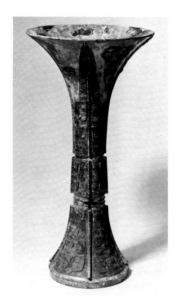

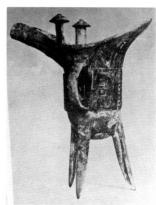

Figure B

Figure A

210 ritual vessels recovered from the tomb of Lady Hao, the royal consort to Wu Ding (see Pl. 22), the 53 *gu* beakers were the most numerous of any one type. The Lilly *gu* is slightly more advanced than the examples from this important tomb. The Fu Hao vessels of this type do not have zoomorphic designs in the smaller registers to either side of the middle, they have no relief eye or mask represented in the rising blades on the trumpet mouth, and the few examples that have flanges in the upper part are not so elegantly tapered to the mouth as is our piece. (See *Fu Hao*, 1980, pls. 42–53.)

The Lilly *gu* appears less attenuated than most, as the central body has a more substantial diameter. Perhaps the closest parallel is one that was excavated just north of Anyang from Cixian, Hebei. (*WW*, no. 11, 1974, p. 90.) However, that example lacks the upper flanges, has relief decor in the upper third, and contains no spirals on the relief elements. Its inscription of *Qi* ("to open or begin") appears to be of the period of Fu Hao's king. (See Kane, *Artibus Asiae*, XXXV, 4, 1973.) A closer example of unknown provenance is in Stockholm. (Fig. A: Gyllensvard and Pope, *King Gustaf VI*, 1966, no. 4.)

The glyph on the interior of the foot is composed of a halberd (*ge*) with a rectangular shape that has been interpreted as representing a severed ear. Some have interpreted this elusive character as representing *huo* ("some"), *guo* ("kingdom" or "capital"), or some other clan name. A very similar inscription is found on a *jue* that, like this *gu*, was in the C. T. Loo collection. Its style and decor could convince one that they were originally part of a set. (Fig. B: Ch'en, *Yin Zhou*, 1977, No. A353 and R41.)

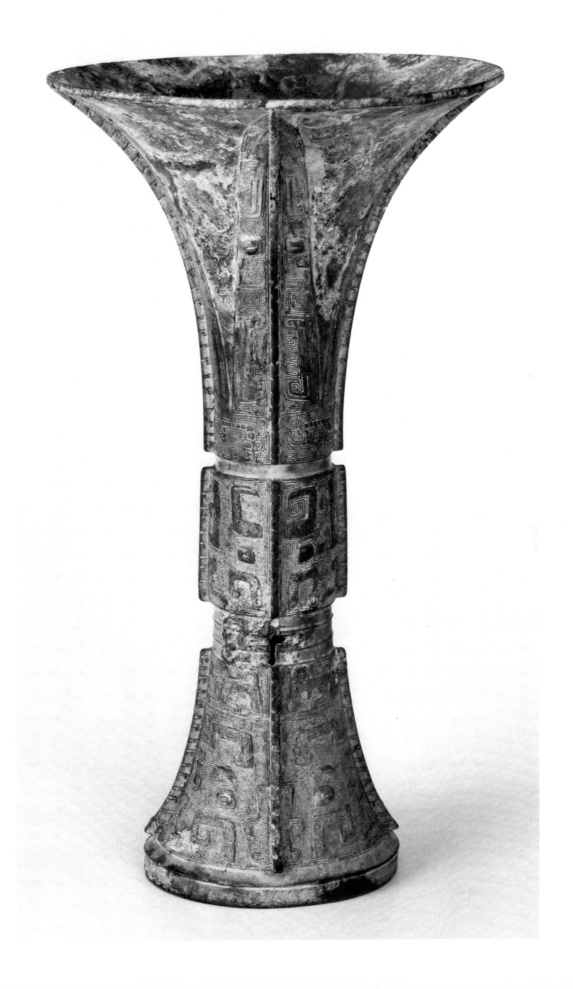

Plate 24
DING
Shang dynasty, 13th–12th century B.C.
Bronze
Height, 8 in. (20.3 cm.)
60.288

The *ding* tripod is one of the most revered of all the ceremonial bronzes. This example is particularly well executed, and the slightly outward-sloping legs contribute to its very strong and imposing presence. Individually, the motifs surrounding this vessel are not unusual, but the combination seen here is unique. In a band around the neck, confronting tiger-like motifs in relief are placed between the legs, and a circular whorl motif, also in relief, is placed between each animal. One extra whorl and tiger motif above the back leg completes the band of decor. Below this band are eighteen hanging blades with a cicada motif.

A handsome inscription is cast in the interior side on a mold seam above a leg. It consists of the title for a female of the highest rank, and the undeciphered pictograph of a lady and a stream or river. Though we do not know her name, her status indicates that she was possibly a consort of a king during the period of the last Shang capital at Anyang.

Published: Louisa G. Huber, *Arts of Asia*, XI, 2, March–April 1981, p. 77, fig. 4.

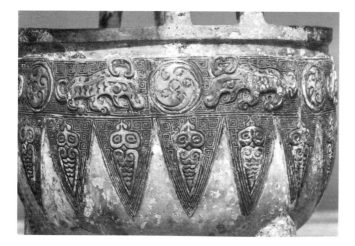

Plate 24,
Details

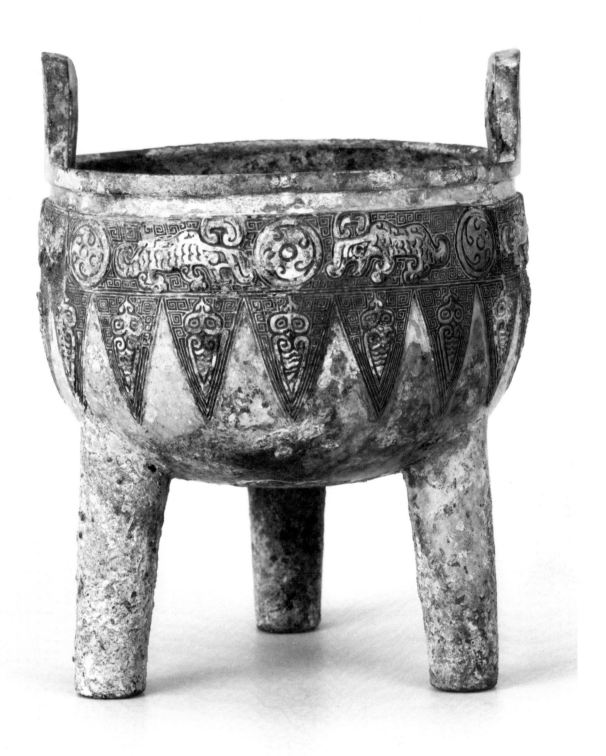

99

Plate 25
GUANG
Shang dynasty, 13th–12th century B.C.
Bronze
Height, 8⅜ in. (21.2 cm.); length, 9 in. (23.0 cm.)
60.43

Three major animal motifs dominate this sculptural vessel, and the rest of the decor is arranged around them. The bottle-horned head at the front end of the lid rests on the wide spout. The softly modeled head joins bodies seen on each side that descend in a gentle reverse S-curve through all registers. The animal appears to be rearing upright, as its forepaws are under the spout and its massive rear legs extend from the middle of the vessel into the lowest decor band. A ridge modeled as a reptile joins the front face and the next main motif, a *taotie* mask, at the end of the lid. With zoomorphic horns in high relief, the end *taotie* mask faces straight upward. Below this face, at the end and confined to the vessel proper, is the third major motif—a scaled dragon looking back upon itself toward the front. Birds and dragons in low relief face forward in the upper register of the body. The handle appears as a scaled body with an animal head well modeled in high relief.

The three main decorative parts of this type of vessel are clearly delineated by the plain bands, which separate the body, spout, and lid, yet there is still an attempt to design the surface independently of these structural divisions.

On the interior side of the lid is a cast inscription of a single character that may represent the name of a tribe distinct from the Shang.

Published: Louisa G. Huber, *Arts of Asia*, XI, 2, March–April 1981, p. 78, fig. 5.

In his discussion of a similar *guang* that also has the major designs crossing the body zones and is now in the Norton Gallery and School of Art, Professor Loehr established a sequence between unflanged vessels having non-divided surfaces with sweeping motifs (type 1), and those decorated in compartments (type 2). The Lilly *guang*, with its heavier appearance and more developed flanges, should follow the transitional example that Loehr uses to illustrate the link between the two types. (See Loehr, *Ritual Vessels*, 1968, no. 34, pp. 84–86.)

As Dr. Huber has noted, the inscription on this *guang* links it with several other bronze vessels, some of which are also related by their surface decoration. The similarities prompted her to raise the possibility that one workshop may have made several vessels for the same person.

Plate 25, Detail

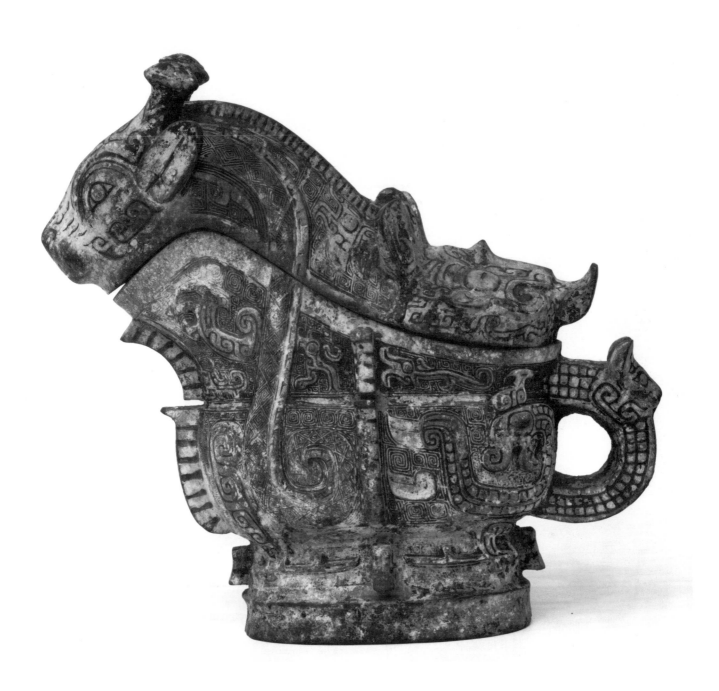

Plate 26
JIA
Shang dynasty, 12th century B.C.
Bronze
Height to caps, 11⅝ in. (29.5 cm.)
60.33

This stately vessel has tall, graceful caps that echo the smoothly curved contour. Three simple *taotie* masks are placed equidistant between the legs in the thin band of decor. The simply rendered *taotie* has two thin bands with projecting hooks extending from the boundaries of the eye motif. The large, tapering legs with a ridge mold line on the exterior center appear to be triangular, but their cross-section is actually more complex. The deep channels in each interior side make for a cross-section resembling an arrowhead standing on the concave center of a C.

A well-cast glyph on the interior bottom between the two front legs consists of a pictograph of a double-roofed building above the character for sheep.

Published: Louisa G. Huber, *Arts of Asia*, XI, 2, March–April 1981, p. 79, fig. 7.

Figure A, Rubbing

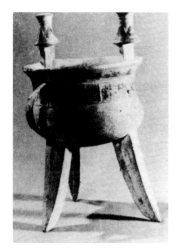

Figure A

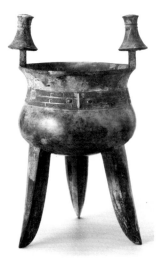

Plate 26, Details

During the Shang dynasty and concurrent with the appearance of decor that had complex flanges and relief, there was clearly an interest in smooth shapes, unadulterated by protrusions. This *jia* is a fine example of the latter aesthetic. The sensuous curves are nowhere disturbed by discontinuities or abrupt juxtapositions. The thin, ribbon-like handle has a well-sculpted bovine head, which becomes a nice representational accent in an otherwise handsomely abstracted design. The simple designs around the bowl and on the caps to the posts have established counterparts on related vessels excavated from the Shang capital of Anyang. (*KKHP*, no. 7, 1954, pl. 21, fig. 29; and *KK*, no. 3, 1979, p. 224, fig. 1 and pl. 3.) Examples bearing this quite rarefied style of design have been found from sites other than those in and near the capital. (Fig. A: *KK*, no. 2, 1981, p. 114, fig. 4–2 and pl. 3–3. This tomb in Luoshan, Henan, was dated to the late Shang and the period of Wu I and Wen Ding. See also Tsou, *Xia Shang Zhou*, 1980, pls. 16 and 17; and Jung, *Shang Chou*, 1941, p. 104, fig. 67.)

The character(s) inscribed in the bottom is often found by itself and within a bow-shaped contour. It may represent a place name or a type of sacrifice.

102

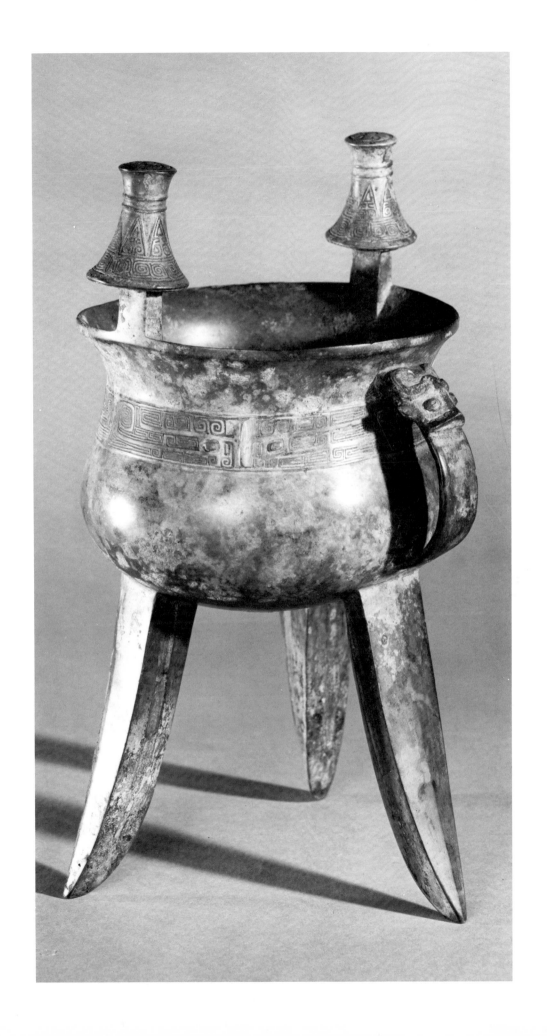

103

Plate 27
LIDING
Shang or Western Zhou dynasty, 11th century B.C.
Bronze
Height, 6⅞ in. (17.5 cm.); diameter, 6⅝ in. (16.7 cm.)
48.13

The classic, strong decor of this vessel makes it the boldest early bronze in our collection. The thick handles have a slight outward curve, which contrasts with the straight interior sides that smoothly join the lip of the rim. On a smooth band below the lip is a bold pattern of C-shaped motifs that interlock one at a time, rather than two into one. The robust *taotie* faces above each leg are depicted on broad surfaces rising evenly in low relief. The *taotie* has large C-shaped horns with C-hooks from the outer edge. Each half of the *taotie* masks is individually executed with a variety of deep, simple lines. Each of the well-executed, smaller dragons flanking the *taoties* was uniquely designed. The columnar legs, which are about half the height of the vessel, have no taper and were cast around a clay core. The two side legs have been filled with metal from the side, and all three have been broken where they join the bowl. The vessel is inscribed on the inside wall near the rim above the front leg.

Published: Bernhard Karlgren, *BMFEA*, no. 31, 1959, pl. 49a; Louisa G. Huber, *Arts of Asia*, XI, 2, March–April 1981, p. 80, fig. 9.

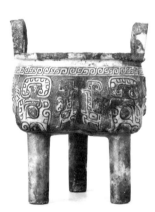

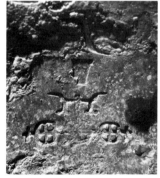

Plate 27, Details

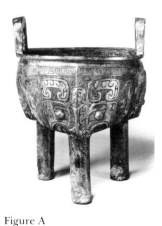

Figure B

Figure A

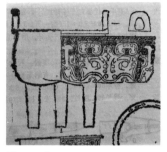

Figure C

Figure D

Even though this *liding* has suffered some damage and several small pieces are missing from the bottom of the bowl, it is a piece of remarkable quality. The deft handling of the motifs is marred only by the imprecise alignment of the three mold pieces, along the center line of each mask. This type of vessel—a hybrid of the tripartite, lobed *li* container and the *ding* tripod—was decorated with broad masks. It was popular from the later Shang into the early reigns of the Western Zhou.

A very similar vessel is in the Idemitsu collection. (Fig. A: *Idemitsu*, 1981, no. 1009.) Related pieces have been excavated from diverse areas of China, yet the closest examples come from areas the Zhou rulers once controlled. (Fig. B: *KKHP*, no. 4, 1980, p. 462, fig. 8 [Zhangjiapo, Shaanxi], and Fig. C: *KKYWW*, no. 4, 1982, p. 23, fig. 13–1 [Fufeng, Shaanxi].) The rather bold and individual treatment of motifs, such as the eyes of the monster mask—which have only a line instead of an outer canthus—and the flanking upright dragons with bottle horns, suggests that this piece came from an area the Zhou culture dominated.

The inscription near the rim may consist of a character that represents the cyclical dating element *yi*, or possibly *she*, ("to ford or traverse"), an axe with its cutting edge down, and the pictogram of a chariot, *che*. A *fangding* formerly in the F. M. Mayer collection of New York has a similar inscription with a slightly differently constructed chariot. In that inscription, the second character has been read *shi* ("to make known" or "to show"). (Fig. D: Ch'en, *Yin Zhou*, 1977, A65 and R157.)

104

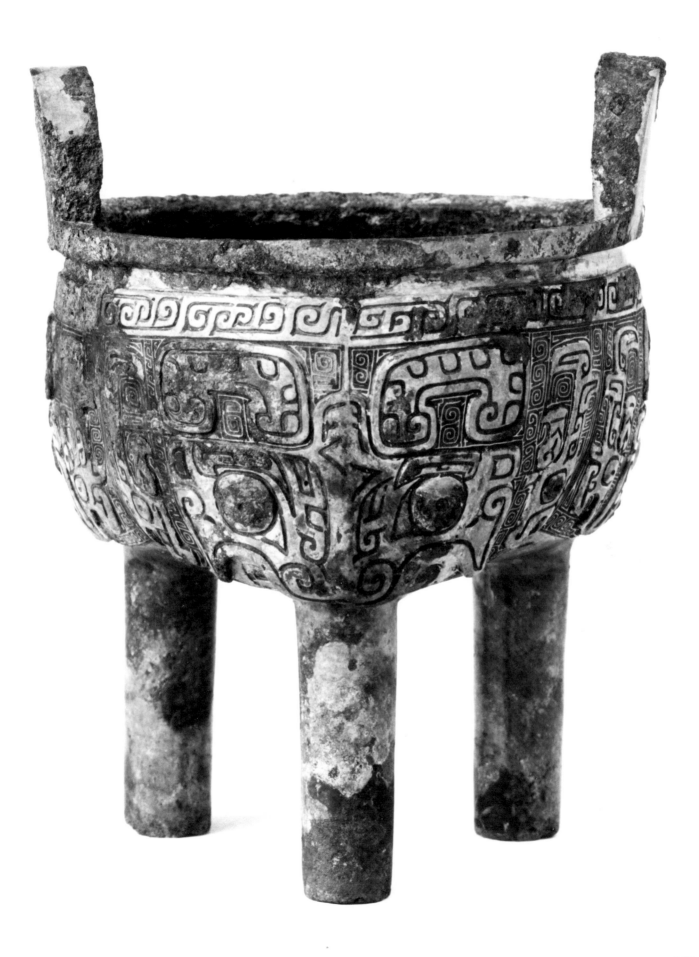

Plate 28
FANGDING
Western Zhou dynasty, 11th century B.C.
Bronze
Height, 7½ in. (19.0 cm.)
60.77

Because corner flanges protrude as far as the edge of the lip and the legs are over half its height, this solid vessel has an air of aloofness. Nearly everything about this *fangding* is standard except for the marvelously unique animal motif worked into the decor band below the top edge. This motif is so startlingly different that it almost works against the formal, ferocious masks of its predecessors. The major parts of this animal (dragon?) are unique in the extensive repertoire of the ancient bronze casters: eyes with double canthus, horns with X's and striations, body with single D-shaped scales, and most notably, the mouth of an uneven zigzag.

The inscription is on the center of the back wall and reads *Shih* ("scribe/historian").

Published: Yutaka Mino and Katherine Tsiang, *Apollo*, CVIII, 199, September 1978, fig. 2, p. 156; Louisa G. Huber, *Arts of Asia*, XI, 2, March–April 1981, pp. 79 and 81, fig. 8.

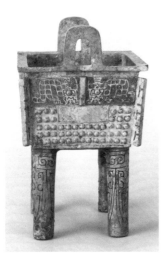

Plate 28, Details

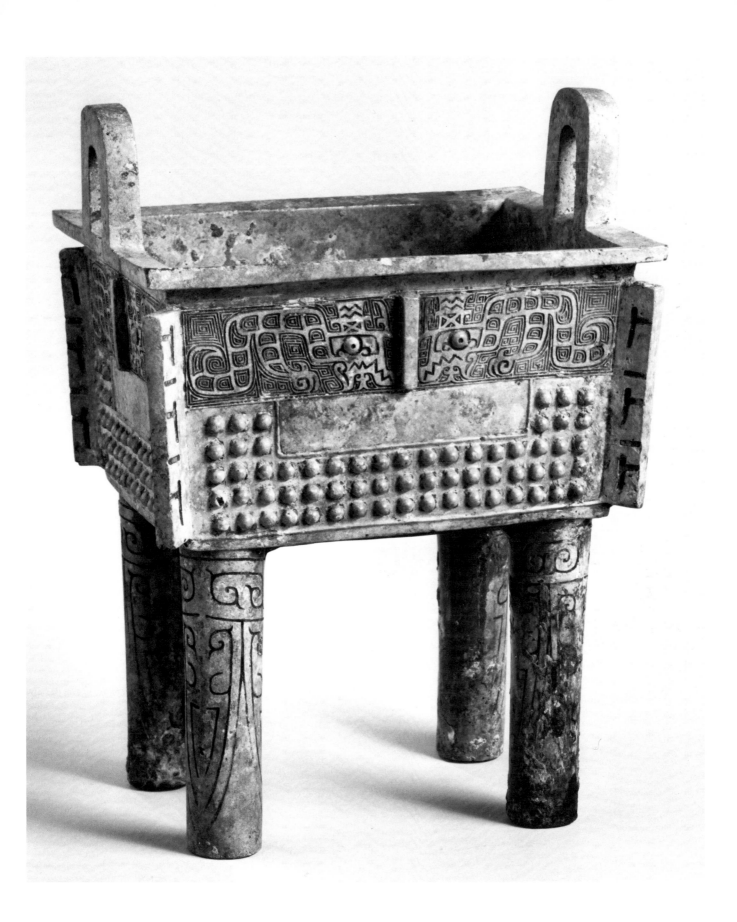

Plate 29
ZUN
Western Zhou dynasty, 11th–10th century B.C.
Bronze
Height, 11 in. (27.8 cm.)
60.21

The stable massiveness of this beaker is emphasized by the thick flanges in the lower two registers and the firm relief of the bold designs on a background of spirals. Yet this sense of heaviness is balanced by the firm curves of the silhouette, which reveal a modestly bulging middle. The three divisions of the *zun* are separated by simple raised lines in a plain band. The stout, strongly flaring neck is without either decoration or flanges. The middle zone of decor contains two pairs of confronting dragons, each with oppositely coiled horn and crest. In the bottom band, below each middle dragon, is a more elephantine dragon sporting an elongated trunk with scales and a wide mouth with large teeth. The almost spherical curve of the middle is maintained by the interior bottom, which joins the sides at the base of this band of decoration.

The inscription in the curved bottom reads *Fu Ding*, "Father Ding." Because this inscription appears on top of a chaplet, the inscription is clearly a relatively recent addition.

Published: Louisa G. Huber, *Arts of Asia*, XI, 2, March–April 1981, p. 80, fig. 10.

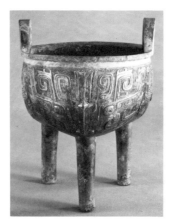

Figure A

The obvious interest in curvilinear patterns has caused the animal motifs to appear almost deformed when compared with the austere and direct examples from the Shang dynasty. The middle dragon design with a hooked snout and strongly curved lower jaw has a face very similar to one that will appear in later bronzes to be even more reduced to its curvilinear elements. (See Pl. 33.) As Dr. Huber has noted, there is in the British Museum a *liding* with decor similar to this central band on our *zun*. The *liding* has no flanges, nor does the beast have an ear in relief or a canthus by the eye, but the vessel is of comparable size, and more details of the decor are similar than not, suggesting that these two may share a common origin. (Fig. A: Rawson, *Ancient China*, 1980, p. 75, fig. 54.)

The confronting animals with elephantine snouts, in the foot segment, are not uncommon on Shang vessels, but the distortion caused by the large head and small body merely accentuate a busy, curling design; they do not impart the solemn character suitable for ritual ceremonies.

Plate 29,
Details

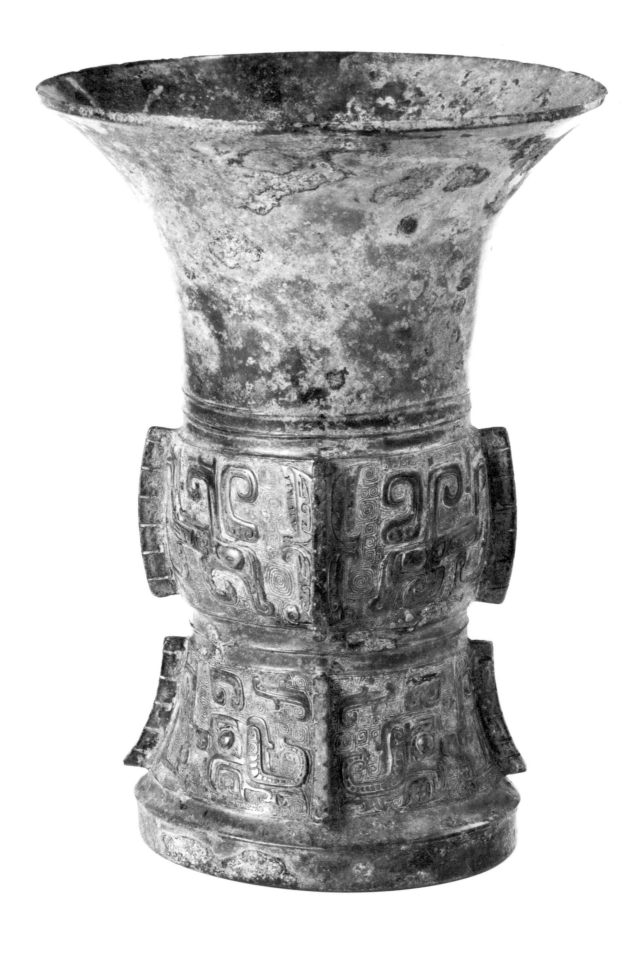

Plate 30
HE
Western Zhou dynasty, 10th century B.C.
Bronze
Height, 10⅝ in. (27.0 cm.)
60.34

The flattened, domed lid with an arched dragon handle is attached to the neck by a cast link. The tall neck is undecorated but for two raised lines, and it handsomely reflects the tight curvature of the disk-shaped body. Similar bands of decoration on the lid and shoulder contain what is left of a *taotie* mask flanked by three rows of repeated motifs, the bottom two being spirals and the top a quill-feather motif. The "ogre mask," bisected by a low flange, repeats twice within the shoulder band and four times around the lid. The inscription under the handle has been read as *Zhong Jing* (?) *zuo bao yi*, or "Zhong Jing made this precious vessel."

Published: Louisa G. Huber, *Arts of Asia*, XI, 2, March–April 1981, p. 82, fig. 12.

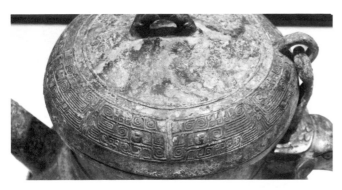

Plate 30, Details

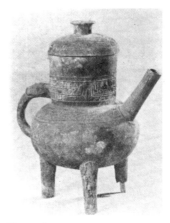

Figure A

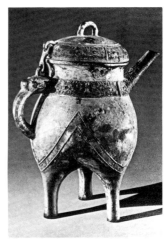

Figure B

This well-proportioned bronze is an appealing variant on one of the oldest ritual vessels to have been made in bronze. In the Shang dynasty the *he* first appeared with hollow feet, like three joined cones, and kept a lobed shape into the Zhou dynasty when the circular variant, usually four-legged, superseded it. The Lilly *he* is a most elegant example of the circular, three-legged type because its proportions are so well balanced between the various parts. The *Ge Fu Wu he*, a rather clumsy example from Luoyang, should illustrate this point. (Fig. A: *WW*, no. 7, 1972, p. 8, fig. 12.)

The "triple band" decoration certainly recalls the earlier Shang tripartite design as seen on the *jia* (Pl. 26), but here the design employs fine spirals in the lower two horizontal bands and a quill-feather motif in the top band. This extremely popular style of band design can be found on many vessels from diverse sites. (See Pl. 31.) The *Luan Bo he* recovered from a Western Zhou tomb in Lingtaixian, Gansu, is a traditionally lobed-style *he* with decor quite similar to the Lilly *he*. (Fig. B: Fong, *The Great Bronze Age*, 1980, cat. no. 44.)

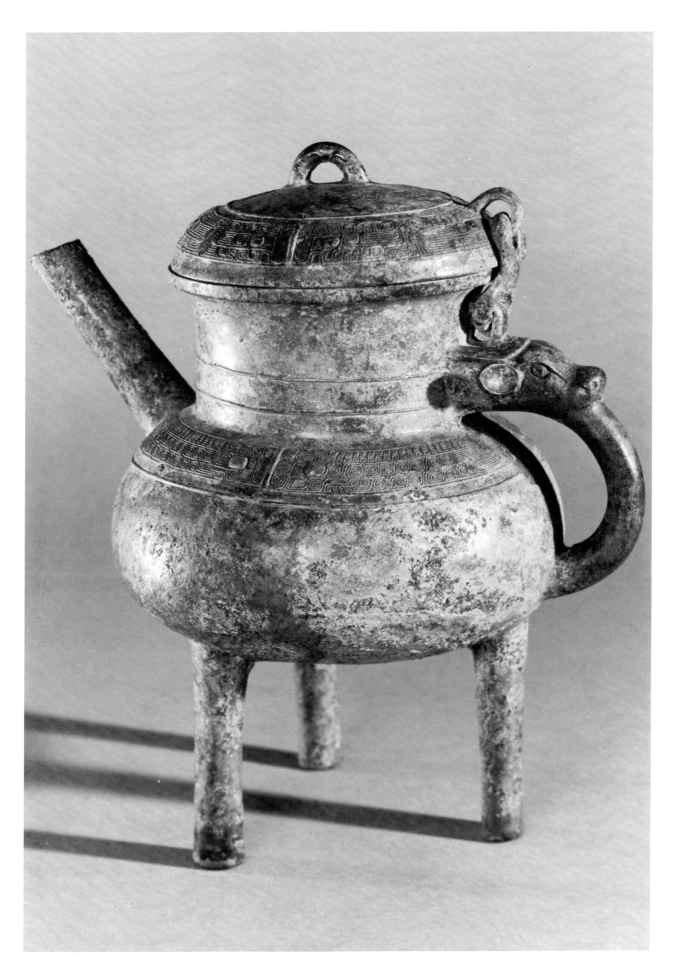

Plate 31
GUI
Western Zhou dynasty, 10th century B.C.
Bronze
Height, 5¼ in. (13.5 cm.)
60.44

The opposing handles and broad foot impart a very stable, heavy appearance. The numerous ribs and two bands of decor add to the staid aspect of the bowl. The decor bands, like those on the *he* (Pl. 30), are basically a row of feather/quill shapes surmounting two rows of spirals. The foot band has four masks, and the neck band has two repeats with a relief mask placed over the medial ridge.

Published: Louisa G. Huber, *Arts of Asia*, XI, 2, March–April 1981, p. 82, fig. 11.

Figure A

Figure B

In the vicinity of Luoyang, mold fragments from a foundry site near the ancient capital of the Western Zhou dynasty have been found. They contain ribs and *taotie* design segments that are very similar to the tripartite pattern as seen here and on the *he* (Pl. 30). (Fig. A: *WW*, no. 7, 1981, p. 60, fig. 19:8 and 11.) A *gui* extremely similar to our example was found at Baofengxian in 1973 and is now in the Luoyang museum. (Fig. B: *WWCLCK*, no. 3, 1980, p. 41, fig. 9.) A provenance of the dynastic capital for this "triple band" design would certainly explain the obvious popularity of the pattern. Consequently, vessels made in the capital were available to administrative envoys, who were needed to control the kingdom—a circumstance that may explain the bowls' appearance in distant locations. Comparable examples have been found as far away as Lingtaixian, Gansu. (See Pl. 30.)

112

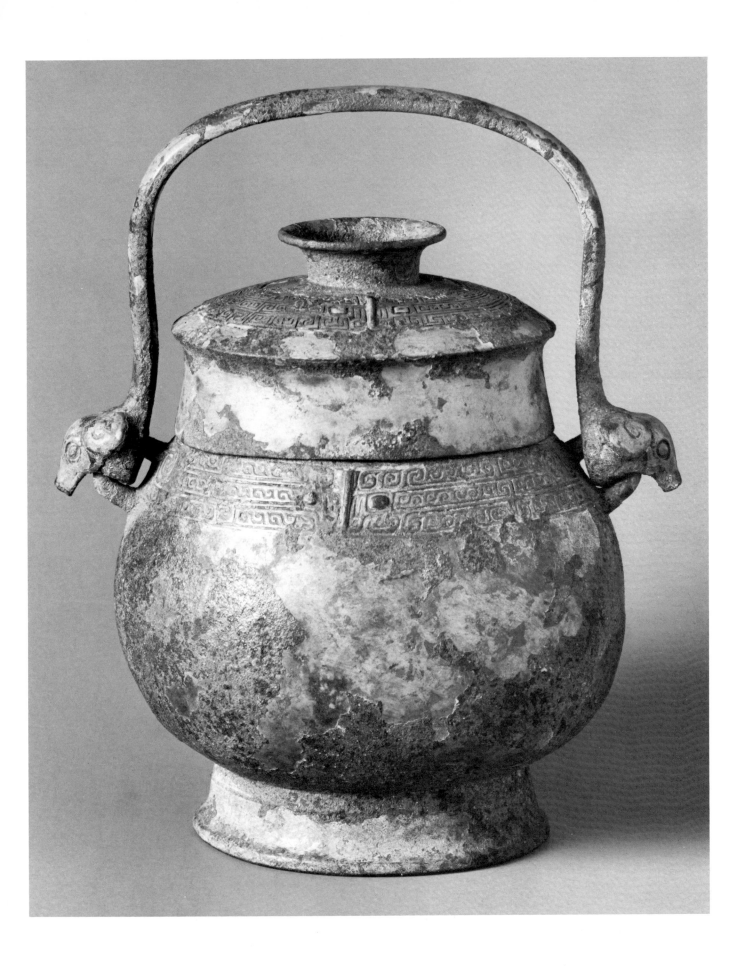

Plate 33
BELL *(ZHONG)*
Eastern Zhou, 6th century B.C.
Bronze
Height, 19 in. (48.2 cm.)
60.65

This oval bell with gracefully tapering sides has the same repeated dragon motif in the zones between the coiled reptilian bosses, in the central rectangle at the base, and on the top as ground for the two stylized tigers. The crux of this angular motif is a ribbon-band dragon body with a different head at each end. One head, with a triangular eye, has a rather elongated and upturned snout, and the other head, with a round eye, has a broad, beak-like snout curving down into its mouth. The S-shaped body between these heads links with the inverted mirror image of itself to form a repeat segment of two dragons and four heads. This compound motif completely fills, and is cut off by, the slightly recessed areas in which it is placed.

Unlike most bells, the Lilly bell has addorsed, rather than confronting, tigers to support the suspension loop. This allows the animals' heads to be clearly and independently articulated and to have a proud, superior poise.

The axis dimensions at the bottom are 12¼ x 9¼ inches (31.1 x 23.5 cm.), and the bell weighs 49 lb 4 oz.

Published: Yutaka Mino and Katherine Tsiang, *Apollo*, CVIII, 199, September 1978, p. 157, fig. 3; Louisa G. Huber, *Arts of Asia*, XI, 2, March–April 1981, p. 83, fig. 13.

Dragons of the eastern Zhou period were as popular a motif as they had been earlier, but their character had greatly changed. No longer having an awe-inspiring, dominating presence, they had been reduced to a mere linear, decorative motif. Intricately intertwined between and within themselves, their various parts—except for their eyes and jaws—become so entangled that it is often difficult to point them out. The dragon motif in this bell remains clearly defined even though the interlaced pattern is tight.

This important bell has a design indicative of the earliest phase of a major style of bronze decoration known as the Liyu (Li-yü) tradition. Dr. Huber, who has written about this bell and this tradition more than once, has succinctly noted that

> Characteristically the dragon bands are narrow, slightly concave in shape, banked at the edges, and sharply right-angled. As the style matures these designs gain in size and refinement. The bands become wider and more supple, banking is replaced by shapely volutes, and instead of the square meanders seen on the bell, the bands come to be embellished by spirals, striations, and granulation, which impart to the ornament rich contrasting textures. The later phases of the style

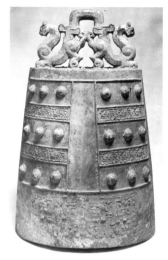
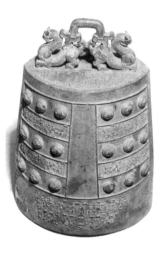

Figure A

Figure B

are also dramatically enlivened by the reintroduction of a *taotie* to the surface decoration. [Huber, *Arts of Asia*.]

Crucial to the dating of our bell is a similar item found in Shaanxi in 1870 and now part of the Shanghai Museum. The 174-character inscription on that bell records that it was made in the state of Qi by the great-grandson of a duke who ruled from 685 to 643 B.C. As Dr. Huber has pointed out, this inscription establishes a reasonable date of the early sixth century for that bell and related ones, such as the bell in the Winthrop Collection at the Fogg Museum. (Fig. A: Gillerman, et al. *Winthrop Retrospective*, 1969, no. 36.) The Winthrop bell, which is a little shorter than ours (14 in.), has two complete design segments in the rectangular central area at the bottom. In the analogous though larger area of the Lilly bell, a half row was added above the repeat pattern to fill up the space. It is interesting that while the Lilly bell has the same motif in all areas of decoration, the Winthrop bell has a different dragon motif in the bands between the bosses.

A bell in the Cincinnati Art Museum has the same dragon motif that the Lilly and Winthrop bells have in the main decor zone, and like the Lilly bell, this same pattern is repeated between the bosses. (Fig. B: *Sculpture Collection of the Cincinnati Art Museum*, Cincinnati, 1970, pp. 112–113.) It is shorter than the Lilly bell (height, 16¾ in. or 42.4 cm.), and was also once in the C. T. Loo collection.

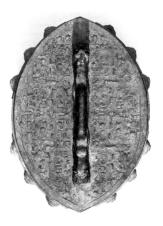

Plate 33, Details

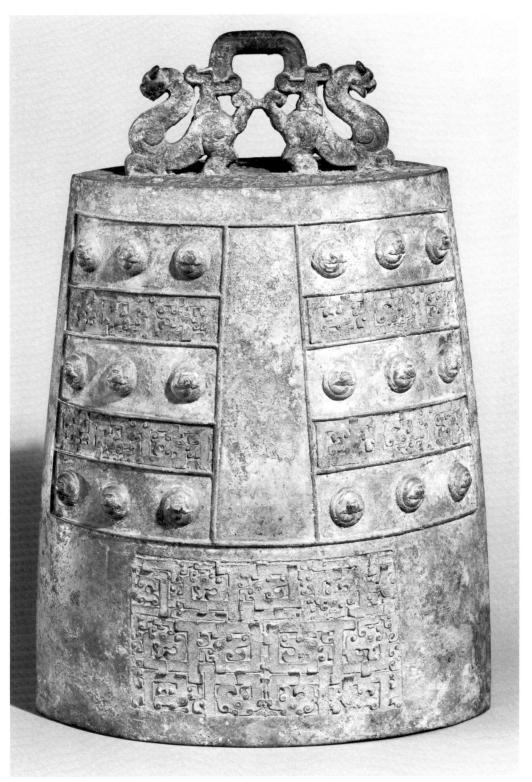

Plate 34
HU
Eastern Zhou dynasty, 6th–5th century B.C.
Bronze
Height, 12¼ in. (31.0 cm.)
60.13

This jar is almost circular, but the axis through the handle (8.4 cm.) is about half a centimeter longer than its right-angled counterpart. The lid, which is surmounted by an open-mouthed bird, is fastened to the handle by a chain of five sections, including two double links, that connect to a loop on the tail of the bird. Three one-inch bands are effectively placed just off the critical parts of the softly curved contour. Each band contains a C-shaped dragon that is intertwined with two similar dragons oriented in opposite directions. At the ends of their bodies, each dragon has similar heads, but these heads are rather unusual in that they have such small snouts and no mouths. Each head is dominated by a petal-shaped ear and an eye dot under a bowed brow. The dragon bodies are covered with fine spirals, and the background is plain. The segments of repeat patterns divide the top, middle, and bottom bands of decor into three, two, and three sections respectively. The color of the container is a mottled olive green, and the weight is 2 lb 10 oz.

Published: Louisa G. Huber, *Arts of Asia*, XI, 2, March–April 1981, p. 85, fig. 14.

Figure A, Schematic

Figure A

in Wenxi, Shanxi, in 1973, Zhu shows that the bronze gourd-shaped vessel with a bird on the lid is a ritual vessel derived from the ceramic "clay gourds" mentioned in early texts. Furthermore, the bird motif on the lid, which is usually larger than that in the Lilly example, is not arbitrary. The shape of this vessel is related to an auspicious heavenly constellation of the same name which in turn is also named after a bird. With the symbolism and imagery established during the Eastern Zhou, this vessel type continued to evolve and change in shape.

The motif of a bird atop a lid can be found from Neolithic and Shang times (cf. Pl. 21). During the Eastern Zhou, birds similar to the one on this lid were particularly popular motifs as spouts and handles for a number of vessel types, and it seems very reasonable that auspicious associations would have developed. It should be noted that birds are not the only animals atop the lids of these distinctively shaped vessels. (A similar *hu* with a feline animal lid is reproduced in Jung, *Shang Chou*, vol. 2, 1941, p. 413, pl. 783.)

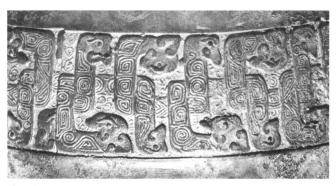

Plate 34, Detail

This type of vessel with a side handle is deceptively similar to an ancient Chinese *hu* such as the Lilly example (Pl. 20), yet the origin of its shape may not be from such a bronze prototype. Some have considered this a bronze version of a type of flask used by the nomads near the China border, and they have argued that the earlier, more asymmetrical examples closely reflect their leather prototypes. However, in an article by Zhu Jieyuan concerning a more asymmetrical *hu* that was found in 1967 in Suide Xian, Shaanxi, an interesting alternative origin was proposed for this type of vessel. (Fig. A: *KKYWW*, no. 2, 1980, pp. 32–41, fig. 1, p. 33.) Based on research by Zhang Han, who wrote about an example in pottery found

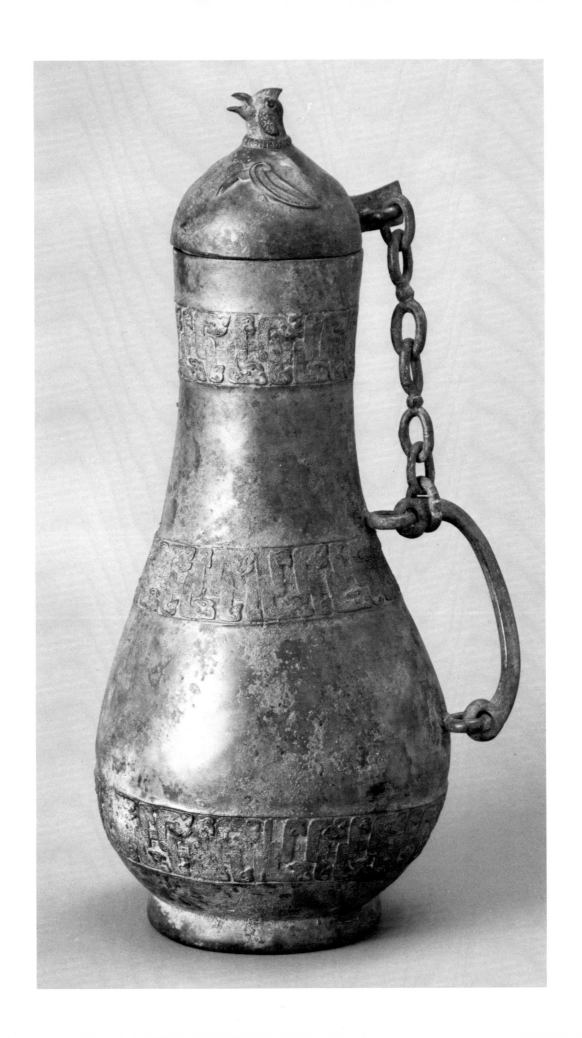

Plate 35
HU
Eastern Zhou, early 5th century B.C.
Bronze
Height, 21½ in. (54.5 cm.)
60.32

To the smallest detail, the fine workmanship on this grand vessel is of the highest quality. The three broad, main bands of decor are separated by two narrow, plain bands that enclose an inlay band with abstract curvilinear designs of varying width. The broad bands are filled with an alternately inverted motif of engouled dragons seen in profile. The dragons, enclosed by a blank band, are filled with fine, delicate spirals; their horns are striped, their snouts are stippled, and they are depicted without relief, flush with the plain background. The surface of this vessel has no relief other than the *taotie* bosses holding the rings. Grooves for cooper wire are present in some areas where the inlay has been lost. The vertical side of the foot is decorated with an interlocking S-shaped design of bands similar to those of the dragons above. The domed lid, which sports four standing rings, has a simple abstract design of even-width inlay, which is of a different character from the elegant lines on the body that have such dramatic width variations.

Published: Louisa G. Huber, *Arts of Asia*, XI, 2, March–April 1981, p. 86, fig. 15.

Because the dragon motif was so arbitrarily handled as a linear design, the incessant variations seem to have been practically inexhaustible. The main dragon motif on this *hu*, though lacking any relief, is otherwise extremely close in design to several well-known and datable bronze vessels. A basin (*jian*) in The Chicago Art Institute has a two-dimensional dragon design that, though raised from the surface, is similar in almost every major respect. (Fig. A: Ch'en, *Yin Zhou*, 1977, no. 842.) In related objects, such as the Cull and Freer *hu*, this design band is in a secondary rather than a primary register, yet the well-accepted dates for those bronzes allow us to propose for this one a date during the first quarter of the fifth century and a provenance of the state of Jin. (Fig. B: Lawton, *Warring States*, 1982, cat. no. 1, and cat. no. 2, pp. 26–29.)

Another source of support for the date and provenance of the Lilly *hu* comes again from Dr. Lawton's fine study of this period. A *dui* in the Freer Gallery of Art contains a band of dragons, without relief, that is quite similar to that on the Lilly *hu*, except that the dragons have not yet consumed the first half of their intertwined counterpart. (Fig. C: Ibid., cat. no. 4, p. 32.) That *dui* is said to come from Liyu, and it was shown to be directly related to molds from the bountiful Liyu-type site at Houma, Shanxi.

Figure A

Figure C

Figure B

120

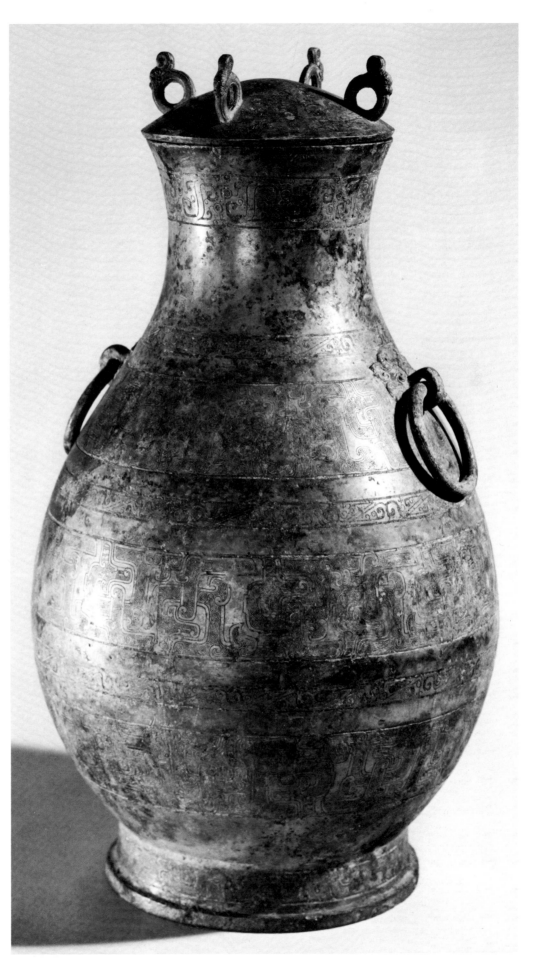

Plate 35, Details

Plate 36
AXLE-CAP *(CHEWEI)*
Eastern Zhou dynasty, 5th century B.C.
Bronze
Height, 3⅞ in. (10 cm.)
60.161

Both ends of the axle-cap are open, and at the inner end there is a stepped increase in diameter and flare to accommodate the linchpins. The motif on the large outer band consists of confronting dragons with diagonally striped bodies and long snouts with a mustache-comma curving back under the opened jaw. The profile dragons have a broad flat band joining their "chests." The lower third of the large band is repeated on the band encompassing the linchpin holes. The largest diameter is 3½ inches (8.9 cm.).

Not previously published.

Figure A

Of the fifteen axle-caps found in tomb 126 of Fenshuiling, Changzhi, Shanxi province, there is one that appears to be remarkably similar to ours. (Fig. A: *WW*, no. 4, 1972, pl. 5.5 length, 10 cm.) As the axle-caps were not from a chariot pit, they were obviously collected and buried with the deceased. This tomb prompted Dr. Lawton to discuss the "heirloom" problem because the date proposed in the excavation report for the tomb (mid-third century, ca. 262 B.C.) is too recent for some of the excavated objects. (*Warring States*, 1982, no. 8—a fourth-century B.C. item; and no. 36—a fifth-century B.C. item.) It seems possible in the present context to hypothesize that the axle-caps might represent "military heirlooms" or booty from some campaign. An axle-cap with similar decor but unknown provenance is reproduced by Karlbeck. ("Notes on Some Chinese Wheel Axle-caps," *BMFEA*, no. 39, 1967—his B13 is actually his fig. 21.)

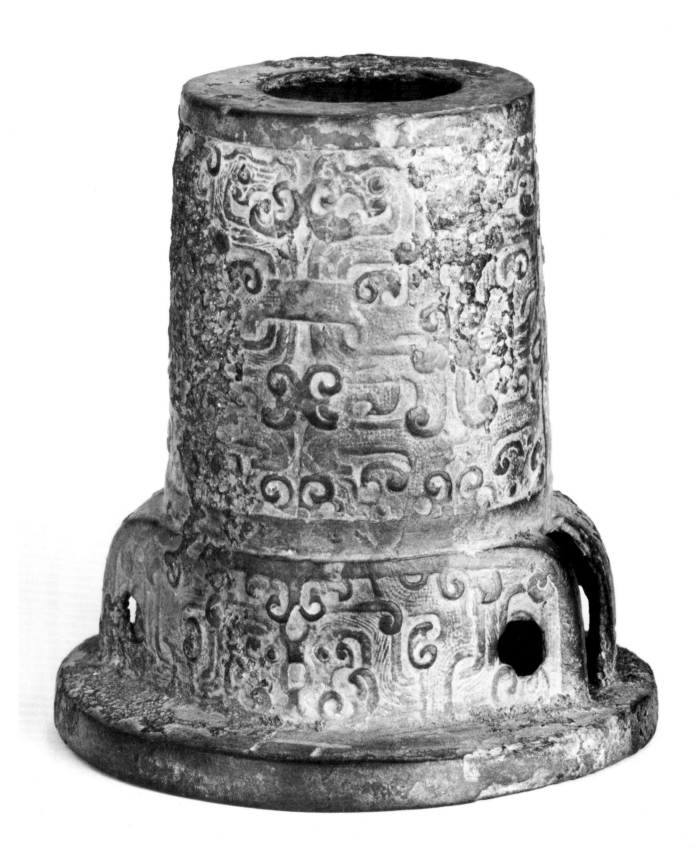

Plate 37
ZHI
Eastern Zhou dynasty, 3rd century B.C.
Bronze with copper inlay
Height, 5⅞ in. (15 cm.); diameter, 3¾ in. (9.5 cm.)
49.6

This cylindrical cup was cast with the linear design raised above the base, thus ensuring that the inlay will serve as a background to the metallic design, which is the reverse of the standard practice. Copper wires are still visible in the grooves, but all the rest of the inlay (probably turquoise) has fallen out. The three horizontal bands at the top, middle, and bottom call to mind the prototype of this cup, which would have been made of wood and been bound to hold the pieces together. In these thin bands one line zigzags from border to border. A V-shaped motif is placed at each vertex of this zigzag line. The main design in the two broad zones around the body is so abstracted that its origins are almost impossible to visualize, yet Dr. Huber has perceptively shown that the design is developed from an abstracted pattern of overlapping birds. The three animal-style feet are joined to the center of the bottom by a broad, Y-shaped ridge. Four chaplets can be seen in each of the three segments defined by the ridge.

Published: Louisa G. Huber, *Arts of Asia*, XI, 2 March–April 1981, p. 87, fig. 17.

This simply shaped, utilitarian vessel did not appear until the late Eastern Zhou, and after its appearance, it is found in bronze, silver, jade, lacquer, stone, and pottery. The even, rectangular nature of the main design appears to fit comfortably into the second stage of the development of inlay bronzes as lucidly discussed by Jenny So. (See Fong, *The Great Bronze Age*, 1980, pp. 305–320. For a discussion of the name and shape of this type of cup, see Wang Chen-feng, *WW*, no. 1, 1964.)

Plate 37, Detail (X-ray)

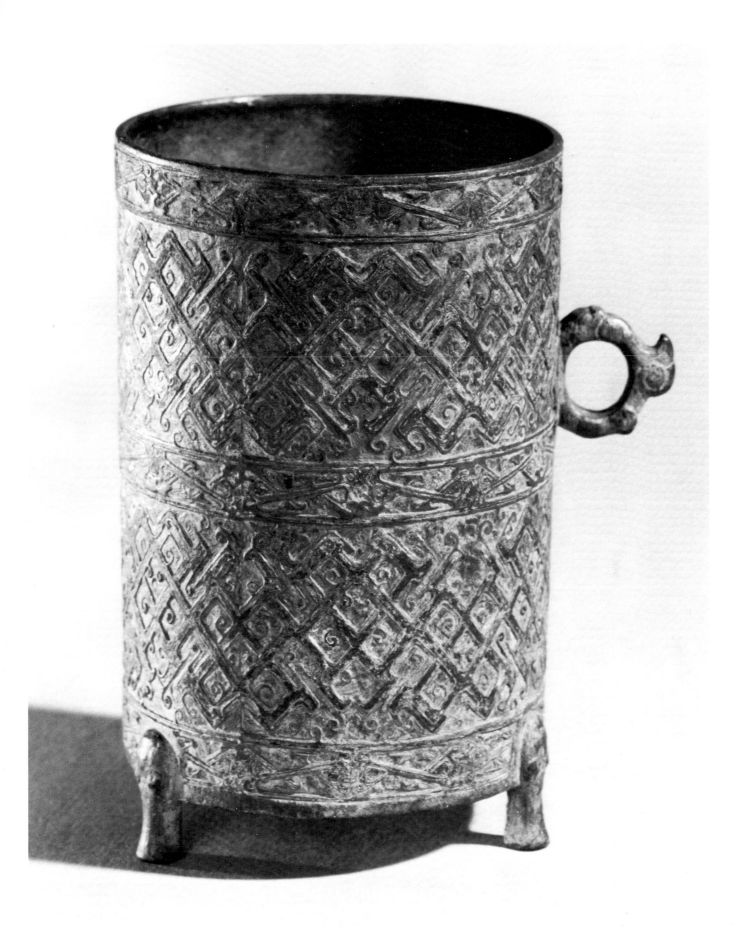

Plate 38
GARMENT HOOK *(DAIGOU)*
Eastern Zhou dynasty, 4th century B.C.
Bronze with malachite, gold, and silver inlay
Length, 5¼ in. (13.4 cm.); width, ¾ in. (2.0 cm.)
60.19

This modest-sized garment hook is rather stout in its proportions because of the fairly thick edge. A rhombic design with curls and circles is inlaid along the smoothly curved back. The knob tends toward the broad end.

Not previously published.

Often called belt hooks or agraffes, similar hooks appear to have been also used to attach objects other than belts to one's garments. In Dr. Lawton's survey of researches on these objects, he locates their appearance in China during the seventh to sixth century B.C. in a context that strongly suggests they were adopted from the costumes of northern nomadic foreigners. (Lawton, *Warring States*, 1982, pp. 89–94.) Evidence from burial sites indicates the hooks have been used from head to waist. A piece very similar in design and length (13.5 x 2.1 cm.) was found in the Luoyang area of Henan. (Fig. A: *KKHP*, no. 8, 1954, p. 154, no. 650:5, fig. 21–9, and also no. 631:1, fig. 21–5.)

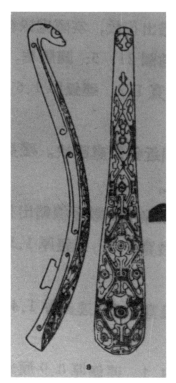

Figure A

126

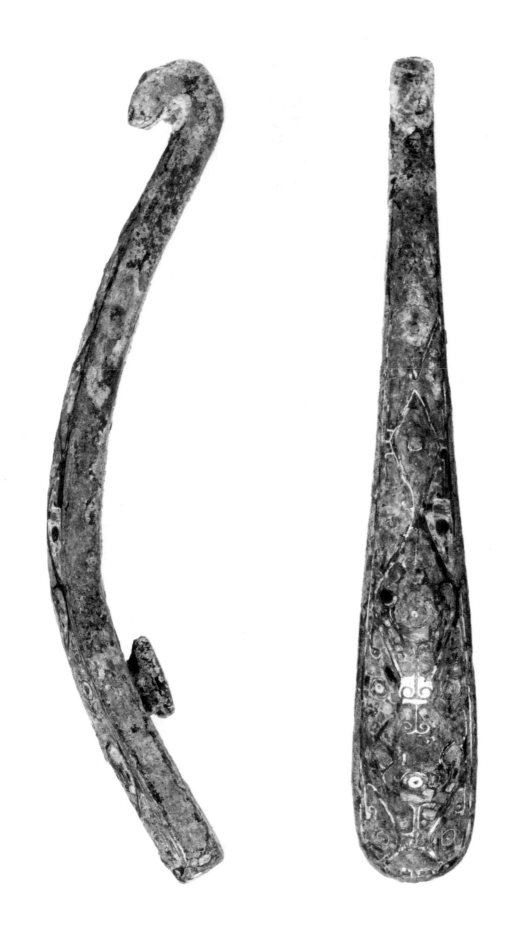

Plate 39
GARMENT HOOK *(DAIGOU)*
Eastern Zhou dynasty, 4th century B.C.
Bronze with turquoise, gold, and silver inlay
Length, 8¾ in. (22.2 cm.); width, 1 in. (2.7 cm.)
60.16

The top surface of this medium-sized garment hook is composed of three flat planes. The graceful, curvilinear design with curls has encircled disks of silver at the corners of the central, rhombic pattern.

Not previously published.

Similar examples can be found in the Freer Gallery, in Stockholm, and among excavations from Luoyang and Erligang in Henan. (See bolder examples in Lawton, *Warring States*, 1982, no. 48; *BMFEA*, no. 38, 1966, pl. 27, 41–43; *Lo-yang Chung-chou-lu*, 1959, p. 104; and *Cheng-chou*, 1959, pl. 26 and 40.)

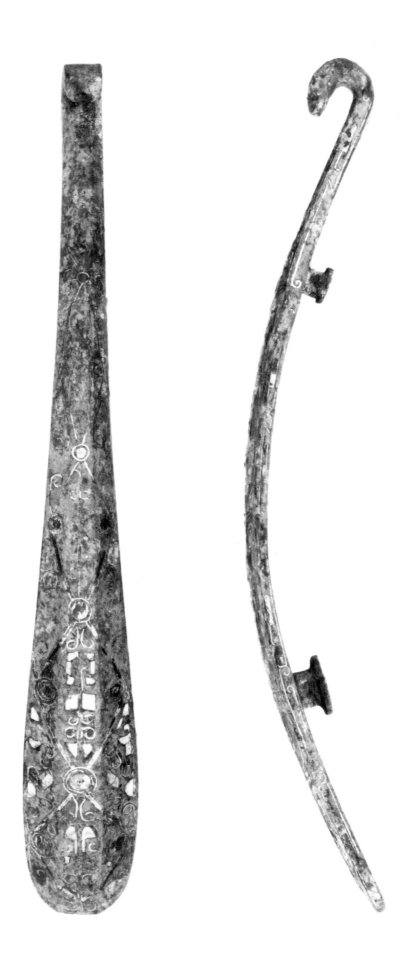

Plate 40
GARMENT HOOK (*DAIGOU*)
Eastern Zhou dynasty, 4th century B.C.
Bronze with gold and silver inlay
Length, 9 in. (23.0 cm.); width, 1 in. (2.6 cm.)
60.17

Sporting two knobs on the bottom—one in its normal position, halfway toward the broad end from the center, and one by the sharply cut neck—this hook has very little taper to its main body. The design on the three flat sides of the top surface is a complex, curvilinear pattern executed with inlaid lines that vary greatly in width. The central design is probably derived from a feline figure. The side edges are also decorated with inlay wires.

Not previously published.

This rare style of hook can join the few better known examples that have been published with the study of a similar but heavier designed piece in the Wessén collection, Stockholm. (The others are in the Menzies collection, the Freer Gallery of Art, and a study by Nagahiro. See *BMFEA*, no. 30, 1958, p. 192 and no. 38, 1966, pl. 39, H2W; and Nagahiro, *Taiko no kenkyu*, 1943, ch. 1 and pl. IX.)

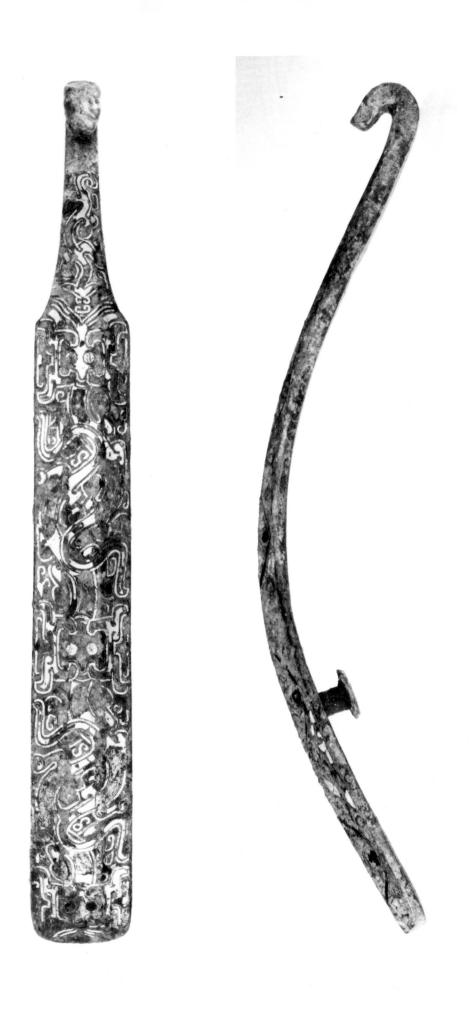

Plate 41
GARMENT HOOK *(DAIGOU)*
Eastern Zhou, 4th–3rd century B.C.
Gold and silver gilt bronze with inlay
Length, 5¾ in. (14.5 cm.); width, 1¼ in. (3.2 cm.)
49.7

At each end of the broad area of decor is a deeply molded design consisting of a heavily toothed monster mask. The masks are joined by two broad curvilinear ribbons between the oval ears. The end of the hook terminates in a much less aggressive face. Highlighting the gold of the decor are four translucent green beads (glass?): one in the center of each forehead and two at each edge under the connecting ribbon motif. The top and sides are gilded, and the back underside is concave with a thin silver coating.

Not previously published.

Examples almost identical to this, but shorter, have been published by Nagahiro and Karlgren. (Nagahiro, *Taikou no kenkyu*, 1943, pl. X, no. 122a; and *BMFEA*, no. 38, 1966, pl. 54, M1W.)

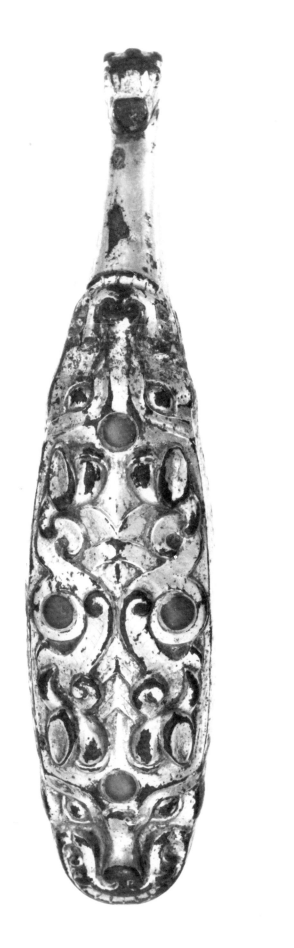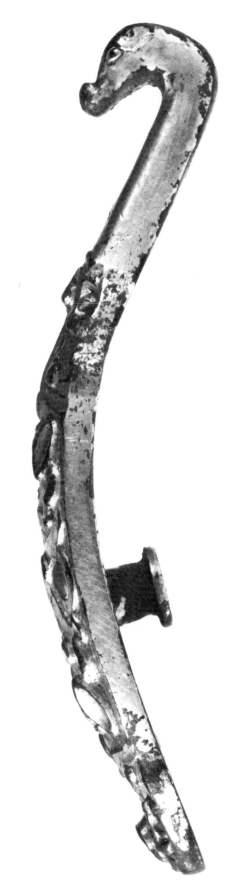

Plate 42
GARMENT HOOK *(DAIGOU)*
Eastern Zhou dynasty, 4th–3rd centuries B.C.
Gilt bronze with turquoise inlay
Length, 3⅝ in. (9.2 cm.)
60.20

The broad face on the shield of this hook is deeply molded and gilded with fine incised lines for accent. Three opaque green beads are inlaid into the eyes and middle forehead. The short hook terminates in a dragon head, and the concave back is covered with a thin sheet of silver.

Not previously published.

Fortunately, this handsome hook is in very good condition. Most examples of this type have lost the inlaid beads. (For an example, see *BMFEA*, no. 38, 1968, pl. 59, no. N31.) A piece identical to this hook is illustrated by Nagahiro (Nagahiro, *Taigo no kenkyu,* 1943, colorplate 2). A similar hook is illustrated by Rawson, *Ancient China,* colorplate X; and Lawton discusses an asymmetrical variation of this type, *Warring States,* 1982, no. 60, p. 110.

Similar examples from Fenshuiling, Changzhi, Shanxi province confirm the late Warring States date for this short but powerful-looking hook. (*KK,* no. 3, 1964, p. 111, pl. 5–17.)

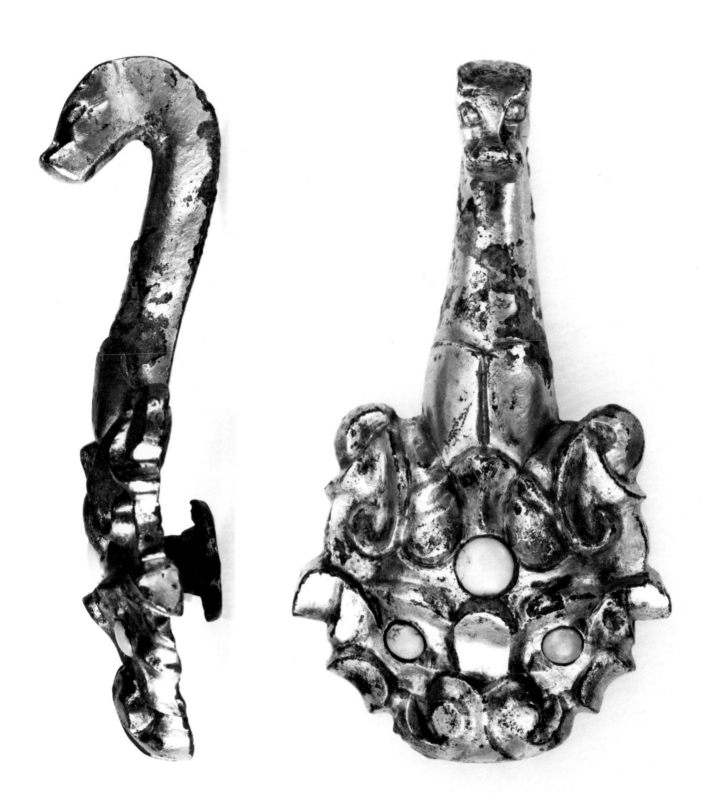

Plate 43
GARMENT HOOK *(DAIGOU)*
Eastern Zhou dynasty, 3rd century B.C.
Bronze with gold and silver inlay
Length, 5⅝ in. (14.3 cm.)
60.18

This round hook has two thin bands of gold at the end,
and a curvilinear design of thin and thick lines paralleled
by thin lines. The design ends in triangular patterns along
the side. The underside is plain except for two inlaid
circles halfway between the knob and the end. On the
face of the knob is inlaid a four-petaled rosette, each petal
of which is filled with five rows of silver inlay dots.

Not previously published.

A similar piece in the Freer Gallery of Art has recently
been published. (Lawton, *Warring States,* 1982, no. 73.)

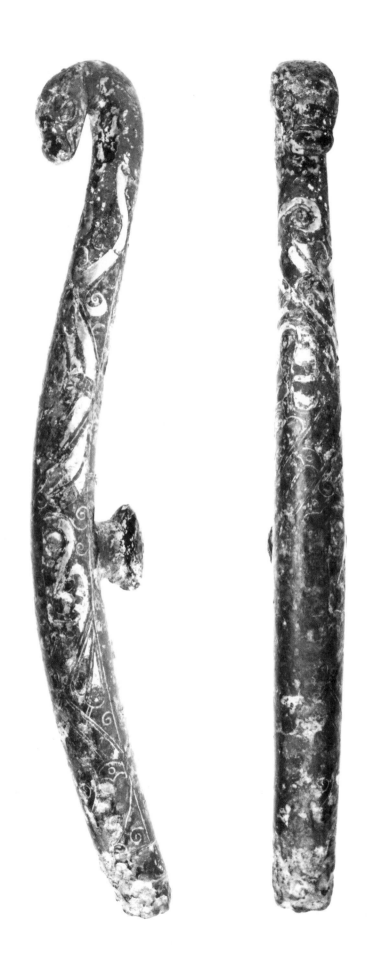

Plate 44
MIRROR (*JING*)
Eastern Zhou dynasty, 4th century B.C.
Bronze
Diameter, 5½ in. (14 cm.)
48.15

The double-ridged loop in the center is on a plain disk, and two smooth concentric concave rings divide the mirror back into two bands. In the outer broad band are four similar feline animals oriented to the center in clockwise procession with heads turned up, looking backward. The long, arching tail accounts for half the length of each of the S-shaped animals. The inner band is empty of design other than the tight uniform background shared by both bands. This background pattern is a rectangular repeat of what Weber calls two stylized, addorsed, and inverted birds with a granulated field between them. (See the following.)

Not previously published.

Some mirrors virtually identical to ours have appeared in Western collections, but the bold design of these broadly modeled, long-tailed cats has not yet been reported in an archaeological context. (*BMFEA,* no. 13, 1941, pl. 20, C61, and no. 40, 1968, pl. 25, C61.) Nevertheless, the background design is common to a large number of mirrors with various main design motifs, and this type of ground pattern, often known as a "comma pattern," is generally considered to indicate an origin within the influential southern culture of Chu, centered around Changsha, Hunan, and extending to Anhui. (Fig. A: from Weber, *Ornaments,* 1973, p. 44, fig. 12. See also *BMFEA,* no. 35, 1963, no. 40, 1968; *KKHP,* no. 1, 1959, and no. 4, 1981; and *Ch'ang-sha,* pl. 21.)

Interestingly, molds for mirrors with different major motifs but similar backgrounds have been found almost as far north as Beijing, and excavated examples with similar ground patterns have appeared from all over China. (Lawton, *Warring States,* 1982, nos. 39 and 40, pp. 85–87. To his concise discussion, a recent find can be added: one from Gansu; *KKYWW,* no. 5, 1982, pl. 4.5.) This same compact ground motif, also found on bronze vessels, is a leading characteristic of what Karlgren has termed the Huai style. (*BMFEA,* no. 13, 1941.)

Figure A

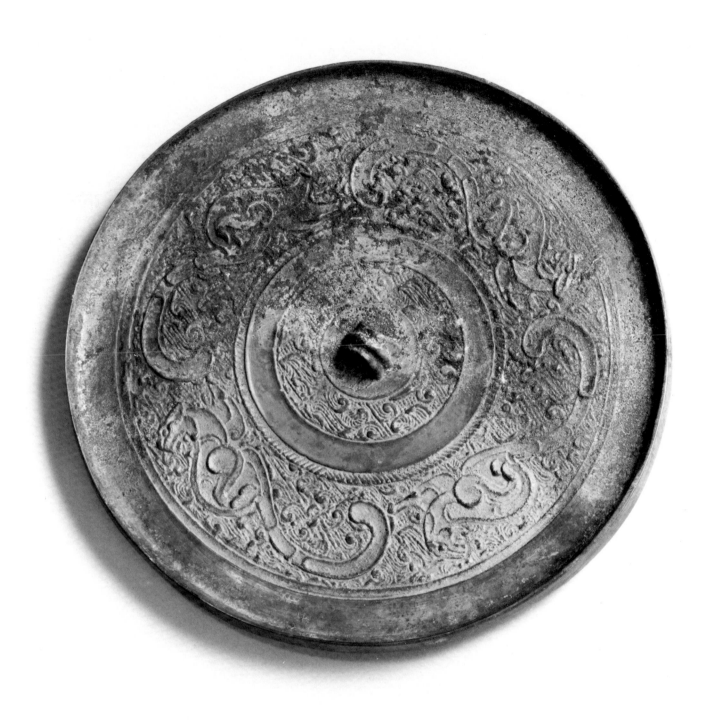

Plate 45

DRAGON AND TIGER MIRROR *(SHUANG LUNG HU JING)*
Eastern Han dynasty, 1st–2nd century A.D.
Bronze
Diameter, 7⅝ in. (19.3 cm.)
60.48

A chain of small beads surrounds the smooth hemispherical central knob. Four long-necked animals separated by encircled nipples stride along the outside ring. Three animals are shown in direct profile heading counterclockwise, and one tiger strides clockwise with its head rendered in a delightful three-quarter view. All have their necks turned back with their heads over their rear haunches. Both pairs of animals are depicted with fur, and each dragon additionally has scales and a long horn atop its head. Two rings with geometric designs bring one to the edge of the mirror. The surface color is black with spots of yellowish green patina.

Published: Umihara Sueji, *Selected Ancient Mirrors Found at Shaoh[s]ing Tombs,* Kyoto, 1939, pl. 57.

This rare and well-cast mirror from Shaoxing, Zhejiang, is typical of a style popular during the Han dynasty. The more common examples include the Daoist (Taoist) figures of the "Queen Mother of the West" (*Xiwang mu*) and her counterpart, the "Duke of the East" (*Dongwang gong*). The later mirrors that were to include the standard directional symbolism, involving four different animals, developed from ethereal and animated prototypes such as this.

Plate 46
SPIRIT-MOUNTAIN MIRROR (*LINGSHAN JING*)
Sui dynasty, A.D. 581–618
Bronze
Diameter, 7¼ in. (18.4 cm.)
60.15

The central knob is placed on the back of a flattened animal enclosed in a grooved square like a pelt. Four different long-tailed animals, softly modeled with powerful curvilinear forms, stride gracefully on the encircling band. They alternate in their clockwise and counterclockwise orientation. Across from the corners of the central square, within a grooved, right-angled corner, is an ogre face biting the enclosing ring. One opposing pair is in profile and the other pair is presented frontally. Outside these raised rings are a band with an inscription and two other abstract bands. The inscribed poem speaks to the past, present, and future of the mirror:

> [From] Spirit-mountain, pregnant with
> precious [metals];
> [Refined while] an immortal envoy watched the
> furnace;
> Shaped round like the daybreak moon,
> [Its] brilliance is pure like the evening pearl.
> [Women of] the Jade Terrace are rare in the
> world;
> [With] rouge powdered [faces], they should be
> pictured.
> [May] a thousand beguilers assemble in this
> reflection,
> And a hundred blessings come quickly.

The mirror surface has corroded to a silver gray with bright green spots.

Not previously published.

In the collection of the Field Museum, Chicago, there is a mirror of similar construction with the same inscription, but a different main body of design that consists of six animals in roundels. (Fig. A: Umihara, *Selected Relics*, vol. 5, 1933, pl. 118.) In the Sui dynasty tomb of Tien Deyuan, excavated in 1954 in Xi'an, a mirror was found near the head that is similar in character to our example. (Fig. B: *WW*, no. 8, 1957, p. 65.) Other examples with varying degrees of similarity have been found in Sui and early Tang tombs. (*WW*, no. 2, 1956, p. 44; *WW*, no. 8, 1959, p. 23; *KKHP*, no. 4, 1959; and *WW*, no. 7, 1979, p. 54.) A nearly identical mirror (D.: 18.7 cm.) is in the Kuboso Collection. (*Far Eastern Antiquities from the Kuboso Collection*, Tokyo, 1982, no. 176.)

Figure A

Figure B

142

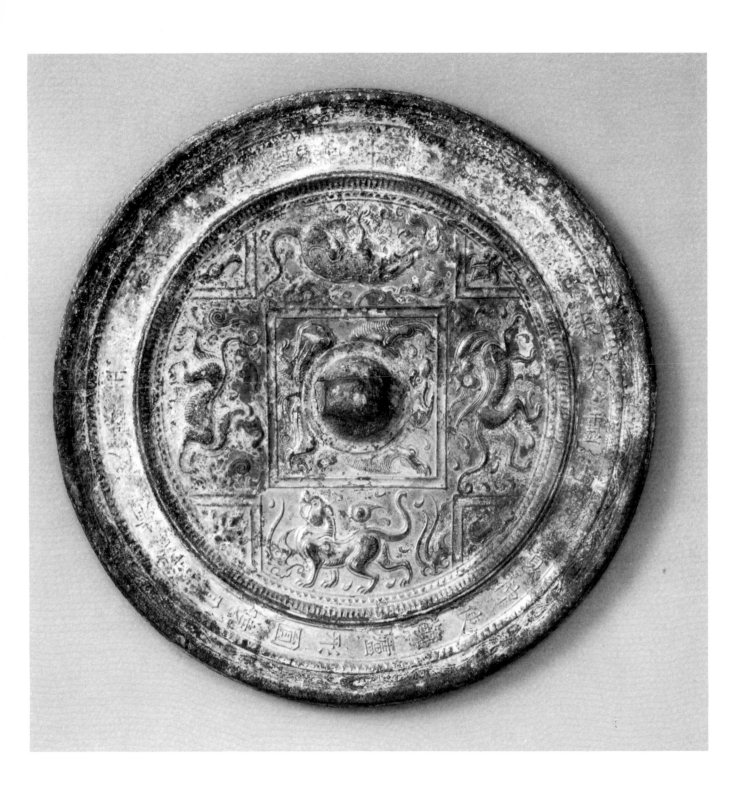

Plate 47
PHOENIX MIRROR
 (SHUANGLUAN XIAN SHOUDAI JING)
Tang dynasty, late 7th to 8th century
Bronze
Diameter, 7 in. (17.8 cm.)
60.14

On a smooth central field a pair of phoenixes with bowed ribbons in their mouths stand on a flower spray facing each other across the knob. Above and below the knob fly two long-tailed birds (parrots?), one with a tied cord and one with a blossoming branch. Outside the encircling ridge and alternating under the eight rounded lobes of the periphery are small insects and flower buds. The surface is basically black with some spots of grayish green.

Not previously published

This handsome mirror is a fine example of those that have decor symbolic of conjugal happiness. The close similarities to examples excavated from a major center of production during the Tang, Yangzhou, as well as its heavy weight and high quality of workmanship, suggest that this example also came from that region of Jiangsu. (*WW,* no. 7, 1979, pp. 53ff.)

Plate 48
LION AND GRAPEVINE MIRROR
 (HAISHOU PUTAO JING)
Tang dynasty, late 7th to 8th century
Bronze
Diameter, 6¾ in. (17.2 cm.)
48.16

Rosettes fill the thin outer band of this well-cast mirror, which is thematically divided by a circular ridge under the restless grapevine. Birds (orioles?), alternate with the grape clusters in the outer band, and the center is populated with seven furry beasts, one of which serves as the central knob. The curving vine is actually constrained to a closed, looped Y-shaped unit that adds an element of order to an otherwise rather free-flowing design. The elegant, silver gray coloring of this mirror is marred only by small areas with brownish black corrosion.

Not previously published.

This type of mirror was one of the most popular produced during the middle of the Tang dynasty. They have often been found in the environs of the capital, Changan (present day Xi'an), and have also been found in Japanese tombs and ceilings of Buddhist temples. (*WWTKTL*, no. 8, 1956; *KK*, no. 5, 1972, p. 62; and *Museum*, no. 349 May 1980, p. 30.) Some have argued that their popularity was caused by the importation of grapes and grape wine through central Asia to the great metropolitan center of the capital around the mid-seventh century, yet it should be noted that the animal and grapevine motif has been found on a Western Han dynasty petticoat from Xinjiang. (Fig. A: *WW*, no. 6, 1960, p. 12, and no. 7, 1962, p. 67 fig. 4.)

The probable area of manufacture for these mirrors is Yangzhou, which was famous during the Sui and Tang for its mirrors. In fact, the largest mirror found in this area north of Nanjing has a lion and grapevine motif and measures 22.2 cm.in diameter. (Fig. B: *WW*, no. 7, 1979, pp. 53–58, fig. 10.)

Figure A

Figure B

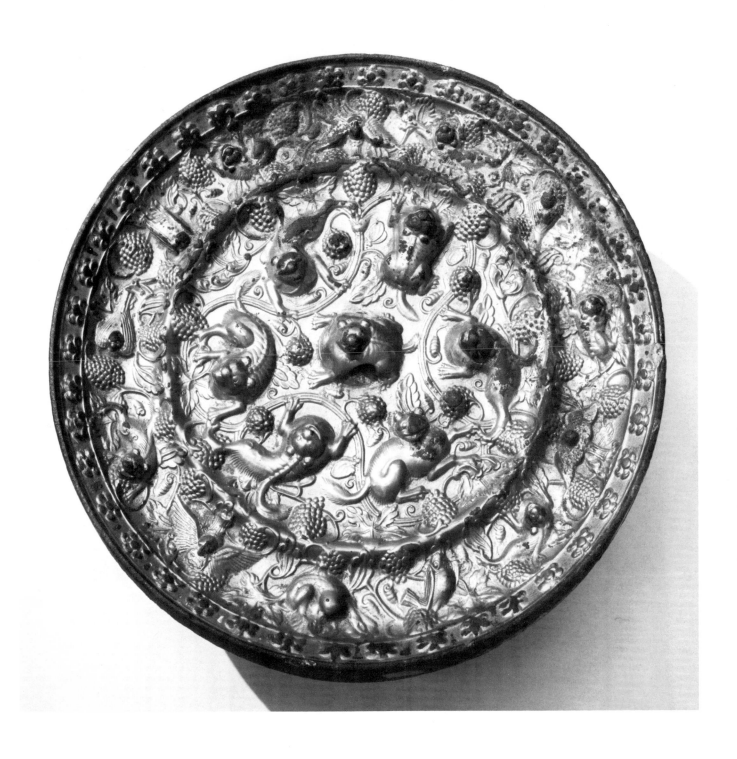

Plate 49
PAINTED BOWL
Western to Eastern Han dynasty
Copper/bronze with dark paint
Height, 3 in. (7.6 cm.); diameter, 6¼ in. (16 cm.)
60.139

On opposite sides of the smooth, thin bowl are two *taotie* bosses with ring handles. Below the rim are two narrow bands. The upper band has a red line that zigzags between the borders and green dots joined to the vertexes that are reminiscent of a floral pattern. Below this band is a band of green dots between red lines. The main body of design below these bands was executed with lively, fluctuating brush strokes. Three animals moving from right to left are depicted among a pattern of swirling ribbon/scarf-like lines. The frontward-facing, running deer and backward-looking dog (fox?) are each outlined with sinuous red lines and have one broad green stroke along their backs. The third animal, with its head lowered, is covered with green dots suggestive of a jackal or leopard.

Not previously published.

The provenance of this style of bowl has been recently re-examined by Diane Nelson in her thorough article on a group of similarly painted bronzes made for funerary purposes. She identified two groups and distinguishes the significant properties of the group to which our bowl belongs (group A) as including "color dominated by red and green, the repeated use of certain ornamental motifs (such as bands of circlets), the integration of pictorial and abstract imagery." (*Artibus Asiae*, XLII, 2/3, 1980, p. 130.) She showed that this group was probably produced around the first century B.C. to first century A.D. in the Shaanxi-Shanxi area, as opposed to the traditional attribution to the more southern region of Changsha. (Ibid., p. 148.)

Plate 49, Details

Plate 50
SILVER BOWL (*JINHUA YINWAN*)
Tang dynasty, 8th century
Silver with gold
Height, 2½ in. (6.4 cm.); diameter, 9 in. (23 cm.)
60.73

The interior bottom of the silver bowl contains a chased design in gold of a stylized, quartered floral motif against a ring background. A clockwise-slanting petal motif surrounds the center and handsomely contrasts with the reversed motif, also in gold, around the everted rim. Several distinctive features of the floral panels on the exterior contrast with the interior. The exterior flowers lack the rigid symmetry and ring ground of the interior, and the leaf veins emanate from the lobed edges rather than from the center. Five small, double panels separate the five larger sprays. There is no design around the slightly flaring foot. The thin bowl is composed of two shells joined over a thin core at the outside, under the rim.

Published: Henry Trubner, *The Arts of the T'ang Dynasty*, Los Angeles, 1957, cat. no. 335; Bo Gyllensvard, *BMFEA*, no. 29, 1957, fig. 96: d and o (line drawing only).

Gold and silver were used by the Chinese as early as the Shang dynasty, but only for decoration and for ornaments. It is not until the middle of the fifth century B.C. that we can identify vessels made of this precious material. (Specifically, around 433 as based on the finds from Suixian, Hubei. See *WW*, No. 7, 1979, pp. 1ff, esp. p. 12, fig. 13; *Zhongguo Wenwu* [Chinese cultural relics], no. 2, 1980, p. 23.) Based on the weight of past finds, it appears that the craft of the gold- and silversmiths may have first developed in the Chu culture of southern China. (*KKYWW*, no. 1, 1980, pp. 115ff.) Vessels from this early period are very scarce, both in archaeological finds and in literary records, and it is not until the Western Han dynasty that we can find proof of their popularity; and more important, motivation for manufacturing and using food vessels from the precious metals of gold and silver. The alchemist Li Shaojun told the Han Emperor Wu Di (140–86 B.C.) that

> A shrine at the stove will summon the super-
> natural, and with the supernatural summoned,
> then cinnabar can be transformed to yellow gold.
> With yellow gold perfected and used in vessels
> for food and drink, then years will be added to
> your life.

This belief in the enduring benefits of using gold was reiterated by various Daoists, and coupled with the preciousness and obvious beauty of the metal, its popularity was to be assured among the aristocracy of later times.

The Lilly bowl was probably once accompanied by a lid that could be inverted to function as another dish. It can stylistically and technically be joined with several other

Figure A

large bowls that all have gilt floral panels, everted rims, and flaring footrings. (Fig. A: *Wen-hua ta ko-ming ch'i-chien ch'u-t'u wen-wu,* Peiking, vol. 1, 1973, p. 45.) Gyllensvard, who has studied this subject extensively, noted in reference to similar bowls that, "This ornamentation undoubtedly represents the end of the T'ang style within this field of patterns, before we come to the more naturalistic motifs from the Five Dynasties and Sung." (Op. cit., p. 189.)

Though the bowls were once considered products of the Middle Tang (755–820), we are forced to reappraise their dating because of their similarity to items with naturalistic motifs in the bountiful cache of 270 beautiful gold and silver objects excavated in 1970 from Hejiacun outside Xi'an and datable prior to 756, the middle of the eighth century. (Fontein and Wu, *Unearthing China's Past*, 1973, p. 176.) Some scholars believe that they may all be products of a single shop in the Tang capital (Watson, *The Genius of China*, 1973, no. 310); while Schafer, a specialist in Tang culture, notes the best wares of precious metal came from Sichuan. (Chang, K. C., *Food in Chinese Culture*, New Haven, 1979, p. 125.) Gyllensvard's relative ordering of bowls like the Lilly example still seems applicable; and our example, appearing to be somewhat transitional in nature, should be placed near the end of this particular Tang tradition, perhaps nearer the turn of the eighth century.

home remedies even doctors use

THE NEXT TIME YOU'RE SICK, YOU MIGHT be able to avoid a trip to the doctor's office by simply pulling something out of the refrigerator. Or the kitchen cabinet. Or even the spice rack. More and more studies are finding that certain foods, spices and other household staples provide effective relief from common health problems. In fact, many physicians, concerned about the overuse of antibiotics and the trend toward treatment overkill for even minor medical problems, are recommending these simple cures. And patients are more than willing to give them a try, considering today's soaring medical costs and shrinking insurance coverage.

To scout out the latest, soundest and most useful home remedies, we talked to top medical practitioners and researchers, including some setters of the self-care trend. The treatments here are more than just folklore—all of them come from doctors with decades of experience and many even boast the kind of scientific credentials usually reserved for prescription medicines. And while we've tried to bypass the overexposed—we're sure you've already heard plenty about both aloe vera and chicken soup—all are likely to be in your house already (no obscure teas or seaweed). So try one out the next time you or your kids are hit with an everyday illness or injury—and if it will make the treatment feel more legit, bill yourself 80 bucks. But keep in mind that, just like prescription medicines, treatments involving natural substances *can* cause side effects. If you experience any unusual reactions to the therapy, discontinue it immediately.

Yogurt beats yeast infections. A new study found that women prone to chronic yeast infections had two-thirds fewer flare-ups when they ate 1 cup of yogurt each day. But the only yogurt

Do you think home remedies are flaky? Not according to doctors, who say some low-tech tactics can be effective—and safer than medicine.

By Catherine Clifford

Inspired by the magic of this Disney animated classic...
a Bradford Exchange recommendation

Welcoming the fair Snow White into their humble home, the Seven Dwarfs celebrate with a rousing dance. Now you can join the fun with a new limited-edition porcelain collector's plate inspired by this classic Disney film. "The Dance of Snow White and the Seven Dwarfs" plate is available now — and it looks like a smart buy. Here's why it's a Bradford Exchange recommendation:

"The Dance of Snow White and the Seven Dwarfs" plate is an important first issue, the first plate in the Snow White and the Seven Dwarfs plate series from Knowles China, an affiliate of the Bradford Exchange, and it celebrates the first feature-length animated film ever made.

It is an impressive work of art. Disney artists created the original art for this plate inspired by the animation from Walt Disney's classic film, *Snow White and the Seven Dwarfs.* Attesting to its importance, each plate is hand numbered and accompanied by a Certificate of Authenticity.

"The Dance of Snow White and the Seven Dwarfs" plate has the potential to appreciate in value because the edition is limited to a maximum of 150 firing days. Once the edition closes, collectors' demand could exceed the supply of plates and force asking prices up.

The Bradford Exchange . . . picking winners since 1973. World-wide, limited-edition plates are the *only* collectibles traded on an organized exchange. And with offices in the United States and twelve other countries, the Bradford Exchange is at the very heart of this exciting international market. That means Bradford analysts can often spot trends in the making.

If, for example, you had followed one of our major recommendations in 1988, you would have bought the "Bibbidi-Bobbidi-Boo" plate from the Cinderella series at $29.90 — a plate that last traded at $57.00.* More recently, if you had acquired the "Mary Poppins" plate from the Mary Poppins series, you would now own a plate that last traded at 151% of its 1989 issue price.

Like any marketplace subject to the laws of supply and demand, the plate market is constantly changing. Some exceptional plates appreciate in value; some plates go down, and many remain at or near issue price. But right now, Bradford Exchange analysts rate "The Dance of Snow White and the Seven Dwarfs" plate as one of the year's top prospects...and we'll back up your purchase with our 365-day guarantee.

To acquire this plate at its $29.90 issue price, simply fill out and mail the order form provided. *Send no money now.* You will be billed when your plate is shipped. But don't delay. The time to get "The Dance of Snow White and the Seven Dwarfs" plate is now, *before* it has a chance to increase in value.

*Reflects last trades on the exchange as cited in the Bradford Exchange Market Report, Vol. IV-2.

SWG-953

© 1992 BGE

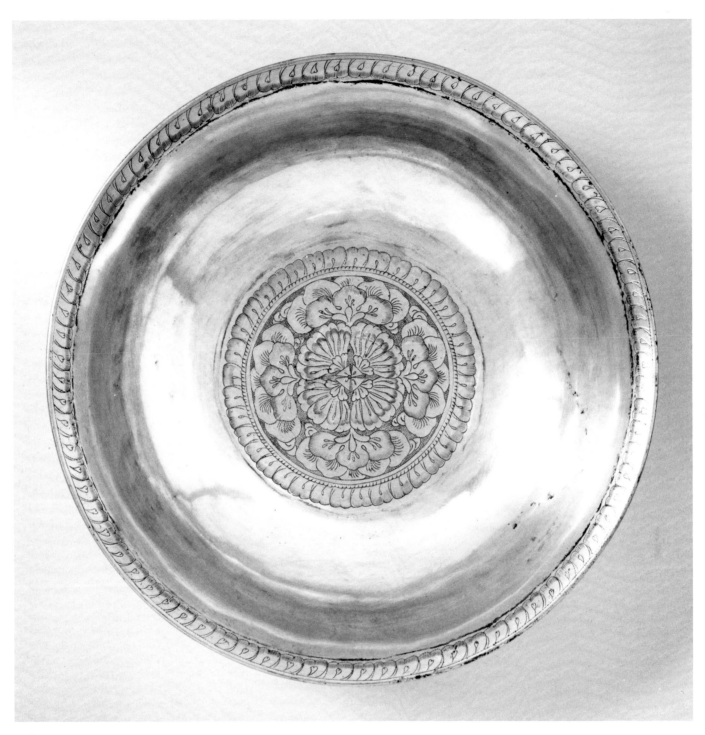

Plate 50, Detail

Plate 51
PITCHER
Tang dynasty style
Lead with engraved decor
Height, 12⅝ in. (32.0 cm.); weight, 11 lb 10.0 oz
60.143

This bulbous, heavy ewer is decorated with an ogival framed image on each side. In one, a phoenix with outstretched wings, a leafy branch in its beak, and a vine-like tail faces a chrysanthemum above stylized mountains. On the other side, an archer—on a horse at full gallop among clouds over mountains—has a bow drawn and aimed back toward a flying crane. Rivets secure the arching handle to the underside of the lip and to the middle of the body. The height to the top of the handle is 15¼ inches (38.7 cm.), and the body diameter is 7½ inches (19.0 cm.).

Published: Alan S. Hartman, *Arts of the T'ang Dynasty*, Indianapolis, 1973, cat. no. 78.

Figure A

Plate 51, Detail

The details of the decor of the vessel are as unusual as its dangerous material, which is quite impractical for use other than as a funerary item (*mingqi*). Some of the motifs on this pitcher of Sassanian/Persian form have relatives from the Tang to Song dynasties. (*BMFEA*, no. 29, 1959, figs. 23 and 571; also *WW*, no. 11, 1961, p. 52.) However, significant differences are apparent when it is compared to a similar object, in the Tenri collection, that has a snake handle. (Fig. A: *Chūgoku bijutsuten shiri-zu 3: Zu-Tō no bijutsu*, Osaka, 1976, p. 33, no. 2–38.) Some of the disturbing details should be noted. Among those in the hunting scene are excessively archaic trees on the mountain tops; a very stylized horse mane; the rider's disproportionately large head and small feet; no saddle; no arrow in the bow; and an unexpected concern with the complexity of forms as shown by the contorted necks of the cranes. The object of the hunt is also quite unusual. Land animals are usually the hunted; there are some rare examples of the hunting of birds—geese or smaller birds—but never such an honored motif as the crane, the symbol of longevity. Quite possibly the above deviations from what we might expect of the Tang craftsman can be explained by the low economic market for which the pitcher was obviously produced, and thus it should not be judged by our standards for the gold- or silversmiths.

Plate 52
BODHISATTVA *(PUSA)*
Sui dynasty or earlier
Gilt bronze
Height, 12½ in. (31.6 cm.); weight, 6 lb
60.47

Standing relaxed, the Bodhisattva sways slightly to its left, taking weight off its right foot. Holding a whisk in its right hand and a covered jar in its left, this compassionate deity has a rather candid air about it. The casting is of good quality, with all the fine details of jewelry and hair clearly articulated on both the front and the back. The subtly modeled facial planes and the gracefully arched eyebrows, executed in low relief, impart an enchanting, sublime expression to this sumptuously dressed deity. The jewelry may have once contained colorful inlay in the circular settings, and the two holes in the lower left hem suggest that the garment had an extension at one time. Pins behind the head and under the feet show that this fine statue was once enhanced by an aureole and a lotus pedestal.

Published: Yutaka Mino and Katherine Tsiang, *Apollo*, CVIII, 199, September 1978, p. 158, fig. 5.

Figure A

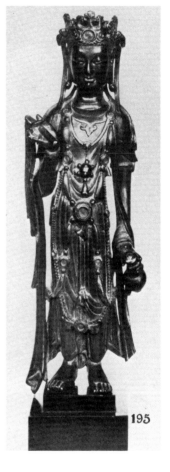

Figure B

Plate 52, Detail

Some features of this statue, such as the broad crown with its central beaded disk, side ribbons, and narrow band of hair; the low forehead; raised eyebrows joining at the nose; and the long neck, are all strikingly similar to a Bodhisattva at Yunmenshan, Shandong. (Fig. A: Siren, *A History of Early Chinese Art,* 1930, pl. 75.) Siren noted the stylistic traditionalism at this early Sui site, and in view of the similarities, it may be possible to posit a Shandong provenance for the Lilly statue, but a definitive attribution cannot yet be made.

A similar statue that has more openwork, a triple-bend pose, and an intact shawl was once in the C. T. Loo collection and is now in the Nelson Gallery-Atkins Museum, Kansas City. (Fig. B: Loo, *Chinese Arts,* 1941, cat. no. 195.) It has been recently discussed as an example of late Sui sculpture possibly from Gansu and representative of a northwest tradition. (Marylin Rhie, "Late Sui Buddhist Sculpture: A Chronology and Regional Analysis," *Archives of Asian Art,* 35, 1982, pp. 27–54, cf. p. 37 and fig. 36.)

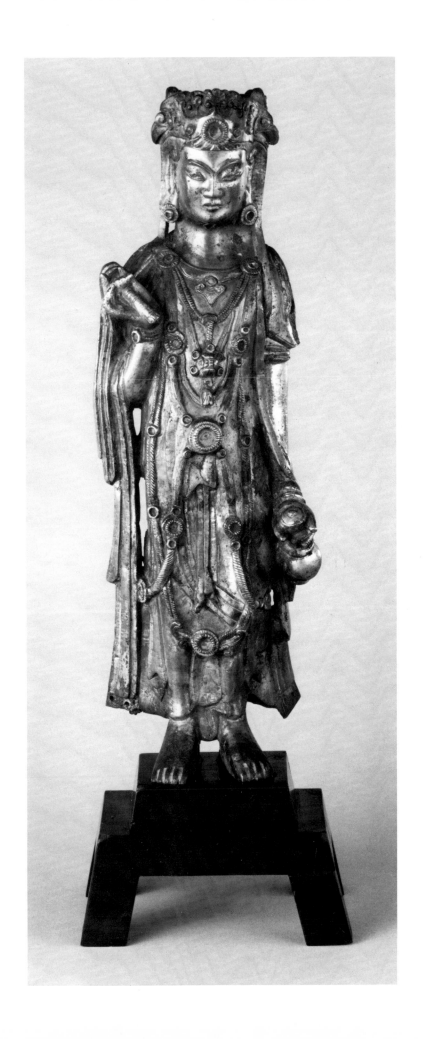

美与宁静

癸亥暮春 君石傅卲署

Ceramics

Plates 53–118

Plate 53
LARGE JAR
Neolithic period, ca. 2500 B.C.
Painted pottery, Banshan (Pan-shan)-type ware
Height, 16¼ in. (41.3 cm.);
 width, 25⁹⁄₁₆ inches (64.9 cm.)
60.144

The large, painted jar has a small, cylindrical neck and a nearly globular body, the lower half of which has nearly straight sides tapering to a small, flat base. Attached to the body at its widest part are two circular handles. At the mouth, directly above the handles, are two small, applied projections that might have served to help secure a cover, now lost. The reddish buff earthenware piece is shaped by hand and the surface, from the handles up, painted with black and purplish-brown pigments. Around the entire upper half of the body is a bold spiral pattern that winds and unwinds itself about four circles evenly spaced around the shoulder. The spiraling lines are painted in alternating black and purplish-brown bands executed with bold strokes of the brush. Along the edges of the black bands are small points forming a sawtooth pattern. A chain of circles linked by horizontal lines forms a lower border to the main motif, and a row of triangular waves and a band of cross-hatched lines decorate the neck.

Not previously published.

A very similar jar, in the Museum of Far Eastern Antiquities, Stockholm, was excavated from the Neolithic burial site at Banshan in Gansu province by the Swedish archeologist, J. G. Andersson. (Fig. A: Andersson, *BMFEA*, no. 15, 1943, pl. 82:1.) Andersson unearthed the first evidence of prehistoric remains in China with his discovery of the site of a Neolithic settlement at Yangshao village, Henan province, in 1921. He went on to find other Neolithic sites in Gansu province, northwestern China, among them the large burial ground at Banshan, which yielded many large, handsome jars, as well as smaller ones, with painted decoration. The most characteristic design on these jars is the striking, large spiral that covers the upper half of the body, as on the jar described here. Numerous examples are known; however, no two pieces are exactly the same in design. (See also *KKHP*, no. 2, 1980, pp. 221–238; and *KKHP*, no. 2, 1978, pp. 193–210, for reports of more recent excavations.)

Figure A

158

Plate 54
JAR
Neolithic Period, ca. 2000 B.C.
Painted pottery, Machang (Ma-ch'ang)-type
Height, 4 in. (10.2 cm)
48.120

The body is of depressed globular shape, the wide mouth
has a slightly everted rim, and the base is flat. Two semi-
circular handles are attached to the vessel, the upper ends
of the handles to the mouth rim and the lower ends to
the shoulder. The orangish buff earthenware is painted
with red and reddish-brown pigments. A diagonal key
fret pattern painted with four or five parallel lines covers
the greater part of the body below a wide, solid red band
around the shoulder. A band of vertical wavy lines encir-
cles the neck, and the handles are painted with horizontal
stripes. Below each handle is a rectangle divided by an X
into four triangles, each of which is marked with a single
dot. The inside of the mouth, too, is decorated—a light
wavy line reserved against the painted, reddish brown
ground.

Not previously published.

Very similar pieces acquired by J. G. Andersson in Gansu
province can be seen to be related to objects first exca-
vated at Machangyan, a site representing a rather later
Neolithic cultural phase in Gansu than the time of the
Banshan urn in Plate 53. (Figs. A and B: Andersson,
BMFEA, no. 15, 1943, pl. 114, upper left, and pl. 115,
center right.)

Figure A

K 5989 ¹/₃

Figure B

Plate 55
JAR
Neolithic period, ca. 2000 B.C.
Painted pottery, Machang (Ma-ch'ang)-type
Height, 2³⁄₁₆ in. (5.5 cm.)
48.121

The jar has a wide mouth with slightly everted rim, a
sloping shoulder, and nearly straight sides that taper
toward a small foot. Two semicircular handles are attached
to the upper part of the vessel, the upper ends to the
mouth rim, and the lower ends to the shoulder. The dec-
oration is painted on the orangish buff body in black and
reddish-brown pigments. On the mouth rim, both inner
and outer surfaces are decorated with rows of dots and
horizontal lines. Below, on the outside, is a band of dou-
ble, wavy lines. The remainder of the exterior surface is
left plain. The interior is painted with an anthropo-
morphic design in reddish brown bands outlined in black.
Four curving limbs branch off from a central trunk, the
two limbs at either end extending toward those at the
opposite end. The limbs terminate in trailing, finger, or
toe-like appendages.

Not previously published.

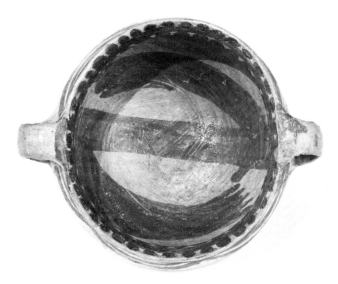

Plate 55, Detail

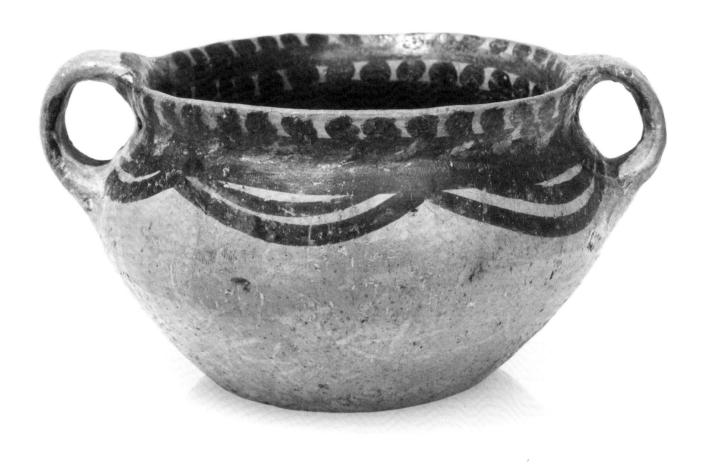

Plate 56
FEMALE FIGURE
Western Han dynasty
Painted earthenware
Height, 23¾ in. (65.4 cm.)
60.74

The slender lady stands with knees slightly bent. The arms, too, are slightly bent and the hands, now lost, were held in front of the body, perhaps carrying something. The wooden rods fitted into the sockets at the ends of the sleeves appear to be original. The figure has a rounded, delicately modeled face with small features and a pointed chin. She wears a full-length, kimono-like robe wrapped closely round her down to the knees, below which it flares outward at the sides. The back is cut flat, giving the figure an angularity otherwise lacking in its mainly cylindrical contours. The sleeves are long and full. The collar of an undergarment peeks out at the neck from inside the robe. An outer garment, a three-quarter-length coat, is worn on top, wrapped and tied below the waist. The hair is combed back and probably worn hanging down behind but is hidden inside the clothing. The figure is made of gray earthenware and covered with a white pigment. Dark reddish-brown borders are painted at the edges of the collar, sleeves, and hem of the coat and at the collar of the robe. The coat appears originally to have been a vermilion red, but only traces of the pigment remain. The hair and the lines of the brows and eyelids are painted in black and the mouth in red.

Not previously published.

A very similar figure, formerly in the collection of Mr. and Mrs. Eugene Bernat, has her hands hidden inside the large cuffs of her sleeves, which are pierced through to make a holder, perhaps for a staff or a large fan. It is reported to have been excavated near Taiyuanfu, Shanxi province, in 1937. (Fig. A: *Important Chinese Ceramics and Works of Art,* Catalogue of a sale held at Sotheby's, New York, Nov. 7, 1980, no. 19.) Closely related figures have been unearthed in more recent years. Two female figures dressed in similar fashion, their hands hidden in wide, double-layered cuffs, were found in Western Han tomb no. 4 at Yinqueshan, Linyixian, in Shandong province. (Fig. B: *KK,* no. 6, 1975, pl. IX:1–4.) On both figures, the hair is depicted as being rolled in a knot at the base of the neck. Another similar female figure, from a Western Han tomb at Hongqingcun, Changan (Xi'an), Shaanxi province, has her long hair hanging down her back and tied with a ribbon near the ends. (Fig. C: *KK,* no. 2, 1959, pl. V:1–3.) Her robe flares out more widely below the knee than those of the figures mentioned previously.

Figure A

Figure B

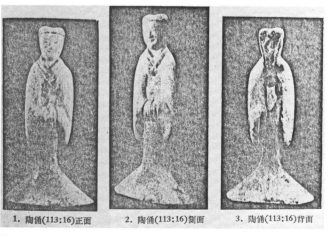

1. 陶俑(113:16)正面 2. 陶俑(113:16)侧面 3. 陶俑(113:16)背面

Figure C

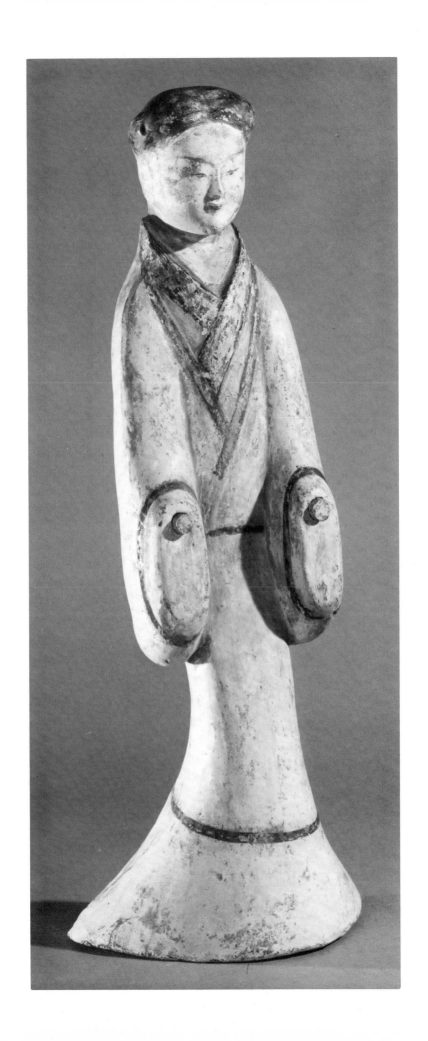

Plate 57
HU
Eastern Han dynasty
Lead-glazed earthenware
Height, 17¼ in. (43.8 cm.);
 diameter, 10¼ in. (26.0 cm.)
60.63

The body is pear-shaped with a long, slender neck that widens abruptly to a trumpet-shaped mouth. The high, foot-like lower portion is flat on the bottom. On the widest part of the body are two molded relief *taotie* masks and ring handles; the rings are attached to the body. The surface of the vessel is decorated with several narrow bands of repeating ornament, a band of vertical ribbing alternating with a row of small triangles. The vase is made of brick red earthenware and covered with a green lead glaze whose surface has taken on a whitish iridescence from long burial. Patches of earth still adhere in many places.

Not previously published.

This unusually shaped *hu* is an excellent example of Han lead-glazed pottery, well preserved and with a beautifully transformed glaze. A piece of nearly identical form was unearthed from an Eastern Han tomb at Liujiachu, Shanxian, in Henan province. (Fig. A: *KKHP*, no. 1, 1965, pl. XVI:1.)

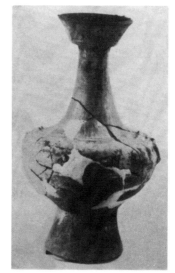

Figure A

166

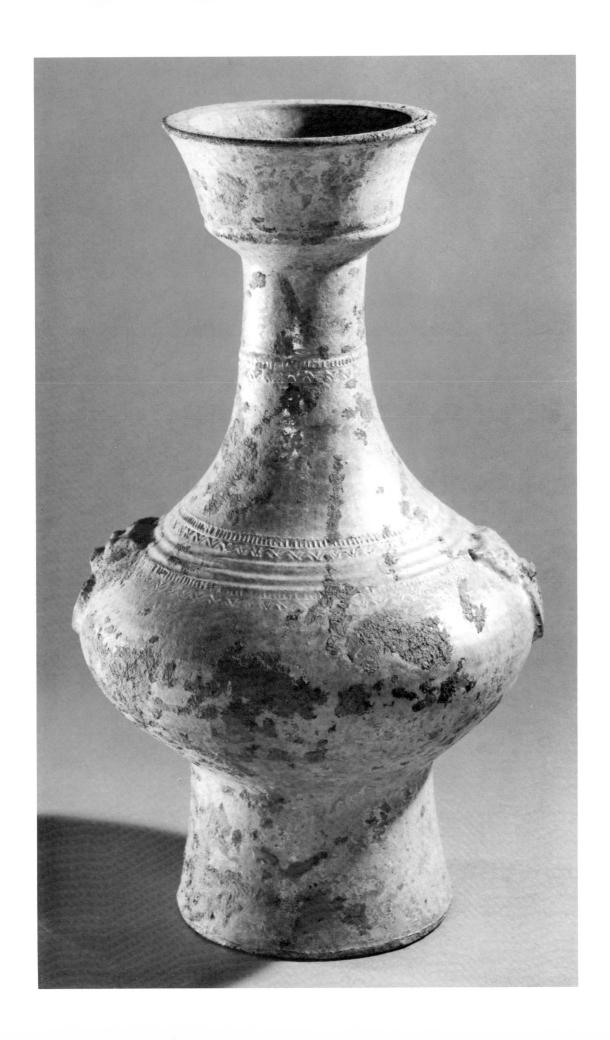

Plate 58
MODEL OF A WELL HEAD
Eastern Han dynasty, 2nd century A.D.
Gray earthenware
Height, 4⅝ in. (11.7 cm.); length, 9½ in. (21.6 cm.)
60.22

The pottery model is made in the form of a rectangular enclosure constructed of thick posts and railings of square section. The railings are molded with relief rectangles and lozenges, a decoration that might have been carved on the original well. The four walls, too, are decorated with molded relief designs: animals and a human figure between horizontal borders of cross-hatched lines, curvilinear patterns, and triangles. On one long side is the figure of a man walking with a banner on which is written the characters *miehuo*, "extinguish fire," that hangs from a pole slung over his shoulder. Behind him is a rooster. This scene is flanked by rectangular panels decorated with triple lozenges. At the far ends are the characters *miehuo* (as on the banner) on the right, and *dongjing*, "eastern well," on the left. On the opposite side of the well is a large ox, drinking at a trough, a rope attached to a ring through its nose. The beast is flanked on one side by a fish and on the other by a rectangular panel filled with curvilinear patterns. Another ox appears on one end of the well; it is also drinking from a trough and tied around the neck. At the other end are two lozenge patterns with a fish on either side. Small rectangular holes in the end railings could have held the pillars that support the beam for mounting a rope and pulley and a roof. The piece is made of unglazed gray earthenware that is encrusted with soil from burial.

Not previously published.

Ceramic models of houses, farmyards, stoves, and wells were frequently buried with the dead during the Han dynasty. They, like the human funerary figures (see Pl. 56), were made to accompany the deceased into the next life. Numerous models of wells sheltered by a roof, and showing a pulley mounted on a beam just under the roof, are known. One such piece, a rectangular well head with stamped ornament on the four walls, was found in tomb no. 83 at Shaogou, Luoyang, in Henan province. (*Loyang Shao-kou Han mu*, Peking, 1959, p. 128, fig. 60:1.) Ceramic well heads with molded ornament and notches in the railings for the roof supports, but having no roofs, were found at the same site. (Fig. A: Ibid., pl. XXXI.) Three well models are known that are nearly identical to the one in the Lilly Collection, none of which has any roof preserved. (See *Ryoneisho Hakubutsukan*, Tokyo, 1982, pls. 184 and 185; *Kandai Bijutsu*, Osaka, 1974, pl. 1:172; and *Tenri Sankokan Zuroku: China*, Osaka, 1967, pl. 148.) It seems possible that roofs were attached originally but made of less permanent materials that have long since deteriorated.

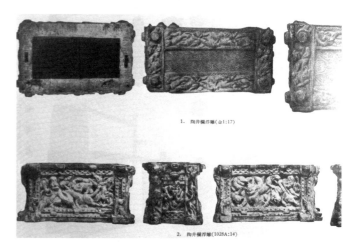

Figure A

168

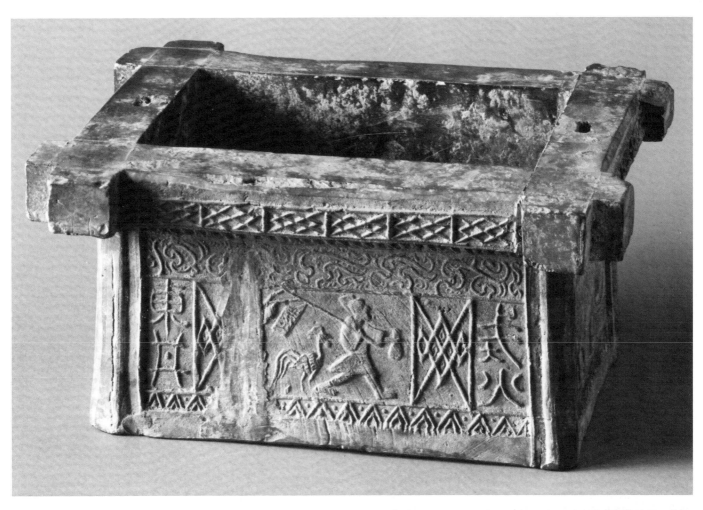

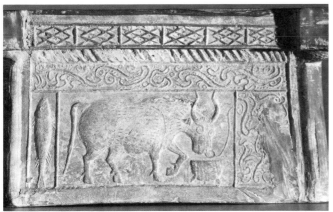

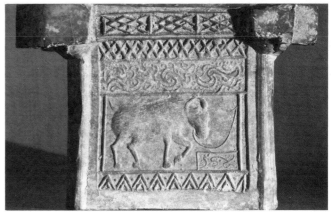

Plate 58, Details

Plate 59
CAMEL WITH RIDER
Tang dynasty, early 8th century
Gray earthenware
Height, 16 in. (40.6 cm.); length, 18½ in. (47.0 cm.)
60.26

A Bactrian camel is depicted in the process of rising from the ground at the urging of its rider. The animal's hind end is raised and its hind feet planted on the ground, but its front legs are still folded beneath it. Its neck is vertical and its head erect, eyes glaring and nostrils flaring. The rider is seated on a blanket between the two humps, his hands tightly clenched, pulling on what must have been a cord that was once threaded through the channels in his fists. He is dressed in foreign garb—a short coat, trousers, boots, and a peaked hat. The sensitivity and detail of the modeling of this figure indicate that it was probably not molded like most tomb figures, but sculpted by hand. It is solid and very heavy. The thick fur on the camel's head and neck, on the humps and the upper part of the legs, is rendered by scratching with a comb-like instrument. Traces of white pigment on the unglazed surface suggest that the figure was painted originally.

Not previously published.

This figure and the very closely related one that follows, Plate 60, are likely to have been made as a pair or part of a larger set of tomb figures. They are very rare and outstanding examples of the Tang sculptor's art. Camels made in a similar style have been excavated in the vicinity of Xi'an, formerly Changan, the capital of the Tang dynasty. Two examples were buried in the tomb of Dugu Sijing and his wife, the Lady Yuan. (Figs. A and B: *Tang Changan chengjiao Sui Tang mu*, Beijing, 1980, pls. LXX and LXXI.) The tomb is dated A.D. 709. One of the camels stands upright with its head thrown back, bellowing. Its rider wears a peaked cap of the same style as that of the figure on the Lilly camel. The other camel from this tomb is shown in the process of standing, its forelegs still bent in a kneeling position. The modeling of the head of each, with mouth open and protruding tongue curled upward, also closely resembles that of the piece under discussion. Two other camels of similar appearance were unearthed from a tomb dated 703. (*Shensi-sheng ch'u-t'u T'ang-yung hsüan-chi*, Peking, 1958, pls. 37–39.) Unlike the Lilly camel, all of the other excavated pieces are covered with lead glaze.

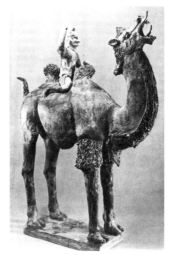

Figure A

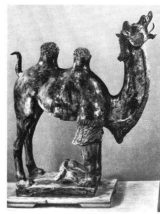

Figure B

170

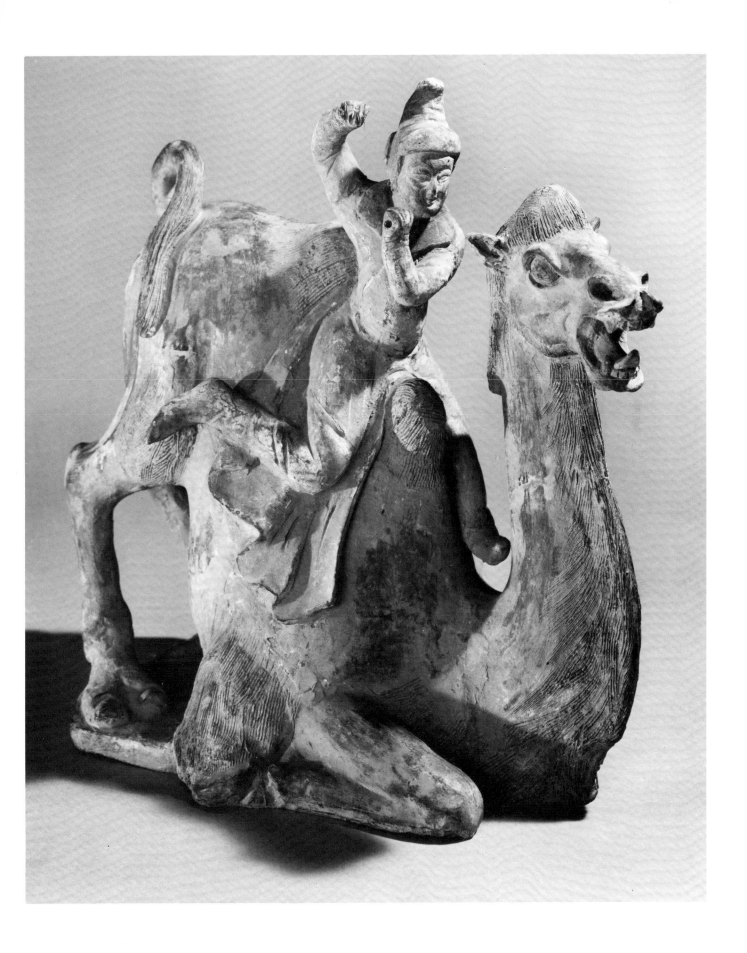

Plate 60
CAMEL WITH RIDER
Tang dynasty, early 8th century
Gray earthenware
Height, 15½ in. (39.4 cm.); length 17½ in. (44.4 cm.)
60.27

See Plate 59. The rider is dressed in much the same style as the one on the camel in the preceding plate but has a full beard and wears no hat on his balding head. His hair falls loose at shoulder length. His facial features, as well as his dress, hair style, and thick beard, are obviously those of a foreigner, a Caucasian. The man sits on an oval blanket that covers the entire back of the camel but allows the humps to protrude through two holes. The clay body of this figure is more brownish in color than that of the one in Plate 59, but is otherwise similar in all respects. It, too, has traces of white pigment on the surface but no glaze, and was probably painted originally.

Not previously published.

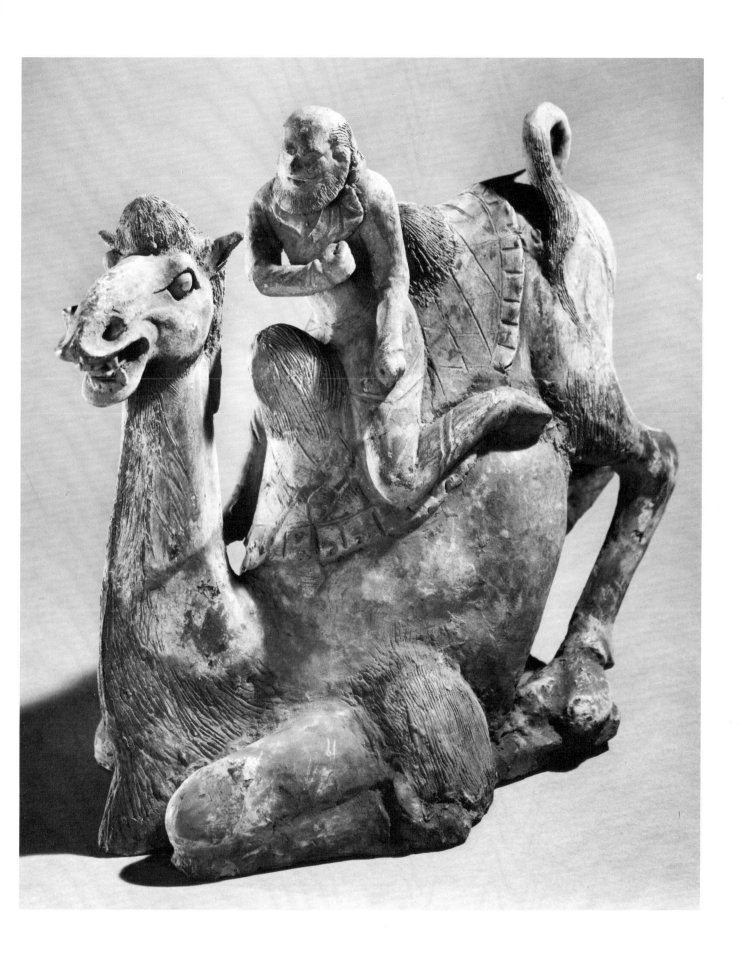

Plate 61
HORSE
Tang dynasty, 8th century
Lead-glazed earthenware
Height, 26 in. (66.0 cm.)
60.75

The horse stands alert, head turned slightly to one side, and fully saddled. Its sleek, muscular contours project a sense of great physical vitality, and its proudly arching neck, bulging eyes, and open mouth express its high spirits. The horse is lovingly groomed and ornamented, its flowing mane neatly combed and its tail bound. Colorful, jewel-like fittings are attached to the bridle and hung from straps running across its chest and rump. Above the tail is a large floral medallion. Molded of buff-colored earthenware and coated with white slip, the body of the horse is covered with dark brown lead glaze down to the fetlocks. The saddle, bridle, and ornamental trappings are bright green and amber yellow. The face, feet, and mane are white. The hooves are set at the four corners of a flat, rectangular base. The hollow body is open at the bottom.

Published: Yutaka Mino, *Arts of Asia* XI, 2, March–April 1981, p. 105, fig. 2.

Very similar horses have been found in Tang tombs dated to the early part of the eighth century. One was unearthed from the tomb of Prince Yide in Quianxian, Shaanxi province. (Fig. A: *WW*, no. 7, 1972, pl. 9:3.) The tomb is dated A.D. 706. Others were excavated in Xi'an, also Shaanxi province, from the tomb of Xianyu Tinghui, a high official who was buried in 723. (Figs. B and C: *Tang Changan chengjiao Sui Tan mu*, Beijing, 1980, color pls. 3 and 4.) Such horses were obviously highly prized by their owners. Aside from being conspicuously expensive and beautiful mounts, fine horses were an important basis of military power and much celebrated in Chinese history and legend. Horsemanship was considered a privilege of the ruling classes and was prohibited to artisans and tradesmen by an imperial edict in A.D. 667. (Edward H. Schafer, *The Golden Peaches of Samarkand*, Los Angeles, 1963, p. 59.) The taller, fleeter central Asian and Arabian strains were considered especially desirable and were associated with the divine steeds of ancient mythology. (Ibid.) During the early Tang period the extension of the borders of the empire farther westward than at any previous time in history ensured the supply of horses for the state. It also opened up the empire to extensive foreign contacts and a bustling foreign trade. The lavish style of ornamentation of the imported horses appears to be of foreign origin as well, probably deriving from the customs of nomadic, hunting, and herding cultures to whom the horse was the chief means of livelihood. For example, the white tufts on the chest band of the pottery horse under discussion appear to be made of animal hair, and perhaps originated as trophies of the hunt. An actual

Figure A

Figure B

Figure C

Figure D

Figure E

Figure F

horse found buried and preserved, frozen, in the tomb of its owner was fitted with an elaborately decorated blanket, saddle, bridle, and straps running across the chest and rump. The tomb is believed to be from about 300 B.C. (Fig. D: *Sekai Bunkashi Taikei*, vol. 13, Tokyo, Kadokawa-shoten, 1961, pp. 101–103.) Gilt bronze ornaments including relief, floral plaques, and pendants made for a horse were unearthed from the tomb of the young Princess Yongtai (Yung-t'ai), who was buried in A.D. 706 in Liangshan, Qianxian, Shaanxi province. (Figs. E and F: *WW*, no. 1, 1964, p. 22, figs. 27 and 28.)

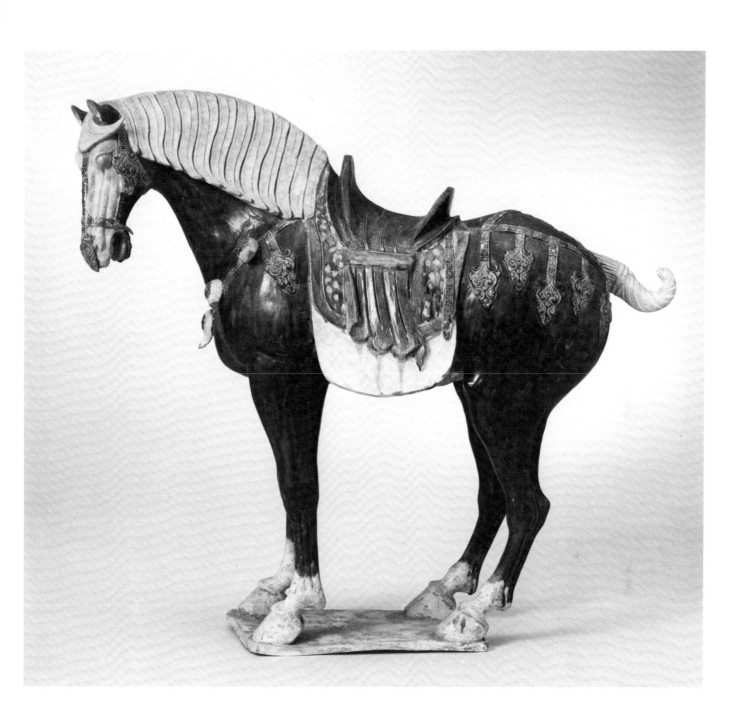

Plate 62
FIGURE OF A GROOM
Tang dynasty, 8th century
Lead-glazed earthenware
Height, 25½ in. (64.8 cm.)
60.76

The male figure stands erect, his brow furrowed, his mouth open as though shouting a command, and his arms tensed. The torso twists slightly to the right and the hands are tightly clenched, grasping the reins of a horse or camel. The figure is dressed in a knee-length coat with open neck and wide lapels. It is wrapped, fastened at the right side, and belted at the waist. The wrinkled sleeves have been pushed up on the forearms. Held back by a band encircling the forehead, the hair is cropped just above shoulder-length. The tall, thickly padded boots are set on a nearly rectangular, flat base. The buff-colored earthenware is coated with white slip, and the coat is glazed. The figure is predominantly amber brown with very pale green coat lapels. The edge of an undergarment, visible at the neck, is dark green. A wide streak of glaze has run down from the coat onto the right foot. The hair, eyes, mustache, and a few whiskers on the chin are painted black, and the mouth is painted red.

Published: Yutaka Mino, *Arts of Asia*, XI, 2, March–April 1981, p. 105, fig. 2.

The figure is that of a foreigner, one of the many seen in China during the Tang dynasty associated with the caravans of traders, foreign envoys, and other travelers. The dress is of central Asian type, probably from Western Turkestan. A similar style of dress is represented in the wall painting of donors from the Buddhist Cave Temple of the Sixteen Sword Bearers in Qizil. (Fig. A: Mario Bussagli, *Painting of Central Asia*, Geneva, 1963, p. 80.) The figures in the painting are more richly attired, with floral borders and embroidery on their coats, but the basic cut is the same: knee-length, belted at the waist, and with wide lapels. They also wear boots, though more tightly fitted, and their heads are bare. A pottery figure of a groom of the same foreign type, dressed in the same style as the Lilly groom but not as finely modeled, recently appeared at auction. (Catalogue of a sale held at Sotheby's, London, on June 15, 1982, no. 179.)

Figure A

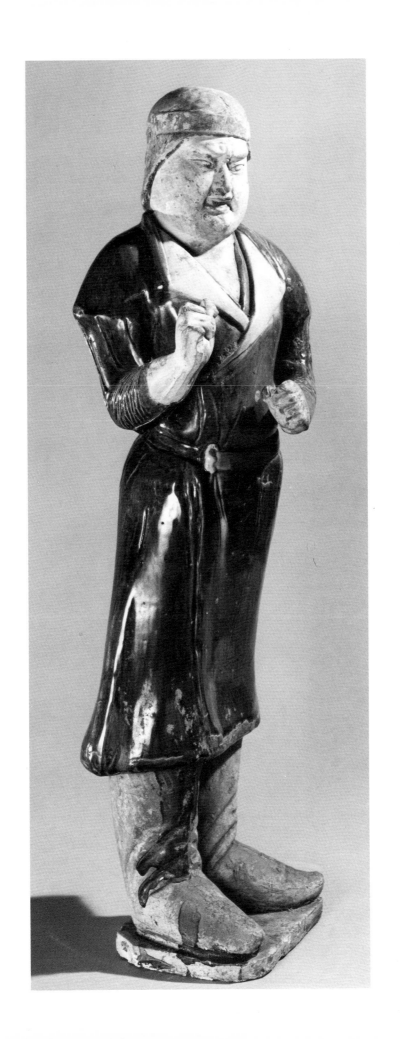

Plate 63
PAIR OF FEMALE FIGURES
Tang dynasty, 8th century
Lead-glazed earthenware
Height, 14¼ in. (36.8 cm.)
60.28
Height, 14½ in. (36.9 cm.)
60.29

Two slender, elegantly dressed ladies stand in identical poses, each with her hands clasped in front of her and hidden in the folds of a long scarf. The two figures are very similar in every respect, though not made from the same mold, as shown by the difference in the ends of the scarves that drape over their hands. Each lady has a rounded, delicately modeled face with small features. Each has her hair pulled up on top of her head and covered with a headdress that comes to a peak a little to the right of center and is tied on the left. Each wears a long dress with long, narrow sleeves. A small, short-sleeved jacket with a wide shawl-like collar is worn on top of the dress, and a long scarf is draped over the shoulders and arms and wrapped around the hands. The long, lobed toes of the formal court shoes curl upward from beneath the skirt. The buff earthenware is covered with white slip and streaked yellow, green, and colorless lead glaze. The dresses are mostly yellow on the upper part, and green below. The jackets are predominantly white but have a streak of yellow, on the right shoulder, that runs down the front. The shoes are bright yellow. The glaze on the lower portion of the figures has partly deteriorated and turned iridescent from burial. The heads are unglazed but the hair, eyes, brows, and finely detailed pattern on a cloth tied around the hair are painted in black. The mouth is red. Unfortunately, much of the painting has worn off.

Not previously published.

Ladies dressed and coiffed in exactly the same manner can be seen in the wall paintings and stone engravings in the tomb of Princess Yongtai, who died in 701 at the age of seventeen and whose tomb at Liangshan, Qianxian, in Shaanxi province, was completed in A.D. 706. (Fig. A: *WW*, no. 1, 1964, pp. 31–33, figs. 61–65, and pl. VI:1.) The exceptionally fine quality of these two figures would seem to indicate that they also came from the tomb of a person of considerable rank.

Figure A

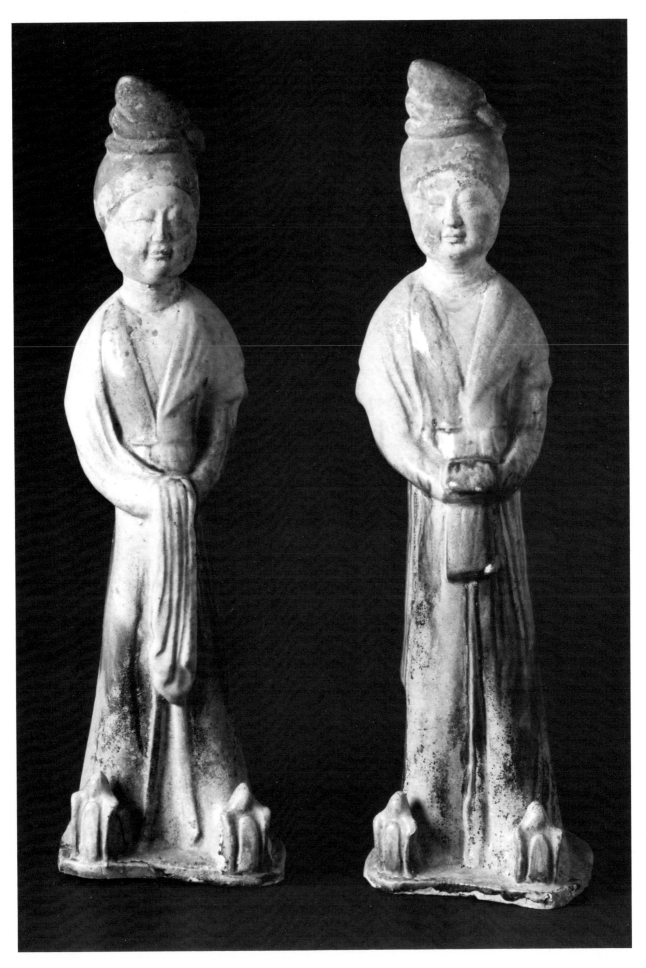

Plate 64
JAR
Tang dynasty, 8th century
Lead-glazed earthenware
Height, 7¾ in. (19.7 cm.); diameter, 7¾ in. (19.7 cm.)
60.30

The nearly globular jar has a swelling, wide shoulder and everted mouth rim. The lower half of the body tapers toward a flaring foot. The base is flat. The buff earthenware is covered with white slip and deep-green, amber-yellow, and colorless lead glaze. The glaze stops unevenly in numerous rounded-edged drips about two-thirds of the way down the body. The inside is unglazed.

Published: Yutaka Mino, *Arts of Asia*, XI, 2, March–April 1981, p. 104, fig. 1.

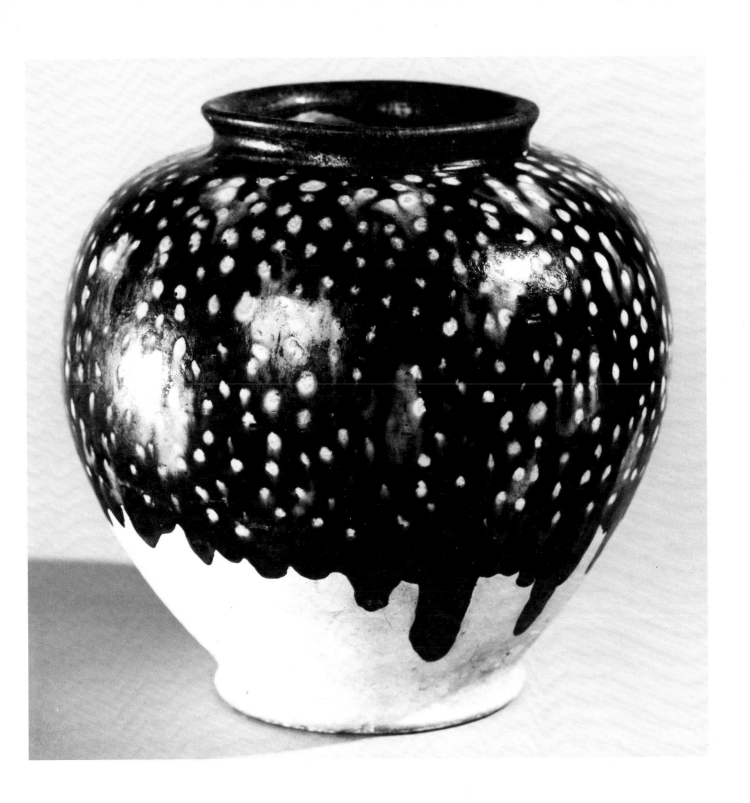

Plate 65
FOOTED DISH
Tang dynasty, 8th century
Lead-glazed earthenware
Diameter, 7½ in. (19.0 cm.)
60.49

The circular dish has a low, everted rim and a flat base supported on three small, round feet. A linear floral pattern is stamped on the flat inner surface, a lotus flower in the center with trefoil shoots, and the large lotus leaves radiate outward from a circle around it. The buff-colored earthenware has a coating of white slip over which the various parts of the decoration are filled in with bright-green, blue, and amber-yellow pigments. The whole is covered with a clear lead glaze. The indented lines of the stamped pattern served to keep the colors from running together during firing.

Not previously published.

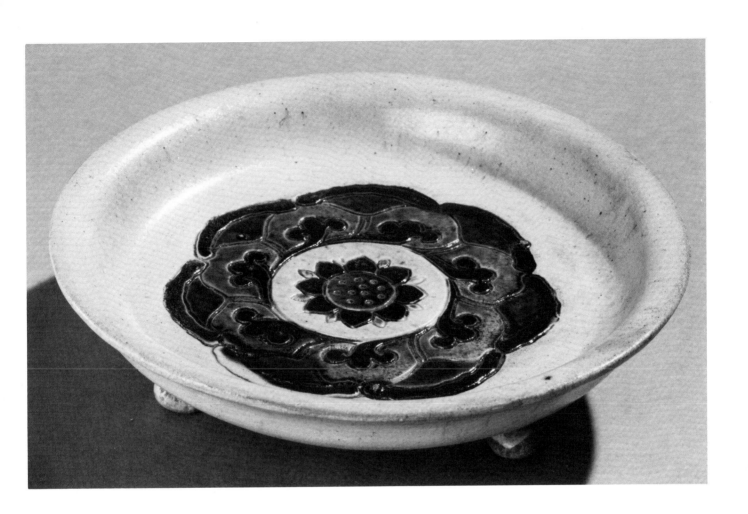

Plate 66
DISH
Liao dynasty, late 11th century
Stoneware with lead glaze
Height, 2⅛ in. (5.4 cm.); diameter, 7⅞ in. (20.0 cm.)
60.157

The dish has gently curving sides, a low, slightly flared foot, and a recessed, convex base. The buff stoneware is covered with white slip and amber yellow glaze that is speckled with black impurities. The glaze stops unevenly one inch above the foot. There are three spur marks on the interior near the center.

Published: Yutaka Mino, *Ceramics in the Liao Dynasty*, New York, 1973, pl. 21.

The Liao dynasty was founded by the Khitan, a nomadic, pre-Mongolian people who, in the period from A.D. 907 to 1124, were able to expand their influence throughout all of Manchuria and the northernmost part of China proper. The Liao dynasty lasted only two hundred years, but it was one of the most outstanding periods in Manchuria's cultural history. Many works of art attest to its vitality. The rather coarse-looking three-color lead-glazed ware of the Liao reflects tastes relatively unaffected by the refinements of Chinese urban civilization. Liao pottery is appealing for its own distinct traits and imperfection and gives an impression of directness and spontaneity. Lead-glazed dishes similar to this one were found in Liao tombs no. II and IV at Xiaolinzhangzi, Ningchengxian, Zhaowudameng. (*WW*, no. 9, 1961, p. 46.)

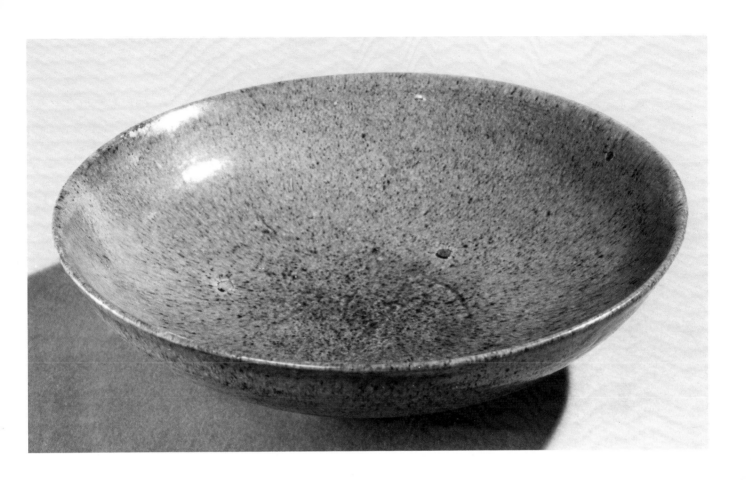

Plate 67
VASE
Northern Song dynasty, late 10th or early 11th century
Cizhou (Tz'u-chou)-type ware
Height, 17¹⁄₁₆ in. (43.2 cm.)
47.153

The tall vase has an elongated, ovoid body, flattened, angular shoulder, long neck, and widely dished mouth with a nearly vertical rim. The foot is flared and the base recessed and flat. The gray stoneware is covered with white slip and decorated with large peony scrolls deeply carved in two horizontal bands, a wide band around the body, and a narrower one on the shoulder. Below the peony scroll band, on the lower part of the body, is a narrow belt of finely incised scrolls and, around the base, a row of upright, overlapping lotus petals.

Published: Ch'en Wan-li, *Sung-tai pei-fang min-chien tz'uech'i*, Peking, 1955, pl. 19; Wilbur Peat, *Chinese Ceramics of the Sung Dynasty*, Indianapolis, n.d., p. 13, pl. 23; Yutaka Mino and Katherine Tsiang, *Apollo*, CVIII, 199, 1978, p. 158, pl. 6; and Yutaka Mino, *Freedom of Clay and Brush*, Indianapolis, 1980, pl. 9.

Cizhou (Tz'u-chou)-type wares are a large body of popular ceramic wares manufactured in northern China from the early Song dynasty onward. Their production at numerous kilns—approximately twenty-one kiln sites have been found thus far—was centered around the Northern Song capital at Kaifeng in Henan province. The chief identifying feature of Cizhou-type wares is the application of a white slip over the clay vessel. This strikingly large and handsome vase belongs to a group of Cizhou wares distinguished by its crisply designed, deeply carved decoration, which is cut through the white slip into the clay beneath. It probably was made at kilns in Dengfengxian, Henan. A fragment of a piece with a similar carved peony design was unearthed at the Quheyao kiln site in Dengfengxian. (Fig. A: *WW*, no. 3, 1964, p. 53, fig. 12:4.)

Figure A

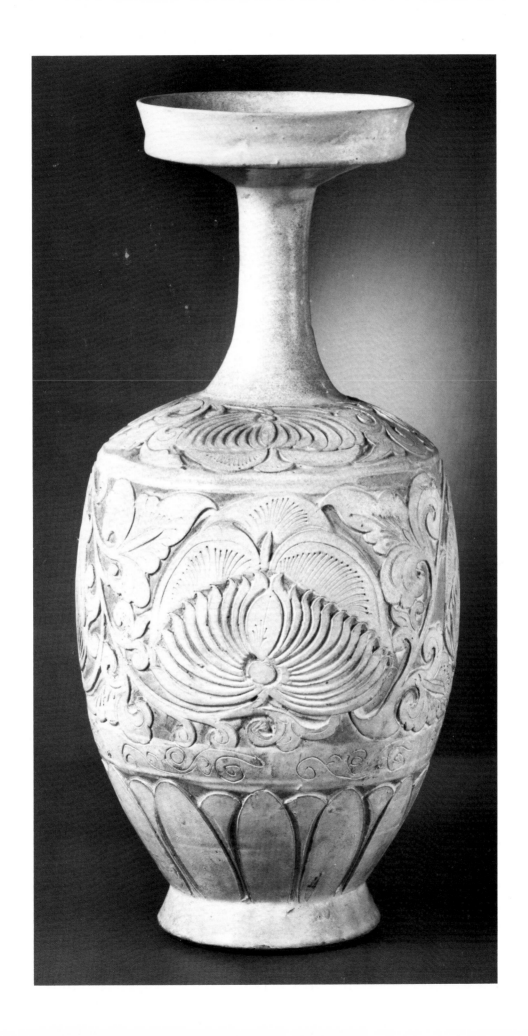

Plate 68
MEIPING
Northern Song dynasty, late 11th or early 12th century
Cizhou (Tz'u-chou)-type ware
Height, 12¾ in. (32.4 cm.)
47.149

The tall vase has an elongated ovoid body with wide, rounded shoulder and small neck. The mouth rim is everted and flattened, the base recessed and flat. The gray stoneware is covered with white slip and transparent glaze. Crackles in the glaze are stained an iron rust color from burial. The piece has no decoration.

Published: Wilbur Peat, *Chinese Ceramics of the Sung Dynasty,* Indianapolis, n.d., p. 8, pl. 11; Yutaka Mino, *Freedom of Clay and Brush,* Indianapolis, 1980, pl. 4.

A plain white *meiping* with a long neck but otherwise similar shape is in the Bristol City Art Gallery (reg. no. 2444). Both examples have the rust-colored stain that is a distinctive feature of ceramics found at Juluxian, the Song dwelling site destroyed by floods in 1108. The finds from this site provide important evidence for the dating of these and a group of other Cizhou wares to the late eleventh and early twelfth centuries.

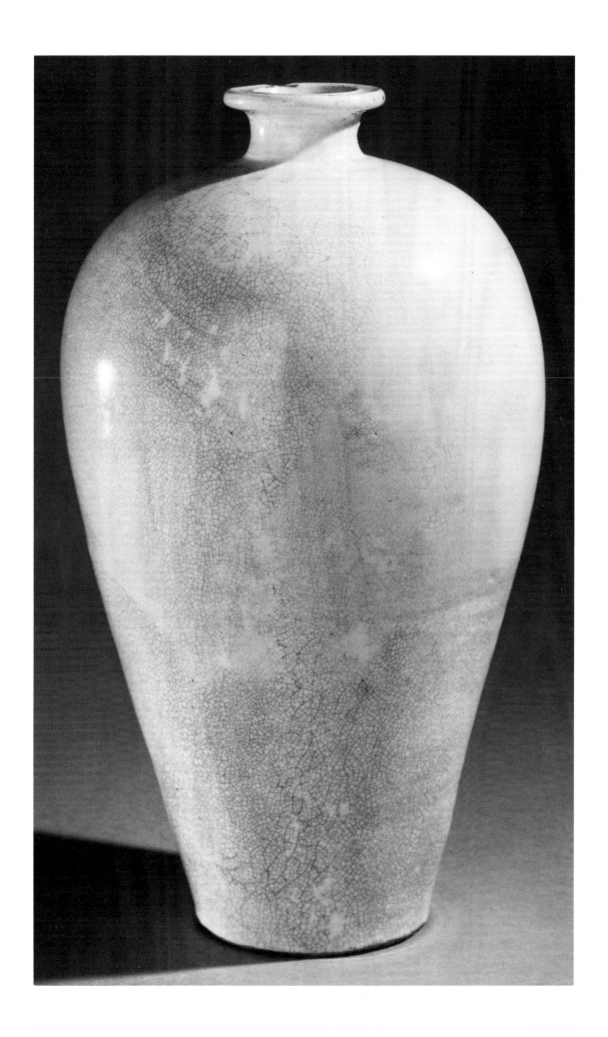

189

Plate 69
VASE
Jin dynasty, 12th century
Cizhou (Tz'u-chou)-type ware
Height, 13¼ in. (33.6 cm.)
48.117

The vase has three pronounced sections: a nearly globular body, a long neck with a widely everted mouth and undulating rim, and a high, flaring foot. A rather thick, raised ridge encircles the top of the foot. The base is small and deeply recessed. The buff stoneware is covered with white slip and transparent colorless glaze under the green lead glaze. The lead glaze, originally a bright, clear green, has become partially opaque and has an iridescent sheen.

Published: Henry Trubner, *Chinese Ceramics*, Los Angeles, 1952, pl. 79; Trubner, *The Arts of the T'ang Dynasty*, Los Angeles, 1957, pl. 183; Yutaka Mino, *Freedom of Clay and Brush*, Indianapolis, 1980, pl. 96.

A nearly identical piece is in the Cleveland Museum of Art. (Jennifer Neils, ed., *The World of Ceramics*, 1982, pl. 117.) A very similar vase with amber yellow glaze was unearthed from a tomb believed to be of the Song period at Zhaogoucun near Taiyuan in Shanxi province. (*KK*, no. 1, 1965, p. 26, pl. 7:8.)

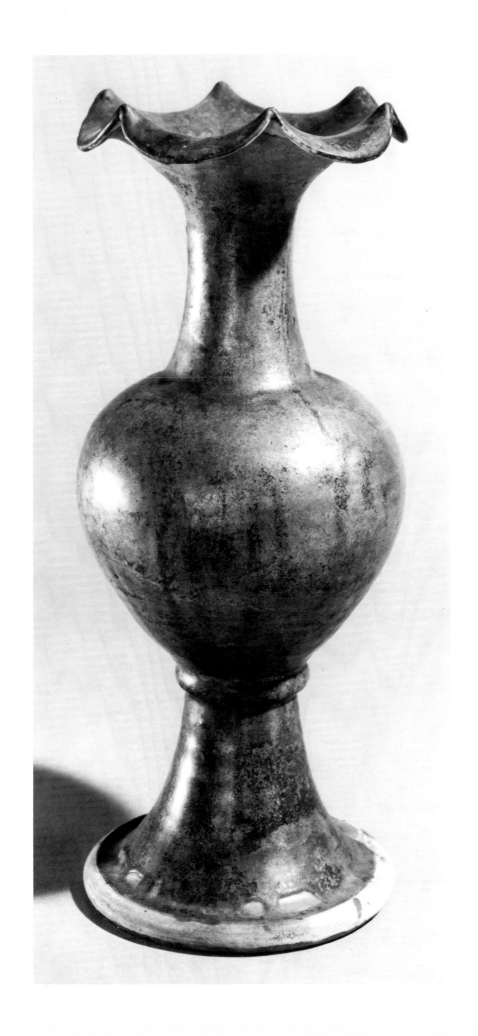

Plate 70
BOTTLE
Jin dynasty, late 12th to early 13th centuries
Cizhou (Tz'u-chou)-type ware
Height, 12 in. (30.4 cm.)
48.118

The pear-shaped bottle has a long, slender neck widening at the top to an everted mouth rim. The foot is low and flared, the base recessed and flat. The brick red stoneware piece is covered with white slip and decorated with an incised design of lotuses in a wide band around the body. The tops of the lotus petals are painted with reddish brown pigment, and the leaves are green. Above that is a band of upright overlapping petals in green, yellow, and white, and around the neck are two narrow, horizontal bands of yellow on a green ground. The entire piece is covered with a transparent lead glaze.

Published: Yutaka Mino, *Freedom of Clay and Brush*, Indianapolis, 1980, pl. 101.

This bottle belongs to a sub-group of the Cizhou-type wares with three-color lead glaze that has incised decoration painted with brown or black accents. A nearly identical decoration of lotuses and upright petals appears on a bottle in the Cincinnati Art Museum. (Mino, *Freedom of Clay and Brush*, 1980, fig. 297.) Another similar piece is in the Freer Gallery of Art. (*Oriental Ceramics: The World's Great Collections*, vol. 9, Tokyo, 1976, fig. 31.) Bottles of this shape, with narrow body and everted mouth rim, were excavated in Datong, Shanxi province, from the tomb of Yan Deyuan, which is dated A.D. 1189. (Fig. A: *WW*, no. 4, 1978, p. 11, fig. 35. See, also, Mino, op. cit., fig. 200.)

Figure A

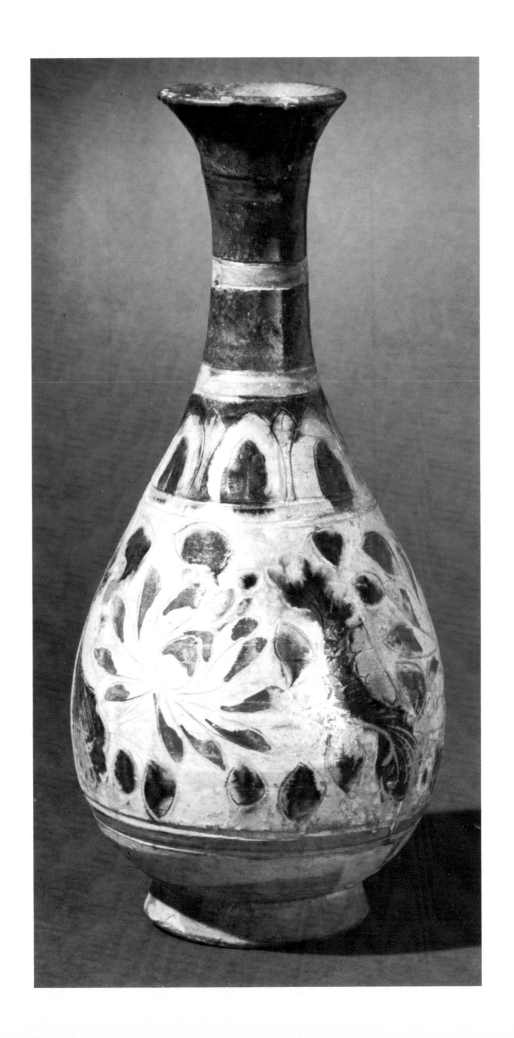

Plate 71
MEIPING
Jin dynasty, late 12th to early 13th centuries
Cizhou (Tz'u-chou)-type ware
Height, 12½ in. (31.7 cm.)
47.151

The tall vase has an elongated ovoid body, rounded shoulder, small neck, and conical mouth. The base is recessed and flat. The buff stoneware is covered with white slip and transparent glaze. Several large peony sprays are painted on the slip under the glaze, effectively filling the surface with ornament. The mouth has been repaired.

Published: Wilbur Peat, *Chinese Ceramics of the Sung Dynasty,* Indianapolis, n.d., p. 13, pl. 21; Ch'en Wan-li, *Sung-tai pei-fang min-chien tz'u-ch'i,* Peking, 1955, pl. 25; and Yutaka Mino, *Freedom of Clay and Brush,* Indianapolis, 1980, pl. 71.

Objects with underglaze decoration painted on the white slip in black or brown pigment make up one of the major groups of Cizhou-type wares. Among these are large numbers of *meiping* that were produced at various kilns for use as wine bottles from the twelfth through the fourteenth centuries. The *meiping* under discussion was believed by Ch'en Wan-li to have originated in Shanxi province, but archaeological evidence supporting this theory has yet to be found. (Ch'en, *Sung-tai pei-fang min-chien tz'u-ch'i,* 1955, pl. 24.)

Plate 72
FIVE-SPOUTED VASE
Northern Song dynasty,
 late 10th or early 11th century
Yue (Yüeh) ware
Height, 11¼ in. (28.6 cm.)
47.152

The tall, ovoid body has a rounded shoulder on which are five, evenly spaced six-sided spouts. The spouts are narrower at the top and are slightly curved so that the openings are directed upward. The straight-sided neck narrows toward the mouth rim. The foot flares outward in two steps. The base is recessed and flat. Two large tree peony sprays are lightly incised on opposite sides of the vase. The large flower, the curving leaves around it, and the thick stem are loosely drawn with fine lines. The petals and leaves are filled in lightly hatched lines. The grayish-white porcelaneous stoneware is covered down to the bottom of the foot with a rather thin, pale bluish-green glaze that has a tendency to streak. The uneven quality of the glaze gives an illusion of depth to the incised decoration so that the peony sprays appear to stand out in relief from the surface of the vessel. The marks of seven small, rectangular kiln supports are visible on the foot rim.

Not previously published.

Comparison with closely related vases shows that this piece is, unfortunately, missing its cover. An example without incised floral sprays on the body but divided into vertical sections by five relief bands is in the Kikusui Kogeikan, Kawanishi-cho, Japan. It has a domed cover that fits over the neck of the vase. The top of the cover is carved with overlapping petals that give it the appearance of an inverted flower. (Fig. A: *Sekai Toji Zenshu*, vol. 12, 1977, pl. 172.) Another five-spouted vase, in the Tokyo National Museum, also capped by a domed lid carved with overlapping petals, has an overlapping petal design incised on the body as well. (Fig. B: Ibid., pl. 173.) It is interesting to note that peony sprays resembling those on the Lilly vase can be seen on Liao ceramics that are probably closely contemporary with it. A Liao pilgrim bottle in the Royal Ontario Museum, Toronto, has two large incised peony sprays, one on either flattened side. The flowers are drawn in a remarkably similar fashion, with four-lobed petals, each enclosing a tiny teardrop, around a small central circle. These are surrounded by large-lobed petals. (Fig. C: Mino, *Ceramics in the Liao Dynasty*, 1973, pl. 11.) A pilgrim bottle of the same shape as the Toronto bottle was found in the tomb of a member of the Liao royal family at Dayingzi, Chifengxian, Jilin province, a tomb that can be dated to the years immediately before and after A.D. 959. (*KKHP*, no. 3, 1956, pl. 7:5.)

Yue ware was produced at a number of kilns, mostly in present-day Zhejiang province, during the Tang and Five Dynasties period, when it came to be recognized as the finest Chinese ceramic ware.

Figure A

Figure B

Figure C

Figure D

Figure E

In the Five Dynasties period, when Zhejiang was part of the state of Wu-Yue, Yue ware was designated for official use by the king. When, in A.D. 978, Qianshu, the king of Wu-Yue, surrendered to the Song emperor, Taizong, Yue ware was at a peak in the history of its manufacture. In that year many objects were made especially in commemoration of the event and sent as tribute to the Northern Song court. These were to have a profound influence on the development of northern ceramic wares, such as Yaozhou (Yao-chou) and Ding (Ting), in the early years of the Song dynasty. The manufacture of Yue ware continued well into the Song period, as demonstrated by a vase in the Percival David Foundation, London, and another in the Yamato Bunkakan, both dated the third year of Yüan-feng, or A.D. 1081. (Figs. D and E: Koyama, *Seiji*, vol. 36 of *Sekai Toji Taikei*, Tokyo, 1978, p. 101, figs. 28 and 29.)

Although the ware is said to have declined in quality and importance after 978, examples such as the Lilly vase show that considerably high standards were maintained for a time before the visibly inferior products of 1081 were made.

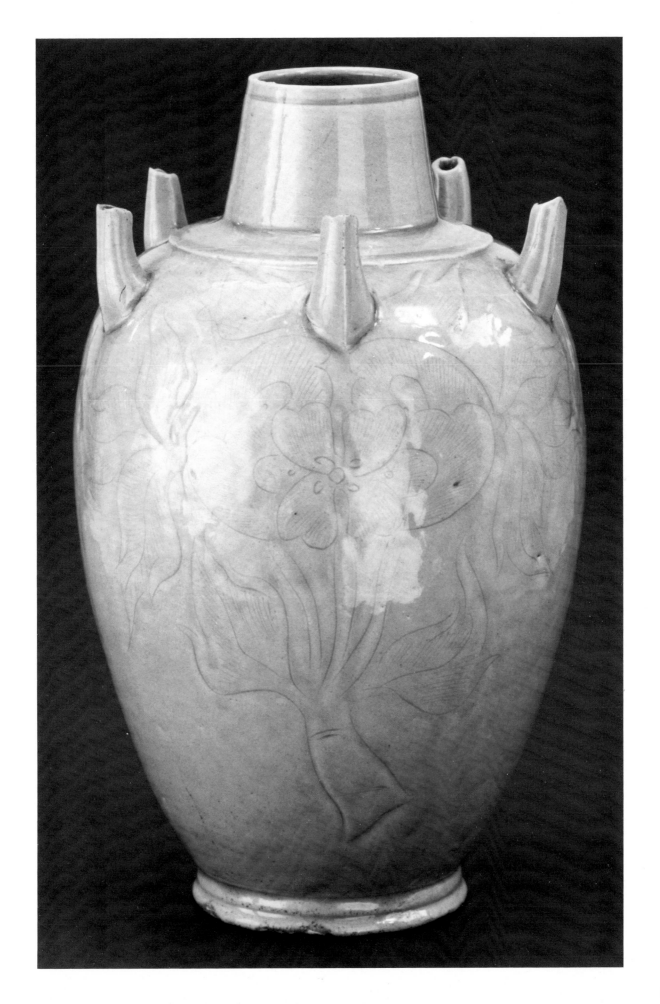

Plate 73
VASE
Northern Song dynasty, early to middle 11th century
Yue (Yüeh) ware
Height, 13¼ in. (33.6 cm.); diameter, 4⅛ in. (10.5 cm.)
60.145

The body is an elongated ovoid with a flattened shoulder, flaring foot, and recessed, flat base. The long, slender, fluted neck widens at the top to form a dished mouth with nearly vertical rim. Two small, plaque-like handles, each molded in the shape of a phoenix in flight, are attached by short posts to the base of the neck. The lower part of the phoenix is attached to the shoulder. The body is carved with relief, overlapping petals that have finely incised veins at either side of a raised central rib. The pale-gray porcelaneous stoneware is covered with olive gray glaze down to the bottom of the foot. The foot rim bears the traces of seven kiln supports.

Published: Henry Trubner, *The Arts of the T'ang Dynasty*, Los Angeles, 1957, pl. 250; Warren Cox, *The Book of Pottery and Porcelain*, vol. 1, rev. ed., New York, 1970, p. 122, fig. 267 (formerly in the Nasli Heeramaneck collection).

The same distinctive type of handle can be seen on fragments of two ewers excavated from the Yue ware kiln site at Shangyu, Zhejiang. (Fig. A: Hughes-Stanton and Kerr, *Kiln Sites of Ancient China*, London, 1980, nos. 67 and 69.) Carved, overlapping petals with raised central ribs and finely incised veins also appear on a fragment, that of a bowl, from the same site. (Ibid., no. 66.)

Figure A

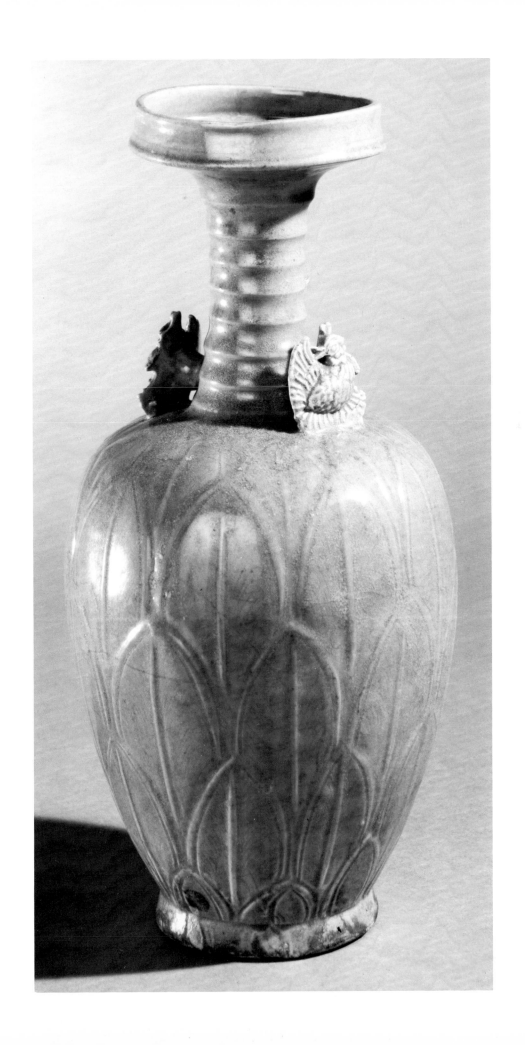

Plate 74
MEIPING
Northern Song dynasty, ca. A.D. 1100
Yaozhou (Yao-chou) ware
Height, 18½ in. (47.0 cm.)
47.135

The tall vase has a greatly elongated ovoid body, rounded shoulder, small neck, and flattened, everted mouth rim. The base is recessed and flat. Boldly carved peony scrolls decorate approximately two-thirds of the surface of the vase, starting on the shoulder. A row of lobed petals is delicately drawn with finely incised and combed lines around the base of the neck. Around the bottom is a wider band of upright, oval petals that is incised in a much more spontaneous manner.

Published: Wilbur Peat, *Chinese Ceramics of the Sung Dynasty*, Indianapolis, n.d., pl. 1; Henry Trubner, *Chinese Ceramics*, Los Angeles, 1952, pl. 174; Yutaka Mino and Katherine Tsiang, *Apollo*, CVIII, 199, September 1978, pp. 158–160, fig. 7; and Yutaka Mino, *Arts of Asia*, XI, March–April 1981, p. 106, fig. 5.

Yaozhou in Tongchuanxian, Shaanxi province, was an important center of the ceramics industry during the Northern Song period and is chiefly known for its production of fine celadon ware with carved decoration. Among the finds at the Yaozhou kiln site were fragments of bowls, jars, ewers, and lamps. (*Shensi T'ung-ch'uan Yao-chou-yao*, Peking, 1965.) *Meiping* of Yaozhou ware are rare. The striking example in the Lilly Collection is one of three known. Another, in the Shanghai Museum in China, has an even more attenuated form and wide horizontal bands of carved decoration covering the vase from neck to base. The third example was formerly in the collection of Oscar Raphael. (Fig. A: *Catalogue of the International Exhibition of Chinese Art*, London, 1935, no. 1338.) The Lilly piece has the most graceful shape of the three and a unique combination of carved and incised ornament.

Figure A

200

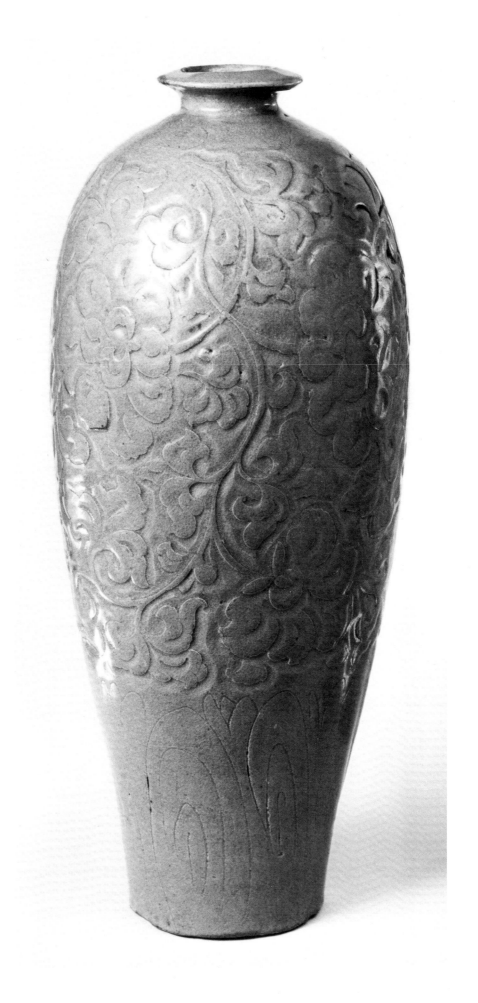

Plate 75
PAIR OF DISHES
Northern Song dynasty, early 12th century
Linru (Lin-ju) ware
Diameter, 6⅝ in. (16.8 cm.)
47.133 and 47.134

The dishes have angular sides, a low foot, and a recessed, flat base. The rim is divided into sections by six small, evenly spaced notches. The inside of each dish is decorated with a molded peony spray, a single large bloom surrounded by curling, three-pointed leaves. The spray is bordered by a leaf scroll band that encircles the central motif about one-half inch below the mouth rim. The exterior of the dishes is marked with incised vertical lines. The two dishes are so similar that one may assume they were both pressed over the same mold.

Published: Ch'en Wan-li, *Chung-kuo ch'-ing-tz'u shih-lüeh*, Shanghai, 1957, pl. 19; Wilbur Peat, *Chinese Ceramics of the Sung Dynasty*, Indianapolis, n.d.; p. 7, pls. 6 and 8; Jan Wirgin, *Sung Ceramic Designs, BMFEA*, 42, 1970, p. 5:k; and Yutaka Mino, *Arts of Asia*, XI, 2, March–April 1981, p. 107, fig. 6.

Fragments of dishes and bowls with similar molded peony flowers and leaves were found at numerous kiln sites in Linruxian, Henan province. (Figs. A and B: *WW*, 8, 1964, p. 17, figs. 5 and 6.) The kilns, established in the Northern Song dynasty in response to the demand for ceramics in the metropolitan area around the capital, mainly produced wares with molded or stamped ornament.

Figure A

Figure B

202

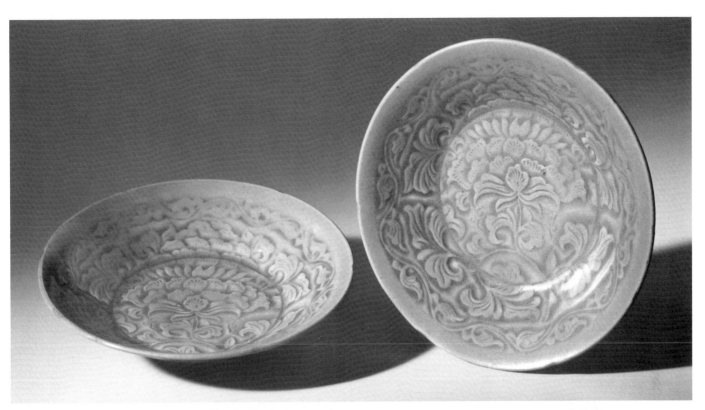

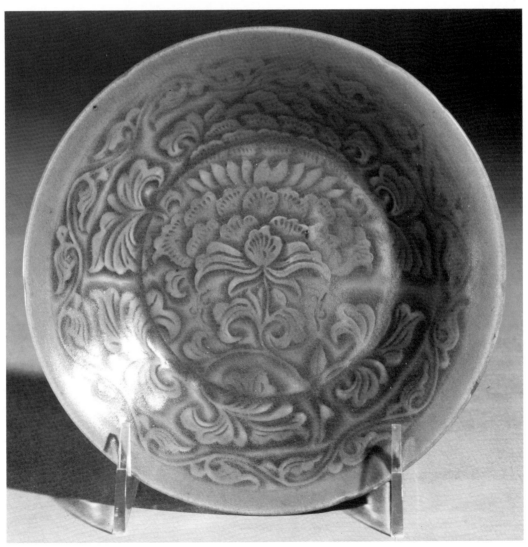

Plate 76
ZONG-SHAPED VASE
Southern Song dynasty, 13th century
Longquan (Lung-ch'üan) ware
Height, 16¼ in. (41.3 cm.)
47.154

The vase is made in the form of an ancient jade *zong*. The body is square in section, with four molded rectangular sides. The mouth and foot are cylindrical, the base recessed and flat. Raised horizontal ridges are molded along the edges of each side and extend around the corners to the adjacent sides, creating the effect of the notches at the corners of the original jade object. The pale-gray porcelaneous stoneware is covered with bluish green glaze that has a broad network of crackles. The color is darker where the glaze has collected in the recesses along the sides. The raised ridges and corners look whitish, in comparison, under the thinner coating of glaze.

Published: Wilbur Peat, *Chinese Ceramics of the Sung Dynasty,* Indianapolis, n.d., p. 7, pl. 5; Henry Trubner, *Chinese Ceramics,* Los Angeles, 1952, pl. 160; Yutaka Mino and Katherine Tsiang, *Apollo,* CVIII, 199, Sept. 1978, p. 160, pl. 8; and Yutaka Mino, *Arts of Asia,* XI, 2, March–April 1981, p. 110, fig. 13.

In the eyes of the Chinese, the achievement of fine celadon ware was all the more admirable because of the resemblance of the ceramic material to the precious stone jade. Chinese connoisseurs often drew comparisons between the subtle green coloring and translucency of celadon glazes and those characteristics of jade. This vase is, thus, a logical extension of the analogy, because it was made in the form of an ancient jade object. The *zong* is traditionally said to have been used in ceremonies worshipping the Earth. Although jade *zong* of this shape were for some time thought to be of the Zhou dynasty, they have in recent years been excavated in association with Neolithic remains (see Pl. 2). The Lilly vase is an unusually large example of this type. Other, smaller vases can be seen in the Brundage Collection, the Nelson Museum-Atkins Gallery of Art in Kansas City, the National Palace Museum in Taibei, and the Shanghai Museum.

Longquan, located in southern Zhejiang province, became an important center of celadon production in the Song dynasty and remained active into the Ming. During the Northern Song period, the Longquan people carried on in the tradition of Yue ware, producing ceramics with olive green glaze and, often, incised and carved decoration. The migration of the Song court to the south, which caused the decline of the northern celadon kilns, spurred the Longquan kilns to new heights. Under imperial patronage in the Southern Song period, the famous thick, sea green and bluish green glazes, as seen on this vase and the two objects that follow Plates 77 and 78, were perfected.

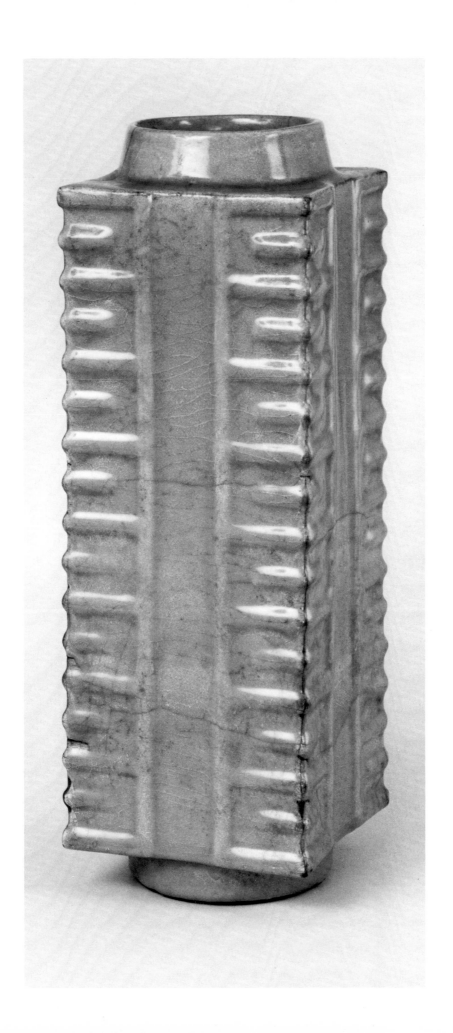

Plate 77
BOWL
Southern Song dynasty, 13th century
Longquan (Lung-ch'üan) ware
Height, 2⅝ in. (6.7 cm.); diameter, 6½ in. (16.5 cm.)
60.153

The hemispherical bowl has a small, tapering foot and a recessed, flat base. The exterior is decorated with relief, and overlapping lotus petals. The petals extend from the foot almost to the rim and give the bowl itself the appearance of a flower. The pale-gray porcelaneous stoneware is covered with light bluish-green glaze down to the foot rim. The base, too, is glazed.

Not previously published.

Bowls and dishes with the same type of carved lotus petals on the outside were found in the bottom of a Southern Song dynasty well at Miaojiaqiao, near Shaoxing, Zhejiang province. (Fig. A: *KK*, no. 11, 1964, p. 558, fig. 1, and p. 4:9.)

Figure A

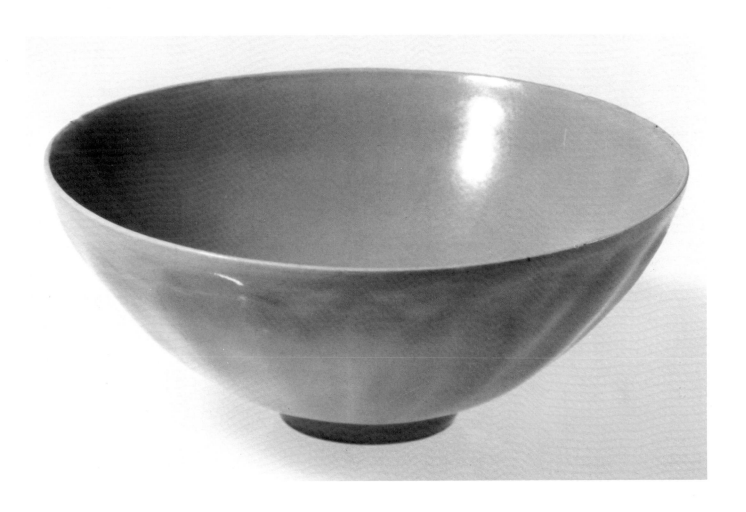

Plate 78
VASE WITH COVER
Southern Song dynasty, 13th century
Longquan (Lung-ch'üan) ware
Height, 9½ in. (24.1 cm.); diameter, 4⅞ in. (12.3 cm.)
47.141

The vase has an ovoid body, a rather wide neck narrowing slightly at the top, a cylindrical foot, and a recessed, flat base. Two rounded ribs encircle the shoulder on which is attached a hand-molded dragon with a long, undulating body. The dragon has horns on its head and winglike tufts on its legs. Its body, marked with scales, winds itself around the vase in pursuit of a large flaming pearl. The slightly domed cover has a wide, flat rim and a knob in the form of a bird with its neck gracefully extended. The gray porcelaneous stoneware is covered with thick, bluish green glaze stopping just above the foot rim.

Published: Wilbur Peat, *Chinese Ceramics of the Sung Dynasty,* Indianapolis, n.d., color pl. 3.

This vase was probably one of a pair originally made for ceremonial purposes. The other vase would presumably have had a tiger on the shoulder, the tiger being the symbol of the West and the dragon of the East. A closely related pair of vases with a dragon and a tiger is in the Percival David Foundation, London. (Fig. A: Medley, *Celadon Wares,* London, 1977, pl. 36.)

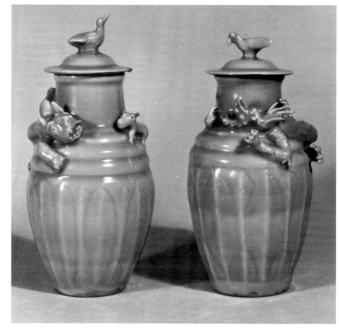

Figure A

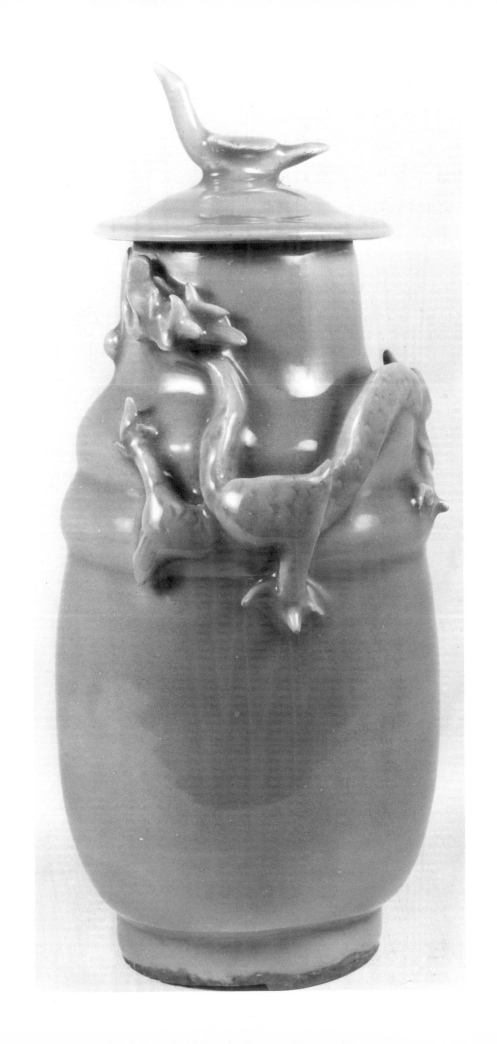

Plate 79
EWER
Ming dynasty, mid-15th century
Longquan (Lung-ch'üan) ware
Height, 9 in. (22.8 cm.)
60.108

The body of the ewer is pear-shaped, widening from the small neck to the fully rounded lower half. The neck widens at the top and turns upward abruptly, forming a thick, vertical mouth rim. The piece rests on a vertical foot and has a recessed, convex base. The long, flat handle is attached at the upper end to the neck, from which it rises vertically and then curves gently around and back down. The lower end of the handle is attached to the lower part of the body. Opposite the handle is a long, slender spout that rises almost vertically from the lower part of the body and then curves outward, away from the neck and mouth. Attached to the base of the neck is a narrow, double strip of clay that terminates in two small spirals where it is joined to the spout to help support it. The ewer is decorated with five horizontal bands of incised ornament. Around the neck and the bottom of the vessel are rows of narrow, upright petals. Below the petals on the neck is a narrow key fret band, and around the base of the neck a row of pendant lotus petal panels, each enclosing a lobed leaf. A stylized floral scroll fills the wide band around the body. The grayish-white porcelaneous stoneware is covered with a slightly olive-toned green glaze. The character *fu* ("happiness") is incised on the base under the glaze.

Figure A

Figure B

Published: Suzanne Valenstein, *Ming Porcelains,* New York, 1971, pl. 67; Suzanne Valenstein, *A Handbook of Chinese Ceramics,* New York, 1975, p. 172, fig. 47; Daisy Lion-Goldschmidt, *Ming Porcelain,* New York, 1978, p. 243 and fig. 266; and Marco Spallanzani, *Ceramiche Orientali a Firenze nel Rinascimento,* Florence, 1978, pl. 25.

The Longquan kilns continued to produce large quantities of wares for the domestic and foreign markets through the Yuan dynasty and well into the Ming. Examples from the Ming period show a decline in quality, and the green glaze usually has a grayish or olive tint. The Lilly ewer, previously assigned a date of about 1400 by Valenstein, can be placed firmly in the middle decades of the fifteenth century by the similarity between its decoration and that of two dated temple vases of Longquan ware in the Percival David Foundation, London. Lotus petal panels closely resembling the ones on the ewer appear on the vase dated the seventh year of Xuande, or 1432. (Fig. A: Medley, *Celadon Wares,* London, 1977, pl. X, no. 98.) The leaves in the floral scroll are very similar to those on the lower half of the vase dated the fifth year of Jingtai, or 1454. (Fig. B: Ibid., no. 99.)

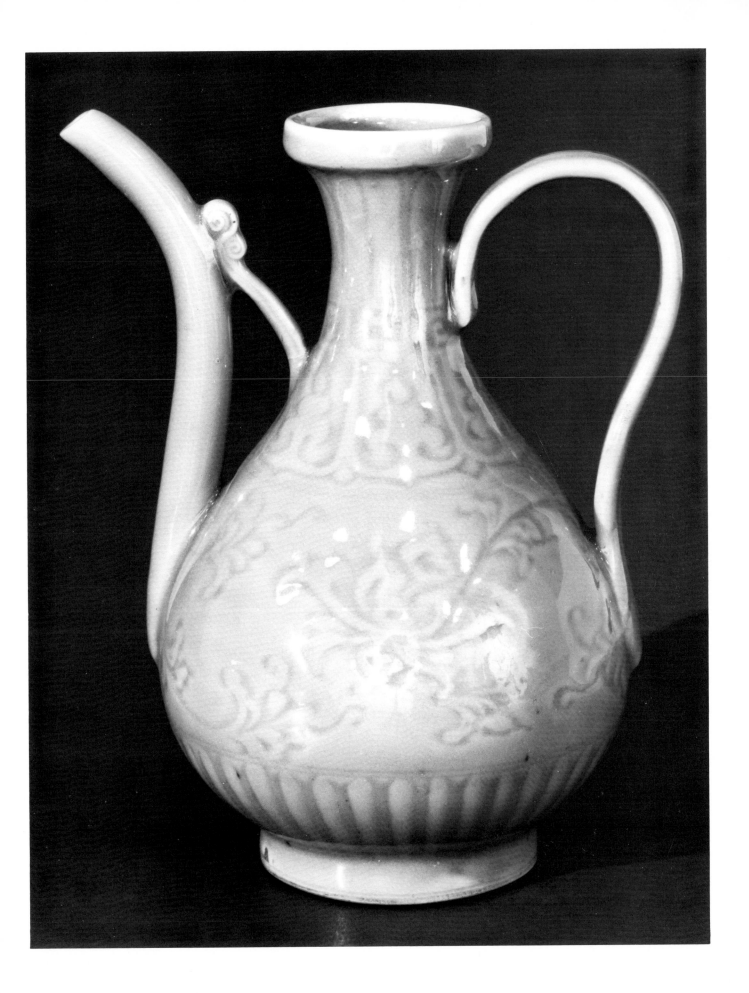

Plate 80
DISH
Late Northern Song or Jin dynasty, 12th century
Ding (Ting) ware
Diameter, 7⅛ in. (20.0 cm.); height, 2¹⁄₁₆ in. (5.2 cm.)
47.139

The dish has rounded sides that taper from the everted mouth rim to the low, neatly finished foot. The base is recessed and flat. The decoration, freely incised on the interior surface, consists of a lotus spray with long, curving stalks and curled, feather-like leaves. A large flower with slender, pointed petals blooms atop one stalk and is flanked by two other stalks without flowers. At the base of the flowering stalk is a large lotus leaf with scalloped edges. Part of the decoration appears to have been incised with a two-pronged instrument, as many of the outlines are double lines that run very close to one another. A groove encircling the edge of the base where the dish turns upward at the sides is probably the result of its being pressed over a mold to achieve the desired shape before it was decorated. The white porcelaneous body is covered by a warm, ivory-toned transparent glaze. The unglazed rim is bound with a dark metal band.

Published: Wilbur Peat, *Chinese Ceramics of the Sung Dynasty,* Indianapolis, n.d., p. 8, pl. 13.

This motif, the graceful, freely drawn lotus spray, can be seen on many Ding (Ting) ware dishes and bowls that were probably made in sets of uniform sizes and shapes. A bowl with similar ornament was found at the Ding kiln site at Jiancicun in Quyangxian, Hebei province. (Fig. A: *KK*, no. 8, 1965, p. 408, fig. 7:16.) This type of lightly incised decoration was introduced in the Northern Song dynasty and continued into the Jin. A very similar dish in the Percival David Foundation, London, has a rather controversial inscription on it dating it in the Shaoxing reign of the Jin dynasty (A.D. 1131–1162). (Lovell, *Illustrated Catalogue of Ting Yao and Related White Wares in the Percival David Foundation of Chinese Art*, 1964, p. 16 and pl. XI, no. 184.)

Although the site of the kilns is known and has been examined by archaeologists, the dating of Ding ware is still highly problematic. The kilns were first established in the Tang dynasty during which time thickly potted pieces, mostly bowls, were produced. The typically warm, ivory color was developed in the Northern Song dynasty when the finest achievements traditionally are said to have been made. Though best known for their exquisite white wares, the kilns also produced black- and brown-glazed wares.

Ding ware was made in large part for imperial use but was not exclusively an official ware. It was available to and much admired by the common people, as evidenced by the discovery of Ding ware objects among the remains of the Song town at Juluxian, Hebei, that was destroyed

Figure A

by flood in 1108. Activity at the kilns in Jiancicun appears to have continued through the Jin and probably into the Yuan dynasty, although some Chinese archaeologists believe that it ceased abruptly at the end of the Northern Song, with the invasion of the North by the Jurchen. (See, also, Pls. 81 and 82.)

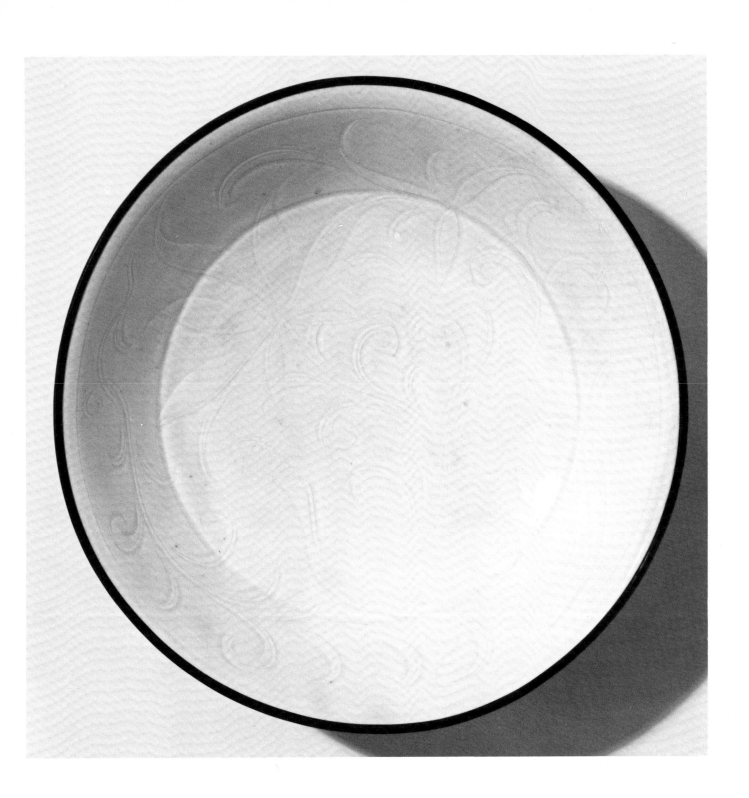

Plate 81
BOWL
Jin dynasty, 12th century
Ding (Ting) ware
Diameter, 7 in. (17.8 cm.); height, 1⅞ in. (4.8 cm.)
47.140

Conical in shape, with a small, neatly finished low foot and recessed, flat base, the bowl is wheel-thrown of fine white porcelain clay and decorated by being pressed over a carved mold. The decoration, which consists of relief floral patterns filling the inner surface of the piece, is enclosed by a narrow key fret band just below the rim. In the center is a small, five-petaled mallow flower around which is a dense pattern of scrolling stems with curled, palmetto-like leaves and four large peony blooms, evenly spaced. The flowers are rendered in a stylized manner, each having a ring of neatly overlapping petals arranged around the clump of curling petals in the center. The entire bowl, with the exception of the mouth rim, is covered with a transparent glaze that has a slightly yellowish gray tint typical of Ding ware. The unglazed rim has been bound with a band of darkened metal, probably bronze.

Published: Jan Wirgin, *Sung Ceramic Designs*, BMFEA, 42, 1970, p. 80:b; Wilbur Peat, *Chinese Ceramics of the Sung Dynasty*, Indianapolis, n.d., p. 8, pl. 12 and color pl. 4.

A similar bowl with molded peony decoration was found at Jiancicun, Quyangxian, Hebei province, in the Ding kiln site. (Fig. A: *KK*, no. 8, 1965, p. 407, fig. 10:3.) According to traditional texts, the kilns at Jiancicun are believed to have produced their finest wares in the late Northern Song period, i.e., the early part of the twelfth century, and to have ceased activity in the Jin Dynasty (after 1127), when the northern part of China fell under the rule of the Jurchen. Historical records of wholesale destruction by the Jurchen are cited as evidence of the demise of the Ding kilns. (*WW*, no. 7, 1959, p. 68.) Neither Koyama Fujio, the first to identify the site of the Ding kilns, nor Chinese archaelogists who subsequently explored the site found any evidence that Ding ware was manufactured after the Northern Song period. However, this seems to be at least in part because of the assignment of the layers of sherds in the large refuse heaps at the site to three historical periods on the basis of already preconceived notions about the dating of various types of Ding ware. Numerous examples with molded decoration were collected from the upper, and lowest, layer, which was assigned to the Northern Song. (*KK*, no. 8, 1965, pp. 394–412.)

Actually, as Hin-cheung Lovell has aptly shown in her treatise on Ding ware, there is strong evidence for the existence of a body of Jin dynasty Ding ware, including three molds for decorating Ding dishes and bowls, one in the Percival David Foundation and two in the British Museum, dated A.D. 1184, 1189, and 1203, respectively.

Figure A

(Lovell, *Ting yao and Related White Wares in the Percival David Foundation of Chinese Art*, London, 1964, p. xxii.) The peonies on the Lilly bowl are very similar to those on the mold in the Percival David Foundation. The mold bears an inscription incised on the bottom that reads, "Made by Wang Shengji on the twenty-sixth day of the fourth moon in the twenty-fourth year of Dading." Dading is the name of the Jin dynasty reign that lasted from 1161 to 1189. (Lovell, op. cit., pl. X, no. 181.)

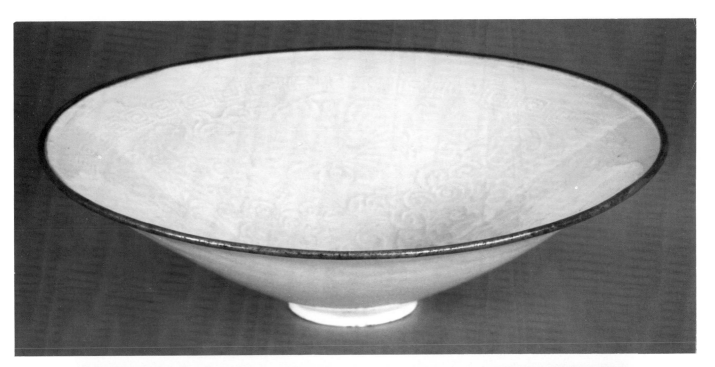

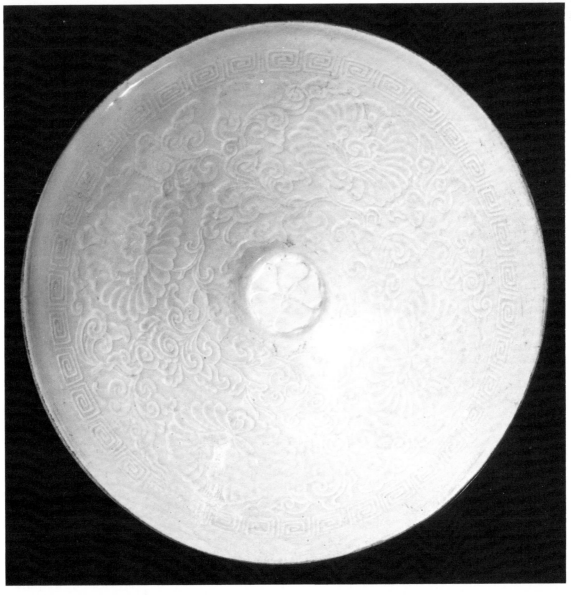

Plate 82
LARGE DISH
Jin or early Yuan dynasty, 13th century
Ding (Ting) ware
Diameter, 11¾ in. (29.8 cm.)
47.138

The shallow dish has rounded sides, a low, vertical foot, and recessed, flat base. The interior surface is richly decorated with molded, relief floral designs. Lotuses and other plants including sagittaria, mallow, and rushes fill the central, circular area around which is a narrow key fret border. Forming an outer frieze around it is a dense pattern of peonies amid veined leaves and scrolling branches. The white porcelaneous dish is covered with a warm, ivory-toned transparent glaze, except for the rim, which is bound with a gold band.

Published: Wilbur Peat, *Chinese Ceramics of the Sung Dynasty,* Indianapolis, n.d., p. 8, pl. 10, and color pl. 4; Yutaka Mino, *Arts of Asia,* XI, 2, March–April, 1981, p. 107, fig. 7.

A fragment of a dish with a very similar molded decoration of lotuses and other flowers in the center and peonies around the well was discovered at the Ding ware kiln site in Jiancicun, Quyangxian, Hebei. (Fig. A: Hughes-Stanton and Kerr, *Kiln Sites of Ancient China,* 1980, pl. 340.) Although this piece was assigned by Chinese archaeologists to the Northern Song period, other evidence points to a much later date for it and the Lilly dish as well. A very similar, complete dish was retrieved from the remains of an ancient ship sunk off the coast of Sin-an, South Cholla Province, South Korea. (Fig. B: *Special Exhibition of Cultural Relics Found off the Sin-an Coast,* Seoul, 1977, pl. 204.) The ship, which was carrying a large cargo of Chinese ceramics, is believed to have gone down in the early years of the fourteenth century. In addition, the style of drawing of the peony scroll band on the Lilly dish closely resembles that of a peony spray in the center of the mold, dated, 1203, in the British Museum. (A sketch of the ornament on the mold is published in Wirgin, *Sung Ceramic Designs, BMFEA,* 42, 1970, fig. 23:b; see, also, Pl. 81.) The leaves are particularly similar in the delineation of their fine, relief veins and in the way the tips twist and curl as they taper to a point.

Figure A

Figure B

216

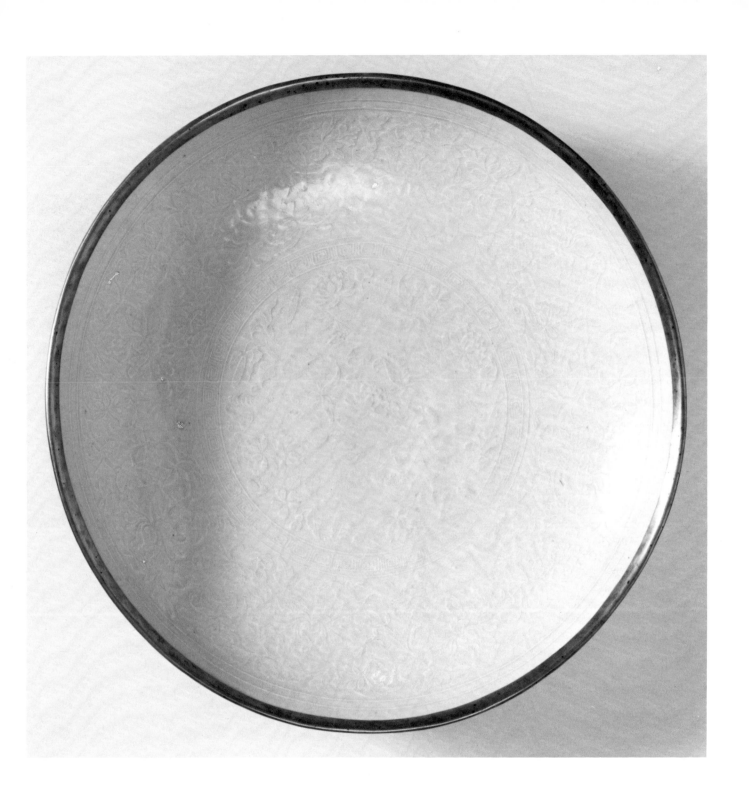

Plate 83
BOWL
Jin dynasty, 13th century
Jun (Chün) ware
Height, 3½ in. (9.0 cm.); diameter, 6 in. (15.2 cm.)
47.131

The deep bowl has rounded sides slightly inverted at the mouth and tapered at the bottom toward the small foot. The base is recessed and convex. The gray stoneware is covered with milky, opalescent blue glaze with two brilliant spots of violet on the exterior. The rim, where the glaze is thin, is a light brown color. The foot rim is unglazed.

Published: Wilbur Peat, *Chinese Ceramics in the Sung Dynasty*, Indianapolis, n.d., pl. 11, pl. 19; Judith and Arthur Hart Burling, *Chinese Art*, New York, 1953, p. 182; Yutaka Mino, *Arts of Asia*, XI, 2, March–April 1981, p. 108, fig. 8.

Jun (Chün) ware was produced at kilns in Yuxian, Linruxian, Xiuwuxian, and Tangyinxian in Henan province. The name Jun was first applied to this type of ware in the early Ming dynasty, when the area now known as Yuxian was called Junzhou. The body of Jun ware is characteristically rather thick and gray in color, and its pale blue glaze is frequently splashed with spots of bright red and purple. Because Jun ware was made for several centuries, from the Song through the Ming dynasties, and few pieces have been excavated in association with readily datable material, its dating is still problematic, generally speaking. However, a deep bowl with rounded sides was among eleven pieces of Jun ware discovered in the tomb of Feng Daozhen, dated 1265, at Songjiazhuang near Datong, Shanxi province. (Fig. A: *WW*, no. 10, 1962, p. 36, fig. 9 left.) On this basis the Lilly bowl can be assigned with some certainty to the Jin dynasty.

Figure A

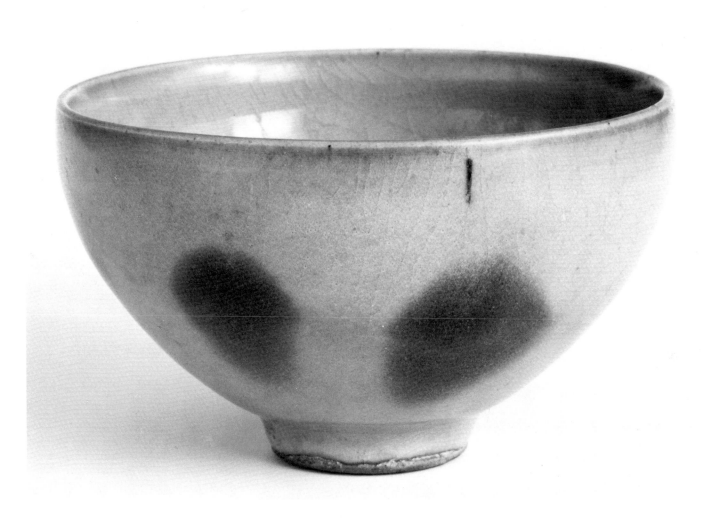

Plate 84
BASIN
Yuan or early Ming dynasty, 14th century
Jun (Chün) ware
Width, 6½ in. (16.5 cm.)
47.156

Made as a base for a flower pot, this shallow basin has a flat, six-lobed rim with thickened edge. The lobing extends down the sides to the foot rim. Three cloud-collar-shaped feet are attached to the bottom of the foot rim. The gray stoneware is covered with pale blue glaze this is suffused with white on the interior, the white streaked on the well and pooled at the bottom of the lobes. On the rim, the white specks are mixed with violet on one half. The exterior is a brilliant purple composed of specks of violet and deep blue in the pale blue. The interior has some grayish, branching linear channels known in Chinese as "earthworm trails." The base, from which the glaze has been mostly wiped off, is burned dark brown and has a ring of eighteen rather large, round spur marks just inside the foot rim. The character *si*, "four," is inscribed on the base, engraved into the already fired piece.

Published: Judith and Arthur Hart Burling, *Treasures of Chinese Art*, Louisville, 1965, pl. 23; Judith and Arthur Hart Burling, *Chinese Art*, New York, 1953, pl. 182.

Plate 84, Detail

Figure A

Often called "bulb bowls," basins of this type would have been used for growing narcissus bulbs or as bases, or stands, for flower pots. George Lee's important study of the group of related wares to which this piece belongs shows that such basins were numbered according to size so that they could easily be matched with flower pots of corresponding size that bore the same number. The deep flower pots are made with similarly lobed sides, small feet, and bases pierced with small holes for drainage.

A fragment of a basin identical in design to the Lilly piece was discovered at a kiln site in Juntai, Yuxian, Henan province. (Fig. A: *WW*, no. 6, 1975, p. 60, fig. 7:2.) The archaeological investigation of the site yielded other basins and a flower pot, as well. (Ibid., fig. 7:1, 3, and 4, and fig. 10:1) Although Chinese archaelogists have expressed the opinion that the kilns at Juntai are of Northern Song date, the associated ceramic material of Cizhou (Tz'u-chou) type that was found at the site can be shown clearly to be from the Yuan dynasty.

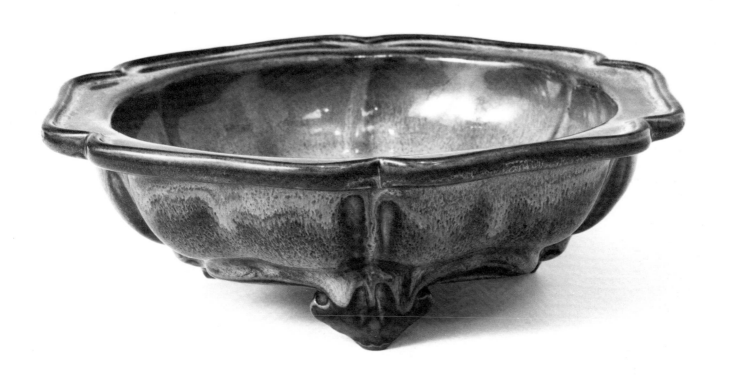

Plate 85
BOWL
Southern Song dynasty, 12th century
Jian (Chien) ware
Diameter, 8⅛ in. (20.5 cm.); height, 3⁵⁄₁₆ in. (8.4 cm.)
47.155

The bowl has a nearly conical shape with an everted mouth rim, small, low foot, and recessed, flat base. The coarse gray stoneware is covered with thick, black glaze showing extensive, fine, reddish brown streaks, or "hare's fur" markings. The glaze stops about one inch above the foot. The unglazed parts of the body are burned dark brown.

Published: Wilbur Peat, *Chinese Ceramics of the Sung Dynasty,* Indianapolis, n.d., p. 10, pl. 16.

This is one of the largest Jian ware bowls in existence. Its shape, too, with the widely everted mouth rim, is unusual, making this a rare and important piece. A Jian ware bowl of more typical shape, having a much less widely everted rim and a low ridge around the outside just below the mouth, was unearthed from the tomb of Zhang Tongzhi in Jiangpuxian, Jiangsu province. (Fig. A: *WW,* no. 4, 1973, p. 64, fig. 11.) The tomb is dated A.D. 1195.

The term Jian ware refers specifically to the wares made in Fujian province, while the Japanese name *temmoku,* also commonly used for these wares, is applied to black wares made in other parts of China as well. Jian ware arose in connection with the growing popularity of tea-drinking in both China and Japan. It is distinctive for its very dark-reddish or purplish-brown foot and black glaze with uncanny effects, known as "hare's fur" or "oil spot," that could occur during firing. Large numbers of Jian ware tea bowls were exported to Japan, where many of the finest examples can be seen today.

Figure A

Plate 86
BOWL
Southern Song dynasty, 13th century
Jizhou (Chi-chou) ware
Height, 2⁹⁄₁₆ in. (6.5 cm.); diameter, 6½ in. (16.5 cm.)
60.31

The rather shallow, rounded bowl has a small, low foot
and a recessed, slightly convex base. The buff stoneware
is covered with dark brown glaze nearly down to the foot.
On the exterior the glaze is mottled with rather large,
irregular yellow spots that create a tortoise-shell pattern.
The interior is heavily sprinkled with a layer of the pale
yellow glaze, part of which, on the sides, has streaked in
firing. Three phoenixes, their long tails trailing behind
them, are in flight around a small plum blossom in the
center and reserved in black against the light ground.

Not previously published.

A bowl of very similar shape, decorated with three phoe-
nixes on the interior and with mottled glaze on the exte-
rior, was found in a Song tomb at Dengbu, Yuganxian,
in Jiangxi province. (Fig. A: *WW*, no. 4, 1964, p. 64, fig.
6.) Bowls with tortoise-shell-like mottled glaze were
unearthed from another Song tomb at Shahebao near
Changdu, in Sichuan province. (Fig. B: *WW*, no. 5, 1956,
p. 80.)

Very similar stenciled designs can be seen on pieces
found at the Jizhou kiln site at Yonghechen, Jianxian, in
southern Jiangxi province. (Chiang Hsüan-i, *Chi-chou-
yao*, Peking, 1958, pls. 19 and 20.)

The Jizhou kilns are believed to have been established
in the Song dynasty and to have been most active during
the Southern Song period. Production continued into
the Yuan and Ming dynasties. The kilns are best known
for their black- and brown-glazed wares, especially bowls,
with distinctive styles of stenciled and other decoration.
The large number of tea bowls made is a reflection of
the growing popularity of tea-drinking in the Song period.
It is interesting to note that Jiangxi province, like Fujian
(the home of Jian ware), was an important tea-producing
area. The majority of Jizhou bowls have a mottled yellow
glaze sprinkled over black glaze. The lighter colored glaze
may be applied in a very casual manner, resulting in ran-
dom spots like the pattern of tortoise-shell, as on the
exterior of the bowl under discussion; or it can be sprin-
kled over cut paper stencils that, when removed, create
patterns reserved in black, as on the interior of this bowl.

Figure A

Figure B

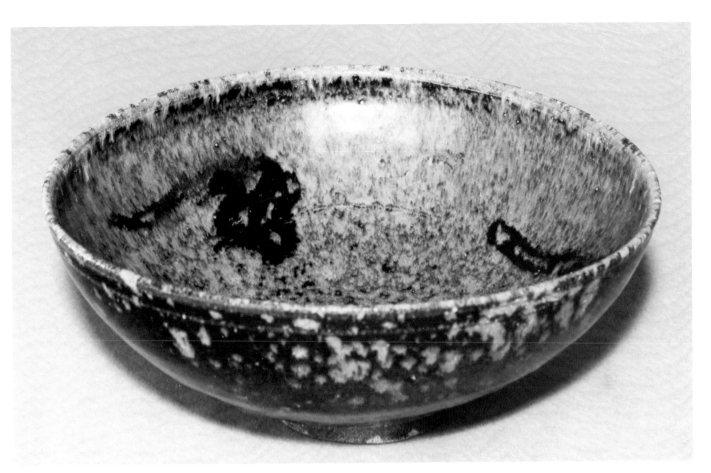

Plate 87
BOWL
Southern Song dynasty, early 13th century
Yingqing (Ying-ch'ing) ware
Height, 2½ in. (6.2 cm.); diameter, 7½ in. (19.0 cm.)
47.142

The bowl is nearly conical in shape, with its sides gently curving at the bottom toward a small, low foot. The base is recessed and slightly convex. The everted rim is divided into six lobes or sections by small triangular notches. The interior of the bowl is decorated with a freely incised and combed peony spray with a single large flower and long, sweeping stems and curling leaves. Finely combed lines add texture to the leaves and petals. The very thin, white porcelain body is covered down to the foot rim with transparent glaze that has a faint blue green tint. Thicker, greenish streaks of glaze appear along the rim on one side.

Published: Wilbur Peat, *Chinese Ceramics of the Sung Dynasty*, Indianapolis, n.d., p. 10, pl. 14.

Yingqing, "shadow blue," also called *qingbai (ch'ing-pai)*, "bluish white," ware is noted for its limpid glaze of very pale-blue or blue-green tint. The body is usually pure white and very thinly potted. Jingdezhen, in Jiangxi province, became the center of production of *yingqing* ware in the Song dynasty. (See *Ching-te-chen Tao-chi Shih-kao*, 1959, pp. 52ff; and *WW*, no. 11, 1980, pp. 39–49.) The great popularity of the ware, both in China and abroad, brought about its large-scale manufacture at numerous kilns in Jiangxi and Fujian provinces, but the products of the Jingdezhen kilns are generally the finest. Excavation of a number of examples of *yingqing* ware from tombs dated 1027, 1057, and 1081, respectively, demonstrates that the ware had attained a high level of development by the end of the eleventh century. *(KK, no. 6, 1963, pp. 343 and 339; KK, no. 11, 1965, p. 571–72; KK, no. 1, 1959, pp. 46–47.)* Numerous other typical pieces of *yingqing* ware were discovered in a tomb dated 1113 at Macheng, Hubei province. *(KK, no. 1, 1965, pp. 21–24.)* Production continued into the fourteenth century when *yingqing* ware was supplanted by pure white wares and painted blue-and-white and underglazed porcelain.

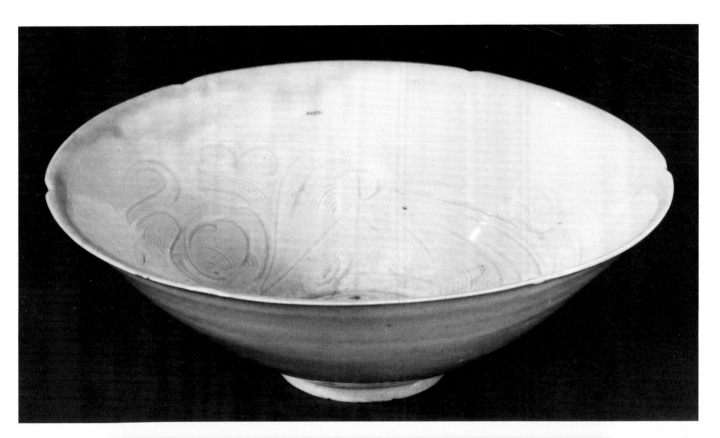

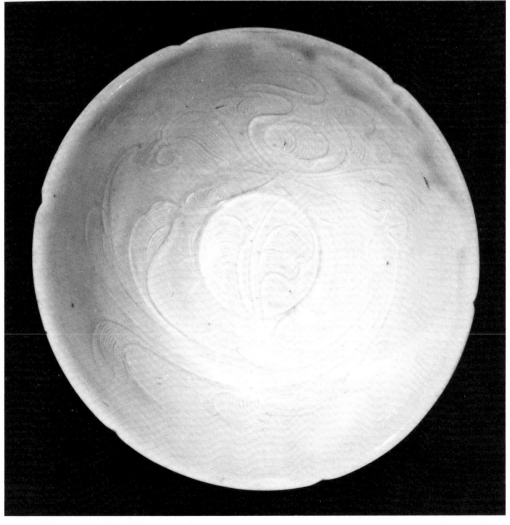

Plate 88
CUP STAND
Ming dynasty, early 15th century
Underglaze red ware
Diameter, 7½ in. (19.0 cm.)
60.94

The small saucer has a flat, foliated rim with eight bracket-shaped lobes that extend down into the cavetto. A raised ring in the bottom would have held a cup, now missing. The foot is very low, and the base recessed and flat. The piece is decorated under the glaze with copper red pigment that is faintly grayish in color. The decoration on the interior is reserved in white on a red ground and arranged in concentric rings. In the centers, enclosed by the raised ring, is a peony spray with a single bloom surrounded by pointed leaves. Around it, on the ring, are small petals with scalloped edges. A *lingzhi* scroll fills the remainder of the base out to the cavetto. In the cavetto are eight flowers, alternately lotuses and peonies, each set in the center of one of the bracket-shaped lobes and surrounded by curling leaves. A band of classic scrolls decorates the rim, and a narrow key fret band appears along the edge of the rim. On the reverse side, sixteen lotus petal panels, each enclosing a trefoil and circle motif, are painted in fine red lines. The white porcelain is covered with transparent glaze of bluish tone. The base, from which the glaze has been mostly wiped off, is burned a streaked orange color with dark brown specks.

Published: Suzanne Valenstein, *Ming Porcelains*, New York, 1970, pl. 2; Yutaka Mino, *Arts of Asia*, XI, 2, March–April, 1981, p. 111, fig. 15.

Figure A

The technique of underglaze painting on porcelain became prevalent in the fourteenth century, in the Yuan dynasty. Cobalt blue, copper red, and, in rarer instances, iron brown pigments were used. Although some scholars argue that there is evidence that cobalt blue, or blue-and-white ware, was introduced in the Song dynasty, this belief has not gained full acceptance. Blue-and-white ware was first made in large quantities for export to the Near East during the Yuan period, and the red and brown painted porcelains appeared at about the same time. Quite common in the fourteenth century, underglaze red ware attained a high point in the early Ming period, after which it gradually declined in use as blue-and-white ware became increasingly popular. Because of the difficulty in controlling the copper red pigment, which requires a strongly reducing atmosphere in firing, the red color frequently has a grayish tone.

This cup stand is a very rare example of its type. Closely related pieces are known, but they are decorated with patterns painted in red on the white porcelain ground, instead of having the main motifs reserved in white and the ground painted in red. (See Lee, *Chinese Art Under the Mongols: the Yüan Dynasty*, 1968, no. 176; and John Addis, "A Group of Underglaze Red," *TOCS*, 31, 1957–1959, pl. 2a.) The shape also occurs in metalworking, from which it may have derived. A gilded and silvered copper cup stand of the Yuan dynasty with a lobed rim and cavetto and dragons in the base around a central *lingzhi* spray is in the Cleveland Museum of Art. (Fig. A: Registration no. 75.12. Purchase, Andrew R. and Martha Holden Jennings Fund.)

Plate 88, Detail

Plate 89
BOWL
Ming dynasty, Yongle period (1403–1424)
Blue-and-white porcelain
Height, 3⅛ in. (7.9 cm.); diameter, 6¾ in. (17.1 cm.)
60.101

The bowl has rounded sides that curve upward, approaching the vertical before flaring outward at the top to form an everted rim. The foot is vertical, the base recessed and flat. The decoration is painted on the white porcelain body in mottled, dark cobalt-blue pigment and covered with transparent glaze. Inside the bowl, at the bottom, is a stylized lotus spray with a single flower surrounded by scrolling vines and curling leaves and enclosed by a double circle. Around it is a composite floral scroll with five large blooms, including chrysanthemum, lotus, and peony alternating with smaller flowers. The blooms are borne on slender stems that rise from a single undulating vine with different types of foliage to match the flowers. A small, daisy-like scroll fills the narrow border along the mouth rim. The exterior, below a key fret border along the rim, is decorated in a wide band with a stylized lotus scroll. Large blooms alternate with smaller ones among curling leaves. A row of upright, narrow petals, each enclosing a trefoil design reserved in white, encircles the lower part of the bowl, and a classic scroll pattern appears in a narrow band around the foot.

Published: Yutaka Mino, *Arts of Asia*, XI, 2, March–April 1981, p. 113, fig. 17.

Blue-and-white porcelain arose in the Yuan dynasty (1279–1368) when it seems at first to have been developed primarily for export to the Near East. Many fine examples of fourteenth-century blue-and-white porcelain can be seen in the collection of Shah 'Abbas (r. 1587–1620) from the Ardebil Shrine, Iran (Pope, *Chinese Porcelains from the Ardebil Shrine*, 1956), and in the Topkapu Sarayi, Istanbul (Pope, *Fourteenth-Century Blue-and-White: A Group of Chinese Porcelains in the Topkapu Sarayi Müzesi, Istanbul*, 1970, rev. ed.). In the Ming dynasty, blue-and-white porcelain, previously considered by men of culture to be quite vulgar, was adapted to Chinese court taste and attained the height of its beauty and refinement. This bowl displays characteristics of blue-and-white porcelain from the early part of the fifteenth century in the rather heavy application of the blue pigment and in the numerous blackish spots contained in the blue, creating an effect referred to in the Chinese as "heaped and piled."

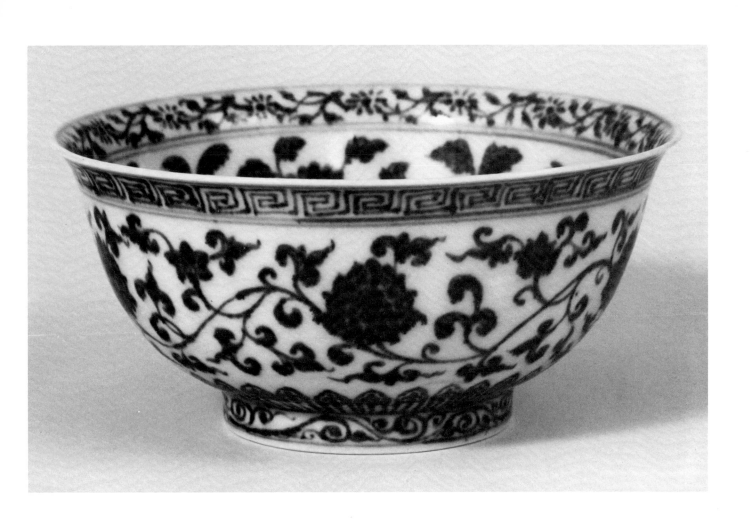

Plate 90
BOWL
Ming dynasty, Yongle period (1403–1424)
Blue-and-white porcelain
Height, 3⅛ in. (7.9 cm.); diameter 6¾ in. (17.1 cm.)
60.102

The bowl is the same shape and size as that in Plate 89 and is decorated in a similar style. On the interior is a central, stylized lotus, around it a composite floral scroll with five large blooms alternating with five smaller ones, and along the rim a floral scroll border with small, daisy-like flowers, as on the preceding bowl. The key fret border and classic scroll around the foot on the exterior are the same, as well. The wide floral scroll band on the exterior, however, like that on the interior, has variegated flowers and foliage. The petals around the bottom enclose only single, narrow petals instead of the reserved trefoil design. The blue pigment is mottled but not as dark as that on the preceding bowl.

Published: Suzanne Valenstein, *Ming Porcelains*, New York, 1971, pl. 6; Yutaka Mino, *Arts of Asia*, XI, 2, March–April 1981, p. 113, fig. 17.

A bowl of the same design is in the Ardebil Shrine Collection (Pope, *Chinese Porcelains from the Ardebil Shrine*, 1956, pl. 47, no. 29.321). Other similar examples are known that have a Xuande reign mark.

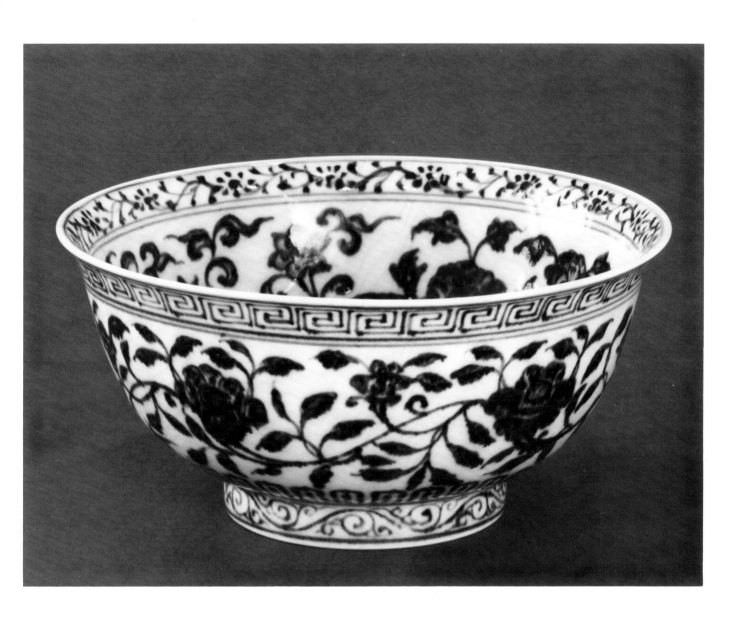

Plate 91
BOWL
Ming dynasty, Yongle period (1403–1424)
Blue-and-white porcelain
Height, 4 in. (10.2 cm.); diameter, 8¼ in. (21.0 cm.)
60.107

The deep bowl has gently rounded sides tapering to a small foot. The rim is nearly vertical. The base is recessed and convex. The bowl is painted on the interior with a central loquat branch within a double circle and a floral scroll around the sides. Three chrysanthemums alternating with three camellias spring from a single, undulating vine-like stem with leaves and small buds around them. Along the rim is a narrow border of ocean waves. On the exterior, a key fret border encircles the rim, and long, narrow, solid blue petals extend from the foot nearly to the border, giving the bowl the appearance of a large flower. The white porcelain and cobalt-blue painting are covered with transparent glaze.

Published: Suzanne Valenstein, *Ming Porcelains*, New York, 1971, pl. 5; Yutaka Mino, *Arts of Asia*, XI, 2, March–April 1981, p. 113, fig. 19.

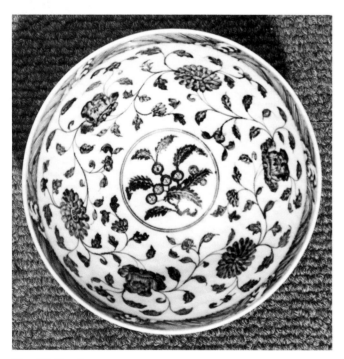

Plate 91, Detail

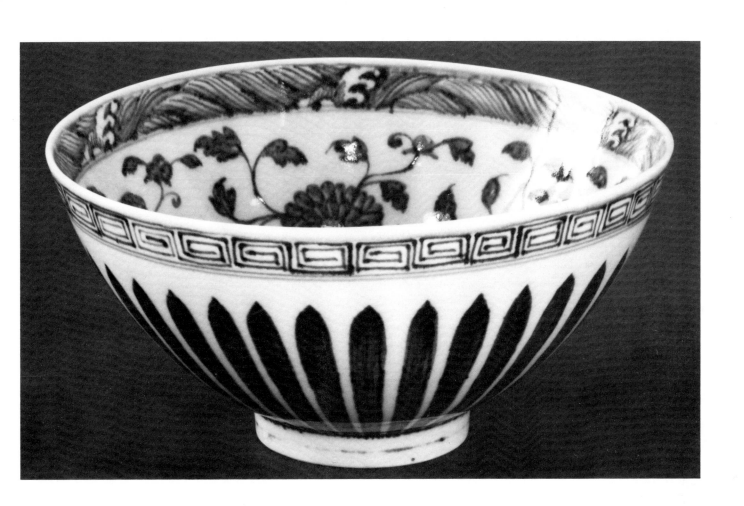

Plate 92
PLATE
Ming dynasty, Yongle period (1403–1424)
Blue-and-white porcelain
Height, 3⅛ in. (7.9 cm.); diameter, 17¾ in. (45.1 cm.)
60.103

The large plate has a flat, foliated rim with twelve bracket-shaped lobes; the lobing extends down the rounded sides as far as the low, wedge-shaped foot. The base is recessed and flat. The piece is decorated with painted designs in underglaze cobalt blue pigment. In the bottom, enclosed by a double, barbed line that repeats the bracket lobing of the rim, is a vine with three large bunches of grapes, veined leaves, and curling tendrils. Around the cavetto are six sprigs of *lingzhi* with curling leaves alternating with six floral sprays of different varieties: camellia, chrysanthemum, gardenia, hibiscus, lotus, and peony. On the rim is a scrolling vine of crepe myrtle and blackberry lilies. The reverse is decorated with twelve floral sprays including all of those seen on the interior, plus the morning glory and carnation. The pure white porcelain and painted decoration is covered with a transparent glaze down to the foot rim. The base is unglazed. The foot rim and areas of the base are tinged with orange.

Published: Yutaka Mino, *Arts of Asia*, XI, 2, March–April 1981, p. 112, fig. 18.

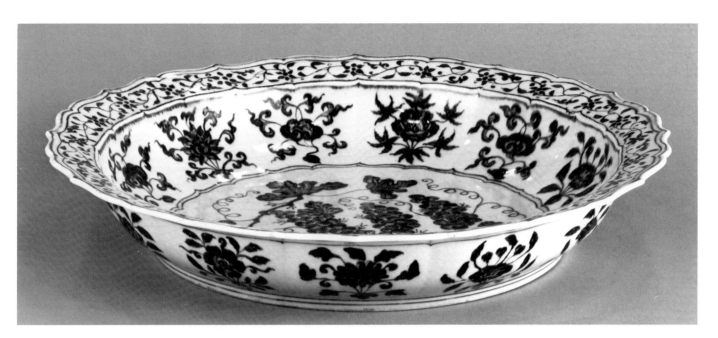

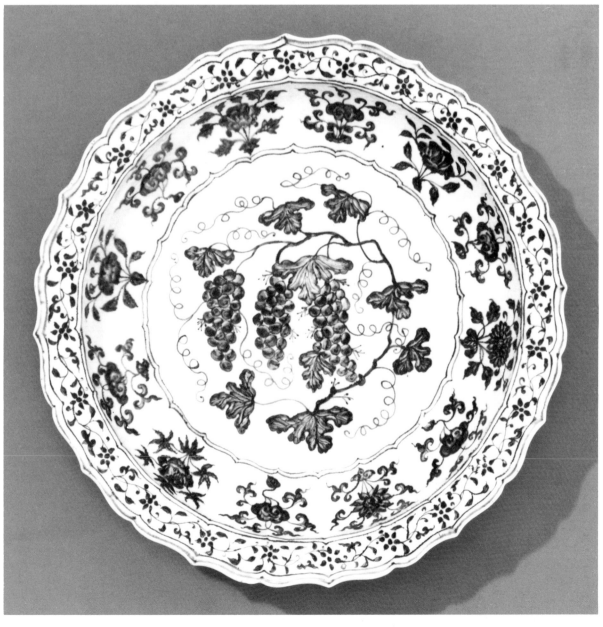

Plate 93
EWER
Ming dynasty, Yongle period (1403–1424)
Porcelain with *anhua* decoration
Height, 10¼ in. (26.0 cm.)
60.90

The pear-shaped ewer has a small neck and nearly con-
ical upper body widening toward a bulbous lower half.
The piece is supported on a small vertical foot. The base
is recessed and convex. The neck widens abruptly at the
top to form an everted mouth rim. A long, curving han-
dle with a thickened ridge along the center is attached to
the neck and to the body at its widest part. At the lower,
pointed end of the handle are three raised bosses, and at
the top of the curved, upper part is a small ring for secur-
ing the cover, which is now lost. A long, tubular spout is
placed opposite the handle, originating on the lower part
of the body and rising nearly vertically, then turning out-
ward, away from the neck and mouth, and tapering toward
the open end. It is secured to the neck by an ornamental
span of an irregular, cloud-like shape. The piece is dec-
orated with incised ornament of the *anhua*, or "secret
pattern," type, the drawing very precise and so lightly
incised on the body that it is only faintly visible under the
glaze. The ornament is divided into horizontal bands—
a narrow band of *rui* lappets encircling the upper part of
the neck, a peony scroll below, and a wide band of flow-
ering hibiscus branches on the body. Around the bottom,
bordering the foot, is a continuous double line whose
reverse curves form a row of mushroom-like lobed forms.
Delicate *lingzhi* scrolls are incised along the length of the
spout. The pure white porcelain is covered with a slightly
bluish transparent glaze.

Published: Judith and Arthur Hart Burling, *Chinese Art*, New York,
1953, p. 189; Suzanne Valenstein, *Ming Porcelains*, New York, 1971,
pl. 9; Suzanne Valenstein, *A Handbook of Chinese Ceramics*, New York,
1975, p. 130, fig. 42; Yutaka Mino and Katherine Tsiang, *Apollo*, CVIII,
199, September 1978, p. 158 and p. 160, pl. 9; Yutaka Mino, *Arts of
Asia*, XI, 2, March–April 1981, p. 111, fig. 16.

Anhua is the most subtle form of decoration used on
Chinese porcelain. The nearly colorless, transparent glaze
does not darken the delicately incised patterns as do the
glazes of celadon or *yingqing (ying-ch'ing)* wares, so that
the only faintly visible patterns detract nothing from our
appreciation of the luminous white porcelain form of the
ewer. The *anhua* style of decoration seems to have enjoyed
a brief vogue in the early part of the Ming dynasty, after
which it hardly ever appears by itself but is used with
other techniques, as on blue-and-white ware or with over-
glaze enamels. Except for the absence of the cover, the
Lilly ewer is virtually flawless and can be seen to repre-
sent the achievement of a new high point of artistic
sophistication and technical proficiency in the early Ming
period. Whereas the Yuan dynasty saw the establishment

at Jingdezhen of white porcelain wares and their deco-
ration in underglaze blue and red, the patronage of the
court in the early Ming dynasty encouraged greater vari-
ety and refinement in materials and in styles of ornament.

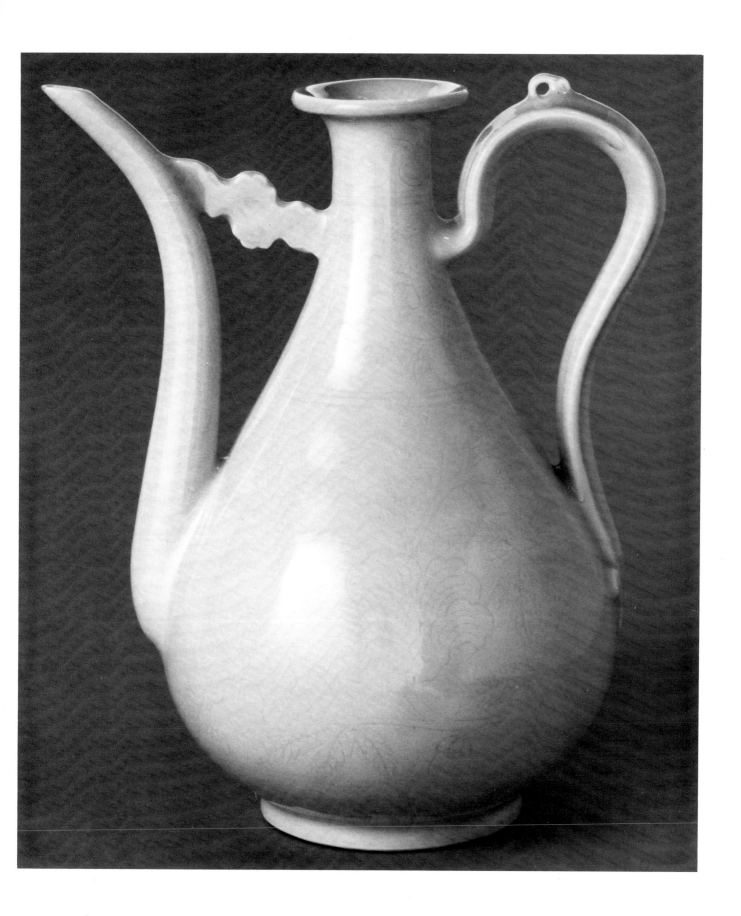

Plate 94
LARGE DISH
Ming dynasty, Yongle period (1403–1424)
Porcelain with *anhua* decoration
Height, 2⅜ in. (6.0 cm.); diameter, 12¼ in. (31.2 cm.)
60.89

The dish has a low foot, recessed, slightly convex base, and rounded sides curving upward to a nearly vertical mouth rim. The surface of the white porcelain body is decorated with finely incised designs of the *anhua* type under the glaze. In the center, within a large double circle, is a bouquet of lotuses and aquatic grasses, the stems tied together with a ribbon. A floral scroll winds around the cavetto, on which thirteen flowers of seven different varieties appear, all except one in pairs. The flowers include camellias, chrysanthemums, lotuses, and peonies. Along the rim is a classic scroll border. The reverse side is decorated with a very similar floral scroll bordered by a classic scroll above and a key fret pattern along the foot. The pure white porcelain is covered with transparent glaze of a faint bluish gray cast. The base is unglazed and white. The foot rim is bright burnt orange with brown specks.

Published: Henry Trubner, *Chinese Ceramics*, Los Angeles, 1952, no. 269, not illustrated.

Plate 95
MEIPING
Ming dynasty, Xuande period (1426–1435)
Blue-and-white porcelain
Height, 13½ in. (34.3 cm.)
60.82

The vase has a high, flattened shoulder, nearly straight sides tapering gradually toward the base, and a very small neck with an everted mouth rim. The base is recessed and flat. The vase is decorated in underglaze cobalt blue of slightly grayish tone with a large, five-clawed dragon striding among drifting clouds in pursuit of a flaming pearl. A row of upright lotus petal panels encircles the base. A four-character inscription, *Xuande nian zhi*, "Made in the Xuande period," is written horizontally on the shoulder, beneath a double line that serves as the upper border to the painted decoration. The painting is skillfully executed in different intensities of blue that create the effect of shading on the scales of the dragon and in the clouds. The blue pigment is slightly blurred under the transparent glaze, giving the ornament an unusual softness and depth. The combination of strength and grace in the robust form of the vase and in the forceful vitality of the painting is representative of the ceramic art of the Xuande period at its finest.

Published: "Ming Blue and White," *Philadelphia Museum Bulletin*, XLIX, 223, 1949, pl. 72; Yutaka Mino and Katherine Tsiang, *Apollo*, CVIII, 199, September 1978, pl. 160, fig. 10; Yutaka Mino, *Arts of Asia*, XI, 2, March–April 1981, p. 113, fig. 20.

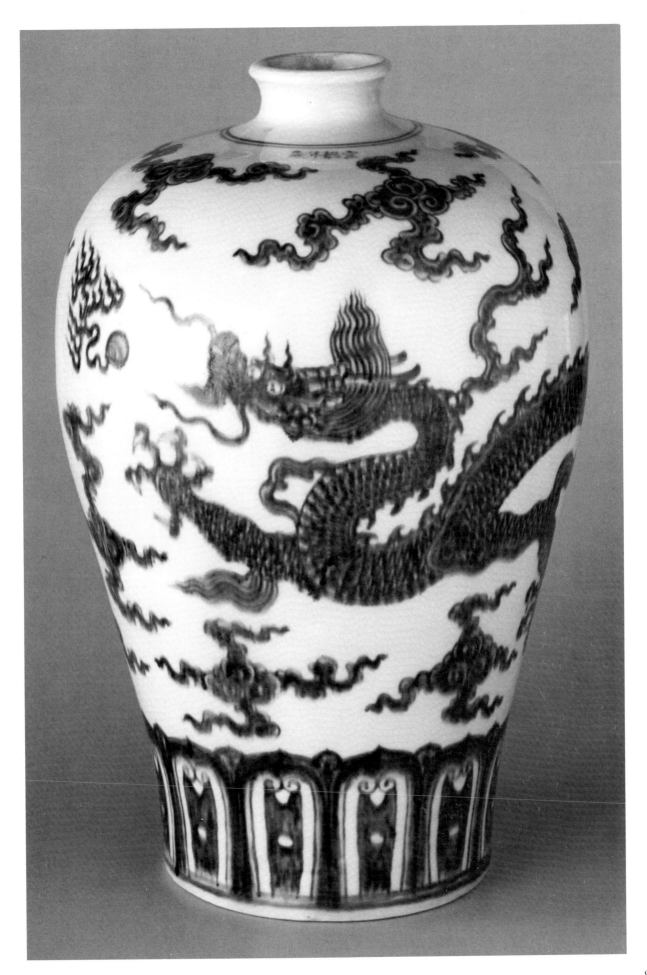

Plate 96
BOWL
Ming dynasty, 2nd half of the 15th century
Porcelain with enamel decoration
Height, 1⁷/₁₆ in. (4.6 cm.); diameter, 8¹/₁₆ in. (20.5 cm.)
60.91

The dish has low, rounded sides, a thin, vertical foot, and a recessed, slightly convex base. Incised on the exterior are two dragons striding among drifting clouds in pursuit of flaming pearls. The interior of the bowl and the base are covered with warm, slightly grayish-toned transparent glaze. Surrounded by blue sky, the dragons are painted in speckled enamel and have blue eyes; speckled blue enamel floats in the background on the biscuit. The foot rim is unglazed.

Published: E. P. Richardson and Paul L. Grigaut, *The Arts of the Ming Dynasty*, Detroit, 1952, no. 164; Suzanne Valenstein, *Ming Porcelains*, New York, 1970, pl. 21.

Figure A

This technique of decoration is rarely seen. The only other very similar example known is a dish in the Freer Gallery, Washington, D.C. *(Oriental Ceramics*, vol. 9, Tokyo, 1976, fig. 114.) Two incised dragons among clouds under a mottled blue glaze that is very similar in appearance to the glaze on these dishes can be seen on a very thickly potted bowl with a Xuande mark on the bottom. (Fig. A: *The Edward Chow Collection, Part One: Ming and Qing Porcelain*, Sotheby Parke Bernet, Hong Kong, 1980, no. 50.)

Plate 96, Detail

Plate 97
DISH
Ming dynasty, Hongzhi period (1488–1501)
Blue-and-white porcelain with overglaze yellow enamel
Height, 1⅞ in. (4.8 cm.); diameter, 10¾ in. (26.3 cm.)
60.87

The dish has shallow curving sides, an everted mouth rim, a low vertical foot, and a recessed, slightly convex base. The white porcelain is decorated with floral designs painted in cobalt blue under the glaze. In the center of the dish is a large hibiscus branch with two blossoms and two buds and veined leaves that are white in the center and blue along the edges. Around the sides, bordered by double lines, are fruiting branches of pomegranate, persimmon, and grape, and a lotus bouquet with a large flower and seed pod, the stems of which are tied with a ribbon. On the exterior is a floral scroll with curling branches, large peony-like flowers, and veined leaves with blue edges, also bordered by double lines. The characters *Da Ming Hongzhi nian zhi*, "Made in the Hongzhi reign of the Great Ming Dynasty," are inscribed within a double ring on the base. The entire dish, except for the foot rim, is covered with transparent glaze. The area around the floral ornament on the interior and exterior is filled in with bright yellow overglaze enamel.

Published: Henry Trubner, *Chinese Ceramics*, Los Angeles, 1952, pl. 300.

The technique of overglaze enamel decoration on porcelain in combination with underglaze cobalt blue painting was probably introduced in the Chenghua period (1465–1487). The very delicate polychrome enameled wares produced in the Chenghua period became much celebrated and, also, much imitated in later centuries. The yellow enamel is used alone on a group of dishes, of which this piece is a fine example, that are painted with rather bold floral motifs in underglaze blue and the background filled in with yellow. The enamel is carefully painted around and precisely up to the outlines of the blue painting. These dishes are inscribed with marks of three successive reign periods, Chenghua, Hongzhi, and Zhengde, which span the years from 1465 to 1521. Over this period of time, they remain remarkably consistent in design, although some stylistic changes can be seen, and it would appear that they were used as an official palace table setting. The color yellow is significant in that it is symbolic of the sun-like pre-eminence of the emperor. An example with a peony-like floral spray in the center and four fruiting branches, including persimmon and peach, around the sides is in the National Palace Museum, Taibei. (Fig. A: Tong Ihua, *Ming Chenghua ciqi zhan-lan*, Taibei, 1976, no. 17.) Around the outside are stylized lotus sprays and the reign mark, written horizontally below the rim. The finest dishes of this type were produced in the Hongzhi period. In the Zhengde period, the fluid

Figure B

Figure A

Figure D

Figure C

strength of the painting and the quality of the yellow enamel declines.

Although the dishes with the flowers and fruit on a yellow enamel ground appear to have been made exclusively in the three reign periods mentioned, the same design can be seen on other types of porcelain of the Xuande (Hsüan-te) period (1426–1435). Dishes painted with the same motifs as those on the Lilly dish but in underglaze brown and underglaze yellow on a white ground, and another example with these motifs reserved in white on a dark blue ground, can be seen in the National Palace Museum, Taibei. (Figs. B, C, and D: Tong Ihua, *Ming Xuande ciqi tezhan mulu*, Taibei, 1980, nos. 129, 130 and 82.) All have a Xuande mark written on the base.

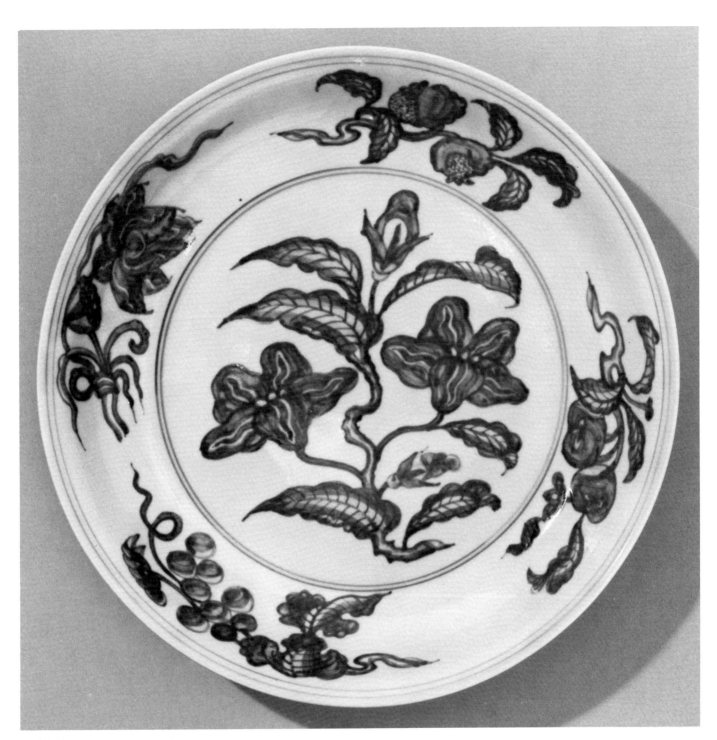

Plate 97, Detail

Plate 98
DISH
Ming dynasty, Zhengde period (1506–1521)
Porcelain with overglaze yellow enamel
Height, 1¾ in. (4.5 cm.); diameter, 8½ in. (21.6 cm.)
60.105

The dish has shallow, curved sides, an everted mouth
rim, a low, vertical foot, and a recessed, convex base. The
porcelain is covered with transparent glaze except for the
foot rim. The yellow enamel is applied over the glaze on
the interior and the exterior down to the foot. The base,
left white, is inscribed with a six-character mark, *Da Ming
Zhengde nian zhi*, "Made in the Zhengde period of the
Great Ming Dynasty," within a double ring in underglaze
blue.

The dish is identical to another in the collection (no.
60.104) that has been broken and repaired.

Not previously published.

Plate 98, Detail

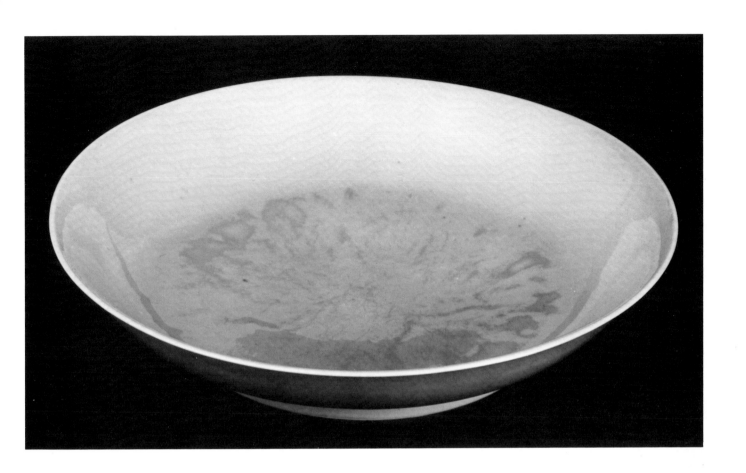

Plate 99
DISH
Ming dynasty, Zhengde period (1506–1521)
Porcelain with green enamel decoration
Height, 1⅞ in. (4.8 cm.); diameter, 8¾ in. (22.2 cm.)
60.86

The dish has shallow, curved sides with an everted mouth rim, a narrow, undercut foot, and a recessed, convex base. On the interior is a dragon among drifting clouds that are incised with fine lines within a circular area in the center. On the reverse are two more dragons striding around the sides on a ground of finely incised waves. The white porcelain body is covered with a transparent glaze, except on the incised dragons and clouds and on the foot rim. The dragons and clouds are filled in with green enamel on the biscuit, save for the claws, streamers, whiskers, and spiny ridge along the back, which are painted over the glaze. A green circle encloses the dragon and another borders the mouth rim on the interior. The dragons on the exterior are also bordered by green lines. On the base, the characters *Da Ming Zhengde nian zhi*, "Made in the Zhengde reign of the Great Ming Dynasty," are inscribed within a double ring in underglaze cobalt blue.

Published: Yutaka Mino, *Arts of Asia*, XI, 2, March–April 1981, p. 114, fig. 21.

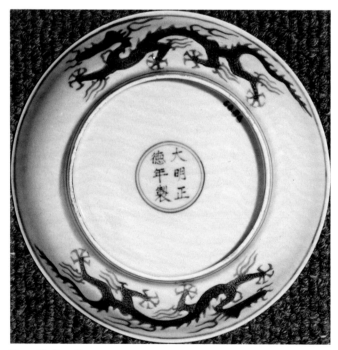

Plate 99, Detail

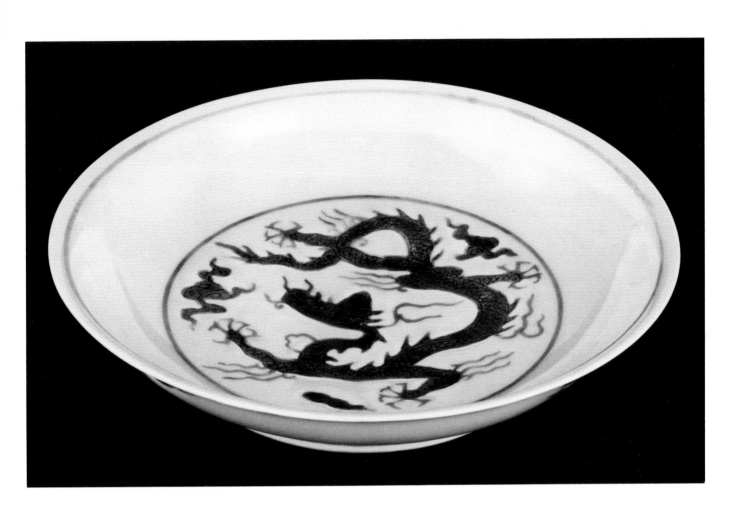

Plate 100

JAR WITH COVER
Ming dynasty, Jiajing period (1522–1566)
Porcelain with underglaze blue and
 overglaze enamel decoration
Height, 17¼ in. (43.8 cm.);
 diameter, 15½ in. (39.4 cm.)
60.88

The large jar has a flattened shoulder and wide body with rounded sides tapering slightly to a wide, flat, recessed base. The short neck and thickened mouth rim are hidden by a cover with an onion-shaped knob. The white porcelain is decorated with scenes of carp swimming in a lotus pond painted in underglaze cobalt blue pigment and brilliant, overglaze enamels. Eight carp are painted in yellow enamel, with outlines of fins, scales, and other details superimposed in red, in a wide band around the middle of the jar. Lotuses, waterfern, duckweed, eelgrass, and other aquatic plants surrounding the fish are painted in yellow, red, green, and black enamels and in underglaze blue. Below this underwater scene is a row of blue, overlapping plantain leaves, and above it, around the shoulder, is a band of polychrome petal panels. Carp and aquatic plants decorate the sides of the cover as well. On the top, radiating from the base of the knob, are strings of beads and jewels from which are suspended the Eight Precious Things, or *babao (pa-pao)*. The knob itself is painted with tightly overlapping petals and resembles a large flower bud. The jar is covered with

Figure A

transparent glaze that stops on the low foot. A six-character reign mark, *Da Ming Jiajing nian zhi*, "Made in the Jiajing period of the Great Ming Dynasty," is written in two columns on the base in underglaze blue. The painting around the body is, unfortunately, badly worn and scratched in places.

Published: Suzanne Valenstein, *Ming Porcelains*, New York, 1970, pl. 42; Yutaka Mino and Katherine Tsiang, *Apollo*, CVIII, 199, September 1978, p. 161, cif. 11; Yutaka Mino, *Arts of Asia*, XI, 2, March–April, 1981, p. 115, fig. 22.

Overglaze enamel painting was introduced into porcelain decoration in the fifteenth century. In the sixteenth century a more exuberant style involving the use of strong colors and bold patterns developed. The large jars decorated with carp, of which there are several other examples, are among the most impressive pieces from the Jiajing period. A very similar jar, missing its cover, was unearthed in Hepingli, Chaoyangqu, Beijing, in 1967. (Fig. A: *WW*, no. 6, 1972, p. 64, and back cover, fig. 1.)

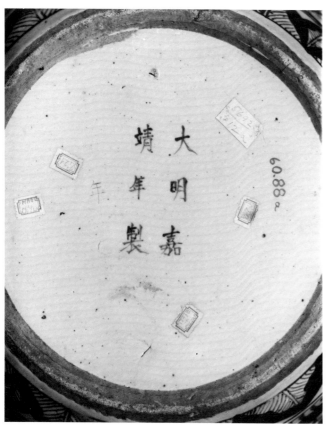

Plate 100, Detail

Plate 101
JAR
Ming dynasty, Jiajing period (1522–1566)
Blue-and-white porcelain
Height, 13½ in. (34.3 cm.); diameter, 18 in. (45.7 cm.)
60.100

The large jar has a wide shoulder, low neck, and thickened mouth rim. On the lower half the sides are nearly straight and taper toward the wide, flat, recessed base. The white porcelain surface has three horizontal bands of ornament painted in deep cobalt blue under the glaze. Sixteen boys are depicted at play in a garden setting in the wide central band. One group of three, playing at scholarly pursuits, is gathered around a table. The boy riding a hobby horse is shaded by another boy holding a lotus leaf. One rides in a small cart pulled by another boy, while still another walks behind with a large fan. The scenes flow continuously around the jar and are bordered below with a row of upright, overlapping leaves. Above, around the shoulder, are four lobed panels enclosing fruit and flower sprays. Between the panels are four precious emblems on a checked ground with small swastikas within each of the squares. A six-character mark, *Da Ming Jiajing nian zhi*, "Made in the Jiajing period of the Great Ming Dynasty," is inscribed in underglaze blue on the base.

Not previously published.

Figure A

A very similar blue-and-white jar with its cover intact was excavated in Chaoyangqu, Beijing, in 1980. The cover is decorated with floral sprays and clouds around the sides and petal panels radiating from the onion-shaped knob on the top. (Fig. A: *WW*, no. 9, 1982, pl. VIII:2.)

Plate 101, Detail

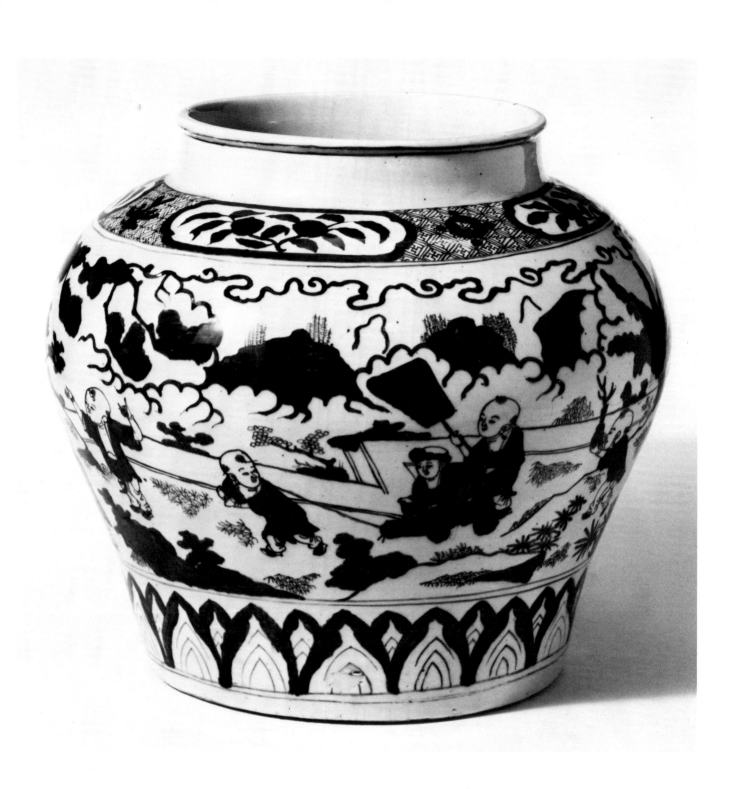

Plate 102
LARGE RING-SHAPED BOX WITH COVER
Ming dynasty, Jiajing period (1522–1566)
Porcelain with underglaze blue and
 overglaze enamel decoration
Height, 3¹⁵/₁₆ in. (10.0 cm.);
 diameter, 15³/₁₆ in. (38.6 cm.)
60.99

The unusual, ring-shaped vessel has straight, vertical sides, a nearly flat top, and a recessed, flat base. The cover is essentially the same shape as the box and fits over the rim of the box. The white porcelain is painted under the glaze with designs in cobalt blue pigment and covered with transparent glaze except on the base and the rims. On the top of the cover is a continuous painted scene comprising twin mountain peaks, a crane, the God of Longevity seated on a large rock, and a young attendant nearby. Approaching the God of Longevity is a procession of the Eight Daoist Immortals among pine and plum trees, bamboo, rocks, and flowers. Close to the edges of the top, bordering the painted scene, are thin double lines. The sides of the box are decorated with stylized lotus scrolls, and the sides of the cover with drifting clouds. The painting around the sides of the cover is bordered by single lines, while that on the lower part is bordered by a single line above and a double line below. On one side of the box is the six-character mark *Da Ming Jiajing nian zhi*, "Made in the Jiajing period of the Great Ming Dynasty," inscribed horizontally in a rectangular panel. The area around this panel and around all of the underglaze painted elements is filled in with a strong overglaze red enamel. The double-line borders on the top of the cover and lower part of the box are filled in with green enamel.

Figure A

Figure B

Published: E.P. Richardson and Paul L. Grigaut, *The Arts of the Ming Dynasty*, Detroit, 1952, no. 171, no illustration.

This is an extremely rare example of its type with a strikingly bold use of color. Only two other ring-shaped boxes are known, both with Jiajing marks. The one in the Metropolitan Museum of Art has very similar ornament painted in underglaze blue. (Fig. A: Warren Cox, *Pottery and Porcelain*, New York, 1944, pl. 140; and Valenstein, *A Handbook of Chinese Ceramics*, 1975, p. 157, pl. 98.) The other, in a private collection in Japan, is decorated with dragons among stylized lotus scrolls. (Fig. B: Ryoichi Fujioka, *Min no Sometsuke, Toji Taikei*, vol. 42, Tokyo, 1975, p. 107, fig. 64.) Unlike the Lilly box, however, neither has any overglaze enamel decoration.

Plate 102, Detail

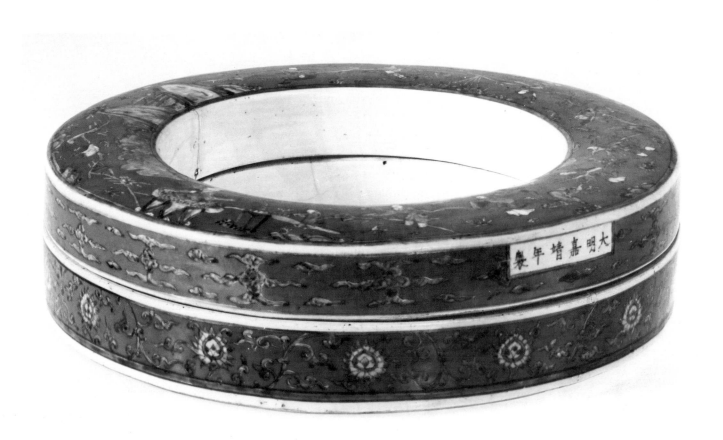

Plate 103
JAR
Ming dynasty, Longqing period (1567–1572)
Blue-and-white porcelain
Height, 5⁵⁄₁₆ in. (13.5 cm.); diameter, 2⁵⁄₁₆ in. (5.9 cm.)
60.96

The body is ovoid in shape, the neck vertical, and the base recessed and flat. The foot is undercut. The white porcelain has horizontal bands of ornament painted in cobalt blue and is covered with transparent glaze, except for the foot rim. Two serpentine dragons cavort among stylized lotus scrolls in a wide central band around the body. Below is a row of upright petal panels and above, on the shoulder, a band of *rui* designs and scrollwork. A narrow key fret band encircles the neck. The six-character reign mark *Da Ming Longqing nian zao*, "Made in the Longqing period of the Great Ming Dynasty," is inscribed on the base within a double ring.

Not previously published.

Because of the brevity of the Longqing reign period—six years—porcelains with this mark are rare. In general they can be seen to carry on the styles of the Jiajing period. It is interesting to note that most of the Longqing marks use the character *zao*, as seen on this piece, instead of the much more common *zhi*, both meaning "to make."

Plate 103, Detail

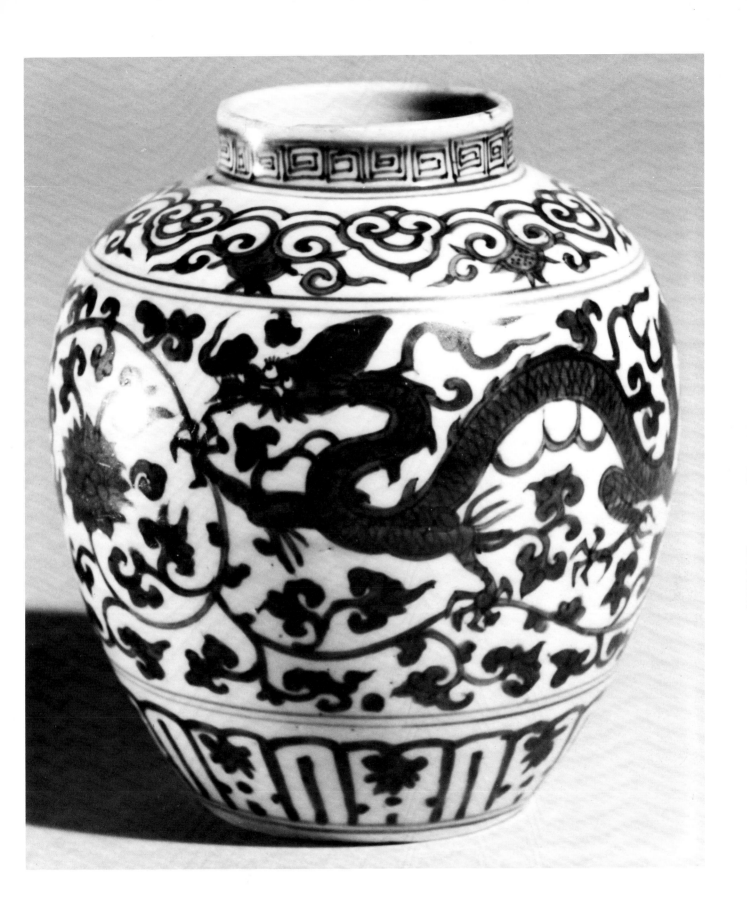

Plate 104
DISH
Ming dynasty, Wanli period (1573–1620)
Blue-and-white porcelain
Height, 1¼ in. (13.2 cm.); diameter, 9½ in. (24.1 cm.)
60.95

The shallow dish has curved sides, an everted mouth rim, and a low foot. The base is recessed and flat. The white porcelain is painted in underglaze cobalt blue with motifs associated with Daoist beliefs. In the center, seated on a rock under a willow tree, is a Daoist sage, probably one of the Eight Immortals. A gnome-like attendant stands beside him holding a bamboo tube. Around him in the landscape are a lizard, a tortoise with a sword piercing its shell, a flying centipede, and artemesia plants and *ling-zhi*, the "fungus of immortality," growing among rocks. The scene is contained within a double-line circle around which, on the sides of the dish, are sprigs of artemesia, palm leaves, and floral sprays, probably all medicinal herbs. On the reverse, alternating with herbs and grasses, are the Five Poisons—the snake, the three-legged horned toad, the centipede, the scorpion, and the lizard—a charm believed to have protective powers. The six-character reign mark *Da Ming Wanli nian zhi*, "Made in the Wanli reign of the Great Ming Dynasty," is inscribed on the base within a double ring.

Not previously published.

The seated figure in the center of the dish is perhaps Zhang Guo (Chang Kuo), usually depicted as a bearded old man carrying a tubular bamboo drum with two sticks inside it. Like the other Daoist Immortals, he is attributed with supernatural powers acquired through the mastery of Nature's secrets. These figures were popular subject matter for art in the Jiajing and Wanli periods, and appear on other porcelain objects in this collection. See the ring-shaped box, in Plate 102, and the figure of Zhongli Quan, in Figure 10.

Plate 104, Detail

260

Plate 105
JAR
Ming dynasty, 16th century
Fahua ware
Height, 6¹¹/₁₆ in. (17.0 cm.);
 diameter 6⁷/₁₆ in. (16.4 cm.)
60.109

The jar has a flattened shoulder, abbreviated neck with a thickened mouth rim, and gently rounded sides that taper toward the foot. The base is recessed and convex. The buff stoneware is decorated in the *fahua* method, with enamel glazes on the biscuit, the colors applied within relief outlines of trailed slip. Around the sides of the jar are three peony sprays, the leaves of which are bright turquoise blue, and the blooms white with a turquoise center; the ground is purple. A band of narrow petals around the shoulder is colored in alternating pairs of turquoise-blue and white. The neck is purple and the mouth, interior, and foot are turquoise. The foot rim is unglazed. On the base, the glaze has been darkened and pock-marked in firing.

Published: Yutaka Mino, *Arts of Asia*, XI, 2, March–April 1981, p. 114, fig. 23.

The name *fahua* refers to the technique of trailing thin outlines of slip on the ceramic body to contain the enamels, keeping the colors from running together. The technique is comparable to that of cloisonné enameled metal, in which metal wires are used to outline the decorative motifs.

263

Plate 106
BOTTLE
Qing dynasty, 17th century
Blue-and-white porcelain
Height, 14½ in. (36.8 cm.)
60.127

The bottle has a slightly depressed globular body, a long, slender neck with a globular swelling about one-third of the way down from the mouth, and a thick, flaring foot. The base is recessed and flat. The white porcelain is decorated with underglaze blue painting and is covered with transparent glaze, except for the foot rim. A group of figures in a landscape setting is depicted on the body. An official traveling with a party of attendants—one holding a canopy over his head, another with a banner, and two grooms carrying long poles—meets a herdsman with his water buffaloes along a riverbank. A willow tree, shrubbery, rocks, and small plants provide a setting for the figures. Beside the water is a steeply eroded embankment. The scene is bordered below with a row of lobed, pendant petals and above with a band of florets and stylized, broad leaves. On the lower part of the neck are three delicately drawn lotuses atop long, slender vertical stems with similar broad leaves. Three smaller, three-pointed flowers with the same stems and leaves appear on the upper part of the neck. On the globular swelling is a horizontal row of lobed petals, like those around the bottom of the body, and a row of trefoil patterns.

Not previously published.

Figure B

Figure A

The political turmoil at the end of the Ming dynasty resulted in a period of decline for the porcelain industry. A revival begun in the middle decades of the seventeenth century and extending into the early part of the Kangxi reign produced a group of fine blue-and-white porcelains, generally referred to as "transitional," between the late Ming and the fully developed wares of the Kangxi period. The foreign flavor of the shape and floral motifs of this piece can be traced to Turkish influence, specifically that of the faience wares made at Isnik. An Isnik bottle of very similar shape, with a bulge in the middle of the long neck and painted decoration in blue and turquoise, is in the Victoria and Albert Museum. (Fig. A: Arthur Lane, *Later Islamic Pottery*, London, 1957, pl. 34A.) It is from the first half of the sixteenth century. A faience dish of the same period is decorated in blue and white with lotuses and stylized leaves that resemble those on the Lilly bottle. (Fig. B: Ibid., pl. 30A.)

Plate 106, Detail

Plate 107
PAIR OF VASES
Qing dynasty, Kangxi period (1662–1722)
Blue-and-white porcelain
Height, 16⅝ in. (42.0 cm.); diameter, 8⅛ in. (20.6 cm.)
60.122
Height, 16¹⁵⁄₁₆ in. (42.9 cm.);
 diameter, 8⅛ in. (20.7 cm.)
60.123

The baluster-shaped vases are nearly identical, each hav-
ing a high shoulder, a rather thick, long neck, and an
everted mouth rim. The lower half of the body tapers
toward the base, then flares outward at the bottom. The
foot is cut in from the edge of the vase. The base is recessed
and flat. The white porcelain is lightly carved, painted in
underglaze blue pigment, and covered with transparent
glaze, except for the foot. Low-relief flowering plum trees
are carved on both pieces. The trunks and branches are
painted in light blue, and the blossoms outlined in blue
and reserved white against surrounding areas of dark
blue. The plum branches appear on the neck of each vase
as well, but they are not continuous with those on the
body. They are cut off at the base of the neck by a narrow
band of delicately painted pine needles and branches
bordered by thin, double lines. The plum branches are
interrupted midway up the neck, as well, by a slightly
raised ring bordered by thin lines. On each vase double
lines encircle the bottom and the top, just below the mouth
rim. A six-character reign mark, *Da Qing Kangxi nian zhi,*
"Made in the Kangxi period of the Great Qing Dynasty,"
is inscribed on the base of each piece within a double
ring.

Not previously published.

Plate 108
LARGE BOWL
Qing dynasty, Kangxi period, dated 1671
Porcelain with underglaze blue and red decoration
Height, 6¼ in. (15.8 cm.); diameter, 15½ in. (39.3 cm.)
60.126

The sides of the nearly hemispherical bowls are curved on the lower half and nearly straight at the top. The foot is thick and has a deep groove cut into the rim. The base is recessed and flat. The white porcelain is painted with floral and abstract scrolling designs in cobalt-blue and copper-red pigments and covered with transparent glaze, except on the grooved foot rim. The interior of the bowl has a six-pointed floral medallion with *lingzhi* motifs between the pointed petals. Within the medallion, among curling blue stems and leaves, are seven red peony blossoms. A double blue circle enclosing the medallion is repeated just below the mouth rim. On the exterior is a wide band of *rui* medallions linked together by tiny *lingzhi* and with *lingzhi* motifs between the medallions at both the upper and lower edges. Within each medallion is a pattern of densely scrolling, stylized leaf patterns and a naturalistically rendered peony spray with a single red blossom. The red is suffused with darker grayish and greenish spots, giving it depth and softness. The blue is applied as a flat wash within thin outlines on the abstract and more stylized elements but is carefully shaded on the more realistic leaves of the peony sprays. An eight-character inscription, *Kangxi Xinhai Zhonghetang zhi*, "Made in the Xinhai year of Kangxi [1671] for the Zhonghe Hall," is written in cobalt blue within a double ring on the base.

Figure A

Figure A, Detail

Figure B

Not previously published.

This bowl, made in the tenth year of the Kangxi reign, is an important dated example of porcelain of the early Kangxi period. The successful combination of underglaze blue and red ornament and the close juxtaposition of abstract and naturalistic floral motifs make it a rare and fascinating piece. A small number of pieces dated to the same year are known, including a large dish decorated with figures standing in a garden, which is in the Percival David Foundation, London (Fig. A: Medley, *Underglaze Blue and Copper Red*, 1976, pl. II, no. 653.), and a pair of small dishes with landscape scenes formerly in the collection of Edward T. Chow. (Fig. B: *The Edward T. Chow Collection*, Sotheby Parke Bernet, Hong Kong, 1980, no. 116.) All of these have the same inscription designating them for use in the Zhonghe Hall, and all are decorated with underglaze blue and red. All have the distinctive, grooved foot rim as well. Closely related pieces, also made for the Yonghe Hall, are dated to subsequent years, 1672 and 1673.

Plate 108, Detail

Plate 109
BOTTLE
Qing dynasty, Kangxi period (1662–1722)
Porcelain with underglaze red decoration
Height, 17 in. (43.2 cm.)
60.115

The body is globular, the neck a very long, slender cylinder, the foot quite small, and the base flat. The impressive white porcelain form is decorated in underglaze copper red with dragons and carp. On the body are two carp leaping up as though completely out of water, each with a tiny dragon issuing from its mouth. Facing each fish is a large, sinuous four-clawed dragon that appears also to be leaping up into the air. On the neck is a third dragon. The painting is executed in thin outlines, each scale individually depicted, with lighter, shaded pigment applied in some areas. The eyes of the fish and dragons are dotted with underglaze blue. A transparent, colorless glaze covers the entire vase except for the foot rim.

Not previously published.

Fish are much appreciated by the Chinese from a purely aesthetic point of view and as an emblem of abundance, harmony, and freedom from restraint. They are frequently depicted in Chinese art. The carp is particularly admired both for its beauty and for its perseverance in swimming against the current to spawn. It is said that those fish who succeed in passing above the falls of *Longmen*, the literal meaning of which is "Dragon Gate," on the Yellow River are transformed into dragons. The legend became a symbol of scholars who pass their official examinations with distinction and was an inspiration to those who strove to attain scholarly degrees and official appointments. This appears to be the theme of the ornament on the Lilly bottle.

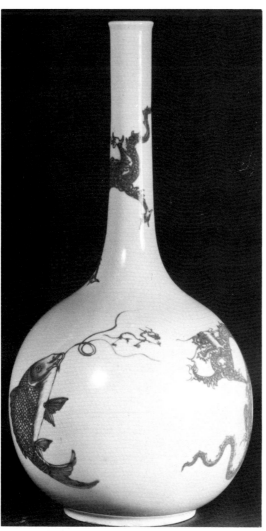

Plate 109, Detail

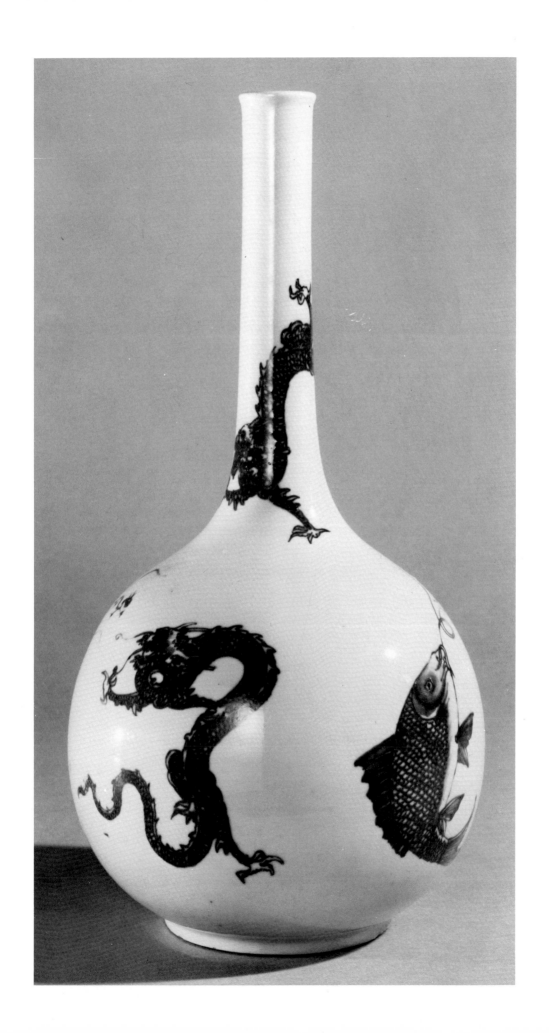

Plate 110

VASE
Qing dynasty, Kangxi (1662–1722)
Porcelain with peachbloom glaze
Height, 8¾ in. (22.2 cm.)
60.125

The vase has an ovoid body, a long, slender neck that flares outward at the mouth, and a small, low foot. Around the bottom of the body, along the foot, is a row of narrow, vertical petals like those of a chrysanthemum. The base is recessed and convex. The white porcelain is covered with a mottled, dusty rose-pink glaze–known as peach-bloom—except on the mouth rim and base, which have a transparent, colorless glaze, and the foot, which is unglazed. A six-character mark, *Da Qing Kangxi nian zhi*, "Made in the Kangxi period of the Great Qing Dynasty," is inscribed on the base in underglaze blue.

Not previously published.

Vessels with peachbloom glaze are known to have been made in only eight specific shapes, all of which are believed to be for use on a scholar's table. These include vases, of which this chrysanthemum vase is one, water containers, a brush washer, and a covered box for red seal ink. (Ralph M. Chait, "The Eight Prescribed Peachbloom Shapes Bearing K'ang-hsi Marks," *Oriental Art,* n.s. 3, 4, 1957, pp. 130–37.) Some of these shapes also appear in other monochrome wares of the Kangxi period, such as *clair-de-lune* and white.

Plate 110, Detail

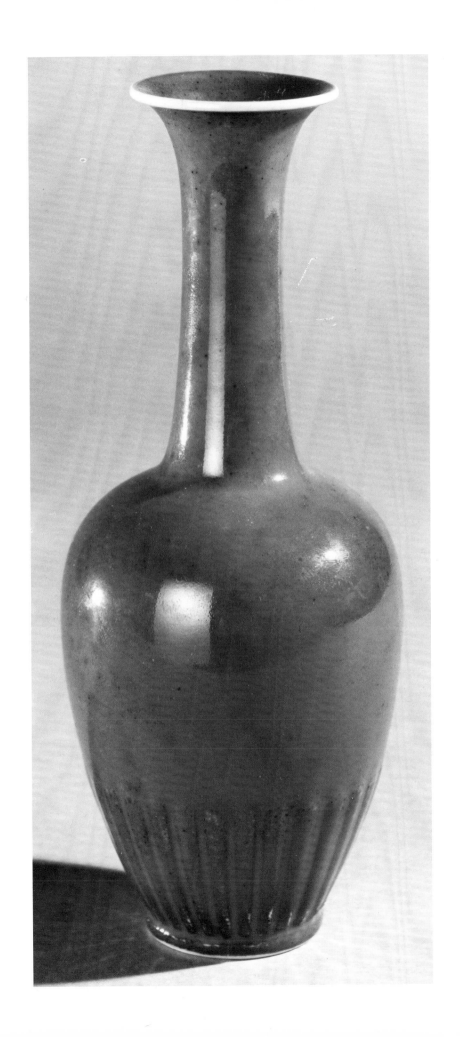

Plate 111
VASE
Qing dynasty, Kangxi period (1662–1722)
Porcelain with *famille verte* enamel decoration
Height, 16¾ in. (42.5 cm.)
60.117

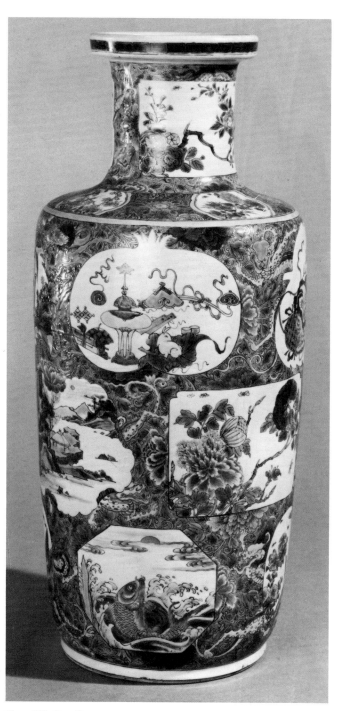

Plate 111, Detail

The cylindrical vase has a high, flat shoulder and cylindrical neck with a thick, everted, and flattened mouth rim. The base is recessed and flat, and has a double ring drawn on it in underglaze blue. The white porcelain is covered with transparent glaze and lavishly decorated with overglaze, polychrome enamels in three shades of green, deep-blue, yellow, grayish-purple, red, and black. Gold accents are used in places, usually with the red enamel. Around the sides of the mouth rim is a key fret band drawn in black and painted over with dark green enamels. On the shoulder are four lobed frames enclosing flowers of the four seasons. The area between them is decorated with colorful blossoms and leaves on a light green ground filled with small spirals. The neck and body are decorated with numerous pictures or views shown though "windows" of various shapes. These are surrounded by peonies and small dragons on a stippled green ground. A very richly patterned effect is created by the dragons cavorting among the dense growth of leaves and brightly colored peony blooms. On the neck are two rectangular windows with a flowering camellia branch in one and chrysanthemums in the other. Three rows of windows appear on the body. In the upper row, two pomegranate-shaped windows alternate with two shaped like mulberry leaves. Each mulberry leaf encloses a lion, one standing by a shore and the other playing with an embroidered ball. The pomegranates contain representations of ancient treasures, instruments of the arts, and emblems of learning and of official rank. In the middle row are two rectangular windows, one with large peonies in bloom and the other with birds and cherry blossoms, alternating with miniature landscape scenes contained within lotus leaves. In the bottom row, a carp leaping out of crested waves appears in one octagonal window and two fish swimming in a pond among aquatic plants are depicted in another. A lotus plant, orchids, and other flowers can be seen in two peach-shaped windows between the fish.

The ornament, of the *famille verte* type, uses transparent enamels and a predominantly green palette. Its fine detail and great complexity, and its juxtaposition of naturalistic representation and ornamental design, are especially remarkable when considered in the light of the harmonious total effect that they create on this impressive piece.

Not previously published.

274

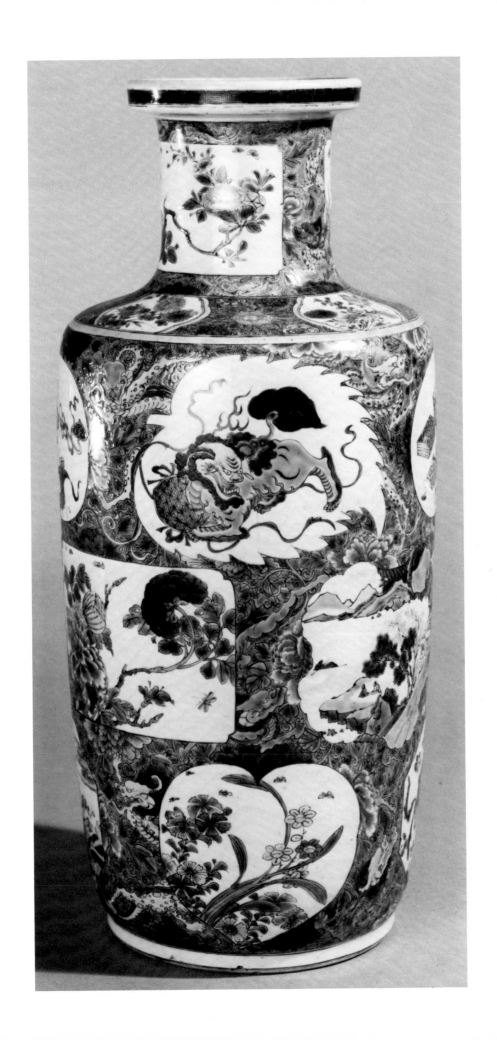

Plate 112
LARGE DISH
Qing dynasty, Yongzheng period (1722–1735)
Porcelain with overglaze enamel decoration
Diameter, 20 in. (50.8 cm.)
60.129

The large dish has rounded sides, an everted mouth rim,
a low, vertical foot, and a recessed, flat base. It is covered
with transparent glaze except on the foot rim and deco-
rated with red, green, and black enamels. On the interior,
a red double character, *shou,* "longevity," is written in
the center in a circular medallion. This is surrounded by
five fluttering red bats, the *wufu,* which also means "five
blessings." The characters are inscribed in solid, deep
orangish-red enamel, while the bats are painted in very
fine outlines and delicately shaded. On the exterior, thirty-
two small bats are reserved on an enameled red ground.
The details of the animals are outlined in black and shaded
with pale green enamel. The six-character reign mark,
Da Qing Yongzheng nian zhi, "Made in the Yongzheng period
of the Great Qing Dynasty," is inscribed within a double
ring in underglaze blue on the base.

Not previously published.

Plate 112, Detail

Plate 113
BOWL
Qing dynasty, Yongzheng period (1723–1735)
Porcelain with *famille rose* enamels
Height, 2⅝ in. (6.6 cm.); diameter, 5¼ in. (13.9 cm.)
60.110

The hemispherical bowl has a nearly vertical mouth rim and a small, vertical foot. The base is recessed and flat. The flawless white porcelain is covered with transparent colorless glaze and painted on the exterior with overglaze enamels of *famille rose* type. Butterflies and flowers are depicted in exquisite detail, arranged in five circular medallions around the sides of the bowl. Each medallion contains a pair of butterflies of different species and two varieties of flowers. The butterflies have finely stippled and shaded wings that are curved to fit into the roundels. One butterfly is shown with a full view of the upper side of its wings and the other depicted with wings half-folded, revealing the underside. The flowers are skillfully arranged between the butterflies, with stems gracefully bending, and the leaves and blossoms that are only partly depicted in order to conform to the circular format. They include the lotus, orchid, peach, and rose. The six-character reign mark, *Da Qing Yongzheng nian zhi*, "Made in the Yongzheng period of the Great Qing Dynasty," is inscribed on the base in underglaze blue within a double ring.

Published: Yutaka Mino, *Arts of Asia*, XI, 2, March–April 1981, p. 114, fig. 24.

About a dozen of these bowls are known, all of them decorated with butterflies and flowers in similarly meticulous manner. (See catalogue of a sale held at Sotheby Parke Bernet, Hong Kong, May 21 and 22, 1979, no. 260.) The development of *famille rose* type enamels in the early part of the eighteenth century, with their opaque colors in many pastel and darker shades, was made possible by the introduction of white to the enameler's palette. (The name *famille rose* refers to the predominance of the color pink on these porcelains.) This allowed the craftsmen to use the enamels much as artists working in European oil paints did, with shading from lighter to darker colors and the application of one color on top of another. *Famille rose* ware with a Kangxi mark is unknown, but by the Yongzheng period (1723–1735) the technique emerged fully developed. The delicacy and refinement of Yongzheng enameled porcelain is unmatched in the Qing dynasty, a period in which Chinese craftsmanship reached the peak of its technical proficiency. The decoration of porcelain in the eighteenth century shows European influence not only in technique, but, with the increasingly intricate styles of ornament that appeared, in taste as well. This Yongzheng bowl is a very fine example of superb technical proficiency governed by a reserved aesthetic sensibility.

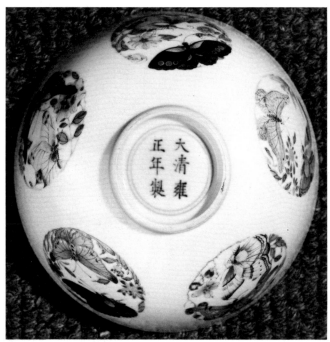

Plate 113, Detail

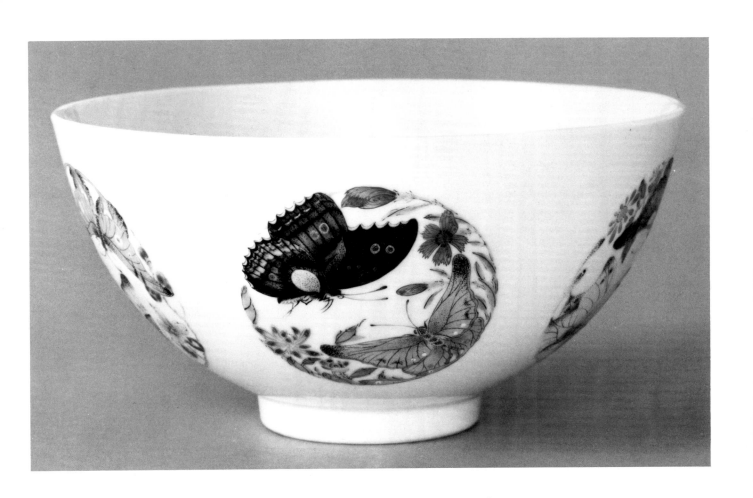

Plate 114
BOWL
Qing dynasty, Yongzheng period (1723–1735)
Porcelain with *famille verte* enamels on a black ground
Height, 2⅝ in. (6.7 cm.); diameter, 5⅝ in. (14.6 cm.)
60.111

The nearly hemispherical bowl has curving sides and a small, vertical foot. The white porcelain is covered with transparent colorless glaze and decorated with overglaze enamels on the exterior. The ornament consists of stylized lotuses and peonies painted in blue, yellow, red, and grayish purple among curling green tendrils and white leaves with red veins, all on a black enamel ground. On the base, inscribed in underglaze blue within a double ring is the six-character reign mark, *Da Qing Yongzheng nian zhi*, "Made in the Yongzheng period of the Great Qing Dynasty."

Not previously published.

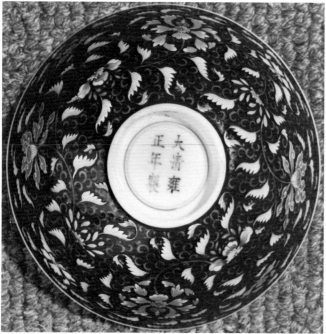

Plate 114, Detail

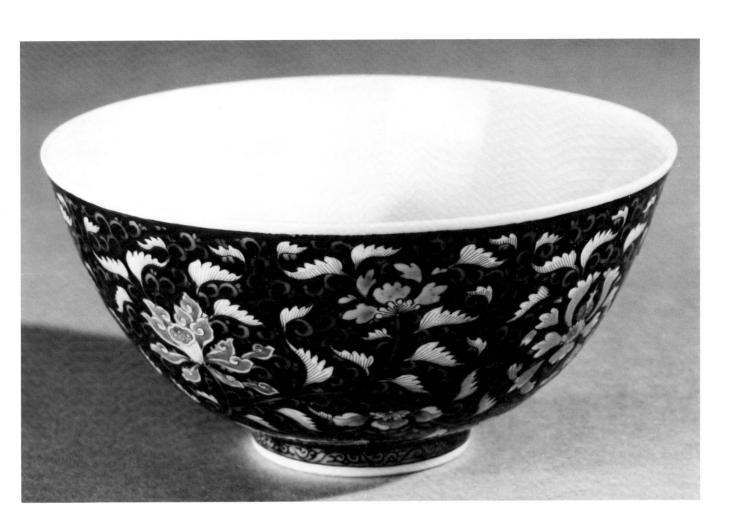

Plate 115
VASE
Qing dynasty, Qianlong period (1736–1795)
Porcelain with *famille rose* enamel decoration
Height, 19¾ in. (50.3 cm.)
60.116

The large vase has a nearly globular body and long cylin-
drical neck. The base is recessed and flat. The white por-
celain is covered with faintly bluish, transparent glaze
and decorated with overglaze enamels of *famille rose* type.
Two large boughs of a peach tree bearing large fruit and
double flowers among slender leaves grow upward from
the bottom of the vase. The larger, forked bough is painted
in tones of gray and black, while the other is a warm
brown color. There are nine peaches in all, the skin mot-
tled with pink and pale green. The delicate white blos-
soms are tinged with green and the petals edged with
pink. The centers, surrounded by clusters of fine sta-
mens, are yellow. The white enamel is thickly applied and
stands out from the surface of the vessel. The slender,
twisting leaves are painted in two shades of transparent
green enamel, bluish green on the top and yellowish green
on the underside, and their veins are outlined in black.
The representation of the various stages of growth of a
peach tree all together—blossoms, young leaves and ripe
fruit—creates a highly successful ornamental effect. A
six-character reign mark, *Da Qing Qianlong nian zhi,* "Made
in the Qianlong period of the Great Qing Dynasty," is
inscribed in seal script in underglaze blue on the base.

Published: *Treasures of Chinese Art,* Louisville, 1965, pl. 43, no illustration.

Plate 115, Detail

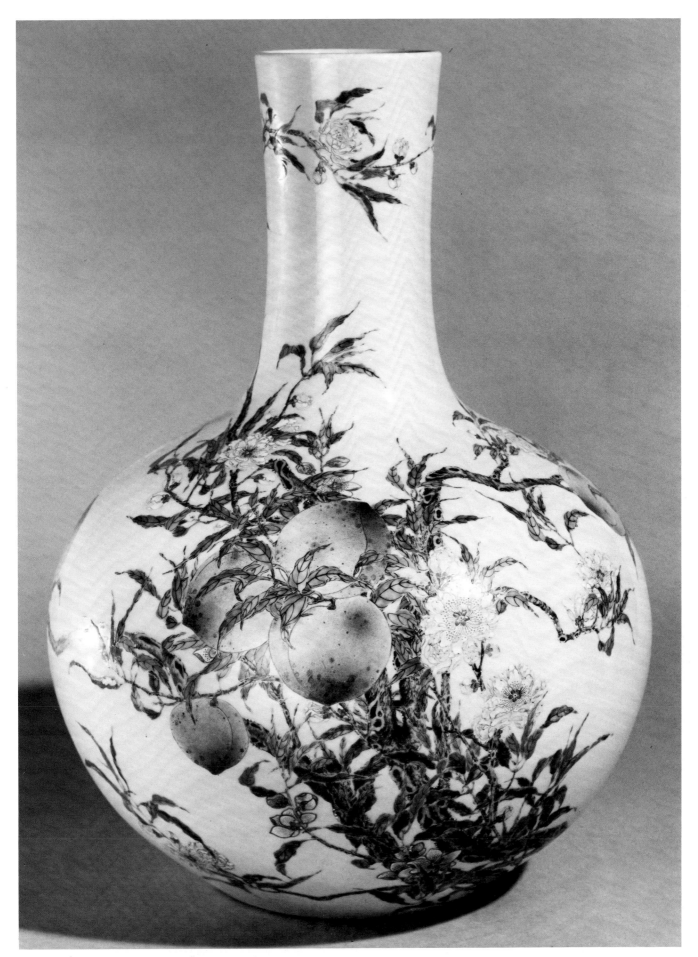

Plate 116
FLASK
Qing dynasty, Qianlong period (1736–1795)
Blue-and-white porcelain
Height, 9½ in. (24.1 cm.)
60.147

The body of flattened circular shape is supported on a splayed rectangular foot. At the top is a nearly cylindrical neck with an everted mouth rim. Two loop handles made in the form of *rui* scepters are attached to the middle of the neck and to the shoulders. The white porcelain is decorated with underglaze cobalt blue painting and covered with a bubbly, transparent glaze. A ring of stylized floral scrolls encircles a raised peach-shaped medallion on either flat face. The central area is decorated with five peaches on a leafy branch with two small bats hovering about. The narrow sides are decorated with *lingzhi* scrolls, as is a narrow border at the top of the neck. On the lower part of the neck a row of *rui* lappets appears above a floral scroll band. A band of leafy scrolls also encircles the foot. The cobalt pigment is applied in small, dark dots within fine outlines, simulating the "heaped and piled" effect of blue-and-white porcelains of the early Ming dynasty. A six-character seal mark, *Da Qing Qianlong nian zhi*, "Made in the Qianlong period of the Great Qing Dynasty," is inscribed in underglaze blue on the base.

Not previously published.

Plate 116, Detail

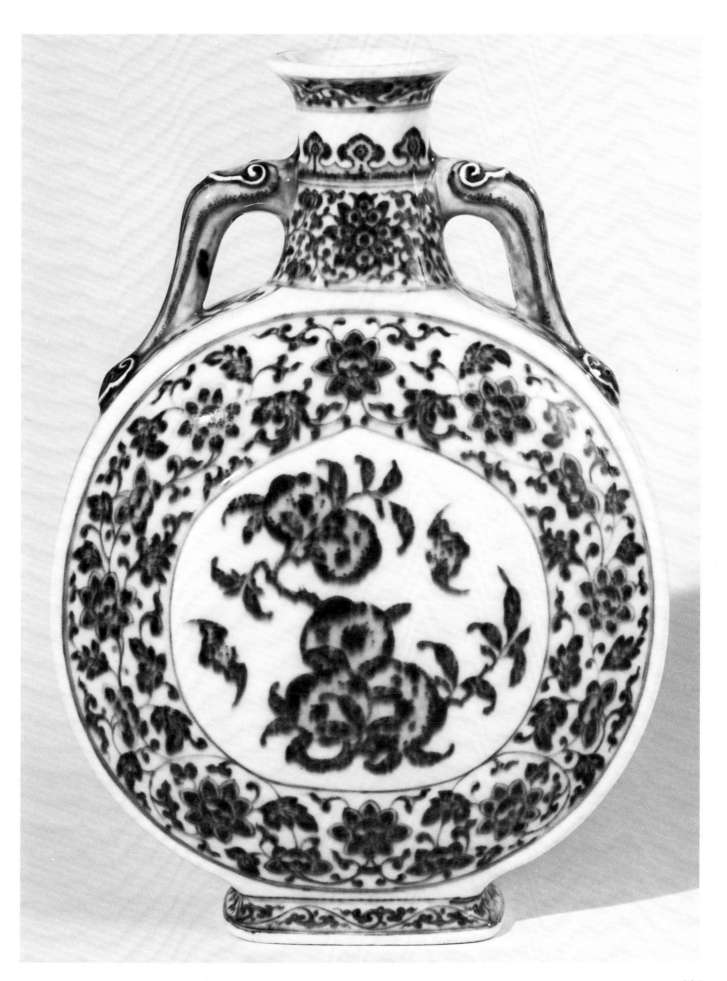

Plate 117
BOWL
Qing dynasty, Daoguang period (1821–1850)
Porcelain with *famille rose* enamels
Height, 2⁷⁄₁₆ in. (6.2 cm.); diameter, 6 in. (15.2 cm.)
60.134

On the upper half the bowl has nearly straight sides that widen toward the mouth. The lower part of the bowl curves under toward the vertical foot. The white porcelain is painted with overglaze enamels of *famille rose* type. The exterior is decorated with stylized, symmetrical floral designs of bright colors on a yellow ground between four oval reserves. The yellow enamel is finely engraved with a delicate pattern of curling fronds. In the oval windows are miniature landscapes of the four seasons rendered predominantly in muted gray tones and soft colors. In the bottom of the bowl is a colorful eight-pointed floral medallion with gold accents on the red enamel. The six-character reign mark written in seal script, *Da Qing Daoguang nian zhi,* or "Made in the Daoguang period of the Great Qing Dynasty," appears in underglaze blue on the base.

Not previously published.

Plate 117, Detail

A nearly identical bowl was shown in an exhibition organized by the Oriental Ceramic Society in 1964. (*Arts of the Ch'ing Dynasty,* London, 1964, no. 239.) Another was sold at auction in recent years. (Catalogue of a sale held at Sotheby Parke Bernet, Hong Kong, 1977, no. 221.) Bowls of this type, sometimes known as "Peking medallion" bowls, were first made in the Qianlong period (1736–1795). The engraved enamel ground could be yellow, deep-pink, lavender, blue, or red. This and many other styles of ornament were continued into the succeeding Jiaqing and Daoguang periods (1796–1850) with little change. A general decline in quality becomes apparent in the nineteenth century, although, as seen in this bowl, some very fine examples were still produced.

Plate 117, Detail

Plate 117, Detail

Plate 118
BOWL
Qing dynasty, Daoguang period (1821–1850)
Porcelain with *famille rose* enamels
 and underglaze blue decoration
Height, 2½ in. (6.4 cm.); diameter, 5⅞ in. (15.0 cm.)
60.133

The sides of the bowl are nearly straight at the top, widen toward the mouth, and curve under at the bottom toward the small vertical foot. The interior is decorated in underglaze blue with a basket of flowers in a double circle in the center and four groups of flowering and fruiting sprays around the sides. The exterior is painted in overglaze enamels. Four roundels are reserved on a deep ruby-pink ground with rather stiff, symmetrical floral designs between them. The pink enamel is finely engraved with small, delicate, wispy fronds. Each of the roundels is bordered by a circular band of gold and decorated with a group of flowering and fruit-bearing plants, much as seen on the interior. The plants represented include the pomegranate, loquat, hibiscus, peach, and camellia. A six-character reign mark, *Da Qing Daoguang nian zhi*, "Made in the Daoguang period of the Great Qing Dynasty," is written in seal script on the base.

Not previously published.

This bowl is closely related to the preceding one, Plate 117.

Plate 118, Detail

Plate 118, Detail

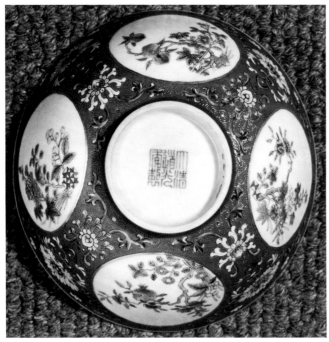

Plate 118, Detail

288

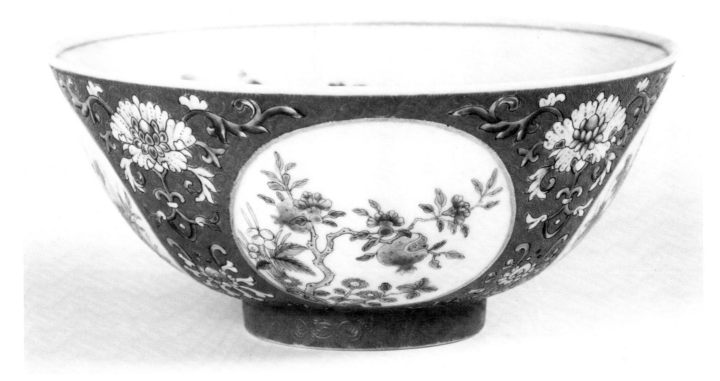

Plate 118, Detail

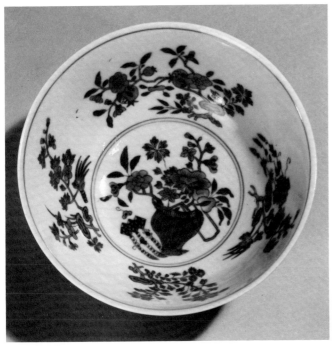

Plate 118, Detail

美与宁静

癸亥暮春 君约傅卯署

Painting

Plates 119–130

Plate 119
RETURNING FISHERMAN *(YUFU GUIZHUANG)*
Hsia Kuei (Xia Gui, active ca. 1200), attributed to
Southern Song dynasty, middle to late 13th century
Ink and light red wash on silk
Height, 9⅜ in. (24.4 cm.);
 width, 10⅛ in. (25.8 cm.)
61.80

Though he was one of the more famous artists of the
Southern Song dynasty, little is now known of Hsia Kuei's
personal and artistic life. He was born during the late
twelfth century in or near the capital at Hangzhou, Zhe-
jiang. He apparently died sometime during Lizong's reign
(1225–1264), having reached the highest rank possible
for a court painter in the reign of Ningzong (1195–1224).
Hsia Kuei is usually linked with his equally famous con-
temporary, Ma Yüan, in the designation of the "Ma-Hsia
School" of painting that became synonymous with the
Southern Song Academy. Through the centuries, this
academic style has been both praised and vilified by
Chinese critics. Hsia Kuei's distinctive styles have been
reinterpreted by many artists, but few, if any, could rival
the concise clarity of his images.

Signed: Your servant [*chen*] Hsia Kuei.

4 seals: 1 seal of Ch'en Ting (Chen Ding), 17th century;
3 seals unidentified.

Published: Ludwig Bachhofer, *Die Sammlung Del Drago*, 1932, pp. 193–
194; Ludwig Bachhofer, *Art News*, May 1937, pp. 127 and 129; Ludwig
Bachhofer, *A Short History of Chinese Art*, New York, 1949; James Robin-
son, *Arts of Asia*, XI, 2, March–April 1981, p. 89, fig. 1.

Within the large number of extant paintings attributed
to Hsia Kuei, two of the better stereotypical waterside
images have passages comparable to this album leaf. One
is a landscape album leaf in the Tokyo National Museum
from the Setsu Collection and the other is the *Twelve Views
of Landscape* in the Nelson Gallery-Atkins Museum, Kan-
sas City. (Fig. A: Suzuki, *Suiboku*, vol. II, no. 14, and Fig.
B: *Eight Dynasties*, 1980, no. 58). Together they share a
similar view of a gently rising plateau, six trees in two
groups, arching shoals, and moored boats. The tops of
the plateaus are smoothly washed, and the sides are ren-
dered with slanting "axe-cut" texture strokes beginning
just below a blank band that designates the edge. The
dark foreground and light distant trees are depicted with
washed trunks bounded by thick strokes, and they have
foliage that softly blurs together.

Beyond their compositional similarities, there are some
telling differences which, with the benefit of hindsight,
suggest that the Lilly album leaf comes from a milieu that
follows the crystallization of a Hsia Kuei tradition. The
precise repetition of the two foreground trees, the exces-
sively abbreviated skiff, and the even simplicity of the
texture strokes on the sides of the land forms all engen-
der a sense of flatness and frailty in the painting that is
not present in the more widely accepted works by Hsia

Figure A

Figure B

Kuei or his contemporaries. In contrast to the two illus-
trated works, this work lacks depth in the texture strokes
that casts a sense of thinness on the image. The differ-
ences are not great, especially when compared to Ming
dynasty recensions, but they are sufficiently evident to
create doubts about the authenticity of the Hsia Kuei
signature.

Returning Fisherman is nevertheless a delicate, lyrical
work, typical of the quiet, waterside scene that became a
classic standard during the Southern Song. The use of
soft red bands of wash above the distant mountains is a
subtle touch that is very reminiscent of Ma Lin's *Land-
scape in Evening Glow*, dated 1254, in the Nezu Art Museum.
(See Suzuki, *Suiboku*, vol. II, no. 43.) Actually, the rela-
tionships of the Lilly painting to Hsia Kuei and to Ma
Lin, and the latter's artistic relationship to his father, Ma
Yüan, strongly suggest that the *Returning Fisherman* is the
work of a middle to late thirteenth-century master closely
working in the Hsia Kuei tradition. In this light, the Lilly
painting joins several other works that have unclear read-
ings of the character in the signature following "Hsia,"
but that can confidently be ascribed to thirteenth-
century artists working in the academic traditions. (See
Eight Dynasties, 1980, nos. 59 and 60.) As such, this sen-
sitive and evocative image is an important document of
the continuity in the academic style centered around
Hangzhou at the close of the Southern Song dynasty.

Plate 120
TIGER *(HU)*
Mu-ch'i (Muqi, active mid 13th century), attributed to
Yuan dynasty, 14th century
Ink on silk
Height, 40¼ in. (102.2 cm.); width, 17⅞ in. (45.5 cm.)
60.46

Until the twentieth century, Mu-ch'i was an artist who had been practically forgotten by his Chinese compatriots. When he is remembered in historical and critical works, the memory is vague and often distinctly unpleasant. His origins were in the western province of Sichuan, but he spent most of his life around the Southern Song capital at Hangzhou. While in the environs of the capital, Mu-ch'i lived in a world divorced from the court, not only because of reported insult(s) he made to a prime minister, but also because he was a monk of the Chan (Japanese: Zen) sect of Buddhism. Once a student of the great master Wu-chun Shih-fan (Wuzhun Shifan, d. 1249), Mu-ch'i became head abbot at the Liutong monastery. It was from this modest Chan temple that Mu-ch'i affected a small Chinese following and greatly influenced Japanese art. He was famous in Japan, and the paintings taken home by Zen monks who went to China were reverently cherished. One Japanese monk-painter, Moku'an, went to China in the years 1326 to 1328 and became so proficient in Mu-ch'i's style that he was hailed as the second Mu-ch'i and given his seals. Often copied and certainly influential on later ink painters, several of Mu-ch'i's works have been preserved in Japan—a fate not always shared by his works that remained in China.

Artist seal: Mu-ch'i
1 seal of the third Ashikaga Shogun, Yoshimitsu (1358–1408, r. 1368–94)

Not previously published.

Figure A

Figure B

Figure C

Figure D

Plate 120, Detail

294

The most famous tiger by Mu-ch'i is the large hanging scroll, signed and dated (1269), in the Daitokuji, Kyoto. (Fig. A: Fontein and Hickman, *Zen Painting,* 1970, cat. no. 10). It is paired with a dragon, and both carry a five-character inscription. Several scholars have correctly alluded to the Daoist, cosmological, or Chan connotations of this pair of beasts. However, in the case of the Daitokuji images, as the phrases on these paintings are taken directly from the composition on "Sage Rulers Obtaining Virtuous Ministers" by Wang Pao (a fellow native of Sichuan active during the first century B.C.), it may be best to see these paintings in more Confucian and/or political terms.* Doing so expands the hitherto narrowly recognized Chan dimensions of Mu-ch'i's interests and grants him a broader field of subject matter. In Japan the tiger and dragon pairing certainly accrued other meanings, and their great popularity and frequent pairing may in no small part be credited to Mu-ch'i, their most renowned painter.

In the fifteenth-century records of the Shogunal collection, three pairs of dragon and tiger paintings were inventoried as works by Mu-ch'i. One pair that is often thought to be one of the three is the signed Daitokuji set mentioned above. Another pair that may have been in the Shogunal collection is the pair now in Cleveland that has a seal(s) of the Ashikaga Shogun(s). (Fig. B: *Eight Dynasties,* 1980, cat. no. 63.) The *Tiger* in the Lilly collection is a likely candidate for being half of the third pair, as it has the Doyu seal of Yoshimitsu. (The dragon that could conceivably have been paired with this painting may be the hanging scroll in the Akimoto Collection. Fig. C: *Higashiyama Gyobutsu,* cat. no. 7. Like the Lilly scroll, this has both a Mu-ch'i and a Doyu seal, the dimensions are compatible, and it lacks the complementing tiger scroll.)

A fourth pair of paintings should be mentioned: a second pair in Daitokuji. (Fig. D: *Shina meiga hokan* [The pageant of Chinese painting], Tokyo, 1936, pl. 198.) Between any two of these four depictions of a tiger, one can find similarities that are not shared with the other two paintings. Some of the major differences are worthy of note. The tiger in the first Daitokuji set (dated 1269, Fig. A) is poised in a position of regal aloofness and solidly placed within separated floral motifs at either side and above. The second Daitokuji tiger (Fig. D) and the Cleveland tiger (Fig. B) both portray bamboo and grasses that overlap the tiger, often becoming confused with its stripes and tending to reduce the immediate presence of the beast. The Lilly example maintains the separation of vegetation and tiger, but lacks the upper, overhanging

Plate 120

motif characteristic of Mu-ch'i's so-called Liutong school. There is an appreciable difference in the patterns of the stripes, a characteristic intrinsically important to the tiger. The tiger in the first Daitokuji set has stripes that close at both ends (to create spaces like parted lips) and are disposed over the body from the head to the tail to emphasize the curved parts of the tiger's form. A decline in the emphasis of the stripes can thus be seen from the Lilly tiger through the second Daitokuji image to the Cleveland example.

In several significant aspects the Lilly tiger is closest to the great model of the first set at Daitokuji, yet in the quality of brushwork, it falls appreciably short, though it

Figure A

Figure B

Figure C

Figure D

surpasses the tiger of the second Daitokuji set. One motif, even though quite minor, is indicative of the painting as a whole and suggestive of a more accurate attribution. The telling motif is the thorn plant that rises from the cluster of leaves at the ground edge, beneath the jutting chin of the tiger.

The thorn is a rather common motif in Chinese paintings, especially in those with birds or epidendrums. Song and early Yuan artists invariably portrayed the plant rather faithfully, particularly emphasizing its naturalistic qualities. The present thorn has unnatural bends, barbs of uneven taper that tend to look like thin leaves, and a wavering line that depicts the stalk abruptly and meaninglessly, thinning where it should be strongest. In short, the thorn lacks the attention to significant, naturalistic aspects so characteristic of the detailed and abbreviated images of thirteenth-century China.

If this painting does not meet the high standards of quality we set for Mu-ch'i, there seem to be two possible alternatives for an attribution. One solution is to attribute the painting to a Japanese artist active in the early Muromachi period (1331–1573) when artists frequently drew inspiration directly from ink paintings imported from China rather than drawing it from nature. Painters such as Tesshu Tokusai (d. 1366) or Gyokuen Bompo (1348–after 1420) come to mind. However, it is not easy to explain why the painting was so quickly accepted as a Chinese one. The seal of Yoshimitsu sets a terminal date, and also identifies this painting as part of a collection of Chinese paintings that included some of the finest works that were then in Japan. Another, more likely possibility is that a Chinese follower or disciple of Mu-ch'i painted the tiger. The painting could thus be seen as an example of the second generation, or the mid-fourteenth century, followers of Mu-ch'i. Either possibility places this interesting painting in a milieu that remains to be properly defined.

*The composition by Wang Pao is included in his biography. (See *Han-shu puchu*, ch. 64 xia, p. 62 in *Erhshihwu shih*, vol. 4, p. 1288.) The relevant passage may be fully translated, after Fontein and Hickman, as "The world must have a sovereign of sagely wisdom and only then will there be officials of virtuous enlightenment. Analogously, as the tiger roars, the wind impetuously blows; and as the dragon rises, the clouds begin to appear." Thus the order of these auspicious signs should be tiger first and dragon second. Furthermore, the symbolism is complete as a diptych without the central Buddhist image that the Japanese have sometimes added. (See Fontein and Hickman, *Zen Painting*, 1970, cat. no. 10, and Shimizu and Wheelwright, *Japanese Ink Painting*, 1976, cat. no. 27.) The implication of enlightened rule that the tiger and dragon signify is an apt explanation for why the great Song emperor and artist Huizong (r. 1101–1126) may have painted a tiger and dragon set.

Plate 121

OLD TREES, BAMBOO, AND ROCKS
 (GUMU ZHUSHI)
Li K'an (Li Kan, 1245–1320), attributed to
Yuan dynasty, 14th century
Ink on silk
Height, 62⅞ in. (159.5 cm.); width, 33¾ in. (85.7 cm.)
60.142

Li K'an came from a family of scholars that for three generations had served the government in prominent positions. Having been born in the north, Li K'an knew no rulers other than the Mongols, and he was thus spared the physical and psychological hardships of witnessing the government's defeat, unlike the Chinese of the Southern Song in 1280. He was fortunate to have been active during one of the more enlightened periods of Mongol rule, as his epitaph emphasizes:

> At the outset of the monarchy of Renzong [1311–1320], the country was at peace with a flourishing civil administration—a time when good, able, and talented scholars of the arts were all placed on the [Emperor's] left and right. . . . At that time, the learned and literarily competent academicians of the dynasty . . . [list] all received fond devotion, for the intelligentsia admired their brilliance. Master Li was among them, his age and virtue were both revered . . .
>
> His literary pursuits [occupied his] spare time. He enjoyed depicting old bamboo, trees, and rocks . . . and prominent officials and eminent people contended to obtain his paintings. Seekers daily came to his door and the master did not reject them. [Chen, *Yuandai huajia*, p. 102.]

While middle aged, Li K'an moved south to Qiantang, Zhejiang, where the great Yuan traditions of painting were beginning to blossom. Yet from his youth through old age, Li K'an was always held in high esteem by the court. Li's stature was such that when he retired with an honorary title, his son was given a post nearby so that he could attend his father. (See *Eight Dynasties*, 1980, cat. no. 104.) Li K'an died at the venerable age of seventy-five in 1320.

Figure A

Figure B

Li K'an was an acknowledged master of bamboo painting, and several of his excellent works on that theme are still extant. He wrote the first painter's manual on the subject of sketching and painting bamboo, in which he stressed the importance of direct observational experience. (His emphasis on direct visual experience may have been influenced by his father, who, as recorded in Li K'an's own epitaph, was famous for his detailed studies of astronomy and calculations for the calendar.) Li K'an's son, Li Shih-hsing (Li Shixing, 1283–1328), was a famous artist in his own right. Shih-hsing's fame rests solely in his paintings of old trees. While certainly a specialist in bamboo painting, the father was also undeniably a master of the old tree theme. Recently the Lilly painting was praised as perhaps "the starkest and most powerful image of old trees surviving from the Yüan period." (Barnhart, *Wintry Forests*, 1972, cat. no. 8.)

3 seals: 1 possibly of Chen Ping-hu (18th century, [X]fenguan zhencang); others unidentified.

Published: Osvald Siren, *Chinese Painting*, vol. 6, New York, 1958, pl. 50; Sherman E. Lee and Wai-Kam Ho, *Chinese Art Under the Mongols*, Cleveland, 1968, no. 224; Richard M. Barnhart, *Wintry Forests*, New York, 1972, no. 8; *The Connoisseur*, 181, 172, December 1972, p. 280; Yutaka Mino and Katherine Tsiang, *Apollo*, CVII, 199, September 1978, p. 162, no. 12; Wai-kam Ho, *Bunjinga suihen*, vol. 3, 1979, no. 59; James Robinson, *Arts of Asia*, XI, 2, March–April 1981, p. 88, fig. 2; She Ch'eng, *Landscape Painting*, vol. 2 of *Zhonghuo shuhua*, Taibei, 1981, p. 37, fig. 20.

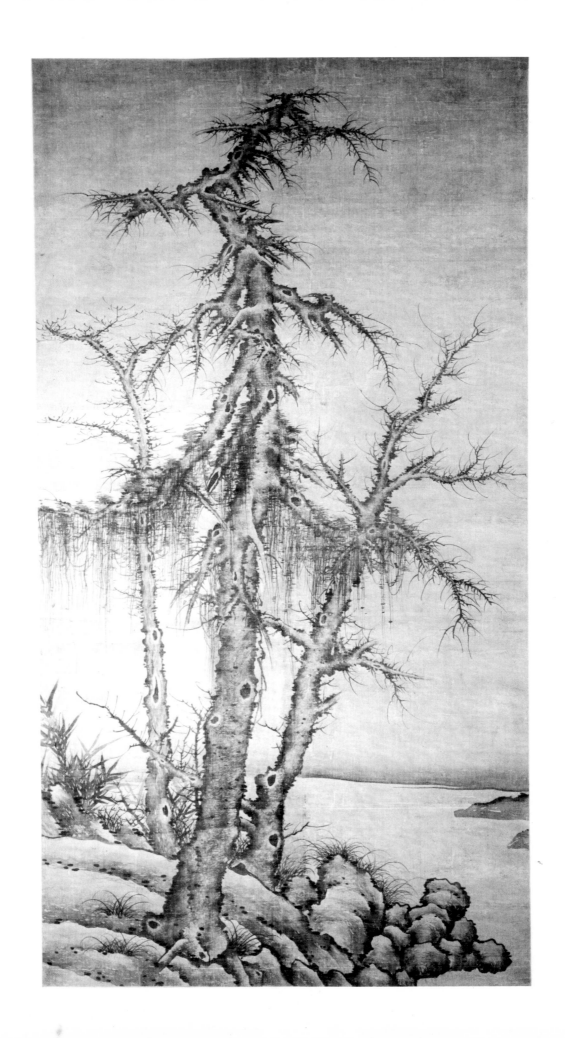

The subject matter of old trees, with or without a cold stream nearby, was a theme of great antiquity even in Li K'an's own time. During the Tang dynasty it was the first theme to break away from the larger genre of landscape painting and become established in its own right as a major division of subject matter. The traditional stereotype is a majestic, leafless tree in a lonely, rugged landscape that reflects the harsh winter the tree has endured. Invested with the symbolic personification that Chinese artists were inclined to impart to landscape painting in general, the powerful image of the lofty tree still proudly standing has become one of the most revered subjects in Chinese painting.

The Lilly painting, which has one grand tree accompanied by two younger trees, is without a signature, colophon, or seal. *Old Trees, Bamboo, and Rock* has nothing but the image itself upon which to rest an attribution to Li K'an. To this end it is worthwhile to view his son's rendering, dated to 1326. (Fig. A: *Eight Dynasties,* 1980, no. 104.) By comparing the shape and structure of the central and right-hand trees in the Lilly painting with the 1326 scroll in The Cleveland Museum of Art, one notices several strikingly similar passages in the upper halves of the trees. Of special interest are two middle branches, located about halfway up the central trees. One is the longest branch extending to the left from the central tree. In the Lilly painting, it can be read as crossing a branch from the left-hand tree, while in the Cleveland painting, which lacks the tree to the left, it reads as a part of the main branch—as a limb that circles back on itself. The

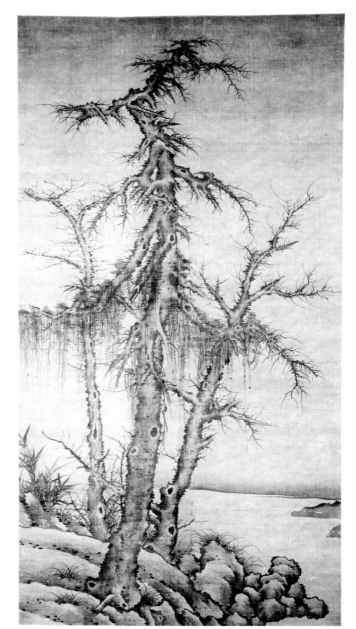

Plate 121

Figure A

Figure B

other noteworthy branch is the longest branch extending to the right from the central tree. In the Lilly painting, it is again a long branch that crosses a tree, this time the right-hand tree. In the Li Shih-hsing painting the analogous passage is composed of two stubby branches; the central branch stops at the right-hand tree trunk, and a new branch issues forth from the trunk of the right-hand tree. The implication seems to be that either the trees in these two paintings are variations by the same person or that the son did indeed closely follow his father.

The authorship of the Lilly painting can be established by the hanging scroll in the National Palace Museum, Taibei, entitled *Twin Pines (Shuangsong tu)*, which has Li K'an's seal. (Fig. B: Wang, *KK 300*, no. 155; YV18.) The articulation of space, the grasses, and contour of the rocks to the right of the trees are obviously similar to those elements in the Lilly scroll. Other similarities, such as the sparse clustering of dots on the ground and, along the silhouettes of the trees, the shape and ink tones of the low clumps of bamboo, the softly modeled land forms, and the short texture strokes of the tree bark all indicate these two paintings are the products of the same hand. The strong sense of verticality, the clarity of branches—either under vines or as they overlap each other—the restrained variety of forms that avoid repetition, and the softness of ink tones throughout all distinguish Li K'an's approach to this venerable theme from the more consistent and heavier hand of his son, Li Shih-hsing. It is thus appropriate to continue the traditional attribution of *Old Trees, Bamboo, and Rocks* to the great early Yuan master, Li K'an.

Plate 122
YAKSHAS LIFTING THE BOWL (YAOCHA JIEBO)
Wang Chen-p'eng (Wang Zhenpeng, early 14th
 century)
Yuan dynasty, 14th century
Ink on paper
Height, 12¼ in. (31 cm.); length, 63¾ in. (162 cm.)
60.35

Soon after the Mongols had established the Yuan dynasty, they actively supported and practiced the Chinese arts of painting and calligraphy. Several famous Chinese artists worked at the court, but none was prized more than Wang Chen-p'eng. Wang assumed a position in the Imperial Archives in 1314 and thus had the opportunity to examine and copy the antique paintings of the imperial collection. He was a favorite of the Princess Sengge (ca. 1283–1331) and her brother, Emperor Renzong (Buyantu, r. 1311–1320). The former, who commissioned paintings by Wang, was an avid patron of the arts and had the most famous collection in the royal family. The Emperor himself bestowed on Wang the name "Hermit of the solitary cloud," which is the legend of the seal in the lower left corner of this painting. (See Chen, *Yuandai huajia*, 1980, pp. 260–265.)

Known primarily as a painter of architecture (*jiehua*), Wang was without parallel in the precision of his draftsmanship and the accuracy of his designs. The amazing complexity and detail of his paintings may have been responsible for much of the great admiration that the Mongols had for his art. The figure and landscape style of Wang Chen-p'eng, with its dense, repetitive strokes and conscious use of formal patterns to supplant the varying designs of the natural world, clearly illustrates one of the most crucial aesthetic changes that took place in the art of the Yuan dynasty. Wang's achievements are too often overlooked, but his contributions to boundary painting and its related figure style deserve the same respect now that they had in their own time.

Artist seal: ci Guyun chushi zhang.

8 colophons and 14 seals: 1 colophon and 2 black seals by T'ing-chün Yung-chang (Tingjun Yongzhang) dated to April 21, 1363; 1 colophon by monk Hung-tao (Hongdao) dated to January 3, 1390; 1 colophon and 2 seals by monk Shou-jen (Shouren) dated to March 19, 1390; 1 colophon by Naito Konan dated to November 15, 1902; 1 colophon by Pai Chien (Bai Jian) dated to 1935 with T'ao Chu (Tao Zhu), Hsüeh Hsüeh-tsan (Xue Xuezan), P'eng Wei-tzu (Peng Weizu), Hsü An (Xu An), Chiang Tsu-i (Jiang Zuyi), and P'an Hou (Pan Hou); 1 colophon and 1 black seal by Tuan Fang (Duan Fang) dated to October, 1908; 1 colophon and 2 seals by Ti Ping-tzu (Di Pingzu) dated to 1924; 1 colophon by monk Lang-wu (Langwu, 20th cent.); 2 seals of Chang Heng (Zhang Heng, 1915–1963); 8 seals of Wang Chi-ch'ien (20th cent.); 3 seals unidentified: Jingzhai zhencang, Shuanglin shuwu, and Xiyu biwan.

Plate 122, Details

Published: Cheng Chen-to, *Yün-hui-chai*, Shanghai, 1942, no. 28; Cheng Chen-to, *Wei-ta-ti-i-shu*, vol. 2, Shanghai, 1952, pl. 4; James Robinson, *Arts of Asia*, XI, 2, March–April 1981, pp. 93–94, fig. 9; Julia K. Murray, *Artibus Asiae*, XXXXIII, 4, 1981–1982, pp. 253–268, figs. 8–10.

The first colophon following the painting, written by the monk T'ing-chün Yung-chang in 1363, explains the confrontation between the Yaksha Demons' Mother (Hariti) and the Buddha.

Once upon a time among the living, there was a Pratyeka-Buddha who achieved the results of the Buddha-way [i.e. nirvana]. The four vargas [monks, nuns, male and female devotees] were happy and rose to dance. On the road they met

302

Plate 122, Left

Plate 122, Right

with a female cowherd who was with child, and forced her to dance [with them]. Consequently she had a miscarriage, and made an oath saying, "In my next life my children will be exhaustively bountiful!" This came to pass and she bore 1,000 children. Five hundred flew to ascend on Heaven, and 500 children were born into the world of men. Their only duty was to eat people. The king of Magadha being distressed by this, told the Buddha. The Buddha dispatched Vaisravana [guardian of the North] to use his spiritual power to gather up the [demon] Yaksha woman's beloved son [Pingala] and use a basin bowl inverted to cover him. The multitude of the Yaksha children's force was unable to effect a release. Thereupon [the mother, Hariti] beseechingly entreated the Buddha. Buddha said, "Yaksha woman, if you are governed by and able to keep the commandments and not kill, then you will be able to achieve the release of your son." The daughter of Mara embraced the commandments and received her beloved child. Furthermore she asked, "Since we do not kill people, what is to be done about [our] hunger?" Buddha commanded the many followers that at the time of eating [the principal meal at noon] to use [monastically] produced rice to relieve their hunger. The command to produce offering food [for monks and spirits] is His transmitted idea. (Extracted from the ordinance text in the Vinaya.)

In a discussion of this Hariti theme, Julia Murray has concluded that the Hariti cult may have had its origins in the Gandharan art of India, but the iconography of this particular narrative is unique to China. She finds that there are two, basically mirror-image, traditions of rendering this theme. One is a short, tripartite rendition in a sequence such as this Lilly painting, and the other is an extended version with greater space devoted for a procession of bizarre demons from the right toward the Buddha entourage at the left end. (Murray, *Artibus Asiae*.)

The Hariti theme is from the scriptures, and it is interesting that this composition is reminiscent of a frontispiece to a sutra. The enthroned Buddha, with attendants emerging from dense patterns of trees and clouds at the right while the rest of the scene unfolds at the left, has counterparts in the painted and woodblock illustrations that often introduce the scriptures. The separation of the Buddha assemblage from the rest of the scene and even

Plate 122, Details

Figure A

some of the specific motifs, such as the unusual cloud style, can be found in these religious images. (Lee and Ho, *Chinese Art Under the Mongols*, 1968, no. 281, *Eight Dynasties*, 1980, no. 49, or *WW*, no. 12, 1982, pl. 4.)

A recently published scroll of this same subject by Chu Yü (Zhu Yu), a follower of Wang Chen-p'eng and one who has no other known works extant, permits us to better understand this work by Wang. (Fig. A: *Iyuan doying*, no. 18, 1982, pls. 3–6, now in the Zhejiang Provincial Museum.) Its layout is more condensed than Wang Chen-p'eng's rendition, and the more flamboyant linear quality has strongly tapered brushstrokes. Compositional variations are apparent in such areas as the processions at the end and the ordering of the celestial deities. In Wang's painting there is less overlapping of activity, and the thunder deity logically precedes the dragon in the rain clouds. The various figures in Wang's example can be found in Chu's version, but the omission of the sensitively rendered face to the Buddha's right is particularly noticeable and unexplainable. At the closer level of details, there are also clear differences between the two versions. Where Chu's brushwork is lively and of interest in itself, Wang's tends to be less independent and always subservient to the image it defines. The two renditions of the demons' wings exemplify the two different approaches: Wang places soft dots on an organic vein pattern, and Chu regiments the dots in an abstract pattern, omitting the veins. In almost every aspect Wang exhibits a tendency, common in the early Yuan, to repeat sensitively a simple motif or formula over a naturalistic framework. Chu Yü's style, on the other hand, characterizes the later trend of freer brushwork that by itself can rival the form it defines.

Throughout Wang Chen-p'eng's handscroll, the character of the line remains subtle and unerringly accurate. The precision with which the warriors' armor and the engine for raising the bowl are depicted reveals the hand of a master of architectural painting. The subtle and numerous varieties of cloud types, rock textures, facial features (both individual and stereotypical), and clothing lineament are so well executed that we must credit Wang Chen-p'eng as being a master of many subjects. This is certainly not the work of a beginner or a standard copyist. The rich variety of techniques displayed in the depiction of the various objects and the avoidance of flamboyance through a controlled restraint of accumulated brushwork are indicative of the early fourteenth century in general, when Wang was at the height of his fame.

Plate 123

BAMBOO, SPARROWS, AND CAMELLIAS
 (*HUAZHU SHANQIN*)
Wang Yüan (active mid-14th century), attributed to
Yuan dynasty, dated 1347
Ink on paper
Height, 47 in. (119.4 cm.); width, 21⅛ in. (35.5 cm.)
60.60

A near contemporary of Wang Yüan called him a recluse (*chushi*), and this may explain why it is hard to discover much about his biography. We do have Hsia Wen-yen's (Xia Wenyen) succinct 1365 account of Wang:

> A native of Hangzhou, when young he practiced painting with Master Chao Wen-min [Meng-fu] instructing him. Thus, all that he painted were studied after the ancients, without one brush-stroke of the Academy style. In landscape he studied Kuo Hsi [Guo Xi], for flowers and birds he studied Huang Ch'üan [Quan, d. 968], and in figures he studied Tang artists; each and every painting being very admirable. Wang Yüan was particularly skilled in doing [colorless] ink flowers, birds, bamboo, and rocks. He was a superior artist of his times. [Chen, *Yuandai huajia*, 1980, p. 522.]

As Wang's teacher died in 1322 and Wang was enlisted to paint a temple wall in 1328, his artistic career was probably well under way around 1320. (Ibid., p. 521.) Most of Wang's extant dated paintings cluster in the mid-1340s, with none late than 1349. Wang thus appears to have been active during the second quarter of the fourteenth century. (His recorded paintings, their authenticity unverifiable, range from before 1300 into the middle 1360s, and suggest he lived to a venerable age.)

Signed: The night before the first of *dinghai* in the Zhizheng reign [February 10, 1347].

Artist seal: Wangshi momiao ["Ink wonder of Mr. Wang"]

1 colophon and 3 seals of Hsü Chih (Xu Zhi, unidentified)

19 seals: 2 of Chang Hsiao-ssu (Zhang Xiaosu, late 16th–17th century); 2 of Liang Ch'ing-piao (Liang Qingbiao, 1620–1691); 1 of Wang Chuan (Wang Zhuan, 1623–1709, son of Wang Shih-min); 2 of Li Tsung-wan (Li Zongwan, 1705–1759); 7 of Chang Jo-ai (Zhang Roai, 1713–1746); 1 of Wang Chi-ch'ien (20th century); 1 possibly of Shen Kuan (Shen Guan, 15th century); 1 possibly of Shen Chou (Shen Zhou, 1427–1509); 2 unidentified.

Published: Osvald Siren, *Chinese Painting*, vol. 7, New York, 1958, p. 140; Theodore Bowie, *One Thousand Years of Chinese Painting*, Bloomington, 1968, pl. 22; Sherman E. Lee and Wai-Kam Ho, *Chinese Art Under the Mongols*, Cleveland, 1968, cat. no. 238; James Robinson, *Arts of Asia*, XI, 2, March–April 1981, p. 90, fig. 4.

Plate 123, Detail

In the genre of flower and bird painting, Wang Yüan stands among the most important innovators during the Yuan dynasty. Prior to his emergence, flower and bird paintings generally concentrated on the pretty, colorful objects of nature, and the artists depicted them as such. Earlier progress had been made in monochrome flower and bird painting, but it was tentative and always on a minor scale. Wang Yüan was the first to bring the then prevalent tendencies of monochrome painting to flower and bird subjects on a grand scale. In this way he was to open the door for countless artists who inclined toward the "amateur" or "scholar" style of painting. Mu Yichin has recently characterized Wang's contribution:

> His specialty was that he preserved a lot of the antique style while being able to blend in the literati ink style. While not being completely delicate in painting, he was also not totally uninhibited in sketching. Within neat and proper, flawless depictions, he employed a touch of spontaneous brushwork. He included plentiful and diverse changes of ink tones, and thus constructed rigorously fine and delicate images that have the special appearance of being clean, pure, light, and simple. [*KKBWY yuankan*, 1979, no. 4, p. 51.]

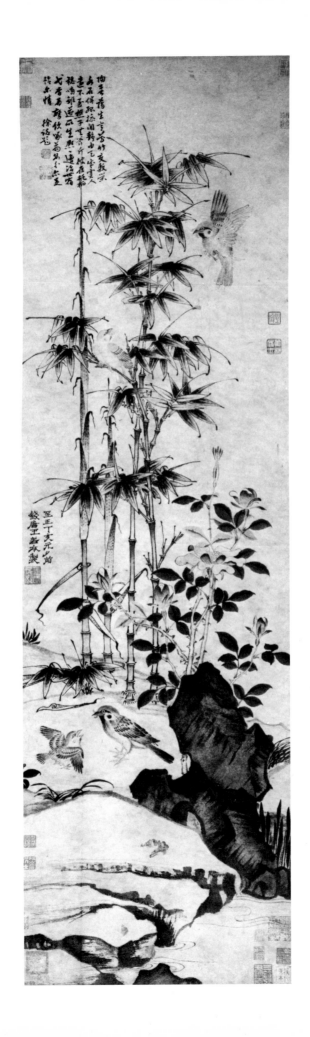

307

From the earliest comments on Wang Yüan to the present ones, his position as an adaptive transmitter of past styles has been stressed. The centralized, vertical composition on a shallow ground plane that we see in the Lilly painting certainly reflects an antique air when compared to the oldest extant flower and bird hanging scroll, the anonymous tenth-century painting excavated from Liaoning. (Fig. A: *WW*, 1975, 12, color plate.) Another early painting, a handscroll in Beijing, is of special interest because it carries an inscription indicating it was painted by Huang Ch'üan for his son, Huang Chü-ts'ai (Huang Jucai). Regardless of its authenticity, that scroll is older than Wang Yüan and purports to be by the same person Wang Yüan is said to have followed. In that scroll there is a pair of tree sparrows practically identical to those in the Lilly painting. (Fig. B: Siren, *Chinese Painting*, vol. 3, 1956, pl. 134)

The implied symbolism of the sparrows in the Lilly painting also affirms the Song antecedents that Wang Yüan drew upon. Wang Feng (d. 1388) commented in 1340 about a handscroll by Huang Ch'üan on precisely this theme: *Sparrows Feeding Chicks*.

> I have heard that paintings of the ancient academies generally were all done for a reason. These three sparrows extract the connotations of the [prohibitions against] three drinks mentioned in the *Shi, Li, Chun-chiu* and *Zhuan* . . . Viewing sparrows feeding chicks, you are able to understand benevolence [*ren*]. By what is benevolence known? It is embodied in the sparrow. The sparrow knows it has a son, and the son knows it has a mother. When hungry it thinks to feed, and eats from his mother's mouth. Ahh the sparrows! To nourish and to rear—still more us men. Who is not dependent on Heaven? The young rely on relatives, and elders care for their relatives. Heaven's dependents are all relatives. Mortal men exert yourselves! [Wang, *Wu-hsi chi*, ch. 1, p. 46.]

Bamboo, Sparrows, and Camellias is evidently based on an antique model, such as one by Huang Ch'üan, that was possibly a symbolic image. As such, it might be considered archaistic. Wang Yüan's teacher, Chao Meng-fu, was a major proponent with well-known successes in the traditions of landscape and figure archaism, but Wang appears to have taken the lead in applying the ideals of archaism to the genre of flower and bird painting. His interests appear oriented toward emphasizing shapes and

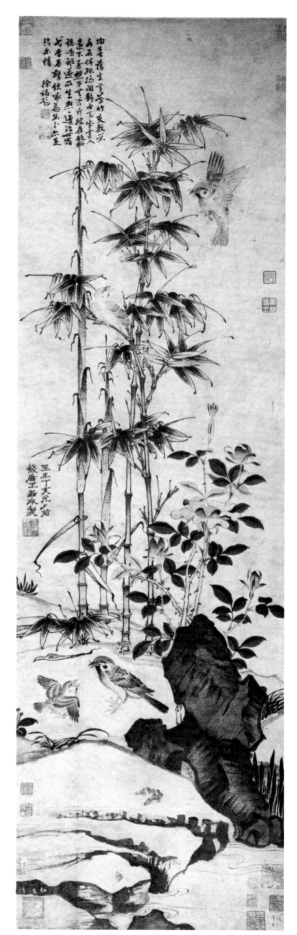

Plate 123

Figure A

forms in a statically balanced composition. Blunt, right-angled compositional forces tend to cancel each other, and areas are treated as spatial pockets—enclosures that are only minimally linked to each other. Motion itself seems frozen. Everything here appears stylized. The brushwork becomes heavier as the motifs become less fleeting and more permanent; thus the progression of darkening, bold ink strokes from the four sparrows, to the camellias, to the bamboo, and finally to the pitted rock. The result is almost too mannered, however, and is saved by only the interesting contrasts of textures that develop among the elements.

The idiosyncratic bamboo leaf ends—either twisted or with one side extended—are perhaps unnecessarily forced and exaggerated; they seem to exist for their own sake rather than as descriptive components. The excessive awkwardness may have its origins in the attempt to evoke a timeless, archaistic feeling in this symbolic vignette of nature, but coupled with the rather weak signature, it unavoidably engenders doubts about this painting's having come directly from the master's hand.

With these possible shortcomings aside, the Lilly painting is executed in a style that is indicative of the achievements made during the second half of the Yuan dynasty. Even though it is after, rather than by Wang Yüan, the image clearly reflects the accomplishments of this famous Yuan artist. Chao Meng-fu surely had taught Wang Yüan not merely to copy the past, but to enlarge upon time-honored traditions by using modern brush methods. The numerous variations of ink tone, as well as the dominance of brushwork from the firmly outlined bamboo and boneless flowers to the feathery birds and solid land forms, all indicate an anxious attempt to exploit the expressive potentials of monochrome brushwork in transfiguring the beautiful details of the world of nature.

Figure B

Plate 124

RETREAT AT THE FOOT OF MT. HUI
 (HUILU XIAOYIN)
Wang Meng, ca. 1308–1385
Yuan dynasty
Ink and light color on paper
Height, 11½ in. (28.5 cm.); length, 29⅛ in. (74 cm.)
60.50

Wang Meng has been consistently praised, from his own lifetime to the present, as one of the great masters of his era—a time that has proven to be one of the most important turning points in the long history of Chinese painting. As a descendant of Chao Meng-fu, he was the granchild of two great painters and the nephew and son of accomplished artists. Thus Wang Meng seems destined to have become a great painter. He was born in Wuxing, Zhejiang, and showed talent from an early age. Wang soon went into political service and held a minor local position. As the Mongol-ruled Yuan dynasty began to lose control of the southern regions, he retired to the Yellow Crane Mountain north of Hangzhou and seems to have enjoyed traveling and meetings with his literary and artistic friends—the ideal life of a hermit. After the Yuan government was defeated and the native-ruled Ming dynasty was established, Wang returned to politics. Unfortunately, the political paranoia of the first Ming emperor, Hongwu (r. 1368–1398), was to end Wang's great career. Having met with several people at the prime minister's home in 1379 to enjoy paintings, Wang Meng was implicated in the prime minister's alleged treason of the following year and thrown into jail, where he died in 1385. (See Cahill, *Hills*, 1976, pp. 120 ff.)

Unlike other "literati painters," Wang Meng has no extant writings other than inscriptions on paintings. As Cahill noted, "His poems are said to have been spontaneous and exuberant, his prose style 'verbose and scornful of the rules,' judgments that suggest some affinity in method and effect between his writings and his paintings." (Ibid.)

The colophon by Hsü Shou-ho on the present painting exemplifies the traditional criticism of Wang Meng's art.

The Yellow Crane Mountain Woodcutter [Wang Meng] sketched *Retreat at the Foot of Mt. Hui* [in a style] derived from Tung [Dong Yuan] and Chü [Ju Ran, both of the tenth century]. [Wang's] brushwork and ink are beautifully displayed, transcending beyond the common, narrow [stylistic] paths. How can such subtle flavor suddenly flourish, totally arousing in one's chest clear and unaffected [sentiments]? Previously, Ni Yü [Tsan] inscribed his [Wang's] small painting, saying, "Shu-ming's [Wang Meng's] brush strength is able to lift a tripod. In the past 500 years there has not been such a master." Just this [one] picture is sufficient to substantiate this, and it is not overly famous . . .

Wang's style was to influence countless later artists for many generations. He was a painter's painter, creating full compositions with a myriad of brushstrokes that resulted in images aptly termed "exuberant, rich and passionate." (Loehr, *Great Painters*, 1980, p. 249.)

Signed: The Yellow Crane Mountain Woodcutter, Wang Meng, painted this for the venerable Yü-lan (Yulan).

Inscription:

> In white hair following the example of Shao P'ing,
> He starts to learn to grow melons.
> His is a family of a former general of 400 years ago;
> While awakening from his spring dream by the Second Spring [at the foot of Mt. Hui];
> The misty water of [Mt.] Tung-t'ing [in Lake T'ai] is merging with the far horizon.
> Wang Meng wrote this for a respected family friend, [Meng] Shu-ching. [W-K Ho, trans.]

(Note: Shao P'ing [c. 200 B.C.] was destitute after the fall of the Qin dynasty, and he is said to have made cloth and raised melons by the east gate of the capital.)

Title and 2 seals of Ch'ien K'uei (Qian Kui, 1313–1384) 21 colophons and 35 seals: 13 transcribed colophons: Yang Wei-chen (Yang Weizhen, 1296–1370), Wu K'o-kung (Wu Kegung, d.1341+), Ni Tsan (1301–1373), Liu Kuan (Liu Guan, 1270–1342), Yüeh Yu (Yue You, 14th century), Ch'ien Liang-yu (Qian Liangyou, 1278–1344), Ts'ao Jui (Cao Rui, mid-14th century), K'o Chiu-ssu (Ke Jiusi, 1312–1365), monk (Sa?) Hui-chien (Huijian, 14th century), Yu-tan ching-nan (Youdan jingnan, unidentified), Sun Hua (14th century), Li Chieh (Li Jie, 14th century), and Kao Ming, (Gao Ming, late 14th century); 1 colophon and 2 seals of Chou Nan (Zhou Nan, 1301–1383); 1 colophon by Wang Ming-chi (Wang Mingji, late 14th century); 1 colophon and 1 seal of Chu Sheng (Zhu Sheng, 1299–1370) (?); 1 colophon and 2 seals of Ch'ien K'uei (1313–1384); 1 colophon (dated 1634) and 3 seals of Hsü Shou-ho (Xu Shouhe); 1 colophon (dated 1849) and 1 seal of Yüeh Ch'ang-lieh (Yue Changlie); 1 colophon (dated 1852) and 2 seals of Wu Ch'üan-tsui (Wu Quanzui); 4 seals of Ch'eng Cheng-kuei (Cheng Zhenggui, act. 1631–1674); 1 seal of An Ch'i (An Qi, 1683–1742+); 4 seals Chou Shou-ch'ang (Zhou Shouchang, 1814–1888); 4 seals of Chang Heng (Zhang Heng, 1915–1963); 3 seals of Ch'en Jen-t'ao (Chen Rentao, 20th century); 1 seal of Hsü An

Plate 124, Detail

Plate 124

(Xu An, 20th century); 1 seal of T'an Ching (Tan Jing, 20th century); 1 seal (on label) of Teng Erh-ya (Deng Erya, 20th century); 5 seals unidentified: Chaosung wo xue, Hou yin, Yue'an, Zhongming, [?]shou tang (partial seal).

Published: Wang Shih-chen (1526–1590), *Yen-chou-shan-jen hsü-kao*, 1577, ch. 168, p. 24; Sun Ch'eng-tse (1592–1676), *Keng-tzu hsiao-hsia chi*, 1600, ch. 8, p. 22b; Chang Ch'ou (1577–1643), *Ch'ing-ho shu-hua fang*, 1616, repr. Taiwan, 1975, vol. 3, hsü, p. 35b; Pien Yung-yü (1645–1712), *Shih-ku-t'ang*, 1682, repr. Taiwan, 1958, ch. 21, p. 298; Ch'en Jen-t'ao, *Chin-kuei lun-hua*, Hong Kong 1956, p. 66; Cheng Chen-to, *Yün-hui-chai*, Shanghai, 1948, pl. 36; Chu Sheng-chai, *Sheng-chai t'u-hua chi*, p. 15; Smith College Museum, *Chinese Art*, pl. 8; Theodore Bowie, *One Thousand Years of Chinese Painting*, Bloomington, 1968, pl. 17; Sherman E. Lee and Wai-kam Ho, *Chinese Art Under the Mongols*, Cleveland, 1968, no. 256; Xie Zhiliu (Hsieh Chih-liu), *Jianyu zagao*, Shanghai, 1979, p. 81; James Cahill, *Hills*, New York, 1976, pl. 56–57; Wai-kam Ho, *Bunjinga suihen*, vol. 3, Tokyo, 1979, no. 43; James Robinson, *Arts of Asia*, XI, 2, March–April 1981, p. 89, fig. 3.

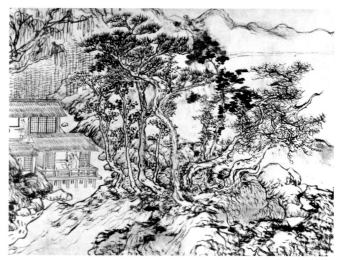

Plate 124, Detail

Wang Meng's painting of a small retreat at Mt. Hui, Wuxi, which is across the Great Lake from his birthplace, is a prime example of the genre of retreat depictions that emerged with widespread popularity during the Yuan dynasty. In the present case, the small retreat is at the east foot of Mt. Hui, where there is a spring whose waters were traditionally valued as the second best under heaven for the making of tea. Several eminent Yuan artists can be associated with this Second Spring, including such greats as Wang's grandfather, Chao Meng-fu, and his friend Ni Tsan, who painted this scene in 1351 on a scroll to which Wang later added a colophon. (Pien, *Shih-ku t'ang*. 1682, 1958, vol. 4, pp. 244-245.) *Retreat at the Foot of Mt. Hui* can be regarded as an example of what has recently been discussed and termed as "landscape of property" in opposition to the more generalized "naturescapes." (Vinograd, *Ars Orientalis*, vol. 13, 1982, pp. 1–29.)

In this painting, so modest that some consider it almost a sketch, we see the full maturity of Wang Meng's brushwork. Wang was not working here with the complex, seething land forms that occupied his later works, but nevertheless, the complexity of his dry, scrubby brushstrokes and wriggling texture strokes are comparable to the best of his most famous works. Wang's undoubtedly close familiarity with the subject may well account for his free rendition, which reveals his basic and vibrant method of building forms.

Typical of Wang Meng's painting in general is the rather simple domestic architecture that is invariably placed in the only calm part of the dynamic image. The main beams and posts of these buildings have the only color to be

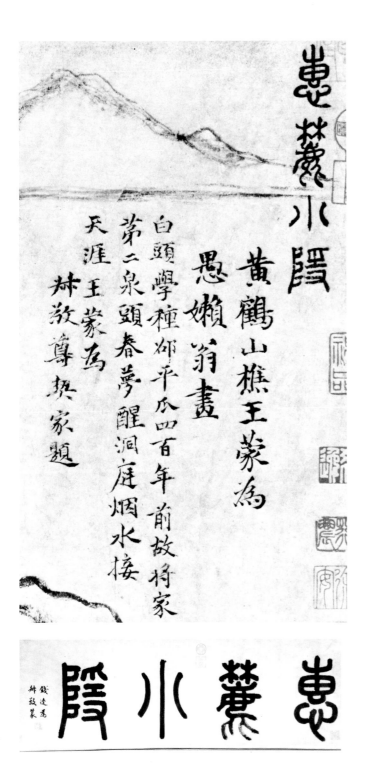

Plate 124, Details

found in the handscroll: a light rouge hue. Another common feature of Wang's style are the rather large-headed, oversized figures that are pursuing their simple activities within the buildings. In the present case, the "Foolish and Lazy Old Man" to whom Wang inscribed the painting may well be portrayed at his desk in the foreground.

The painting has a few areas of damage, and those are explained in its recorded history. Chang Ch'ou, writing in 1616, records that by his time, when it was in the collection of a Mr. Wang of Taiyuan, the original painting had already been cut in half to be divided between two brothers. Because Chou Nan's colophon follows the transcribed colophons on the ruled paper, the handscroll was apparently divided before his death in 1383. Furthermore, the two dedications by Wang Meng may indicate his awareness of the division. The first section (the present painting) had Wang Meng's inscription and a transcription in clerical script of the poems that remained with the second half. Chang Ch'ou did not know where the second half had gone, and he fervently inquired about it so the scroll could be made complete again. Unfortunately, no one has located the second half of this abruptly ended painting.

More recently, Ch'en Jen-tao wrote that when he obtained this painting in 1947 from Chang Heng, the incomplete passages made him think it was a preliminary sketch. He later heard that after it left his collection, someone did not like the sparseness and filled in areas in the trees and leaves. Fortunately, the painting was reproduced before it was retouched (Cheng, *Yün-hui-chai*, pl. 36), and it is easy to see that the in-painting was minor, and not the disaster Ch'en claimed. (See Ch'en, *Chin-kuei lun-hua*, 1956, p. 66.) Only a few lines were added behind the building, and they are in character with the pattern that was there. All the rest is from the skillful brush of Wang Meng.

The wide variety of foliage and land textures Wang Meng used on this scroll indicate an enthusiastic creativity that borders on experimentation. He exhibits a scope and power of brushwork that makes this painting one of the best of his few mature works outside of China.

313

Plate 125
THREE CATALPA TREES *(SANZU)*
Shen Chou (Shen Zhou, 1427–1509)
Ming dynasty, 15th century
Ink on paper
Height, 43¾ in. (111 cm.); width, 16 in. (41 cm.)
60.140

Shen Chou was perhaps the greatest and most influential artist of the early Ming dynasty. Born near Suzhou, Shen spent his entire life in that active artistic center of China. He never served in the government, ostensibly because he had to care for his mother, who died three years before he did, having lived to be almost a hundred. Shen's reverence for the past, both artistic and historical, was a profound force in his painting and his life. He was well traveled through the rich regions around Suzhou, visiting both friends and famous sites, and the results of these trips, preserved as paintings, calligraphies, or poems, are some of the finest artistic works of any time.

Signed: Changzhou, Shen Chou

Artist seals: Youzhu ju; Qinan; Shitien

Inscription:

> Fan Kung's hand planted objects of a thousand
> years,
> Fitting for descendants' nurturing care.
> Over and over leaves fall returning to the ages;
> Again and again good spring rises from the earth.
> Watch them as Chi Cha guarded the auspicious
> trees.
> From Chuang-tzu I know the beauty of their
> timber;
> So for you I take the brush and paint their
> likeness—
> Bright sun, the wind, the rain awe lesser plants.
> [trans. R. Edwards]

1 colophon and 2 seals of Chou Ting (Zhou Ding, 1401–1487); 2 seals unidentified: Qizong zhenshang; Changqi Shen shi tushi zhi zhang

Published: *1000 Jahre*, Haus der Kunst, Munich, 1959, no. 53; Richard Edwards, *Field of Stones*, Washington, D.C., 1962, pp. 33–34, no. XXVI, pl. 20C; Roger Goepper, *The Essence*, London, 1973, pls. 56–57; Richard M. Barnhart, *Wintry Forests*, New York, 1972, p. 49, no. 13; Richard Edwards, *The Art of Wen Cheng-ming*, Ann Arbor, 1976, pp. 41–42, no. IV; Yutaka Mino and Katherine Tsiang, *Apollo*. CVIII, 199, September 1978, p. 162, fig. 13; James Robinson, *Arts of Asia*, XI, 2, March–April 1981, pp. 91–92, fig. 6.

Plate 125, Details

Before the time of Shen Chou, the practice of recording one's travels or sights visited, except for a few isolated examples, was practically nonexistent. Paintings of famous places tended to record geographical images and not the experiences or emotions of the traveler. The numerous paintings by Shen Chou like this one establish him as the first major artist to indulge in the genre that was later to

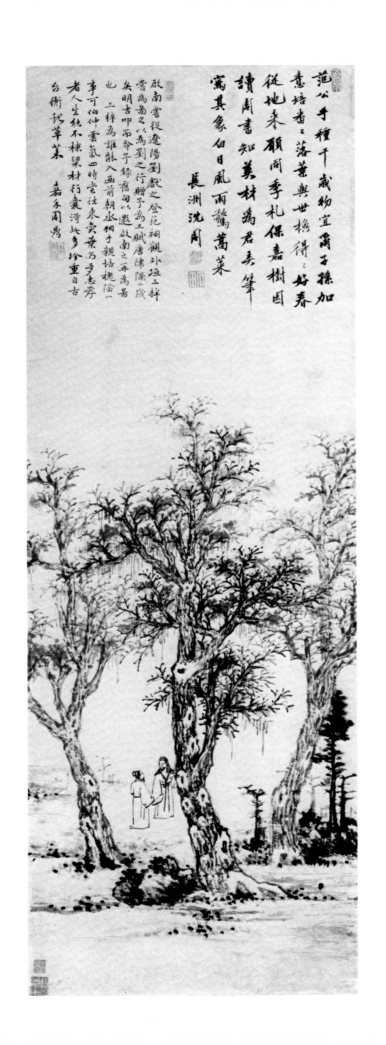

become a popular tradition. Chou Ting's colophon explains the circumstances surrounding this example:

> Shen Chou once climbed to the Fan ancestral temple with Liu Hsien-chih of Liao-yang and looked on the three catalpa trees by the outer wall. Later he did a painting of them for Liu as a going-away present. I wrote three *fu* (prose-poems) in T'ang dynasty form. After two years, Ming-chi called and asked me to copy these old phrases as a request to Shen Chou to do the painting again. [trans. R. Edwards]

As the man for whom Shen Chou painted a copy two years earlier was in Suzhou in 1479, a date around 1481 for this version is reasonable. Thus *Three Catalpa Trees* can "represent Shen Chou's art in its full maturity." (Edwards, *The Art of Wen Cheng-ming*, 1962, p. 41.) Shen Chou's commitment to the bold presentation of basic forms, as well as this pictorial theme of two scholars in the rarified environment of stately trees, was to influence many later generations of artists.

This is a painting that is as much a portrait of the catalpa trees as it is of the two past visitors to the shrine of Fan

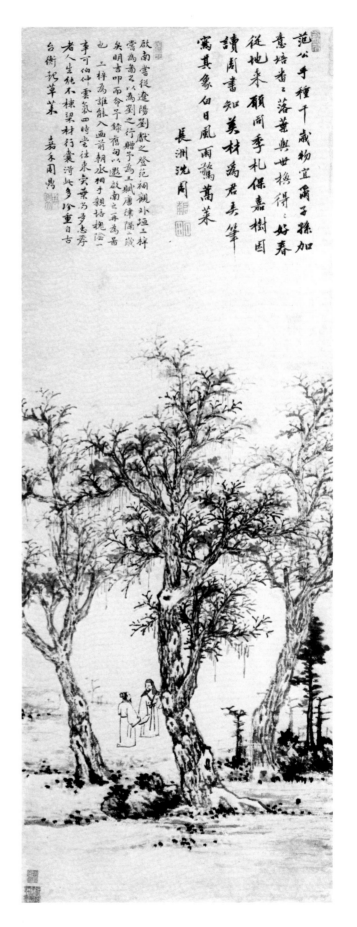

Plate 125

Plate 125, Detail

Chung-yen (Fan Zhongyen, 989–1052). This shrine, located at the base of Tienping Mountain, just west of Suzhou, commemorates an idealistic and compassionate Song dynasty statesman who donated land and developed regulations for a charitable trust held by his clan for the benefit of its needy members. His administrative regulations enabled this institution, like the trees, to last for centuries. This kind of trust became intimately related to the economics of the clan system that was to develop during the ensuing centuries. Certainly, as Shen Chou's poem implies, these symbolic trees are "Fitting for descendants' nurturing care."

This evocative image, executed in Shen Chou's typically bold style of blunt brushwork, is captivatingly simple in its direct presentation of the essential characters—three venerable trees and two visitors. There is no background needed other than the memory of the past, and the position and ink tones of the trees minimally establish the complete setting for the two guests beneath the mingling branches. From the colophon we know that Shen Chou had the comfortable distance of two years between his copies of this scene. Perhaps the enriched recollection afforded by this length of time contributed to the profound vision that Shen Chou captured.

Plate 126
LADY CARRYING A LUTE *(PIPA SHINU)*
Wu Wei, 1459–1508
Ming dynasty
Ink on paper
Height, 49¼ in. (125.1 cm.); width, 24¼ in. (61.3 cm.)
60.36

Every so often in the history of Chinese painting, a great nonconformist emerges who does not quite fit the mold of his times, and whose unorthodox life and/or style of painting raises havoc for traditional critics. Wu Wei was such an exceptional genius. He was born in 1459; his father soon died after having impoverished the family. As a poor orphan, Wu learned to paint, without a teacher, and at the age of seventeen he went to Nanjing to seek his fortune. There, his career blossomed. During the ensuing years, he was summoned by three emperors to paint at their courts. His success at court coincided with one of the high points of the Ming Academy. The Emperor Xianzong (r. 1464–1487) was moved to praise rather than punish Wu when he uninhibitedly appeared drunk before the throne and in a swashbuckling manner responded to the emperor's demand for a painting of pine trees in the wind. The onlookers grew pale experiencing his creative force, and "the emperor drew a deep breath and said, 'This is truly the brush of an immortal!'" (See Cahill, *Parting at the Shore*, 1978, pp. 98–106.) Between Wu's sojourns in the capital—his residence ended there once with his expulsion and once with his resignation—he is said to have been constantly entertained with wine and women by the rich of Nanjing who sought his art.

The exuberance of Wu Wei's life seems well reflected in his painting style, and the strength of Wu Wei's style lies in his brushwork. Firm and aggressive, it is never hesitant or subservient to the image, but rather equal to it. Wu worked in a bold fashion, making the character of his lineament augment the form that it described. Often Wu's use of descriptive brushwork approached the limits of expressive propriety that were acceptable to his contemporaries. Yet, regardless of the bravura exhibited by his brushwork in landscape or clothing, Wu seems always to have paid close attention to the faces in his paintings and to have taken great pains to bring forth their passion and emotion.

Signed: Hsiao-hsien ("Little Immortal").

Artist seal: Hsiao-hsien Wu Wei.

3 colophons and 10 seals: 1 colophon and 1 seal by Sun I-yüan (Sun Yiyuan, 1484–1520); 1 colophon and 2 seals by Huang Chi-shui (Huang Jishui, 1509–1574); 1 colophon by Wang Yin (active early 16th cent.); 1 seal by Li Tso-hsien (Li Zuoxian, 1828 *juren*); 6 seals unidentified: Deyi xuancang; Huanghao shanfang tuji; Jin[X] jianding; Jin[X] shending zhenji; Shenlutang yin; and [X]lu yuan (partial seal).

Plate 126, Detail

Published: Osvald Siren, *Chinese Painting*, New York, 1958, vol. 4, p. 136; Detroit Institute of Arts, *Arts of the Ming Dynasty*, cat. no. 20 (not illustrated); James Cahill, *Parting at the Shore*, New York, 1978, pl. 47, pp. 105ff; James Robinson, *Arts of Asia*, XI, 2, March–April 1981, p. 93, fig. 7; She Ch'eng, *Figure Painting*, vol. 1 of *Zhongguo shuhua*, Taibei, 1981, p. 76, no. 51.

Throughout the long history of Chinese painting, figure painting has been the oldest and most revered of the major genres. Ancient critics had argued that painting should be didactic so as to enrich the moral nature of the audience. Variations on this concept were to support the foundation of the tradition of narrative illustration. This inspired portrait by the untrammelled genius, Wu Wei, belongs to that tradition.

In this simple image of a lady with her lute, Wu has explored practically every possibility of brushwork and ink tone. Delicately thin lines describe the facial features; sinuously long strokes delineate the clothing next to the body; and short, wavy brushwork depicts the fluttering loose ends of material. The ink tones run the full gamut, from the charcoal black hair to the pale gray sash.

The demure lady with a bowed head and thoughtful, almost wistful expression seems to be embracing her wrapped lute as a most cherished item. With no background or ground plane, she is surrounded by an air of eternity, and her profile pose imparts a sense of self-secured independence.

As to who this lady may be, we have a clue from one of Wu Wei's followers, namely Kuo Hsü (Guo Xu, 1456–1528 +). Kuo was one of the several artists Wu influenced who cultivated an air of eccentricity about their lives and

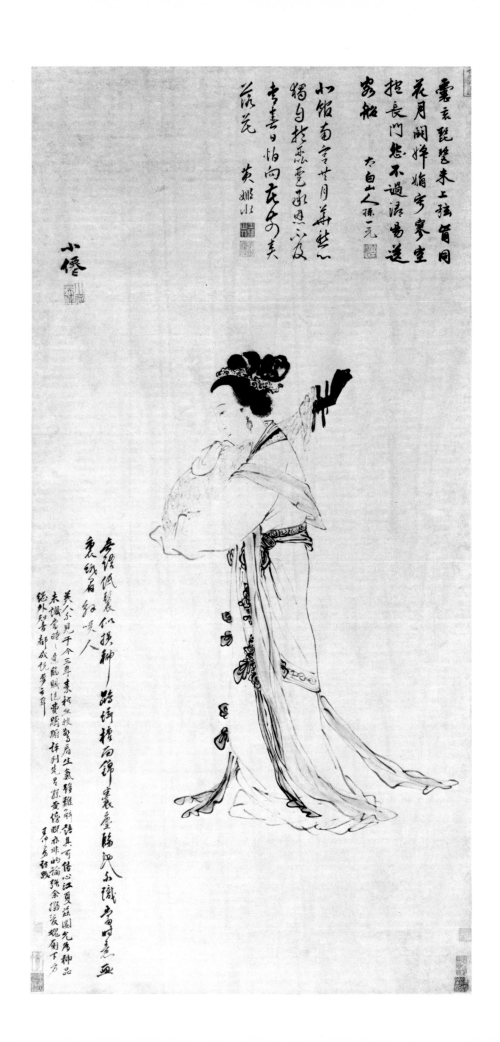

319

art. In the Palace Museum, Beijing, is a painting by Kuo with his calligraphy that depicts the central characters of Po Chü-i's (Bo Juyi, 772-846) *The Lute Song* ("Pipa xing"). (Fig. A: *Iyuan duoying*, no. 13, 1981, p. 16. See, also, Wu's portrait of the Lady Wu-ling, p. 34.) The pose and dress are so similar that one must conclude that Wu Wei's painting also depicts this same female lute player, the most famous in history.

Lawrence Sickman has concisely summarized the story in his remarks on an excellent traditional illustration to this famous poem by Ch'iu Ying (Qiu Ying, ca. 1494–1552).

> The poem relates how Po Chü-i went to Hsün-yang (Chiang-chou) to say farewell to a friend whose boat was moored by the riverbank. It was evening, and across the water he heard the sound of a lute from another boat. The instrument was played with such skill that he knew the musician must have been trained in the capital. Indeed, the player had been a famous courtesan in the capital until her beauty faded and she was married off to a tea merchant who lived at Hsün-yang. She was invited to join the two friends on the boat and, as night drew on, she entertained them with a song of moving sadness. [*Eight Dynasties*, cat. no. 164, p. 201.]

The Lute Song and the story surrounding it was a popular theme for sixteenth-century artists. The more traditional artists, like Ch'iu Ying, tended to conceive the illustration in terms of a riverside landscape with boats. But considering the emotions of the tale, it is most appropriate to emphasize the lady, as Wu has done. With no setting whatsoever, the portrait has a somewhat antique air. In her absolute isolation, she is reminiscent of the Tang dynasty figure style popular during her lifetime. Wu deserves much credit for this novel approach to an established theme so brilliantly executed.

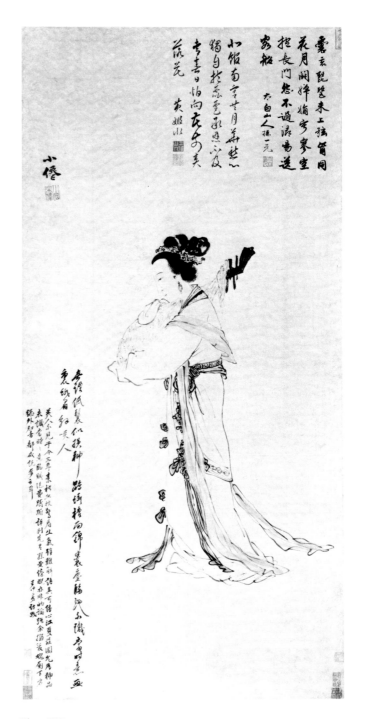

Plate 126

Figure A, Detail

Plate 126, Figure A

Plate 127
PEACOCK (*KONGQUE*)
Lu Chao-yang (Lu Zhaoyang, active mid-16th century)
Ming dynasty, dated 1552
Ink and colors on silk
Height, 70½ in. (179 cm.); width, 41¾ in. (106 cm.)
48.119

From the gazetteer of Shaxian, a region in the center of Fujian, comes the terse record that "[Several artists] and Lu Chao-yang were all good at subjects of feathers and fur with skill craftsmanship that in some areas seem superior to Ching-chao (Pien Wen-chin)." (*Shaxianzhi*, 1928 ed., ch. 11, p. 1.) Lu Chao-yang, like many of the artists at the Ming court, is barely mentioned in the traditional texts and is survived by only a few known works. Possibly, many of the paintings by these lesser-known artists have had their seals and signatures replaced by more pious attributions to the earlier artists who were often their original sources of inspiration.

Signed: Feifei shanren, Lu Chao-yang.

Artist seal: Lu[?] zhi tushu.

Published: Ludwig Bachhofer, *Short History of Chinese Art*, New York, 1946, color plate and p. 126; ———. *An Exhibition of Ancient Chinese Paintings*, Chicago, 1940, cat. 22; James Robinson, *Arts of Asia*, XI, 2, March–April 1981, p. 93, fig. 8.

The artist with whom Lu Chao-yang and other painters of Fujian are inevitably compared is the greatest artist of the region, Pien Wen-chin (Bian Wenjin, ca. 1354–1428). Pien was the great court artist who led flower and bird painting to a position of prominence in the academy during the early Ming dynasty. As Sherman Lee has observed, "Pien Wen-chin should certainly be credited with the initiation of a consistent, tradition-minded style of bird-and-flower painting continued by his successors…[including] the most famous of all, Lü Chi." (*Eight Dynasties*, 1980, cat. no. 121.)

A painting by Lü Chi (Lu Ji, active ca. 1500), now in the National Palace Museum, Taibei, and remarkably similar to this painting in the Lilly Collection, illustrates how well traditions last. (Fig. A: Cheng Chen-to, *Ku-kung*, vol. 4, 1965, pl. 27; MV90.) In Lü Chi's image the peacock standing on the rock and looking over itself counterbalances the flowering tree, and with the tree, encloses its companion, which is about to bite a chrysanthemum leaf. The scene is solidly grounded at the right edge, and tree sparrows are in the branches above. In Lu Chao-yang's rendition of essentially the same theme, done a generation later, the stabilizing rock has been replaced by the tree trunk itself, which grows from the sloping ground and turns back at an acute angle to exit horizontally at the right. The central peacock looks over its back toward this same edge and its companion. The latter is preening itself, being partially occluded by the central bird. The whole image seems directed toward the side,

Figure B

Figure A

with little stabilizing verticality. Nevertheless, the greater interaction between the participants of Lu Chao-yang's image creates a psychological cohesiveness that is absent in Lü Chi's earlier work, even though that has a formal stability of the disparate motifs.

Another fine painting by Lu Chao-yang, one that portrays predatory rather than decorative birds, shows a similar tendency to organize the image in terms of crossed diagonal motifs at the edge, under a canopy of branches. (Fig. B: now in Shanghai, *WW*, no. 1, 1963, pl. 19.) This bold monochrome manner appears often in the repertoire of these Fujian artists for well over a century. It is certainly present in the works from Pien Wen-chin to Lu Chao-yang and his near contemporary, Ch'en Tzu-ho (Chen Zihe). Evidently these bold and fine manners coexisted, and do not necessarily indicate a progression of style or taste in the academy. In fact, one may argue that the colored style represents the more thoroughly courtly traditions, in keeping with the subject matter, and that the bold monochrome manner is closest to the regional traditions of this distant southern province. Also, it may be time to distinguish this particularly bold manner from its usually labeled (and now outdated) "Che School" counterpart. Because of the lack of dated works in this genre, the painting by Lu Chao-yang in the Lilly Collection is an important chronological monument in a tradition of painting that is sparsely annotated with such fine, dated examples.

Plate 128
COLORED EPIDENDRUM AND BAMBOO
 (ZHUSE LANZHU)
Ma Shou-chen (Ma Shouzhen, 1548–1604)
Ming dynasty, dated 1604
Ink and colors on gold-flecked paper
Height, 10⅜ in. (26.5 cm.); length, 90⅜ in.(229.5 cm.)
60.25

Women artists have always had a respected, albeit secondary position in the history of Chinese painting, and among the many that are known to us now, few, if any, are as famous as Ma Shou-chen or as great an artist as this handscroll reveals her to have been. Unlike most noted female artists, she was an independent woman, unrelated to any other painter. As Chou T'ien-chiu (Zhou Tianqiu, 1514–1595), a fellow epidendrum painter, wrote in 1580, she "resides in Jinling [Nanjing] and is well enough refined in the 'female arts' to be the head of the 'gay quarters.' In sketching epidendrum and bamboo she is without equal." (Hu, *Shih-ch'ü pao-chi san-pien*, 1816, 1969, p. 2120.) Ma's works were widely famous in her own times. Not only were they treasured by the elegant dandies, but her artistic fame had spread so far that envoys from Thailand knew to buy and collect her fans. (Chiang, *Wu-sheng shih-shih*, 1720, ch. 5, p. 3a–b.)

Ma Shou-chen was a devout Buddhist and an accomplished poet. She kept company with some of the most eminent men of letters, among whom was her greatest paramour, Wang Chih-teng (Wang Zhideng, 1535–1612). Her liaison with Wang, whom she once wanted to marry, is the most popularly known part of her life. This relationship reached its climax in what was to be her last year of life, the year she painted this handscroll. In that year, she bought a boat with several decks, loaded it with several dozen beauties, and took it to The Garden of Willow Catkins *(Feixuyuan)* to celebrate the occasion of Wang's seventieth birthday. The feasting lasted almost a month, and the story has since been worked into an opera. (See Liu, "Wang Chih-teng," *Dictionary of Ming Biography;* vol. 2, 1976, p. 1362 and K'ung kuang-t'ao, *Yüeh-hsüeh-lou,* ch. 5, p. 17b.)

Signed: Xianglan nushi, Ma Shou-chen.

Artist seals: Ma Xianglan yin, Shou-chen, and Xianglan nushi.

Inscription: In the *jiachen* cycle of the Wanli period [1604] during an autumn month while sitting in the Jinweishui Retreat.

3 seals: 1 seal of Liang Chang-chü (Liang Zhangzhu, 1775–1849); 2 seals unidentified; Jiuwan zhongren and De[X] shending.

Not previously published.

As with most women artists, whose choices of subject matter tended to reflect an interest in the beautiful details of nature, Ma Shou-chen is best known as a painter of epidendrums or orchids. The artist she is traditionally credited with having modeled her style upon was Chao Meng-chien (Zhao Mengjian, 1199–1267). Chao was instrumental in elevating this subject matter from the larger flower and bird genre to a scholarly tradition in its own right because of his specialization in this plant and his prowess with a monochrome, outline style. Judging by the number of specialists, and the number of artists whose oeuvres include depictions of this plant, epidendrum painting had reached new heights of popularity by the middle of the sixteenth century.

In this stunning handscroll Ma Shou-chen has used a rather dry, light, pastel coloring throughout, which is in contrast to her more common monochrome, outlined painting. The soft tones of the elegant, gray blue leaves and the smooth, light green plants with maroon highlights blend harmoniously with the other subtle colors and ink tones of her delicate brushwork. The nine epidendrum plants of the scroll echo the primary associations this plant has for the Chinese, which are from the poetry of Ch'ü Yüan (Qu Yuan, ca. 300 B.C.), who wrote of cultivating nine fields *(wan)* of this fragrant plant. (The middle seal at the beginning also alludes to this thought in its legend, which reads "A Person among Nine Fields.")

Each plant, except for the last, which stands in splendid isolation, has a different partner against which its character can be contrasted. The heavy, smooth fungus; the rough, solid rock; the even, five-leafed bamboo, like an insect swarm; the round berries; or the stiff thorns—each joins an epidendrum to create independent compositions that are masterfully linked together.

The large rock at the climax of this scroll is most unusual in the manner of its execution. The dry, short texture strokes of brown are unparalleled by any other artist. Because they are so unusual, these strokes add an air of naturalism that the traditionally textured rocks, such as those all-too-familiar painterly rocks in the upper left, could no longer possess. The precious monochrome epidendrum is ingeniously placed in a reclusive position to the lower left of the dominating rock. This unobtrusive setting enhances the associations of the epidendrum, which has so subtle yet pure a fragrance, with the neglected statesman of virtuous ideals.

Plate 128, Details

Plate 129
TWENTY-FOUR SEASONAL FLOWERS
 (ERSHISI FANHUA)
Wei Chih-k'o (Wei Zhike, active ca. 1600)
Ming dynasty, dated 1604
Ink and colors on paper
Height, 12½ in. (31.7 cm.); length, 184¾ in. (469 cm.)
60.141

Wei Chih-k'o, later called Wei K'o, and his elder brother
Wei Chih-huang appear to have stayed together for most
of their lives, and so they are paired by later critics. They
worked in the burgeoning artistic world of seventeenth-
century Nanjing. Wei Chih-k'o was perhaps the superior
of the two in poetry and the painting of flowers. Of his
flowers, his renditions of narcissus and epidendrum are
usually singled out as being particularly accomplished.

Wei Chih-k'o and his brother painted for a living and
found success in the prospering regions around Nanjing.
The use of opaque, rather heavy colors and heavy out-
lines is consistent not only with a manner of painting
popular in their northern city (as opposed to the Suzhou
area), but also with techniques of printing. Indeed, one
of their great contributions to the art world was their
participation in a popular and influential series of wood-
cuts, the *Ten Bamboo Studio Painting Manual (Shizhuzhai
huapu)*. The epidendrum, bamboo, and prunus sections
with which they were involved were published between
1621 and 1624.

Signed: Julu Wei Chih-k'o.

Artist seals: Wei Chih-k'o yin and Heshushi.

Inscription: Sketched in the Changganshou room during
middle autumn of the *jiachen* cycle [1604].

Title label and 1 seal by Teng Erh-ya (1884–1954).

10 seals: 1 possibly of Wen Ting (Wen Ding, 1766–1852)
(Houshan suocang); 1 possibly of Wang Wen-yüan (Wang
Wenyuan, Qing dynasty) (Dongwu wanglienjing cang
shuhua ji); 7 seals unidentified: Biehao ji'an; Limin wu-
shih; Maozhai wanshang; Yingning guan jiancangyi; xia-
opin; Yizu xinjian; and [?]Yatang.

Not previously published.

Plate 129, Details

Plate 129, Details

Plate 130
LANDSCAPE ALBUM (*SHANSHUI CE*)
Wang Kai (Wang Gai, active ca. 1677–1705)
Qing dynasty
Ink and colors on paper
Height, 9⅞ in. (25 cm.); width, 14⅛ in. (36 cm.)
61.119

Wang Kai's fame and obscurity both seem to stem from his traditionalism. Because he worked in Nanjing in the late seventeenth century, his reputation as an artist was somewhat eclipsed by the more original and avant-garde masters that were making their Nanjing region an important center of art, rivaling the long-established fame of the southern cities. Wang is summarily noted as the only student of Nanjing's great Kung Hsien (Gong Xian, d. 1689), and he is omitted from the list of great local artists that nearly every area had.

Yet this very same traditionalism was no doubt behind Wang Kai's involvement with a block-printed painter's manual, *The Mustard Seed Garden*, that was to become so important to those who did not have access to great painting collections. The influence of this painting manual, which summarized and codified past Chinese traditions, has long been known to have been substantial in Japan, and its full impact on the average and better painters in China has not yet been completely explored. Wang was involved with the first part of this manual, the first edition of which appeared in 1679. In that first section, he dealt with the more intellectual aspects of the ideals and landscape traditions of the past. Other illustrated manuals had existed for specialized subjects such as bamboo or prunus, but *The Mustard Seed Garden* was the first important manual that codified landscape traditions. In retrospect, it seems that Wang's temperament and style were well suited for his involvement with a printed manual. His apparent interest in forms, structure, and composition, rather than complex brush techniques for surface textures and ink tonalities, is precisely what he needed to find success and satisfaction in wood block prints.

Signed: Xiushui brother, Wang Kai.

15 artist seals: 8 (An-chieh); 1 (Wang); 1 (Kai);
5 (Wang Kai).

Inscription: See below.

1 colophon by Chang Ta-ch'ien (Zang Daqian) dated 1953.

Published: *Kuka-in Shitsu Kanzo Gakan; Sekai Bijutsu Zenshu*, vol. 20, China IV, p. 41, fig. 91; Yonezawa Yoshiho, *Kokka*, 725, August 1952, pp. 264–270; Osvald Siren, *Chinese Painting*, vol. 7, New York, p. 432; Wilbur Peat, *An Album Painting*, Indianapolis, pp. 2–6; James Robinson, *Arts of Asia*, XI, 2, March–April 1981, p. 97, fig. 13.

Leaf A: Summer Wood and Falling Shadows, made by recording half of Chü-jan's [Juran, ca. 975] "River Pavilion Scenery"

Leaf B: Study of the Green Creeper, After Hsü Wei [Xu Wei, 1523–1591]
Leaf C: Similar to Huang Kung-wang [Huang Gong-wang, 1269–1354]
Leaf D: After Liu Sung-nien [Liu Songnian, ca. 1200]
Leaf E: Hanging Rainbow
Leaf F: Mi [Fei, 1051–1107] liked to paint "A Thousand Cliffs and Ten Thousand Valleys"
Leaf G: Behind the Peach Blossom Spring
Leaf H: Min [Fujian] women soak lotus to make cloth.
Leaf I: In the mountain is embraced the fragrant [i.e. virtuous] who all day long sits cross-legged
Leaf J: Twenty *li* of plum blossoms on Stone Pillar along the river

Wang writes on the last leaf that

> There are twenty miles [*li*] of plum blossoms on Stone Pillar along the river, forging ahead to open especially early. Recently I have been too lazy to write poems. With this ten [leaf] album completely painted, I am unable to quit. But then what? As one begets two, I have not only inscribed this painting, but have also arranged to see the plum [blossoms]!

It is precisely the casual and personal quality of this album that makes it so attractive. In paintings so intimate in scale and style, Wang candidly reveals a side to his art that is not often seen in his more imitative works. Even the leaves described as derivative of others are done in an individualistic manner with perhaps only a hint of the inspiring work.

As Chang Ta-ch'ien noted in his colophon, Wang K'ai's painting could rival those of his fellow Nanjing artists Fan Ch'i (Fan Qi) and Kao Ts'en (Gao Cen), and in this album's sensitive coloring and free brushwork, he has surpassed their usual quality. This album is a wonderful combination of several trends that met in seventeenth-century Nanjing: an angular, precipitous, and geometric Anhui style; a moody, dense native tradition, exemplified by Wei Chih-k'o's use of color (Pl. 129) or Kung Hsien's ink work; and the Western perspective and vision imported with the merchants and missionaries. In each leaf of this album, Wang has exhibited a wide and sophisticated talent through his ingenious variations of design, color harmony, and calligraphy. This intimate work shows the master in a relaxed and personal light not often found in his other works.

Plate 130, Leaf A

Plate 130, Leaf B

Plate 130, Leaf C

Plate 130, Leaf D

Plate 130, Leaf J, Detail

Plate 130, Leaf E

Plate 130, Leaf F

桃源後有寧石の入頭舟術

必由邨楳艶侍御寫圖梅

不可得逢此意欲

Plate 130, Leaf G

閒頻渥芙蓉
夜織布績密
先潔伏晨之
微有書氣凍
可作書画看
客言友乃成
晨幅

Plate 130, Leaf H

Plate 130, Leaf I

Plate 130, Leaf J

Remainder of the Collection

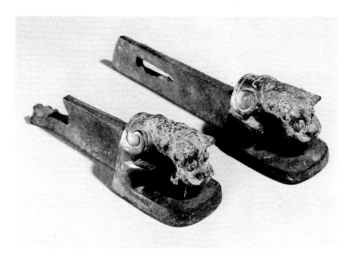

Figure 1
LINCHPINS
Western Zhou dynasty
Bronze
Length, 4⅝ and 5½ in. (11.7 and 14 cm.)
60.23

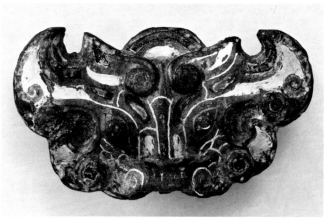

Figure 2
ORNAMENT
Eastern Zhou dynasty style
Date uncertain
Bronze with gold and silver inlay
Length, 3¼ in. (8.3 cm.)
60.158

Figure 3
GOOSE-SHAPED *ZUN*
Eastern Zhou dynasty style
Date uncertain
Bronze
Height, 7 in. (17.8 cm); length, 14½ in. (36.8 cm.)
48.116

Figure 4
GLASS BOWL
Han—Six Dynasties style
Date uncertain
Glass
Diameter, 8¾ in. (21.2 cm.); height, 3⅞ in. (9.8 cm.)
60.85

Figure 5
BOX WITH COVER
Jin dynasty, 12th century
Ding (Ting) ware
Porcelain with cream white glaze
Diameter, 4½ in. (11.4 cm.)
47.150

Figure 6
JAR WITH COVER
Southern Song dynasty, 12th century
Guan (*Kuan*) ware
Gray porcelaneous stoneware with grayish-green crackled glaze
Height, 3½ in. (8.9 cm.)
47.148

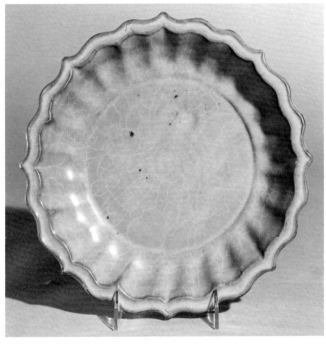

Figure 11
BOWL
Ming dynasty, Jiajing period
 (1522–1566)
Porcelain with deep blue glaze
Six-character mark of Jiajing
 within a double circle
Height, 2¾ in. (7.0 cm.);
 diameter, 6 in. (15.2 cm.)
60.106

Figure 10
Zhongli Quan (ONE OF THE EIGHT DAOIST IMMORTALS)
Ming dynasty, Jiajing period (1522–1566)
Blue-and-white ware
Height, 15⅝ in. (39.0 cm.); width, 7½ in. (19.0 cm.)
60.97

Figure 12
PAIR OF WATER POTS
Qing dynasty, Kangxi period
 (1662–1722)
Porcelain with peachbloom glaze
 and incised, archaistic dragon
 medallions
Six-character mark of Kangxi
Height, 3½ in. (8.9 cm.);
 diameter, 5 in. (12.7 cm.)
60.120 and 60.121

Figure 13
VASE
Qing dynasty, Kangxi period (1662–1722)
Porcelain painted in overglaze *famille verte* enamels, with
 "powder blue" ground painted in gold
Height, 17¾ in. (45.1 cm.)
60.118

Figure 15
BOTTLE
Qing dynasty, Kangxi period (1662–1722)
Porcelain with crackled copper-red *sang-de-boeuf* glaze
Height, 9 in. (22.9 cm.)
60.131

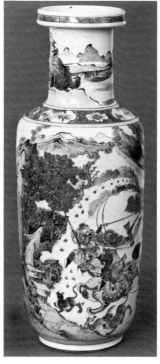

Figure 14
VASE
Qing dynasty, Kangxi period (1662–1722)
Porcelain painted in overglaze *famille verte* enamels
Height, 18¼ in. (46.3 cm.)
60.150

Figure 16
WATER POT
Qing dynasty, Kangxi period
 (1662–1722)
Porcelain with pale grayish-blue
 (*clair-de-lune*) glaze
Six-character mark of Kangxi
Height, 2¾ in. (7.0 cm.)
60.138

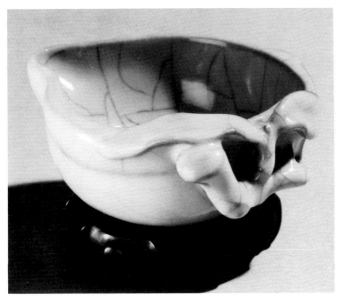

Figure 17
PEACH-SHAPED BRUSHWASHER
Qing dynasty, Kangxi period (1662–1722)
Guan (Kuan)-type ware
Porcelain with bluish-gray crackled glaze
Height, 1⅞ in. (4.9 cm.); length, 5 in. (12.7 cm.)
60.137

Figure 19
BOTTLE
Qing dynasty, Yongzheng period (1723–1735)
Porcelain with pale grayish-blue (*clair-de-lune*) glaze
Six-character mark of Yongzheng
Height, 5⅜ in. (13.0 cm.)
60.114

Figure 18
DISH
Qing dynasty, Yongzheng period (1723–1735)
Porcelain with incised decoration and pale grayish-green glaze
Six-character mark of Yongzheng
Diameter, 8 in. (20.3 cm.)
60.130

Figure 21
WATER POT
Qing dynasty, 18th century
Guan (Kuan)-type ware
Porcelain with bluish-gray crackled glaze
Height, 2½ in. (6.4 cm.)
60.136

Figure 20
BOTTLE
Qing dynasty, Qianlong period (1736–1795)
Guan (Kuan)-type ware
Porcelain with crackled, pale grayish-blue glaze
Six-character mark of Qianlong
Height, 8⅛ in. (20.6 cm.)
60.135

Figure 22
VASE
Qing dynasty, 18th century
Guan (Kuan)-type ware
Gray porcelaneous stoneware with grayish blue glaze
Height, 7¼ in. (18.4 cm.)
47.145

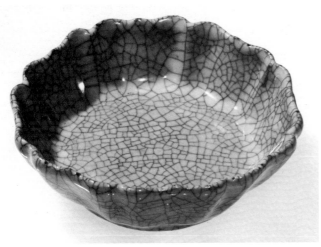

Figure 23
BRUSHWASHER
Qing dynasty, 18th century
Ge (Ko)-type ware
Gray porcelaneous stoneware with crackled gray glaze
Diameter, 5½ in. (14.0 cm.)
47.147

Figure 25
BOTTLE
Qing dynasty, 18th century
Porcelain with coral red glaze
Height, 10⅛ in. (25.7 cm.)
60.113

Figure 24
Gu (Ku) VASE
Qing dynasty, Qianlong period (1736–1795)
Porcelain with grayish blue (*clair-de-lune*) glaze
Six-character seal mark of Qianlong
Height, 6¾ in. (17.1 cm.)
60.124

Figure 26
WATER POT
Qing dynasty, 18th century
Porcelain with apple-green enamel glaze over crackled gray glaze
Height, 3 in. (7.6 cm.)
60.112

Figure 28
PAIR OF CHICKEN CUPS
Qing dynasty, 18th century
Porcelain with underglaze blue and overglaze *doucai* (*tou-ts'ai*) enamel
 decoration
Six-character mark of Chenghua
Height, 1⅜ in. (3.5 cm.); diameter, 3⅜ in. (8.6 cm.)
60.92 and 60.93

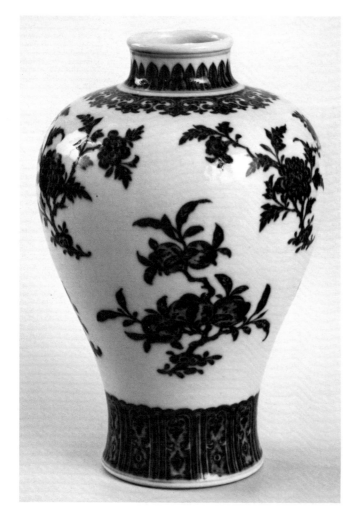

Figure 27
MEIPING
Qing dynasty, Qianlong period
 (1736–1795)
Blue-and-white porcelain
Six-character seal mark of
 Qianlong
Height, 10 in. (25.4 cm.)
60.148

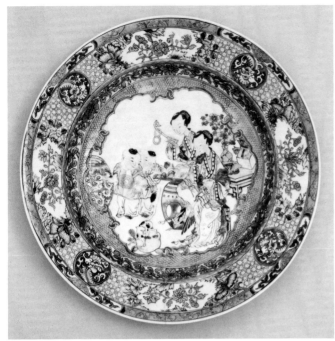

Figure 29
PLATE
Qing dynasty, mid-18th century
Porcelain with overglaze *famille rose* enamels and gilding
Diameter 8⅜ in. (22.2 cm.)
60.128

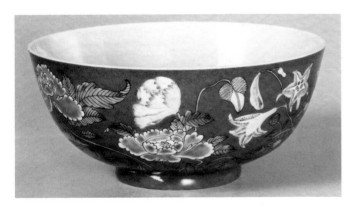

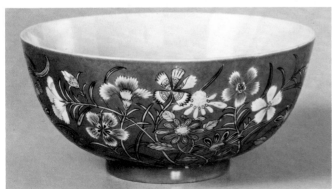

Figure 30
PAIR OF BOWLS
Qing dynasty, 19th century
Porcelain painted in overglaze *famille verte* enamels on a coral red
 ground
Four-character mark of Yongzheng
Height, 2⅝ in. (6.4 cm.); diameter, 5⅞ in. (15.0 cm.)
60.80 and 60.81

Figure 31
SNOW SCENE (*XUEJING*)
Wen Cheng-ming (Wen Zhengming, 1470–1559),
 attributed to
Ming dynasty, 17th century
Ink and light color on paper
Height, 40 in. (101.5 cm.); width, 18½ in. (47 cm.)
60.39
Seal of Wen Cheng-ming
Colophons signed: Wen P'eng (1498–1573); Chu Lang
act. mid 16th); Wang Chih-teng (1535–1612); Chou T'ien-ch'iu
(1514–1595); Wen Yüan-fa (1529–1595), dated 1569.
Actually by Liu Yüan-ch'i? See 1632 snow scene in *Zhongguo wenwu*,
No. 4, 1982, p. 22.

Figure 33
BAMBOO AND CALLIGRAPHY (*SU MI HEZO*)
Signed: Su Shih (Su Shi, 1036–1101), bamboo
Signed: Mi Fei (1051–1107), calligraphy
Qing dynasty, 17th century (?); remounter's inscription dated 1615
Ink on silk
Height, 9¾ in. (24.8 cm.), length, 72⅜ in. (183.8 cm.)
60.37

Figure 32
LANDSCAPE WITH FIGURE (*SHANSHUI*)
Cha Shih-piao (Zha Shibiao, 1615–1698)
Qing dynasty, 17th century
Ink and light color on paper
Height, 70⅜ in. (177.7 cm.); width, 30½ in. (77.5 cm.)
60.42

Figure 34
MOUNTAIN LANDSCAPE (*SHANSHUI*)
Mi Fei (1051–1107), attributed to
Ming dynasty, 17th century (?)
Ink on paper
Height, 30½ in. (77.5 cm.); width, 16⅝ in. (42.2 cm.)
60.38
Colophon signed Hsieh San-pin; colophon dated 1638
signed Ch'eng Chia-sui.

344

Figure 35
LADIES AND PARROT (*GUANNU YINGWU*)
Signed: Ch'iu Ying (Qiu Ying, early 16th century)
Qing dynasty, 18th century (?)
Ink and colors on silk
Height, 37 in. (94 cm.); width, 21½ in. (54.6 cm.)
60.64

Figure 36
LI PO RETURNING DRUNK (*ZUILI HUIJIA*)
Signed: T'ang Yin (Tang Yin, 1470–1523)
Qing dynasty, 1644–1912
Ink on paper
Height, 9⅜ in. (23.8 cm.); width, 8¼ in. (21 cm.)
60.151

Figure 37
LANDSCAPE AFTER TUNG YÜAN (*FANG BEIYUAN SHANSHUI*)
Signed: Lan Ying (1585–1664 + ?), dated 1652 at age 74 *sui*
Japanese copy?
Ink and light colors on paper
Height, 50⅝ in. (128.5 cm.); width, 15½ in. (39.4 cm.)
60.41

Selected Bibliography

Abbreviations used:

BMFEA. *Bulletin of the Museum of Far Eastern Antiquities,* Stockholm.
KK. *Kao-ku* [prior to 1959 called *Kao-ku t'ung-hsün*].
KKBWY yuankan. *Gugong bowuyuan yuankan* [*Palace Museum Quarterly*], Beijing.
KKHP. *Kao-ku hsüeh-pao.*
KKYWW. *Kao-ku yu wen-wu.*
TOCS. *Transactions of the Oriental Ceramic Society,* London.
WW. *Wen-wu* [prior to 1959 called *Wen-wu ts'an-k'ao tz'u-liao*].
WWCLCK. *Wenwu ciliao cungkan* [*Wen-wu tz'u-liao ts'ung-k'an*].

Andersson, Johan Gunnar. "Researches into the Prehistory of the Chinese." *BMFEA,* no. 15, 1943.

Ayers, John. *The Baur Collection: Chinese Ceramics.* vols. 1, 2, and 3, Geneva, 1968–1969.
——————. *Victoria and Albert Museum, London.* vol. 6 of *Oriental Ceramics, The World's Great Collections.* Tokyo and New York, 1971.
——————. *The Seligman Collection of Oriental Art: Chinese and Korean Pottery and Porcelain,* vol. 2, London, 1964.

Ayers, John, and Rawson, Jessica. *Chinese Jade Throughout the Ages,* London, 1975.

Bachhofer, Ludwig. *A Short History of Chinese Art.* New York, 1946.

Barnhart, Richard M. *Wintry Forests and Old Trees: Some Landscape Themes in Chinese Painting.* New York: China House Gallery, 1972.

Barrett, Douglas, et al. *The British Museum, London,* vol. 5 of *Oriental Ceramics, The World's Great Collections.* Tokyo and New York, 1981.

Bowie, Theodore. *One Thousand Years of Chinese Painting, T'ang to Ch'ing (800 to 1800).* Bloomington: Indiana University Art Museum, 1968.

Cahill, James. *Hills Beyond a River: Chinese Painting of the Yüan Dynasty, 1279–1368.* New York and Tokyo, 1976.
——————.*Parting at the Shore: Chinese Painting of the Early and Middle Ming Dynasty, 1368–1580.* New York and Tokyo, 1978.

Chang Kwang-chih. *The Archaeology of Ancient China.* New Haven, 1972.

Ch'ang-sha. See Hsia.

Chen Gaohua. *Yuandai huajia shiliao.* Shanghai, 1980.

Ch'en Jen-t'ao. *Chin-kuei lun-hua.* Hong Kong, 1956.

Ch'en Meng-chia. *Yin Zhou qingtungqi fenleitulu (In Shu seidoki bunrui zuroku).* 2 vols. Tokyo, 1977.

Cheng Chen-to. *Yün-hui-chai ts'ang T'ang Sung i-lai ming hua chi.* Shanghai, 1948.
——————. *Wei-ta-te i-shu ch'uan-t'ung t'u-lu.* 2 vols. Shanghai, 1951–1952.
——————. *Ku-kung po-wu-yüan so-ts'ang Chung-kuo li-tai ming-hua chi.* 5 vols. Peking, 1964–1965.

Cheng-chou Erh-li-kang. Peking, 1959.

Cheng Te-k'un. *Chou China,* Vol. 3 of *Archaeology in China.* Cambridge, England, 1963.

Chiang Hsüan-i. *Chi-chou-yao* [Jizhou (Chi-chou) ware]. Peking, 1958.

Dohrenwend, Doris. *Chinese Jades in the Royal Ontario Museum.* Toronto, 1971.

Edwards, Richard. *The Field of Stones: A Study of the Art of Shen Chou (1427–1509).* Washington, D.C., 1962.
——————. *The Art of Wen Cheng-ming (1470–1559).* Ann Arbor, 1976.

Eight Dynasties of Chinese Painting: The Collections of the Nelson Gallery-Atkins Museum, Kansas City, and the Cleveland Museum of Art. Cleveland: Cleveland Museum of Art and Indiana University Press, 1980.

Fong Wen, ed. *The Great Bronze Age of China: An Exhibition from the People's Republic of China.* New York, 1980.

Fontein, Jan, and Hickman, Money L. *Zen Painting and Calligraphy.* Boston, 1970.

Fontein, Jan, and Wu Tung. *Museum of Fine Arts, Boston.* vol. 10 of *Oriental Ceramics, The World's Great Collections.* Tokyo and New York, 1980.
——————. *Unearthing China's Past.* Boston, 1973.

Fu Hao, see Yinxu Fu Hao mu.

Gettens, Rutherford J. *The Freer Chinese Bronzes.* Vol. 2, *Technical Studies.* Washington, D.C., 1969.

Gillerman, Dorothy W.; McKim, Gridley; and Mertens, Joan R. *Grenville L. Winthrop: Retrospective for a Collector.* Cambridge, 1969.

Goepper, Roger. *The Essence of Chinese Painting.* London, 1973.

Goodrich, L. Carrington, and Fang Chaoying, eds. *Dictionary of Ming Biography (1368–1644).* 2 vols. New York, 1976.

Gyllensvard, Bo. *Museum of Far Eastern Antiquities, Stockholm.* Vol. 8 of *Oriental Ceramics, The World's Great Collections.* Tokyo and New York, 1982.

Gyllensvard, Bo, and Pope, John. *Chinese Art from the Collection of H. M. King Gustaf VI Adolf of Sweden.* Stockholm, 1966.

Hayashi, Minao. "Jade of the Liang-chu Culture." *Museum.* no. 360, March 1981, pp. 22–23.

Higashiyama Gyobutsu. Tokyo, 1976.

Ho Wai-kam; Iriya, Yoshitaka; and Nakada, Yujiro. *Ko Kobo, Gei San, O Mo, Go Chin* [Huang Kung-wang, Ni Tsan, Wang Meng, Wu Chen]. Vol. 3 of *Bunjinga suihen.* Tokyo, 1979.

Hsia Nai, et al. *Ch'ang-sha fa chüeh pao-kao.* Peking, 1957.

Hu Ching, et al. *Shih-ch'ü pao-chi san-pien.* 1816. Reprint, Taipei, 1969.

Huber, Louisa G. "Ancient Chinese Bronzes." *Arts of Asia,* XI, 2, March–April 1981, pp. 74–87.

——————. "The Traditions of Chinese Neolithic Pottery." *BMFEA,* no. 53, 1981.

Hughes-Stanton, Penelope, and Kerr, Rose. *Kiln Sites of Ancient China.* London: Oriental Ceramic Society, 1980.

Idemitsu 15th Anniversary Catalogue. Tokyo: Idemitsu Museum of Arts, Tokyo, 1981.

Jades of Yinxu. Beijing, 1981.

Jung Keng, *Shang Chou i-ch'i t'ung-k'ao.* 2 vols. Peking, 1941.

Kane, Virginia. "The Chronological Significance of the Inscribed Ancestor Dedication in the Periodization of Shang Dynasty Bronze Vessels." *Artibus Asiae,* XXXV, 4 1973, pp. 335–370.

Karlbeck, Orvar. "Notes on Some Chinese Wheel Axle-caps." *BMFEA,* no. 39, 1967.

Karlgren, Bernhard. "Notes on a Kin-ts'un Album." *BMFEA,* no. 10, 1938, pp. 65–81.
——————. "Huai and Han." *BMFEA,* no. 13, 1941, pp. 1–128.
——————. "Bronzes in the Wessén Collection." *BMFEA,* no. 30, 1958.
——————. "Marginalia on Some Bronze Albums." *BMFEA,* no. 31, 1959, pp. 289–331.
——————. "Some Characteristics of Yin Art." *BMFEA,* no. 34, 1962, pp. 1–28.
——————. "Some Pre-Han Mirrors." *BMFEA,* no. 35, 1963, pp. 161–169.
——————. "Chinese Agraffes in Two Swedish Collections." *BMFEA,* no. 38, 1966, pp. 83–159.

Kelly, Charles Fabens, and Ch'en Meng-chia. *Chinese Bronzes from the Buckingham Collection.* Chicago, 1946.

Laufer, Berthold. *Jade: A Study in Chinese Archaeology and Religion.* Chicago, 1912.

Lawton, Thomas. *Chinese Art of the Warring States Period: Change and Continuity, 480–222 B.C.* Washington, D.C., 1982.

Lee, Sherman E. and Ho Wai-kam. *Chinese Art Under the Mongols: The Yüan Dynasty.* Cleveland: Cleveland Museum of Art, 1968.

Loehr, Max. *Early Chinese Jades.* Ann Arbor, 1953.

_____. *Ritual Vessels of Bronze Age China.* New York, 1968.

_____. *Ancient Chinese Jades from the Grenville L. Winthrop Collection in the Fogg Art Museum, Harvard University.* Cambridge, 1975.

_____. *The Great Painters of China.* New York, 1980.

Loo, C. T. *An Exhibition of Ancient Chinese Ritual Bronzes.* (The Detroit Institute of Arts, Detroit.) New York: C. T. Loo & Co., 1940.

_____. *An Exhibition of Chinese Arts.* (Sale catalogue.) New York, 1941.

_____. *An Exhibition of Chinese Archaic Jades.* (Arranged for Norton Gallery of Art, West Palm Beach.) New York: C. T. Loo & Co., 1950.

Lovell, Hin-cheung, *Illustrated Catalogue of Ting yao and Related White Wares in the Percival David Foundation of Chinese Art.* London: University of London, 1964.

Medley, Margaret. *The Chinese Potter: A Practical History of Chinese Ceramics.* New York, 1976.

_____. *Illustrated Catalogue of Underglaze Blue and Copper Red: Decorated Porcelain.* London: Percival David Foundation of Chinese Art, University of London, 1976.

_____. *Illustrated Catalogue of Celadon Wares.* Section 7. London: University of London, 1977.

Mino, Yutaka. *Ceramics in the Liao Dynasty: North and South of the Great Wall.* New York: China Institute of America, 1973.

_____. *Freedom of Clay and Brush Through Seven Centuries in Northern China: Tz'u-chou Type wares, 960–1600 A.D.* Indianapolis: Indianapolis Museum of Art and Indiana University Press, 1980.

_____. "Chinese Ceramics." *Arts of Asia,* XI, 2, March–April 1981, pp. 104–115.

Mino, Yutaka, and Tsiang, Katherine, "Chinese Art in the Indianapolis Museum of Art." *Apollo,* CVIII, 199, September 1978, pp. 156–163.

Mu Yichin. "Wang Yuan he tadi mobi huaniao." [Wang Yuan and his flower and bird ink painting]. *KKBWY yuankan,* no. 4, 1979, pp. 48–51.

Murray, Julia K. "Representations of Hariti, the Mother of Demons, and the Theme of 'Raising the Alms-bowl' in Chinese Painting." *Artibus Asiae,* XLIII, 4, 1981–1982, pp. 253–268.

Nagahiro, Toshio. *Taiko no kenkyu.* Kyoto, 1943.

Neils, Jenifer, ed. *The World of Ceramics: Masterpieces from the Cleveland Museum of Art.* Cleveland: Cleveland Museum of Art and Indiana University Press, 1982.

Oriental Ceramics, The World's Great Collections. 11 Vols. New York and Tokyo: Kodansha, 1980–1982.
 Vol. 5: *The British Museum, London* by Douglas Barrett.
 Vol. 6: *Victoria and Albert Museum, London* by John Ayers.
 Vol. 7: *Musée Guimet, Paris* by Madeleine Paul-David, et al.
 Vol. 8: *Museum of Far Eastern Antiquities, Stockholm* by Bo Gyllensvard.
 Vol. 9: *The Freer Gallery of Art, Washington, D.C.* by John Pope, et al.
 Vol. 10: *Museum of Fine Arts, Boston* by Jan Fontein and Wu Tung.

Oriental Ceramic Society, *The Arts of the Ch'ing Dynasty.* London: Oriental Ceramic Society, 1964.

_____. *The Ceramic Art of China.* London: Oriental Ceramic Society, 1971.

Paul-David, Madeleine, et al. *Musée Guimet, Paris.* Vol. 7 of *Oriental Ceramics, The World's Great Collections.* Tokyo and New York, 1981.

Pien Yung-yü (1645–1712). *Shih-ku-t'ang shu hua hui-k'ao.* 1682. Reprint, Taipei, 1958.

Poor, Robert. *Ancient Chinese Bronzes, Ceramics and Jade in the Collection of the Honolulu Academy of Arts.* Honolulu, 1979.

Pope, John A. *Chinese Porcelains from the Ardebil Shrine.* Washington, D.C.: Smithsonian Institution, Freer Gallery of Art, 1956.

_____, et al. *The Freer Gallery of Art, Washington, D.C.* Vol. 9 of *Oriental Ceramics, The World's Great Collections.* Tokyo and New York, 1981.

Pope, John Alexander; Gettens, Rutherford John; Cahill, James; and Barnard, Noel. *The Freer Chinese Bronzes.* Vol. 1, *Catalogue.* Washington, D.C.: Freer Gallery of Art, Oriental Studies, no. 7, 1967.

Rawson, Jessica. "The Surface Decoration on Jades of the Chou and Han Dynasties." *Oriental Art,* XXI, 1, Spring 1975, pp. 36–55.

_____. *Ancient China, Art and Archaeology.* London, 1980.

Robinson, James. "Chinese and Japanese Paintings." *Arts of Asia,* XI, 2, March–April, 1981.

Salmony, Alfred. *Archaic Chinese Jades from the Edward and Louise B. Sonnenschein Collection.* Chicago, 1952.

Sekai Toji Zenshu [Catalogue of world ceramics]. Vol. 10 [Song and Liao], and vol. 11 [Yuan and Ming]. Tokyo: Kawade Shobo, 1955 and 1956.

Sekai Toji Zenshu [Catalogue of world ceramics]. Vol. 11 [Sui and Tang], vol. 12 (Sung), and vol. 13 [Liao, Jin and Yuan]. Tokyo: Shogakukan, 1976, 1977, and 1981.

Shang Zhou kaogu. Beijing: Wen Wu Press, 1979.

She Ch'eng. *Zhongguo shuhua* [Chinese painting and calligraphy]. Vol. 1, *Figure Painting,* and vol. 2, *Landscape Painting.* Taibei, 1981.

Shimizu, Yoshiaki, and Wheelwright, Carolyn. *Japanese Ink Painting.* Princeton, 1976.

Siren, Osvald. *A History of Early Chinese Art: Sculpture.* London, 1930.

_____. *Chinese Painting, Leading Masters and Principles.* 7 vols. New York, 1956–58.

Suzuki, Kei. *Ri To, Ba En, Ka Kei* [Li T'ang, Ma Yüan, Hsia Kuei]. Vol. 2 of *Suiboku bijutsu taikei.* Tokyo, 1974.

Tang Changan chengjiao Sui Tang mu [Excavations of the Sui and Tang tombs at Xi'an]. Beijing, 1980.

Trubner, Henry. *Chinese Ceramics.* Los Angeles, 1952.

_____. *The Arts of the T'ang Dynasty.* Los Angeles, Los Angeles County Museum, 1957.

Tsiang, Katherine R. "Chinese Jade." *Arts of Asia,* XI, 5, September–October 1981, pp. 77–83.

Tsou Heng. *Xia Shang Zhou kaoqu xuelun wenji* [Essays on the archaeology of the Xia, Shang and Zhou dynasties]. Beijing, 1980.

Umihara Sueji. *Obei shucho Shina kodo seika* [Selected relics of ancient Chinese bronzes from collections in Europe and America]. 7 vols. Osaka, 1933.

_____. *Selected Ancient Mirrors Found at Shao-h[s]ing Tombs.* Kyoto: Kuwama Bunseido, 1939.

Valenstein, Suzanne. *Ming Porcelains: A Retrospective.* New York: China Institute in America, 1971.

_____. *A Handbook of Chinese Ceramics.* New York: The Metropolitan Museum of Art, 1975.

Wang Shih-chieh, ed. *Ku-kung ming-hua san-pai chung,* [KK300]. Taichung, 1959.

Watson, William. *Archaeology in China.* London, 1960.

_____. *The Genius of China.* London, 1973.

Weber, George W., Jr. *The Ornaments of Late Chou Bronzes.* New Brunswick, 1973.

Wirgin, Jan. "Sung Ceramic Designs." *BMFEA,* no. 42, 1970.

Xie Zhiliu. *Jianyu zagao.* Shanghai, 1979.

Yinxu Fu Hao mu. Beijing, 1980.

Zhu Jieyuan. "Suide faxian Zhanguo niaogai tunghu." *KKYWW,* no. 2, 1980, pp. 32–41.

Index of Chinese and Japanese Characters

An Ch'i 124 安岐

An-chieh 130 安節

anhua 93, 94 暗花

Anhui 2, 3, 44 安徽

Anyang 4, 9, 10, 13, 14, 21, 23, 24, 26 安陽

Ashikaga Shogun 120 足利將軍

Banshan 53, 54 半山

Baofengxian 31 寶豐縣

Beijing (Peking) 20, 100, 101 北京

bi 1, 9, 18, 19 壁

biehao Ji'an 129 別號奇菴

Caoxieshan 1 草鞋山

Ch'a Shih-piao Fig. 32 查士標

Chan 120 禪

Chang Ch'ou 124 張丑

Chang Heng 122, 124 張珩

Chang Hsiao-ssu 123 張孝思

Chang Jo-ai 123 張若靄

Chang Ta-ch'ien 130 張大千

Changan 48, 56, 59 長安

Changqi Shenshi tushuzhizhang 125 長溪沈氏圖史之章

Changsha 44 長沙

changyue 8 長鉞

Changzhi 36, 42 長治

Chao Meng-chien 128 趙孟堅

Chao Meng-fu 121, 123, 124 趙孟頫

Chaosung woxue 124 巢松臥雪

Chaoyangqu 100, 101 朝陽區

che 27 車

chen 119 臣

Ch'en Jen-t'ao 124 陳仁濤

Ch'en Ting 119 陳定

Ch'en Tzu-ho 127 陳子和

Ch'eng Cheng-kuei 124 程正揆

Ch'eng Chia-sui Fig. 34 程嘉燧

Chengdu 86 成都

chewei 36 車書

Chi-chou, see Jizhou 吉州

Chiang Tsu-i 122 蔣祖詒

Chien, see Jian 建

Ch'ien Kuei 124 錢遠

Ch'ien Liang-yu 124 錢良右

Chifengxian 72 赤峯縣

ch'ing-pai, see qingpai 青白

Ch'iu Ying 126, Fig. 35 仇英

Chou Nan 124 周南

Chou Shou-ch'ang 124 周壽昌

Chou T'ien-ch'iu 128, Fig. 31 周天球

Chou Ting 125 周鼎

Chu 17, 44, 50 楚

Chü-jan 124, 130 巨然

Chu Lang Fig. 31 朱朗

Chu Sheng 124 朱昇

Ch'ü Yüan 128 屈原

Chuihong 130 垂虹

chün, see jun 鈞

chushi 123 處士

ci Guyunchushi zhang 122 賜孤雲處士章

Cixian 23 磁縣

Cizhou 67, 68, 69, 70, 71, 84 磁州

daigou 38–43 帶鈎

Daoist 45, 120 道家

Datong 70, 83 大同

Dayingzi 72 大營子

Dengfengxian 67 登封縣

Denghu 86 鄧埠

Deyi xuancang 126 得一軒藏

De[X] shending 128 德[X]審定

Ding 72, 80, 81, 82 定

ding 24, 27 鼎

dinghai 123 丁亥

dongjing 58 東井

Dongwang Gong 45 東王公

DongWu WangLianjing cang shuhua ji 129 東吳王蓮涇藏書畫記

Douwan 19 竇綰

Doyu 120 道有

Dugu Sijing 59 獨孤思敬

dui 35 敦

e 13 鵝

Erligang 39 二里崗

erniao 12 二鳥

Ershisi fanhua 129 二十四番華

fahua	105	法花
Fan Ch'i	130	樊圻
Fan Chung-yen	125	范仲淹
fangding	27	方鼎
fangyi	21	方彝
Feifei shanren	127	非非山人
Feixuyuan	128	飛絮園
Feng Daozhen	83	馮道真
Fenshuiling	36, 42	分水岭
Fu Ding	29	父丁
Fu Hao	4, 9, 10, 13, 14, 22, 23	婦好
Fufeng	27	扶風
Fujian	85, 127, 130	福建
Gansu	30, 31, 44, 53, 54	甘肅
gaokuan yingwu peidai	10	高冠鸚鵡佩帶
ge	4, 5, 23	戈
Ge Fu Wu he	30	戈父戊盉
gu	23, 28	觚
guang	25	觥
Guangdong	1, 2, 3	廣東
Guanghan	7	廣漢
gui	6	圭
gui	30, 31	簋
Gumu zhushi	121	古木竹石
gung	119	公
guo	23	國
Gyokuen Bompo	120	玉畹梵芳
haishou putao jing	48	海獸葡萄鏡
Hangzhou	119, 120	杭州
Hao, Lady (see Fu Hao)		
he	30, 31	盉
Hebei	19, 20, 80, 81, 82	河北
Henan	20, 22, 26, 38, 39, 53, 57, 67, 75, 83, 84, 100, 101	河南
Heshu shi	129	和叔氏
Hongqingcun	56	洪慶村
Hou yin	124	侯印
Houma	35	侯馬
Houshan suocang	129	後山所藏
Hsia Kuei	119	夏珪
Hsia Wen-yen	123	夏文彥
Hsiao-hsien	126	小仙
Hsieh San-pin	Fig. 34	謝三賓
Hsü An	122, 124	徐安
Hsü Chih	123	徐�
Hsü Shou-ho	124	徐守和
Hsü Wei	130	徐渭
Hsüeh Hsüeh-tsan	122	薛學讚
Hu (jar)	20, 21, 34, 35	壺
hu (tiger)	14, 15, 120	虎
Hu Hsiao-cho	126	胡小琢
Huai	44	淮
huang	17	璜
Huang Chi-shui	126	黃姬水
Huang Ch'üan	123	黃筌
Huang Chü-ts'ai	123	黃居寀
Huang Kung-wang	130	黃公望
Huanghao shanfang tuji	126	黃鶴山房圖籍
Huazhu shanqin	123	花竹山禽
Hubei	20, 87	湖北
Hui-chien, see Sa		
Huilu Xiaoyin	124	惠麓小隱
Huizong (r. 1101–1126)	120	徽宗
Hunan	44	湖南
Hung-tao	122	弘道
huo	23	或
jia	26, 30	斝
jiachen	128, 129	甲辰
jian (basin)	35	鑑
jian	85	建
Jiancicun	80, 81, 82	澗磁村
Jiangpuxian	85	江浦縣
Jiangsu	1, 21, 85	江蘇
Jiangxi	86, 87	江西
Ji'anxian	86	吉安縣
jiehua	122	界畫
Jilin	72	吉林
Jin	35	晉
jing	44	鏡
Jingdezhen	87	景德鎮
Jingzhai zhencang	122	敬齋珍藏
Jin[x] jianding	126	金[X]鑑定
Jin[x] shending zhenji	126	金[X]審定真跡
Jiuwan zhongren	128	九畹中人
Jizhou	86	吉州
jue	22	爵
Julu	129	鉅鹿
Juluxian	68, 80	鉅鹿縣
jun	83, 84	鈞
Juntai	84	鈞台
Kaifeng	67	開封
Kao Ming	124	高明
Kao Ts'en	130	高岑
K'o Chiu-ssu	124	柯九思
Kongque	127	孔雀
Kung Hsien	130	龔賢
Kuo Hsi	123	郭熙
Kuo Hsü	126	郭詡

Lan Ying	Fig. 37	藍瑛
Lang-wu	122	朗悟
leiwen	32	雷紋
Li Chieh	124	李節
Li K'an	121	李衍
Li Shih-hsing	121	李士行
Li Tso-hsien	126	李佐賢
Li Tsung-wan	123	厲京萬
Liang Chang-chü	128	梁章鉅
Liang Ch'ing-piao	123	梁清標
Liangzhu	1, 2	良諸
Liaoning	123	遼寧
liding	27, 29	鬲鼎
Limin Wushi	129	立民吳氏
Lingshan jing	46	靈山鏡
Lingtaixian	30, 31	靈臺縣
Lingzhi	88	靈芝
Linru (Lin-ju)	75	臨汝
Linruxian	75, 83	臨汝縣
Linyixian	56	臨沂縣
Liu Kuan	124	柳貫
Liu Sung-nien	130	劉松年
Liu Yüan-chi	Fig. 31	劉原起
Liujiachu	57	劉家渠
Liutong	120	六通
Liyu	35	李峪
Lizong (r. 1235–1264)	119	理宗
Longquan	76, 77, 78, 79	龍泉
Loshan	26	羅山
lu	16	鹿
Lu Chao-yang	127	盧朝陽
Lü Chi	127	呂紀
Luan Bo he	30	隒伯奎
Luoyang	30, 38, 39, 58	洛陽
Ma Lin	119	馬麟
Ma Shou-chen	128	馬守真
Ma Xianglan yin	128	馬湘蘭印
Ma Yüan	119	馬遠
Machang	54, 55	馬廠
Macheng	87	麻城
Mancheng	19	滿城
Maozhai wanshang	129	茅齋玩賞
meiping	68, 71, 74	梅瓶
Meng Shu-ching	124	孟叔敬
Mi Fei	130, Fig. 33, Fig. 34	米芾
Miaojiaqiao	76	繆家橋
Miehuo	58	滅火
Moku'an	120	黙庵
Mu-ch'i	120	牧谿
Muromachi (1333–1573)	120	室町

Naito Konan	122	內藤湖南
Nanjing	48, 126, 128, 129, 130	南京
Nanking, see Nanjing		
Ni Tsan	124	倪瓚
niaoxing kedao	11	鳥形刻刀
Ningchengxian	66	寧城縣
Ningzong, (r. 1195–1234)	119	寧宗
Pai Chien	122	白堅
P'an Hou	122	潘厚
Panlongcheng	20	盤龍城
Peking, see Beijing		
P'eng Wei-tzu	122	彭維梓
Pien Wen-chin	127	邊文進
Pinggu	20	平谷
Pipa xing	126	琵琶行
Po Chü-i	126	白居易
Qi	33	齊
qi	23	啟
Qianshu	72	錢俶
Qiantang	121	錢塘
Qianxian	61, 63	乾縣
Qinan	125	啟南
qingbai	87, 93	青白
Qingjiang	21	清江
Qinweishui	128	秦淮水
Qizong zhenshang	125	起宗真賞
Quheyao	67	曲河窯
Quyangxian	80, 81, 82	曲陽縣
ren	123	仁
Renzong (r. 1311–1320)	121	仁宗
(Sa) Hui-chien	124	(薩)惠鑑
Sanzu	125	三梓
Sengge	122	
Shaanxi	3, 27, 33, 34, 56, 61, 63, 74	陝西
Shahebao	86	沙河堡
Shandong	56	山東
Shangyu	73	上虞
Shanshui ce	130	山水冊
Shanxi	4, 34–36, 42, 69, 70, 71, 83	山西
Shanxian	57	陝縣
Shao P'ing	124	邵平
Shaogou	58	燒溝
Shaoxing	45, 76	紹興
Shaxian	127	沙縣
she	27	涉
Shen Chou	123, 125	沈周
Shen Kuan	123	沈觀
Shenlutang yin	126	湛露堂印
shi	27	示
shi (historian)	28	史

Shilou 4 石樓

Shitian 125 石田

Shixia 1, 2 石峽

Shizhuzhai huapu 129 十竹齋畫譜

Shou-jen 122 守仁

Shu-ming 124 叔明

shuang longhu jing 45 雙龍虎鏡

Shuanglin shuwu 122 雙林書屋

shuangluan xian shoudai jing 47 雙鸞銜綬帶鏡

Shuangsong tu 121 雙松圖

Sichuan 7, 86, 120 四川

Songjiazhuang 83 宋家庄

Su Shih Fig. 33 蘇軾

Suidexian 34 綏德縣

Sun Hua 124 孫華

Sun I-yuan 126 孫一元

Suzhou 125, 129 蘇州

Taipingchang 7 太平場

Taiyuan 69 太原

T'an Ching 124 譚敬

T'ang Yin Fig. 36 唐寅

Tangyinxian 83 湯陰縣

T'ao Chu 122 陶誅

taotie 19–23, 25–26, 27, 30–33, 35 饕餮

Teng Erh-ya 124, 129 鄧爾疋

Tesshu Tokusai 120 鉄舟德濟

Ti P'ing-tzu 122 狄平子

Tian Deyuan 46 田德元

Tianping 125 天平

T'ing-chün Yung-chang 122 廷俊用章

tixing dao 3 梯形刀

Tongchuanxian 74 銅川縣

Ts'ao Jui 124 曹睿

Tuan Fang 122 端方

Tung-t'ing 124 洞庭

Tung Yüan 124 董源

tungnei yuyuan ge 4 銅内玉援戈

Tz'u-chou, see Cizhou

Wang Chen-p'eng 122 王振鵬

Wang Chi-ch'ien 122, 123 王季遷

Wang Chih-teng 128, Fig. 31 王穉登

Wang Chuan 123 王撰

Wang Feng 123 王逢

Wang Kai 130 王槩

Wang Meng 124 王蒙

Wang Ming-chi 124 王鳴吉

Wang Pao 120 王襃

Wang Wen-yüan 129 王聞遠

Wang Yin 126 王寅

Wang Yüan 123 王淵

Wangshi momiao 123 王氏墨妙

Wei Chih-huang 129 魏之璜

Wei Chih-k'o 129 魏之克

Wen Cheng-ming Fig. 31 文徵明

Wen Ding 26 文丁

Wen P'eng Fig. 31 文彭

Wen Ting 129 文鼎

Wen Yüan-fa Fig. 31 文元發

Wenxi 34 聞喜

Wenxian 22, 26 溫縣

Wu Ch'üan-tsui 124 伍銓萃

Wu-chun Shih-fan 120 無準師範

Wu Ding 10, 22, 23 武丁

Wu K'o-kung 124 吳克恭

Wu Wei 126 吳偉

Wu Yi 26 武乙

Wu Yue 72 吳越

Wucheng 21 吳城

Wuguancun 4 武官村

Wuxing 124 吳興

xi 22 徙

Xi'an 46, 48, 56, 59, 61 西安

Xianglan nushi 128 湘蘭女士

Xianyu Tinghui 61 鮮于庭誨

Xianzong (r. 1464–1487) 126 憲宗

Xiaoliuzhangzi 66 小劉伏子

Xiaopin[X] 129 小品〔X〕

Xinjiang 48 新疆

Xiushui (Hsiu-shui) 130 繡水

Xiuwuxian 83 修武縣

Xiwang Mu 45 西王母

Xiyu 122 惠玉

Xuejiagang 2, 3 薛家崗

Ya Yi 22 亞矣

Yamato Bunkakan 72 大和文華

Yang Wei-chen 124 楊維楨

Yangshao 53 仰韶

Yangzhou 47, 48 楊州

Yaocha jiebo 122 藥义揭鉢

Yaozhou 72, 74 耀州

yazhang 7 牙璋

Yen Deyuan 70 閻德源

yi 27 乙

Yide 61 懿德

yin 1 陰

ying-ch'ing, see yingqing

Yingningguan jiancang yin 129 櫻寧館鑑藏印

yingqing 87 影青

Yinqueshan 56 銀雀山

Yinxu, see Anyang

yizi xinjian 129 一字心堅

Yonghe tang 108 永和堂

Yonghezhen 86 永和鎮

Yoshimitsu (r. 1368–94) 120 義滿

you 20, 32 卣

Youzhu ju 125 有竹居

Yü-lan 124 惠嬾

Yu-tan ching-nan 124 游儋景南

Yue 72, 73 越

Yue'an 124 瀹菴

Yüeh, see Yue

Yueh Ch'ang-lieh 124 俞昌烈

Yüeh Yu 124 岳榆

Yufu guizhuang 119 漁夫歸莊

Yuganxian 86 余干縣

Yuxian 83, 84 禹縣

Zhaigoucun 69 寨溝村

Zhang Guo 104 張果

Zhang Tongzhi 85 張同之

Zhangjiapo 27 張家坡

Zhaowudameng 66 昭烏達盟

Zhejiang 45, 72, 73, 76, 119, 121, 124 浙江

Zhengzhou 20 鄭州

zhi 37 厄

zhong 33 鍾

Zhong Jing zuo bao yi 31 仲競作寶彝

Zhongli Quan 104, Fig. 10 鍾離權

Zhongming 124 仲茗

Zhuse lanzhu 128 設色蘭竹

zong 1, 2, 76 琮

zun 29, Fig. 3 尊

[X]fen guan zhencang 121 [X]芬館珍藏

[X]lu yuan 126 [X]露園

[X]shou tang 124 [X]壽堂

[x]ya tang 129 [X]雅堂

Pronunciation Guide

PINYIN	WADE-GILES	sound
B	P	Bee
C	Ts'	iT'S
Ch	Ch'	CHew
D	T	Dog
G	K	Good
J	Ch	maGic
K	K'	Key
P	P'	Pay
Q	Ch'	CHeek
R	J	Rinse
T	T'	Tick
X	Hs	wiSH
Z	Ts	aDZe
Zh	Ch	Joy

Introduction

by R. W. Sherin, Assistant Conservator
Indianapolis Museum of Art

Late in 1981 we began our technical investigations of the bronzes in the Eli Lilly Collection of Chinese Art. With the encouragement and support of the IMA's Curator of Oriental Art, Dr. Yutaka Mino, the analytical procedure was outlined and carried out by Dr. Leon Stodulski, Ms. Portia Bass, and Ms. Mary F. Striegel of the Analytical Chemistry Division of Indiana University-Purdue University at Indianapolis. Mr. James Robinson, assistant curator of Oriental Art, took charge of the project.

A cooperative effort was necessary among scientist, curator, and conservator to obtain, assimilate, and apply this new information. Such cooperation between the Indianapolis Museum of Art staff, the Analytical Chemistry Division of I.U.P.U.I., and several high-technology industrial organizations has brought forth this important, in-depth look at the Chinese bronzes in the Lilly Collection.

X-radiography is a very useful tool in the technical studies of ancient bronze vessels. It reveals much information about their true condition. Our first task, then, was to radiograph each of the bronzes. Dr. Stodulski arranged to do this with Detroit Diesel-Allison, a division of the General Motors Corporation located in Indianapolis. Its representatives generously offered us the use of their 300 kV radiography unit. Mr. Lawrence Hipsher, chief x-ray technologist, made the radiographs. These pictures alone have provided us with much new and important information and have also confirmed a few previous suspicions.

All radiographs presented here were made with a Norelco MG-300 kV, at an average film distance of 40 inches. Kodak Industrex M Film, in Lead-Pack form, was used. The radiographs were processed in a Kodak X-Omat automatic developer. All exposures were made in the range 160–200 kV, 6ma, for one to two minutes.

In order to proceed with the material analyses, we needed minute samples of representative alloy. The radiographs allowed us to make a more precise determination of appropriate and representative sites from which to extract metal samples for the next step in the study—the analysis of the alloys. To do this elemental analysis accurately, we employed analytical techniques known as Atomic Emission Spectrography and Atomic Absorption Spectrometry. It was determined that the complete anal-

yses could be accomplished with only 15 milligrams of alloy per sample.

Using the radiographs to guide us, we selected an obscure but apparently representative site on each vessel from which to extract the sample. Sampling was done with a new #60 high-speed steel drill bit for each sample, using a foot-operated, rheostatically controlled, flexible-shaft drilling apparatus. In order to maximize the purity of the sample, i.e., minimize the undesirable negative influences of corrosion products on the analyses, the first half-millimeter or so of sample was collected separately and labeled. Drilling was then continued until the needed amount was obtained. The sample was next examined under a microscope to ascertain its relative purity. If it was too contaminated, drilling was continued until a cleaner sample was obtained.

Once a sufficiently clean sample was collected from each site, the small hole created was immediately and completely filled with pigmented microcrystalline wax to match the surrounding color of the corrosion products, or patina, on the surface of the vessel. Sample sites on each vessel were documented both in writing and in photographs, for future reference.

The following examples illustrate some of the technical features revealed in the radiographs:

Jia (IMA 60.33, Pl. 26.) The presence of a significant number of "blowholes" (indicating porosity of the alloy)—seen as small black spots—is clearly illustrated. These blowholes were made by evolved gases trapped when the molten alloy was poured into the mold, because of insufficient "feeding" of molten metal during solidification. As a result, small voids were created in the cast form when these gases, upon cooling, gradually diffused through the metal. A knowledge of the location and concentration of these voids can indicate relatively weaker areas of a vessel, and likelier sites for possible accelerated corrosion activity.

As previously mentioned, radiographs readily indicate the existence and extent of cracks and other casting flaws created by unequal stresses during improper cooling of the molten alloy in the mold.

Gui (IMA 60.44, Pl. 31.) Shrinkage cracks can be seen in the handle. In the lower part of the handle is a very obvious area of segregated low density. This area probably resulted from migrating gases and other impurities that became trapped during the pour because of improper mold design. "In normal solidification and subsequent cooling, part of the nonmetallic constituents are trapped and remain segregated because of their inability to diffuse through the [metal] grains."[1] "Internal cracks, also known as 'flakes,' hairline cracks, or cooling cracks, are the result of unfavorable cooling conditions . . . they are actual discontinuities in the metal and are potential sources of failure."[2]

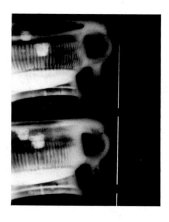

1. George L. Kehl, *Metallurgy and Metallurgical Engineering Series*, New York, 1949, p. 196.
2. Ibid., p. 202.

Gui (IMA 60.44, Pl. 31.) Another radiograph of the same vessel, this time made through the bottom: the segregation of the metal grains and the presence of denser areas (seen in the radiograph as white lines and on the bottom of the vessel, seen with the naked eye, as raised lines) would also indicate a rapid or uneven cooling process, known as chilling, of the molten alloy. The result is a discontinuity in the metal, a greater heterogeneity, and an area of relative general weakness. "Crystalline heterogeneity depends

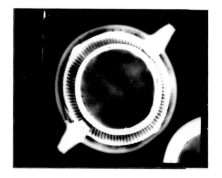

upon the manner of solidification and the crystalline growth of the metal or alloy."[3]

The number and precise locations of the chaplets are also obvious.

3. Ibid., p. 176.

Gui (IMA 60.44, Pl. 31.) In a third view of this same vessel, a significant area of repair can be detected just to the side of one of the handles. The area appears to have been filled with lead or lead-tin solder, and the necessary decor then incised into the newer, softer metal.

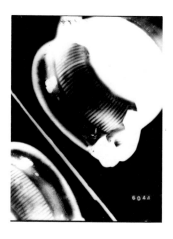

The art of soldering is an ancient process. It is therefore difficult, if possible at all, to make a determination as to whether or not a repair is a "new" one or an "ancient" one. Lead-tin solders vary in their percentage composition, with a 1:2, Pb:Sn combination (37% Pb : 63% Sn) having the lowest melting point of all possible combinations of these two metals. It is also the "hardest" of all the lead-tin soft solders. It therefore possesses the two properties most desirable in a soft solder (used for repair purposes): a low melting point (183° C), and strength. N.B.: A soft solder of 54% Pb : 46% Sn + ¼–½% antimony added is the *strongest* form of soft solder.

To lower the melting point further, bismuth (Bi), cadmium (Cd), or mercury (Hg) can be added to a soft solder. It will be very interesting to make a thorough study of the precise elemental compositions of all lead-tin solders used for repairs made to the Lilly bronzes in an attempt to find a link between some or all of them. It is hoped that such a study can be a significant part of the continuing technical investigation of these fine bronzes.

Guang (IMA 60.43, Pl. 25.) It can be seen here that the initial cast was imperfect, evidenced by areas of excessive porosity (blowholes) and seemingly amorphous areas of significantly lower density in the lid to this vessel (between the standing horns).

The radiograph of the body gives evidence of a less-than-perfect original cast, necessitating what appears to be the addition of a significant amount of a denser material at the base—probably a second alloy pour—to complete the form.

354

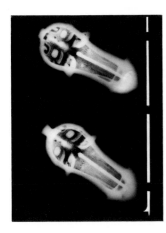

Often—more often than one might expect—missing parts and sometimes entire sections have been extensively "restored" at some point in a vessel's history. Such restorations were most often made with lead, lead-tin solder, copper metal, or plaster of paris. Usually they are cleverly disguised by the application of a falsified patina of some kind, making it very difficult if not impossible for the naked eye to determine their very existence, much less their extent. Such repairs often do not hold together because these repair materials simply do not adhere well to old, corroded metal.

Hu lid (IMA 60.32, Pl. 35.) This lid is suspected of not being original to the body with which it is now associated. For one thing, stylistically speaking, the decor of the lid does not match that of the body. This would indicate that, if this lid is authentic, it was probably originally mated with a different body.

The radiograph indicates that this lid may have been modified to adapt it to function as a lid for this vessel. It appears that it may have been increased in diameter by the addition of a dense(r) alloy, probably lead-tin solder, all around its perimeter.

The elemental analyses show that a sample (#12) taken from this perimeter, at the edge, contains about 50% lead, 50% tin—with no evidence of any copper or zinc. This evidence substantiates the prior conjecture that a lid was "extended" to fit this vessel.

Fangyi (IMA 60.84, Pl. 21.) The vessel has been once broken into at least six pieces, and appears to have been "spot-soldered." The cracked bottom, too, apparently has been rather minimally repaired, as there are only two spots of solder. In addition, it can be seen that a piece along the top edge was less than perfectly aligned at the time of the repair.

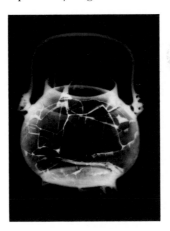
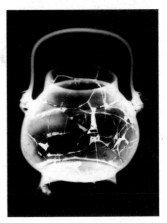

You (IMA 60.24, Pl. 32.) The actual condition of this vessel was a surprise, as all repairs had been cleverly hidden beneath a falsified patina. The many broken pieces have been remarkably reassembled with, in all probability, a lead-tin solder. All broken pieces appear to be original to the vessel, as judged by their similar densities in the radiograph. Small, hairline cracks can also be seen as black lines. Note also the existence of blowholes in some of the soldered joins.

You (IMA 60.24, Pl. 32.) Another radiograph shows the opposite side of this same vessel.

You lid (IMA 60.24, Pl. 32.) The lid to this vessel had been suspected of being a complete forgery. This conclusion, up to the time of this study, had been entirely based on a visual examination of its surface and decor. The radiograph immediately indicates a substantial difference between the character of the *metal* of the lid and that of the *alloy* of the body—the material of the lid is much more uniform and homogeneous. A join can even be readily seen in its perimeter, which may indicate, because of a lack of

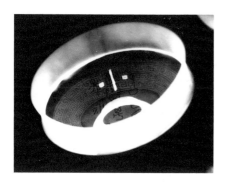

significant density, a forge-welded join. This, then, would further suggest that the lid had not been cast at all, but rather had been fashioned, at a much later time, out of sheet copper. The elemental analyses of the lid corroborated this observation by indicating that it contains 95.6% copper, almost pure.

He (IMA 60.34, Pl. 30.) This vessel also was severely damaged and cleverly repaired, probably with solder. Note also the broken and repaired spout.

The significant differences in density between adjacent areas, most easily seen on the upper part of the body, probably indicate varying degrees of corrosion activity.

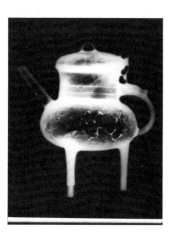

Analyses of Bronzes

by L. P. Stodulski, P. Bass, and M. F. Striegel

Introductory Comments:

Prior to this study, the Lilly Oriental bronzes had not been sampled or subjected to any modern materials analysis techniques. It was therefore our purpose to determine quantitatively, as accurately as possible, the concentrations of those metallic elements most likely to be of archaeological or art historical significance to the Museum's scholars. Furthermore, we proposed to accomplish this with the expenditure of as little of the valuable sample material as was practical. The instrumental techniques chosen for these analyses were the mutually complementary ones of Atomic Emission Spectrography (AES) and Atomic Absorption Spectroscopy (AAS). AES is especially suitable for analyses of materials that contain a large number of different elements in low to trace concentrations. It also has the advantage of enabling the analyst to determine qualitatively these elements simultaneously from the consumption of a single, very small sample. AAS requires that certain specialized pieces of equipment be used for the analysis of each element of interest, which means that these elements must be determined one after the other, rather than simultaneously (as with the AES technique). This usually demands the expenditure of more sample material than is needed for AES analysis—a disadvantage that is more than compensated for by the fact that AAS analyses provide results of greater accuracy for elements present in major and minor amounts than is usually possible with the AES technique. Also, by careful refinement of this method, and by using the sensitive instrumentation available today, the analyst can provide very accurate results from the consumption of an extremely small sample. By using both of these analytical techniques, the analyst has the best of both worlds—being able to determine the major and minor elements with a high degree of accuracy, and also being able to determine the presence or absence, and the concentrations of, many trace elements as well. The ultimate goal of such an analysis is to provide an elemental "fingerprint" of an unknown material, of sufficient scope and accuracy that it can be used to clearly characterize that material. It is of prime importance to know exactly how much reliance can be placed on the analytical data generated, so that one is able to state with confidence that a particular difference between the compositions of two samples is, or is not, truly significant—and not merely

because of the experimental uncertainty inherent in the analytical method employed.

The present study reports the determination of copper (Cu), tin (Sn), lead (Pb), zinc (Zn), arsenic (As), nickel (Ni), iron (Fe), manganese (Mn), silicon (Si), phosphorus (P), antimony (Sb), and aluminum (Al) by AES analyses, and of copper, tin, lead and zinc by AAS analyses. A complete discussion of the physical principles behind the operation of these two analytical techniques is beyond the scope of this appendix. However, the special analytical methods that were developed for this study are briefly described. The accuracy of these methods was determined by analyses of standard materials of known composition, and a comparison of the experimental results with the "known" values is also presented. Finally, the information obtained from these studies, and its art historical and curatorial significance, are discussed.

Description of Analytical Methods
Atomic Emission Spectrographic Analyses:

The instrument used in this phase of the study was an Applied Research Laboratories Spectrographic Analyzer. This instrument operates in the following manner—a small, solid sample of the material to be analyzed is placed in a direct-current electric arc, quickly heated to a temperature in excess of 4000 degrees F, and vaporized over a period of time. During this process, some of the electrons within the sample's atoms are removed from their stable room-temperature positions—a process called excitation. When the excited, gaseous atoms reach a slightly cooler part of the electric arc, electrons return to their initial positions. In so doing, they emit the precise amount of energy that was required to excite them in the first place—energy in the form of a series of wavelengths of ultraviolet and visible light. It has long been known that the series of wavelengths emitted by each of the different chemical elements, the emission spectrum of that element, is unique to that particular element. The exact wavelength of each individual emission line in the emission spectra of all the elements has been accurately measured. When an unknown material is vaporized as described above, the elements contained within it simultaneously emit all of their respective wavelengths. An instrument such as the Spectrographic Analyzer is designed to generate, collect, and separate these wavelengths, and to record them permanently, as a series of closely spaced lines of varying intensities, on a strip of photographic film. Thus, by scrutinizing the film and searching for the characteristic emission lines of particular elements, the analyst is able to determine, qualitatively, whether these elements were present in the vaporized sample. Furthermore, the intensity of a given atomic emission line is proportional to the amount of the element that gave rise to it. Quantitative determinations of the amounts of the different elements present in a sample of unknown composition are therefore achievable by measuring the intensities of individual emission lines from those elements and comparing them to the intensities of lines of the same wavelength obtained by vaporizing standard materials containing known amounts of the given elements.

The development of the quantitative AES method for the analyses of the Lilly alloy samples required the use of a series of twelve different National Bureau of Standards (NBS) and British Chemical Standards (BCS) bronze and brass alloys that contained accurately known amounts of the twelve different elements previously mentioned. A sample of 99.999% pure copper metal was also used. A 5.0-milligram portion of each standard alloy was weighed on an analytical balance to within ± 0.1 milligram, thoroughly mixed with an equal weight of a 90% (by weight) pure graphite powder/10% (by weight) germanium dioxide mixture (to eliminate loss of sample during heating), placed in a graphite sample electrode, and completely vaporized by the electric arc of the Spectrographic Analyzer over a period of two minutes. Multiple samples of each standard alloy were vaporized. The intensities of previously selected emission lines (referred to as analytical lines)—one from the spectrum of each of the twelve elements to be determined—were measured from the films produced as a result of the excitation and consumption of each standard sample. The intensity values obtained for each analytical line were averaged and plotted against the known percent concentration of the respective element contained in the standard sample vaporized. A computer was used to produce this "emission intensity versus element concentration" calibration curve. The computer was also programmed to provide the equation of the curve that best fit all the experimental data points plotted. Calibration curves for each of the twelve elements were thus obtained. The one for copper is shown in Figure I.

The reliability of the AES analytical method was determined in the following manner: three of the available standard alloys were re-analyzed as if they were unknown materials, and the percentage of each element was calculated from the appropriate calibration curve equation. Three "composite alloys" were also produced by mixing together exactly 2.50 ± 0.01 milligrams of each of two different standard alloys, and similarly analyzed. Duplicate determinations of each of these standard materials were done. Comparisons of experimentally calculated percent compositional values with known (true) values of percent element provided a measure of method accuracy. The difference between duplicate analyses of the same standard material gave an estimate of the reproducibility of the analytical method. The experimental uncertainty of the AES technique was obtained by calculating the percentage difference between the experimental and known values, and averaging these individual positive and negative deviations from the known value, without regard to sign, to obtain an "average percent absolute error" for each element determined. Average errors varied from ± 10% (of the value calculated) for copper to ± 50% for silicon—an element present in quite low con-

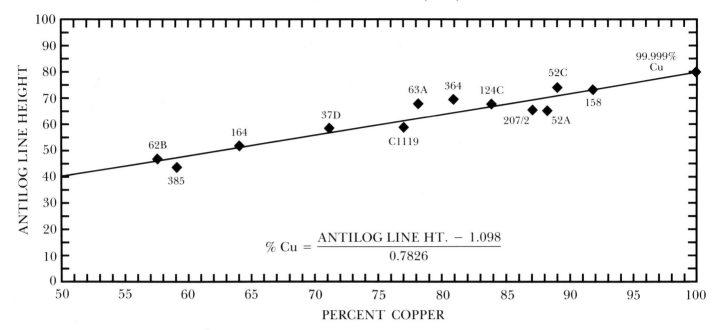

FIGURE I: Calibration curve for Cu 2978.27Å line in the range of 55–100%. NBS and BCS standard alloys, and pure copper metal, are indicated.

centrations, and therefore very difficult to determine accurately. Average errors for most of the other elements were in the region of ± 15% to ± 20%.

The results of AES analyses of the standard and composite alloys are shown in Table I. The experimental uncertainty associated with each value determined is also indicated. It should be pointed out that in any analysis, an average of replicate determinations generally gives a better estimate of the true value than does an individual determination, as positive and negative experimental errors tend to cancel each other. This is seen in the average values calculated from the duplicate analyses of the standard alloys. However, it was known from the very beginning of this study that sufficient sample for even duplicate analyses of some of the Lilly bronze alloys might not be available, and that the results of single determinations would therefore have to be relied upon to provide the elemental "fingerprint" desired. Inspection of the results of individual alloy composition determinations in Table I, and comparison of them with both average experimental and known values, reveals that they do provide a good estimate of alloy composition. Furthermore, the experimental uncertainty of each value determined provides a realistic estimate of the reliability of that value. Attention is also drawn to the fact that the copper content of these alloys was determined by two different procedures—by measurement of the copper analytical line intensity, as described above, and also by difference—that is, by adding together the percentages of all the minor and trace elements present, and subtracting this value from 100%. The results of both methods are shown in Table I for four of the six standards analyzed. It is obvious that the difference procedure provides the more accurate value. The copper content of the remaining two standards could not be precisely deter-

mined by the difference procedure as their zinc content is greater than the maximum amount that could be accurately determined by the AES method. Several alloys also contain amounts of particular elements that are less than the detectability limit of the method. When either case occurs, the maximum or minimum percent concentration values of that element are given in Table I.

The actual analyses of the Lilly bronze alloys followed the procedure outlined for the standard alloy analyses. A 5.0-milligram* portion of each sample was weighed, mixed with 90% graphite/10% germanium dioxide, placed in a graphite electrode and vaporized in the Spectrographic Analyzer for exactly two minutes. Great care was taken to ensure that all conditions for the analysis of the unknown materials were exactly the same as those for the standard alloys. The intensities of the analytical lines of the twelve elements of interest were measured from the spectrographic films, and the percent concentration of each element calculated from the appropriate calibration curve equation. The results of these analyses are presented in Table III, along with the Atomic Absorption analytical data, and are discussed in a later section.

* An idea of the relative size of this sample can be obtained by considering the fact that an average paper clip weighs about 450 milligrams—90 times the weight of the samples required for these analyses.

Atomic Absorption Spectrometric Analyses:

These studies were conducted using a Varian 875 Atomic Absorption Spectrometer. In the AAS technique, a solution of the sample to be analyzed is introduced into the instrument, broken up into tiny droplets, and sprayed (or aspirated) into a high-temperature flame. Once in the flame, the solvent rapidly evaporates, leaving behind tiny particles of solid material that contain all the elements in the original sample. The temperature of the flame is

Table I: Atomic Emission Spectrographic Analyses of Standard Alloys

NBS 124C

ELEMENT	PERCENT ELEMENT CALCULATED			PERCENT KNOWN
	TRIAL 1	TRIAL 2	AVERAGE	
Cu	81.2 ±8.1	81.2 ±8.1	81.2 ±8.1	84.22
Cu*	84.1	86.3	85.2	
Sn	5.39 ±0.54	4.88 ±0.49	5.14 ±0.51	5.13
Pb	4.53 ±0.68	3.86 ±0.58	4.20 ±0.63	4.74
Zn	4.79 ±0.72	3.89 ±0.58	4.34 ±0.65	4.93
As	<0.015	<0.015	<0.015	~0.002
Fe	0.192±0.096	0.186±0.093	0.189±0.095	0.107
Ni	0.67 ±0.13	0.63 ±0.13	0.65 ±0.13	0.60
Sb	0.32 ±0.13	0.22 ±0.008	0.27 ±0.11	0.20
Al	<0.50	<0.50	<0.50	—
Si	<0.005	<0.005	<0.005	0.002
P	<0.05	<0.05	<0.05	0.024
Mn	<0.10	<0.10	<0.10	—

BCS 207/2

ELEMENT	TRIAL 1	TRIAL 2	AVERAGE	PERCENT KNOWN
Cu	83.1 ±8.3	79.3 ±7.9	81.2 ± 8.1	87.3
Cu*	87.1	88.9	88.0	
Sn	9.82 ±1.5	8.56 ±1.3	9.19 ±1.4	9.74
Pb	≤1.0 >0.15	≤1.0 >0.15	<1.0 >0.15	0.70
Zn	2.12 ±0.32	1.68 ±0.25	1.90 ±0.29	1.60
As	0.077±0.019	0.10 ±0.025	0.09 ±0.022	0.066
Fe	0.054±0.027	0.06 ±0.034	0.061±0.031	0.029
Ni	0.45 ±0.090	0.37 ±0.074	0.41 ±0.082	0.29
Sb	0.16 ±0.064	0.13 ±0.052	0.14 ±0.056	0.10
Al	<0.50	<0.50	<0.50	0.014
Si	≥0.015	≥0.015	≥0.015	0.016
P	<0.05	<0.05	<0.05	0.018
Mn	<0.10	<0.10	<0.10	—

NBS 37D

ELEMENT	TRIAL 1	TRIAL 2	AVERAGE	PERCENT KNOWN
Cu	81.2 ±8.1	79.3 ±7.9	80.3 ±8.0	70.78
Cu*	<88.6	<89.5	<89.0	
Sn	1.58 ±0.32	0.92 ±0.18	1.25 ±0.25	0.97
Pb	≤1.0 >0.15	≤1.0 >0.15	≤1.0 >0.15	0.94
Zn	>8.0	>8.0	>8.0	26.65
As	<0.015	<0.015	<0.015	—
Fe	0.17 ±0.076	0.13 ±0.065	0.152±0.076	0.076
Ni	0.63 ±0.13	0.46 ±0.092	0.55 ±0.11	0.58
Sb	<0.10	<0.10	<0.10	—
Al	<0.50	<0.50	<0.50	—
Si	<0.005	<0.005	<0.005	—
P	<0.05	<0.05	<0.05	—
Mn	<0.10	<0.10	<0.10	—

*Copper by difference

Table I, cont'd.

NBS 158/NBS 63A

| ELEMENT | PERCENT ELEMENT CALCULATED | | | PERCENT KNOWN |
	TRIAL 1	TRIAL 2	AVERAGE	
Cu	72.3 ± 7.2	91.1 ± 9.1	81.7 ± 8.2	84.67
Cu*	85.9	86.5	86.2	
Sn	5.57 ± 0.56	5.57 ± 0.56	5.57 ± 0.56	5.37
Pb	4.53 ± 0.68	4.19 ± 0.63	4.36 ± 0.65	4.46
Zn	1.68 ± 0.25	1.21 ± 0.18	1.45 ± 0.21	1.34
As	<0.015	<0.015	<0.015	0.014
Fe	0.71 ± 0.18	0.79 ± 0.20	0.75 ± 0.19	1.0
Ni	0.21 ± 0.042	0.21 ± 0.042	0.21 ± 0.042	0.16
Sb	0.28 ± 0.11	0.27 ± 0.11	0.28 ± 0.11	0.25
Al	<0.50	<0.50	<0.50	0.27
Si	>>0.015	>>0.015	>>0.015	1.36
P	0.47	0.41	0.44	0.29
Mn	0.59	0.86	0.73	0.66

NBS 124C/NBS 62B

ELEMENT	TRIAL 1	TRIAL 2	AVERAGE	PERCENT KNOWN
Cu	79.3 ± 7.9	77.6 ± 7.8	78.5 ± 7.9	70.81
Cu*	<85.6	< 85.2	<85.4	
Sn	2.28 ± 0.46	2.67 ± 0.27	2.48 ± 0.50	3.05
Pb	2.52 ± 0.38	2.46 ± 0.37	2.49 ± 0.37	2.51
Zn	>8.0	>8.0	>8.0	21.45
As	<0.015	<0.015	<0.015	~ 0.003
Fe	0.51 ± 0.077	0.48 ± 0.072	0.50 ± 0.075	0.464
Ni	0.36 ± 0.072	0.51 ± 0.10	0.44 ± 0.088	0.435
Sb	0.22 ± 0.088	0.14 ± 0.056	0.18 ± 0.072	0.103
Al	≤0.50	≤0.50	≤0.50	0.49
Si	0.014 ± 0.007	0.015 ± 0.008	0.015 ± 0.008	0.025
P	<0.05	<0.05	<0.05	0.012
Mn	0.50 ± 0.10	0.56 ± 0.11	0.53 ± 0.11	0.65

NBS 52A/BCS 207/2

ELEMENT	TRIAL 1	TRIAL 2	AVERAGE	PERCENT KNOWN
Cu	79.3 ± 7.9	79.3 ± 7.9	79.3 ± 7.9	87.74
Cu*	88.0	86.6	87.3	
Sn	8.17 ± 1.2	10.2 ± 1.5	9.19 ± 1.4	8.79
Pb	<1.0 >0.15	<1.0 >0.15	<1.0 >0.15	0.36
Zn	3.02 ± 0.45	2.38 ± 0.36	2.70 ± 0.41	2.39
As	0.028 ± 0.007	0.027 ± 0.007	0.028 ± 0.007	0.035
Fe	0.064 ± 0.032	0.057 ± 0.029	0.061 ± 0.030	0.040
Ni	0.48 ± 0.096	0.54 ± 0.11	0.51 ± 0.100	0.51
Sb	≤0.10	≤0.10	≤0.10	0.052
Al	<0.50	<0.50	<0.50	0.007
Si	0.012 ± 0.006	0.015 ± 0.008	0.014 ± 0.007	0.0085
P	<0.05	<0.05	<0.05	0.0095
Mn	<0.10	<0.10	<0.10	0.01

*Copper by difference

adjusted so that it is hot enough to break down these particles into single, neutral atoms, but not hot enough to excite them, as is purposely caused to happen in the AES technique. While in the flame, these neutral atoms can absorb certain specific wavelengths of light that are being passed through the flame. The amount of energy absorbed is proportional to the concentration of the absorbing atoms in the flame, which is, of course, proportional to the concentration of those atoms in the original sample. By comparing the absorbances of standard solutions containing known amounts of given elements with the absorbances of these same elements in unknown sample solutions, a quantitative estimate of the elements contained in the unknown sample solution is obtained.

An atomic absorption spectrometer is designed to permit absorption of energy by only one particular element at a time. This is accomplished by passing only those wavelengths of light through the flame that can be absorbed by atoms of the particular element being determined. These highly specific wavelengths are provided by a special radiation source called a hollow cathode lamp. These principles are illustrated by the following example: if a solution of an alloy containing copper, tin, lead, zinc, and trace amounts of many other elements is aspirated into the flame of a spectrometer that has been fitted with a copper hollow cathode lamp, only the neutral copper atoms will absorb a portion of the radiation passing through the flame. Atoms of tin, lead, zinc, and those of the other elements present will remain unaffected. In order to determine the lead content of this alloy, a lead hollow cathode lamp must be substituted, and a further portion of the solution aspirated again. This procedure is repeated, using the appropriate radiation source, for each element determined.

Thus, the analysis of Cu, Sn, Pb, and Zn in the present study required the use of four separate hollow cathode lamps. It was also necessary to develop a separate set of instrumental conditions for the analysis of each of these four metals. Conditions such as flame temperature, sample aspiration rate, the portion of the flame through which the radiation beam passes, and radiation intensity from the lamp all had to be optimized for each element in order to provide maximum instrumental sensitivity, and thereby reduce the amount of sample required for accurate analytical results to be obtained. In a very real sense, the analyses of these four elements required the development of four separate analytical methods. A complete listing of all these conditions, and the reasons for them, will not be given here. However, some of the conditions required for the analysis of tin are illustrative of the precautions that were necessary in these studies. It was discovered that tin-containing alloys dissolved completely in acid solution, but that tin exhibited the tendency to precipitate back out of solution after a few days. Therefore, solutions containing tin had to be measured within twenty-four hours of sample dissolution. The analysis of tin also required a very hot nitrous oxide/acetylene flame, whereas the other three elements were better handled using a cooler compressed air/acetylene flame. And finally, it was found that the presence of large amounts of copper gave falsely high tin percentages. This effect was compensated for by adding known amounts of copper to the standard tin solutions used to determine the percentage of tin in the Lilly bronze alloys.

Quantitative AAS analyses required the establishment and use of a separate calibration curve for each metal. Standard solutions of each of these metals were prepared from 99.999% pure copper, tin, lead, and zinc, weighed to an accuracy of at least \pm 0.10% on an analytical balance, dissolved in a small amount of 3 parts concentrated hydrochloride acid/1 part concentrated nitric acid mixture, and diluted with distilled water to known volumes. Each of these metal solutions was further diluted to produce a series of standard solutions, of precisely known concentration, for each metal. Each series of standard solutions were then used to provide the respective calibration curve. All volumetric glassware used was specially calibrated to within \pm 0.10%. A computer was used to plot absorbance of standard solution versus concentration of metal in parts per million (ppm) and the equation of each calibration curve derived. Typical calibration curves for tin and lead are shown in Figure II.

The precision and accuracy of the AAS methods were determined by duplicate analyses of five NBS and BCS alloys. A 10-milligram portion of each alloy was weighed to an accuracy of \pm 0.01 milligrams, dissolved in the concentrated acid mixture, and diluted with distilled water to volume using a calibrated 50-milliliter volumetric flask. These standard alloy solutions were aspirated into the spectrometer, and the absorbance of one metal measured in all five solutions before instrumental conditions were readjusted for the measurement of the next metal. Tin was always determined first, because of its tendency to come out of solution. Freshly prepared standard solutions were alternately aspirated in between the alloy solutions and used to generate a new calibration curve for each analysis, thus preventing day-to-day instrumental variations and possible deterioration of standard solutions from influencing the analytical results. Also, each standard and alloy solution was measured at several different times during the course of an analysis, which usually required about three hours, as a check on instrument stability. The whole procedure was performed two separate times, with new standard solutions being prepared, new portions of alloy being weighed out and dissolved, and new sets of calibration curves being plotted each time. In this way, the reproducibility and accuracy of the entire analytical method was determined.

The results of the duplicate analyses of the five NBS/BCS alloys, together with their known percentages of copper, tin, lead, and zinc, are presented in Table II. It was again observed that the average of duplicate determinations provides better accuracy than do single determinations. The average percent absolute error for these elements was calculated to be \pm 1.52% for copper, \pm 1.64% for tin, \pm 2.12% for lead, and \pm 2.99% for

LEAD ANALYSIS LILLY BRONZES 1-4-83

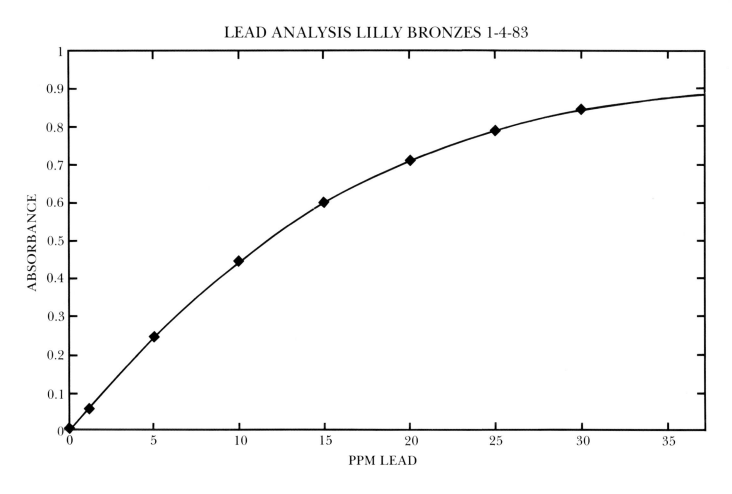

TIN ANALYSIS LILLY BRONZES 1-3-83

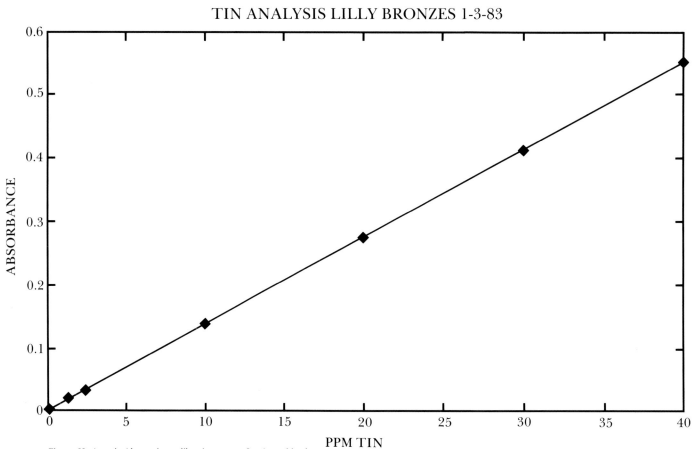

Figure II: Atomic Absorption calibration curves for tin and lead.

Table II: Atomic Absorption Analyses for Standard Alloys

	COPPER			
		PERCENT CALCULATED		**PERCENT**
STANDARD	**TRIAL 1**	**TRIAL 2**	**AVERAGE**	**KNOWN**
BCS 364	80.53 ± 1.23	80.85 ± 1.24	80.69 ± 1.23	80.60
NBS 37D	71.31 ± 1.09	68.58 ± 1.05	69.95 ± 1.07	70.78
NBS 158	91.47 ± 1.40	92.17 ± 1.41	91.82 ± 1.40	90.86
NBS 124C	82.27 ± 1.26	87.11 ± 1.33	84.77 ± 1.30	84.22
BCS 207/2	88.10 ± 1.35	89.25 ± 1.33	88.68 ± 1.36	87.30
	TIN			
BCS 364	9.09 ± 0.149	9.30 ± 0.153	9.20 ± 0.151	9.30
NBS 37D	0.97 ± 0.0159	0.94 ± 0.0154	0.96 ± 0.0157	0.97
NBS 158	1.10 ± 0.0180	1.03 ± 0.0169	1.07 ± 0.0175	0.97
NBS 124C	4.79 ± 0.0786	5.29 ± 0.0868	5.04 ± 0.0827	5.13
BCS 207/2	9.49 ± 0.156	9.66 ± 0.158	9.58 ± 0.157	9.74
	LEAD			
BCS 364	9.21 ± 0.195	9.39 ± 0.199	9.30 ± 0.197	9.20
NBS 37D	0.92 ± 0.0195	0.92 ± 0.0195	0.92 ± 0.0195	0.94
NBS 158	<0.17	<0.17	<0.17	0.004
NBS 124C	4.67 ± 0.099	5.05 ± 0.107	4.86 ± 0.103	4.74
BCS 207/2	0.71 ± 0.0151	0.71 ± 0.0151	0.71 ± 0.0151	0.70
	ZINC			
BCS 364	0.15 ± 0.0045	0.13 ± 0.0039	0.14 ± 0.0042	0.13
NBS 37D	26.79 ± 0.804	25.62 ± 0.769	26.21 ± 0.786	26.65
NBS 158	2.03 ± 0.0609	2.07 ± 0.0621	2.05 ± 0.0615	2.07
NBS 124C	4.87 ± 0.146	5.15 ± 0.155	5.01 ± 0.150	4.93
BCS 207/2	1.58 ± 0.0474	1.62 ± 0.0486	1.60 ± 0.048	1.60

Table III: Elemental Compositions of Lilly Oriental Bronze Samples

SAMPLE	DESCRIPTION	PERCENT ELEMENT											
		Cu	Sn	Pb	Zn	As	Ni	Fe	Mn	Si	P	Sb	Al
1 (c) (foot rim)	48.115; pl. 23 Shang, 13-12th century	≤74*	≥15	≥10	<0.03	>0.10	≤0.05	≤0.004	<0.5	≥0.015	<0.05	<0.02	<0.5
4 (a) (foot rim)	60.32; pl. 35 Eastern Zhou, early 5th century	≤74*	≥15	≥10	<0.03	>0.10	0.23 ±0.047	0.071 ±0.03	<0.5	0.008 ±0.004	<0.05	0.17 ±0.07	<0.5
7 (c) (mouth)	60.32	76.0 ±1.2	14.0 ±0.23	2.86 ±0.061	0.00055 ±0.000017	>0.10	0.17 ±0.034	0.15 ±0.07	<0.5	>0.015	<0.05	0.19 ±0.07	<0.5
10 (a) (cover-interior flange)	60.32	66.3 ±1.0	11.7 ±0.19	18.7 ±0.40	0.0011 ±0.00003	>0.10	0.14 ±0.028	0.22 ±0.11	<0.5	0.002 ±0.001	<0.05	0.18 ±0.07	<0.5
12 (a) (cover-edge)	60.32	n.d.	~50	~50	n.d.							~0.5–1%	
13 (b) (cover-ring)	60.32	~80–90	~5–10	~5–10	n.d.								
16 (b) (leg)	60.77; pl. 28 Zhou, 11th century	73.5 ±1.1	13.1 ±0.21	7.41 ±0.16	0.009 ±0.00027	>0.10	≤0.05	1.3 ±0.32	<0.5	≥0.015	<0.05	0.082 ±0.030	<0.5
18 (b) (leg)	60.288; pl. 24 Shang, 13-12th century	69.6 ±1.1	16.9 ±0.28	5.97 ±0.13	0.007 ±0.00021	>0.10	<0.05	0.068 ±0.034	<0.5	>0.015	<0.05	<0.02	<0.5
21 (d) (loop/handle)	60.288	~80–90	~5–10	~1–5	n.d.								
25 (b) (loop/handle)	48.13; pl. 27 Shang-Zhou 11th century	80.6 ±1.2	12.3 ±0.20	3.42 ±0.073	0.013 ±0.0004	>0.10	<0.05	0.051 ±0.026	<0.5	≤0.005	<0.05	<0.02	<0.5
28 (b) (leg)	48.13	n.d.	~50	~50	n.d.							~0.5–1%	
31 (a) (bottom flange)	60.21; pl. 29 Zhou, 11-10th century	72.3 ±1.1	11.9 ±0.20	11.8 ±0.25	0.026 ±0.00078	≥0.10	<0.05	0.21 ±0.11	<0.5	0.011 ±0.005	<0.05	0.071 ±0.03	<0.5
34 (a) (post)	60.33; pl. 26 Shang, 12th century	78.9 ±1.2	12.4 ±0.20	7.21 ±0.15	0.102 ±0.0031	0.065 ±0.016	≤0.05	≤0.004	<0.5	≤0.005	<0.05	<0.02	<0.5
37 (b) (1inch pin-end)	60.23; Fig. 1 Western Zhou	87.7 ±1.3	7.32 ±0.12	1.75 ±0.037	0.006 ±0.00018	>0.10	<0.05	0.025 ±0.013	<0.5	≥0.015	<0.05	<0.02	<0.5
39 (a) (pin-end)	60.158; Fig. 2 Date uncertain	88.0 ±1.4	1.26 ±0.021	3.28 ±0.070	0.004 ±0.00012	≥0.10	0.31 ±0.061	0.036 ±0.018	<0.5	<0.005	<0.05	<0.02	<0.5
43 (a) (ring interior)	60.161; pl. 36 Eastern Zhou, 5th century	72.4 ±1.1	11.6 ±0.19	13.1 ±0.28	0.005 ±0.00015	>0.10	≤0.05	0.18 ±0.027	<0.5	<0.005	<0.05	0.082 ±0.03	<0.5
45 (b) (cover edge)	60.24; pl. 32 Modern cover	95.6 ±1.5	0.05 ±0.0008	0.65 ±0.013	0.123 ±0.0037	0.065 ±0.016	<0.05	0.018 ±0.009	<0.5	0.009 ±0.005	≤0.05	0.063 ±0.03	<0.5
51 (a) (foot)	60.44; pl. 31 Zhou, 10th century.	67.0 ±1.0	10.9 ±0.18	17.4 ±0.37	0.007 ±0.0021	0.066 ±0.016	<0.05	0.086 ±0.043	<0.5	<0.005	<0.05	<0.02	<0.5
53 (c) (leg)	60.34; pl. 30 Zhou, 10th century	79.9 ±1.2	11.4 ±0.19	5.77 ±0.12	0.0145 ±0.00044	>0.10	<0.05	≤0.004	<0.5	0.005 ±0.003	<0.05	0.04 ±0.02	<0.5
57 (a) (foot rim)	60.43; pl. 25 Shang, 13-12th century	68.9 ±1.1	6.47 ±0.11	21.6 ±0.46	0.023 ±0.00069	>0.10	<0.05	0.003 ±0.0015	<0.5	>0.015	<0.05	≥0.90	<0.5

*Copper by difference

zinc. These are used to estimate the experimental uncertainty associated with each percentage concentration value calculated.

One very important fact can be concluded from the data in Table II—the AAS method is much more accurate than the AES method for the determination of these four elements, with experimental errors in the AAS analyses being about one-tenth those determined for the AES analyses.

The analyses of the Lilly Bronze samples followed exactly the procedure outlined for the analyses of the standard alloys. Results of these analyses are presented in Table III and discussed in the following section.

Results of the Analyses of the Lilly Oriental Bronze Alloys

Fourteen objects were sampled; the elemental compositions of these alloys are presented in Table III. Multiple samples were taken from three different objects; IMA 60.32 had very small amounts of material removed from the vessel foot (sample #4), the mouth (sample #7), and from three separate sites on the cover (samples #10, 12, and 13). IMA 48.13 was sampled at a site known to contain original alloy (sample #25) and also in an area that, from x-radiographic evidence, was suspected of being a later repair (sample #28). IMA 60.288 was sampled at two different sites (samples #18 and 21). As previously mentioned, each sample taken was closely inspected under a microscope and the extent of alloy corrosion and/or contamination estimated. It was not possible to obtain absolutely clean, unreacted alloy from these ancient vessels in every case. However, an awareness of the extent of sample corrosion or contamination aided in the interpretation of the final analytical results. The relative purity of these samples was classified as being:

(a) clean alloy—no corrosion and/or contamination,
(b) small amount of corrosion and/or contamination,
(c) medium to large amount of corrosion,
(d) large amount of corrosion to completely corroded.

The designation of relative sample purity, and a general description of the site from which each sample was taken, are indicated in the first column of Table III. The second column contains the IMA accession number, the plate number, and a brief description of the sampled vessel.

Whenever possible, that is, when at least 15 milligrams of sample were available, these materials were analyzed by both the atomic emission and atomic absorption methods. In these cases, only the more accurate AAS results for copper, tin, lead, and zinc are presented in the table. However, AES determinations of these four elements agreed with the AAS results in every case, within the experimental uncertainty of the AES method. The percentages of all the other elements (i.e., arsenic, nickel, iron, manganese, silicon, phosphorus, antimony, and aluminum) were determined by AES analyses only. Two samples (#25 and 57) were done in duplicate by AAS; the average percentages obtained for Cu, Sn, Pb, and Zn are given in the table. All other compositional values in the table are the results of single determinations. Estimates of experimental uncertainty are also provided. Samples #1 and 4 were analyzed for all elements by AES only—shortage of sample precluded AAS analyses. Also, samples #12, 13, 21, and 28 each weighed less than 5 milligrams, the minimum amount required for quantitative AES determinations. Therefore, 2.0-milligram portions of each of these were analyzed by AES and estimates of the amounts of Cu, Sn, Pb, and Zn present were obtained by visual comparison of their emission line intensities with those produced from vaporization of 2.0-milligram samples of NBS and BCS standard alloys.

Observations from Analytical Results

With one exception, the modern cover of IMA 60.24, all of the vessels analyzed proved to be leaded bronze. It is also quite obvious from the results shown in Table III that none of the alloys contains more than trace to very small quantities of zinc. This is in accord with the findings of other reported bronze analysis studies, which state that zinc was not used as a component of Chinese bronze alloys prior to the Han dynasty (206 B.C.–A.D. 220). It is almost certain that the small amounts of zinc found in the Lilly bronzes were not intentionally added.

The main feature of the compositions of these alloys is their variability. Concentration of lead especially varies widely. No clear pattern of alloy composition is apparent and it would be premature to search for one, as the number of vessels analyzed is, at present, too small to produce meaningful conclusions.

There are, however, certain observations that can be made. The cover from 60.24 has been identified as being of modern origin on the basis of stylistic considerations. X-radiographs of this cover also reveal the lack of internal features (voids within the material) that are quite prominent in the vessel to which it supposedly belonged and that a piece of sheet copper was probably attached at a later time. The composition of sample #45 taken from the edge of this cover shows that it is almost pure copper, with practically no tin and very little lead and zinc present. That the composition of this material is completely different from those of the ancient alloys determined serves to reinforce the other observations made about the age of this object. Sample #28, from an area of IMA 48.13 suspected of being previously repaired, has a composition of roughly equal amounts of tin and lead, with no copper or zinc detected, but does contain a small amount of antimony. This material is a soft solder, and would be used for its properties of low melting point and ease of workability when solid—properties of obvious value when used to carefully repair metal or alloy objects.

An interesting challenge in interpretation of the analytical results is posed by the multiple samples taken from IMA 60.32. Material from the mouth of this vessel (sample #7) has a much lower lead content than the sample taken from the foot (sample #4). It therefore seems possible that the foot of this vessel was cast separately, using an alloy of different composition. In addition, the cover

of this vessel is stylistically different from the vessel body. This cover, from which three samples were removed (samples #10, 12, and 13), is also of a different composition than the body. Sample #10 contains much more lead than does the body of the vessel, and thus resembles the alloy taken from the foot more than it does the body alloy. The cover was also shown to contain "repaired" areas (by x-radiography); sample #12, from one of these areas, has a composition of about 50% tin/50% lead, with no copper or zinc in evidence, but again containing a small amount of antimony. Sample #13 was so corroded, and of such small size, that we can only say that the alloy was once a leaded bronze.

It is apparent that materials analysis data, in combination with x-radiographic and art historical evidence, can be quite helpful in answering specific questions such as those discussed. However, general conclusions about ancient metallurgical practices require not only accurate analytical methods, but equally important, the availability of a large body of authentic objects that can be sampled and studied. The results presented here represent only the first phase of a continuing art-historical/materials analysis study of this most interesting group of ancient Chinese artifacts.

Acknowledgements

We wish to thank Mr. Lawrence Hipsher of Detroit Diesel-Allison Division, General Motors Corporation, for help in the production and interpretation of the x-radiographs, and Dr. Douglas Schrader of Varian Associates, Inc., for allowing us to use its Atomic Absorption Spectrometer in these studies. The contributions of Dr. David Malik, Rebecca Love, and Mrs. Barbara McDaniel (Department of Chemistry, Indiana University-Purdue University at Indianapolis) in developing the computer programs are also greatly appreciated.

We finally would like to thank the Oriental Department for making available for study the authentic bronze vessels of the Eli Lilly Collection.

Technical Observations
Yutaka Mino and James Robinson

Plate 20
HU

The *hu* was cast from a two-section piece mold that joined at the ends of the two design segments, above the rectangular holes of the foot. A ridge (mold seam?) is located on the exterior bottom joining the cruciform holes. Two chaplets (spacers) are in the seam at the bottom, four around the plain surface below the main decor, and possibly two others are in the neck and the plain band between design bands. From the overflow of metal at the base of the knob, it appears that the lid and stem were cast onto the knob. The surface color is a mottled, darkish green. The other dimensions of the *hu* are diameter, 2¾ inches (6.9 cm.) at the mouth and 4⅞ inches (12.6 cm.) for the body. The weight with lid is 1 lb 15.5 oz.

Plate 21
FANGYI

There is a seam under the lugs indicating a mold join, but other seams are not visible. The bottom appears to have four chaplets in three corners, and the lid appears to have two. This thin-walled vessel has suffered some damage in the past. There are several fracture lines in the lid and body, and presumably soft solder has been used to rejoin the several broken pieces of the body. The top knob of the lid may be the only replaced piece. The body is a purplish gray with patches of deep green patina. The dimensions of the mouth are 4¾ x 3¾ inches (12.2 x 9.5 cm.). The weight is 2 lb 15.5 oz.

Plate 22
JUE

The pointed tip opposite the spout has been broken and repaired. The solid posts, handle, and grooved legs were apparently cast onto the caps at the same time. A four-piece mold, joined at the flanges, was used to cast the body. The smooth olive green color is accented by a black inlay. The *jue* weighs 1 lb 3 oz.

Plate 23
GU

Technically, this is one of the finest vessels in the collection. The metal is smooth without many voids, and the casting is sharp and accurate to the smallest detail. Only one mold seam can be discerned on the bottom side of

one flange between a *taotie*. In the center of the bottom is a large square chaplet and an antique (?) repair. The overall color is a grayish green with heavy spots of light blue. This vessel's other dimensions are: diameter, 6¾ inches (17.3 cm.), and weight, 2 lb 10 oz. The percentages of major constituents are as follows:

74 (copper); ≥15 (tin); ≥10 (lead); <0.03 (zinc).

Plate 24
DING

Seams of the three-piece mold that was used to cast the body can be seen in the middle of each hanging blade that is above a leg, and it is obvious that the molds were well aligned. The single tiger motif is bisected by the mold seam. Seven rectangular chaplets can be discerned in the bottom of the bowl. There is black inlay in the grooves and the surface is a grayish green. The diameter of the bowl is 6¼ inches (16.0 cm.), and the vessel weighs 3 lb 12.5 oz. The analysis of a sample taken from the leg yielded percentages of major constituents as follows:

69.6 (copper); 16.9 (tin); 5.97 (lead); 0.007 (zinc).

Plate 25
GUANG

The many voids in the bronze slightly affected the quality of casting by creating holes that prohibited the accurate transfer of the design from the mold. Several of these areas where the design did not register were filled with a subsequent pour(s) of metal. The dragon horns and "tongue" of the rear *taotie* and the bottle horns of the front beast were made separately, and the lid was cast to them. The black fill inlay highlights the bluish gray color of the surface. The other dimensions include: width, 6 inches (15.2 cm.); and weight, 3 lb 7.5 oz. without the lid, which weighs 1 lb 15.5 oz. The analysis of the major elements in the sample taken from the foot rim yielded these percentages:

68.9 (copper); 6.47 (tin); 21.6 (lead); 0.023 (zinc).

Plate 26
JIA

The tall, hollow caps on the posts were placed into the mold and the vessel was cast on to them. A three-piece mold was used to cast the vessel, and the seams can still be seen on the front surface of each leg and behind the flat handle. Each mold section contained one complete design segment. Three rectangular chaplets are in the front part of the bottom, yet each remains in a separate

section defined by lines from the three legs to the center. The deep grooves in both sides of each leg have a thin layer of metal enclosing the clay core, and in the handle side groove of each leg a rectangular hole pierces this layer of metal, exposing the clay core. These holes may be remnants of a core positioning technique used at the foundry. The radiograph shows the metal to be fairly smooth and even textured except for the area by the rear leg and handle, which is dense with air pockets. This may indicate the casting vent was at the bottom of this rear leg. The color is a shiny, dark green, and the other dimensions are as follows: height to mouth, 9 inches (22.7 cm.); diameter at mouth, 6¼ inches (15.8 cm.); and weight, 5 lb 3 oz. An analysis of the major constituents yielded the following percentages:

78.9 (copper); 12.4 (tin); 7.21 (lead); 0.102 (zinc).

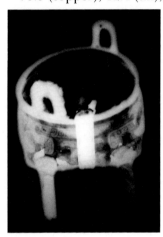

Plate 27
LIDING

The vessel appears to have been made from one pour, and the mold seams bisect the faces above the legs. Three large rectangular chaplets were placed near each leg toward the center of the bowl. The clay in the core of the two side legs has been replaced by a metal fill. The repairs made around the tops of the legs were probably recent and done with a soft solder compound. The black inlay in the grooves highlights the bluish green color of the metal. The diameter of the bowl is 6⅝ inches (16.7 cm.), and the weight is 4 lb 12 oz. The metal samples taken from the back of the left handle and a leg yielded the following percentages of the major constituents:

80.6 (copper); 12.3 (tin); 3.42 (lead); 0.013 (zinc).

Plate 28
FANGDING

A well-cast vessel with moderate porosity in the metal, it was made with a four-piece mold that joined at the

corner flanges. The legs are solid, and the vessel was apparently cast in one piece. Two ridges as broad as the legs join the legs diagonally, and two small relief lines parallel each larger ridge. Four rectangular chaplets are spaced equally near the central point where the diagonals cross. The measurements for the bowl are as follows: length, 6⅞ inches (17.4 cm.); width, 5⅝ inches (14.4 cm.); depth, 3½ inches (9 cm.); and weight, 8 lb 2 oz. The analysis of the major elements in the sample yielded the following percentages:

73.5 (copper); 13.1 (tin); 7.41 (lead); 0.009 (zinc).

Plate 29
ZUN

The seams from the four-part piece mold are visible on the lower end of each flange. Three reinforcements, equally spaced between the exterior convex bottom and the inside wall, were cast with the vessel. The radiograph through the bottom shows that the inscription is in an irregularly shaped piece of metal that is now surrounded by a light line and intrudes on the chaplet. The color is a smooth, mottled blackish green. The diameter at the mouth is 8¼ inches (21.1 cm.), and the weight is 5 lb 5 oz. The analysis of the sample yielded the following percentages of the major constituents:

72.3 (copper); 11.9 (tin); 11.8 (lead); 0.026 (zinc).

Plate 30
HE

The vessel has been shattered and well restored with the original parts for all but possibly a few pieces. The mold seam discernible in the handle and by the spout suggests a two-piece mold was used to cast the *he*, as does the seam present in the arched motif on the lid. Other dimensions for this mottled light green vessel include: diameter, 5⅜ inches (13.7 cm.) at mouth; 7⅛ inches (18.0 cm.) of body; and a weight of 5 lb 13.5 oz. The analysis of the major elements yielded the following composition percentages:

79.9 (copper); 11.4 (tin); 5.77 (lead); 0.0145 (zinc).

Plate 31
GUI

The *gui* was cast with a piece mold that joined in the middle of the handles, and the core in the C-shaped handles is still visible. The other measurements for this vessel include: diameter of mouth, 7⅜ inches (18.8 cm.); width across handles, 10¼ inches (26.0 cm.); and weight, 4 lb 4.5 oz. The surface is a grayish color with areas of brownish red corrosion. Analysis of the sample yielded the following percentage composition for the major elements:

67.0 (copper); 10.9 (tin); 17.4 (lead); 0.007 (zinc).

Plate 32
YOU

The exterior of the base has a grid design of raised lines, and the chaplets in the bottom are randomly placed. Two chaplets are of particular note. One is under part of the inscription, showing that the characters were not cast with the vessel. The other interesting chaplet has a fine spiral pattern of *leiwen* on it. This means that an old, possibly broken or unsuccessfully cast vessel was salvaged and used in the manufacture of this object. The practice of recycling old bronzes is manifested in other bronze vessels. (See Gettens, *The Freer Chinese Bronzes*, vol. 2, 1969, p. 101.)

The radiograph shows that the body of the vessel was smashed and repaired, and that the metal of the cover and handle is practically flawless if compared with that of the body. The forge-welded line joining the sheet of metal used to make the lid is clearly visible. The analysis of the metal from the lid confirms its modern date. The color of the vessel is grayish green with areas of brown and blackish-green patina. The dark coloring may not be all natural as it also occurs on the modern cover. The body weighs 6 lb 3 oz. Analysis of the metal in the cover, yielding the following percentages, showed it to be practically pure copper:

95.6 (copper); 0.05 (tin); 0.65 (lead); 0.123 (zinc).

Plate 35
HU

The seams from the two-part mold can be determined by the interruptions in the design bands that occur in each side halfway between the pre-cast *taotie* bosses. The seams are very unobtrusive and prove to be no interruption to the designs, which cross them smoothly. The other dimensions of this vessel include: diameter, 12¾ inches, (32.4 cm.) for the body; 6¾ inches (17.0 cm.) for the mouth; and weight, 32 lb 4.5 oz. Samples taken from the body yielded the following composition percentages for the major elements:

76.0 (copper); 14.0 (tin); 2.86 (lead); 0.00055 (zinc). The entire circumference of the lid rim has been built out (made to fit the container?) with metal of a high lead content, as shown in the radiograph. The analysis of the metal of the lid yielded in percentages:

66.3 (copper); 11.7 (tin); 18.7 (lead); 0.0011 (zinc).

Plate 36
AXLE-CAP (CHEWEI)
The analysis of the metal yielded the following composition percentages for the major elements:

72.4 (copper); 11.6 (tin); 13.1 (lead); 0.005 (zinc).